741.092 RAP

£28.50

UNIVERSITY OF WESTMINSTER

Failure to return or renew overdue books may result in suspension of borrowing rights at all University libraries

Due for return on :

10 NOV 1995

- 9 JAN 1996

- 9 FEB 1996

- 4 MAR 1996

1 3 FEB 1997

- 3 FEB 1998

2 8 MAY 1998

2 5 JAN 1999

1 2 JAN 2000

- 7 JAN 2002

1 3 NOV 2003

Information Resource Services
HARROW LIBRARIES
Watford Road Northwick Park
Harrow Middlesex HA1 3TP
Telephone 071 911 5000 ext 4046 (ML) ext 4109 (A&D)

D1342572

HARROW COLLEGE LIBRARY

3 8022 00047558 2

2/88

DRAWINGS BY RAPHAEL
AND HIS CIRCLE

Drawings by Raphael and his Circle

From British and North American Collections

J. A. GERE

The Pierpont Morgan Library · New York

COPYRIGHT © 1987 BY THE PIERPONT MORGAN LIBRARY

29 EAST 36 STREET, NEW YORK, N.Y. 10016

PRINTED IN THE UNITED STATES OF AMERICA

LIBRARY OF CONGRESS CATALOGUE CARD NUMBER 87–62239

ISBN 87598–083–X

COVER ILLUSTRATION:

38 Raphael *Head of a Young Man with Curly Hair; a Left Hand*

Photograph: Courtesy of Christie's

This exhibition has been sponsored by the IBM Corporation and the Robert Lehman Foundation. Additional support has been provided by the National Endowment for the Arts and by an indemnity from the Federal Council for the Arts and Humanities. It has been presented in conjunction with "Italy on Stage 1987," a celebration of Italian cultural traditions.

THIS BOOK HAS BEEN COMPOSED, PRINTED AND BOUND

BY MERIDEN-STINEHOUR PRESS

MERIDEN, CONNECTICUT AND LUNENBURG, VERMONT

THE DESIGN IS BY STEPHEN HARVARD

CONTENTS

PREFACE

THIS EXHIBITION has been planned for more than a decade, and in preparation for at least four years. When I first began to work on the exhibition of drawings by Michelangelo which was held at The Pierpont Morgan Library in 1979, I hoped that some day the Library might have comparable ones of Raphael and Leonardo. There were very few works of these greatest draughtsmen and painters of the High Renaissance in American public or private collections. Nor had we had in this country exhibitions of any real significance. The Morgan Library exhibition of Michelangelo drawings was taken principally from the marvelous collection at the British Museum. Since then there have been outstanding shows of Leonardo's drawings and sketches, usually from the Royal Collection at Windsor, in a number of American institutions.

In 1983–84 there were celebrations of the five-hundredth anniversary of Raphael's birth in several European cities and also in America. The exhibitions of drawings held at the British Museum and the Louvre were distinguished occasions. It was clear that it would probably be impossible to have an exhibition in the United States on a scale of those in Europe: the problems of securing loans and the financing of a large exhibition here devoted only to drawings by Raphael would have been insurmountable. We also wished to make a contribution to Raphael studies which would have been very difficult if we had limited our showing to well-known published drawings by the master. I felt that it would be of unusual value to scholars and to the public generally if we could see Raphael in relation to the artists working in his circle in Rome. Therefore, nearly half of the works described in this volume are by Raphael; the others are by Giulio Romano, Giovanni Francesco Penni, Perino del Vaga, Polidoro da Caravaggio, and Baldassare Peruzzi.

With the support of the Director of the British Museum, Sir David Wilson, we began negotiations with that institution and the three other great collections in England. They have been extremely generous; when we had difficulty in obtaining works necessary in establishing relationships or showing critical aspects of an artist's work, the Royal Library at Windsor Castle and the Devonshire Collection at Chatsworth invariably came to our assistance and provided yet another loan. Our indebtedness to those two collections and to the British Museum and the Ashmolean Museum in Oxford is enormous. The exhibition in New York is overwhelmingly dependent on them. We owe special thanks to Sir David and to Mr. John Rowlands and Mr. Nicholas Turner at the British Museum; at Windsor, to Mr. Oliver Everett and the Hon. Mrs. Jane

Roberts; at Chatsworth, to the Duke and Duchess of Devonshire and to Mr. Peter Day; at the Ashmolean, to Mr. Christopher White and Dr. Nicholas Penny. Other lenders who have graciously permitted us to show drawings in their collections are: the Ball State University Art Gallery, Duke Roberto Ferretti, the Isabella Stewart Gardner Museum, The J. Paul Getty Museum, The Armand Hammer Foundation, Robert and Bertina Suida Manning, Mr. Joseph F. McCrindle, The Metropolitan Museum of Art, The National Gallery of Scotland, Barbara Piasecka-Johnson, Mr. David E. Rust, Vermeer Associates, The Victoria and Albert Museum, and three anonymous lenders.

From the beginning of our plans for this exhibition, we had hoped to have the catalogue prepared by the distinguished student of Italian drawings, Mr. J. A. Gere, former Keeper of Prints and Drawings at the British Museum, who had worked on Raphael for so many years, and was the co-author, with Mr. Turner, of the catalogue of the British Museum exhibition of 1983. We are above all grateful to him. We should also like to thank Mrs. Cara Dufour Denison, who has been most helpful here at the Morgan Library, as have Miss Priscilla Barker, Miss Deborah Winard, and Mr. David W. Wright; others assisting us have been Ms. Elizabeth Allen, Mr. Timothy Herstein, Mr. David A. Loggie, Mr. Francis S. Mason, Jr., Mrs. Patricia Reyes, Ms. Nancy Seaton, Ms. Lynn Thommen, Ms. Stephanie Wiles, and Miss Elizabeth Wilson. We are also indebted to Miss Bernice Davidson and Mr. Philip Pouncey. It has, as always, been a pleasure to work with Mr. Stephen Harvard and his colleagues at Meriden-Stinehour Press. The exhibition has been made possible by generous grants from the IBM Corporation and the Robert Lehman Foundation. Additional support has been provided by the National Endowment for the Arts and by an indemnity from the Federal Council for the Arts and Humanities.

As I write these words at the end of March, I am still Director of The Pierpont Morgan Library, but I shall be Director of The Frick Collection by the time the exhibition opens. I have been very close to this exhibition from its inception, and am deeply grateful to have been able to work on it as well as on so many others for nearly eighteen years at the Morgan Library.

CHARLES RYSKAMP

INTRODUCTION

THIS EXHIBITION of ninety-one drawings by Raphael and his Roman circle, drawn from collections in Britain and the United States, will be seen as in some sense a sequel to that of twenty-four drawings by Michelangelo from the British Museum which The Pierpont Morgan Library mounted in 1979. The names of Michelangelo and Raphael are often coupled and contrasted, as if they formed one of those pairs of contemporaries—Rubens and Poussin, Ingres and Delacroix, Turner and Constable—who have come to be seen as the focal points of opposing artistic tendencies. In the case of Michelangelo and Raphael this would be an oversimplification: Michelangelo exercised a decisive influence on the younger artist, and the difference between them was mainly one of personality and temperament. Michelangelo originated the traditional stereotype of the "poor, lonely and independent old artist man." His genius was essentially solitary, and his inspiration sprung from the most profound level of his inner consciousness. Raphael was sociable by temperament, and so much the product of his environment that he was to an almost abnormal degree susceptible to the influence of others. When his career is surveyed as a whole, its most striking feature seems to be his power of singling out whatever he found of value in the work of his contemporaries and absorbing and transmuting it in terms of his own creative imagination. He had a no less remarkable ability to formulate universal artistic concepts communicable not only to his own followers and contemporaries but also to later generations. It would be an anachronism, and also an injustice, to describe Raphael as an "academic" artist; but it is he above all who stands behind all later academic art, and it was the principles of design and composition deduced from his later work that formed the basis of the "Grand Style" that was to dominate European painting for the next three hundred years. As Joshua Reynolds said of him, "it is from his having taken so many models, that he became himself a model for all succeeding painters: always imitating and always original."

Raphael received his early training in Umbria, in the studio of Perugino, whose graceful but limited and retardataire style he developed to the utmost pitch of refinement. He also assisted Pintoricchio with the decoration of the Piccolomini Library in Siena Cathedral (see Nos. 3 and 4). By about 1504 he had absorbed everything that his Umbrian masters could teach him, and transferred the center of his activities to Florence. He had a way of finding himself in the right place in exactly the right moment: the four or five years that he spent there coincided with a brief period when Florence had

once again become the focus of intense artistic innovation. It so happened that Leonardo da Vinci and Michelangelo were there at that time, and that each had been asked to carry out a fresco of a subject from Florentine history in the Palazzo della Signoria. The cartoons that they made for these had an overwhelming effect on the younger generation of artists. Leonardo's *Battle of Anghiari* was the culmination of the development towards the High Renaissance style which he had initiated in Florence twenty-five years earlier with his unfinished *Adoration of the Magi*; Michelangelo's *Bathers*, the only completed section of the cartoon for his *Battle of Cascina*, prefigures the disintegration of the High Renaissance style into what is now called Mannerism. These works were to exercise a profound effect on Raphael, but this did not become apparent until after he had left Florence and established himself in Rome (see Nos. 13 and 19).

Raphael's activity in Florence was mostly confined to smallish panels of *The Holy Family* or *The Virgin and Child*; but in Pope Julius II, who invited him to Rome in 1508, he found a patron with the means and the opportunity to employ him on the large-scale projects that his genius required for its fullest expression, and the perceptiveness to allow him an entirely free hand. As part of his plan to make Rome visibly the capital of Christendom, Julius brought Michelangelo from Florence to paint the ceiling of the Sistine Chapel and Raphael to decorate the Pope's private apartments in the Vatican. The result was that Rome came to supplant Florence as the vital center of artistic activity. The first paintings that Raphael carried out in the Vatican, in the Stanza della Segnatura (see Nos. 13–16), are the culmination of his Florentine experience, enriched and enlarged by the scale on which he was required to work and by the grandeur and scale of Rome herself. Between the Segnatura and the adjoining Stanza d'Eliodoro came a stylistic break reflecting the influence of Michelangelo's Sistine ceiling (completed 1511–12). The lighting is more dramatic, the color darker and more intense, and the compositions more animated and more tightly knit. This Michelangelesque phase was followed, in the Tapestry Cartoons which were the chief work executed for Julius's successor Leo X (see Nos. 26–30), by a return to the more serene mood of the Segnatura frescoes, with a greater degree of academic idealization. The Cartoons have been described as "the Parthenon Sculptures of Modern Art." It was they above all that established the classical formulae of figure composition from which the "Grand Style" ultimately derived. In his later years, Raphael's conceptual tendency of mind led him to attach more importance to invention than to execution, and as time went on pressure of work obliged him to rely more and more on the help of studio assistants. The power of synthesis that enabled him to absorb a succession of varied stylistic influences was balanced by a power of analysis that made it possible for him to break down the complicated process of realizing a large-scale work in such a way that much of the labor could be delegated to a team of highly trained assistants. Nowhere is the contrast between Michelangelo and Raphael more apparent than in the organization and function of their studios.

Michelangelo germinated his ideas in solitude, and his thoughts were incommunicable. He employed a number of *garzoni* when decorating the Sistine ceiling—it would have been physically impossible to carry out so vast an undertaking single-handed—but their function seems to have been of a purely mechanical and even menial kind. Raphael, on the other hand, attracted to himself and admitted to participation in his creative processes some of the most talented of the younger generation. The later careers of Giulio Romano, Perino del Vaga and Polidoro da Caravaggio, each of whom developed brilliantly in his own individual way, are testimony to Raphael's quality as an inspiring teacher.

Considered simply as works of art in their own right, Raphael's drawings are some of the most beautiful ever made, but it is characteristic of the highly disciplined quality of his mind that his approach to drawing should have been essentially utilitarian. He was not one of those artists, of whom Rembrandt is the most obvious example, who loved drawing for its own sake and used it as an alternative medium for the expression of pictorial ideas. From the unusually precocious age when he reached artistic maturity, Raphael seems never to have made a drawing except as a necessary stage in the realization of a finished work. He was not self-consciously preoccupied with the attractive "look of the sheet." No artist of the period made such extensive use of the time-saving technique of preliminary sketching with the stylus; often we find him concentrating on one particular aspect or detail of a study, leaving the rest only roughly sketched in; once a study had served its immediate purpose it was either abandoned or used as basis for a further study by tracing through to another sheet. His drawings illustrate the well-organized method of building up a composition that he had learned during his apprenticeship in Perugino's studio, and which was to become standard academic practice. They include rough sketches for compositions; more carefully finished drafts; studies for separate groups of figures; studies for single figures, often drawn from a model posed in the studio in order to fix a pose or study the fall of drapery; a complicated composition would reach its final form as a small *modello* drawing which served as basis for the full-scale cartoon; and even at this late stage Raphael introduced the additional refinement of the "auxiliary cartoon" (see No. 38).

The present exhibition is both an abridgment and an enlargement of the one held in the British Museum in 1983 to celebrate the five-hundredth anniversary of Raphael's birth, which set out to include every drawing by him in British collections. All but eighteen of the 102 drawings were catalogued as by Raphael himself, the remainder being attributed to his studio assistants Giulio Romano and Giovanni Francesco Penni. Of the ninety-one drawings now shown at The Pierpont Morgan Library, only forty-eight are by or attributed to Raphael himself. Greater emphasis is given to the studio, and the artists included in this section, in addition to Giulio and Penni, are the two slightly younger studio assistants Perino del Vaga and Polidoro da Caravaggio and

Raphael's Sienese contemporary and associate in Rome Baldassare Peruzzi. All but ten of the forty-eight sheets catalogued under the name of Raphael come from four collections: the British Museum, the Ashmolean Museum in Oxford, the Royal Library at Windsor Castle and the Devonshire Collection at Chatsworth. With the exception of No. 5, the others come from public and private collections in the United States, as do a further three which in 1983 were still in England: No. 14, formerly in the Loyd Collection, and Nos. 28 and 38, formerly at Chatsworth.

The scope of the London exhibition made possible a balanced survey of all phases and aspects of Raphael's development as a draughtsman. This one is on a relatively smaller scale, and its scope has been further limited by what it was not possible to borrow, with the result that the Umbrian period has had to be reduced to a token representation. It must be looked upon as an anthology, and one in which the emphasis is on Raphael's Roman period, with particular reference to his relationship with his studio. His two principal assistants were Giulio Romano (b. c. 1499) and the enigmatic Giovanni Francesco Penni (b. 1496). They collaborated closely with Raphael on such decorative projects as the Psyche Loggia in the Villa Farnesina (see No. 35) and the Stanza dell' Incendio in the Vatican, and after his death it was they who inherited the business and goodwill of the studio, continuing in partnership until Giulio's departure from Rome in 1524. Perino and Polidoro were only very slightly younger (Perino was born in 1501 and Polidoro probably at about the same time), but they seem to have been less closely involved in Raphael's activities. Vasari says that both began their careers in the Vatican Loggia, the decoration of which is datable 1518–19.

Whatever effect the intervention of studio assistants as executants in the collaborative undertakings of Raphael's later years may have had on the final result, there is no reason to doubt that his was the directing creative intelligence. This complicates the already difficult problem of drawings connected with his later works, some of which are clearly by him and others apparently products of his studio. In technique and style Giulio and Penni were trained to follow him as closely as possible, so that in these respects his drawings and theirs are indistinguishable. The criterion of "quality" is always subjective and often fallible—especially when the creative invention was the master's. The most reliable guide is the underlying artistic personality of the draughtsman, in so far as this can be inferred from the work of his independent maturity; and even here the possibility has always to be borne in mind that the master, especially if like Raphael he died relatively young, may have adumbrated motifs and turns of expression which his followers went on to develop more fully and which have come to seem typical of them.

Giulio in fact presents a fairly straightforward problem. The years from 1524 until his death in 1546 he spent at the court of Mantua. Much of his Mantuan work has survived in the form of paintings and drawings. It reveals a profoundly anti-classical Mannerist mentality, in every way the converse of Raphael's. The stylistic divergence

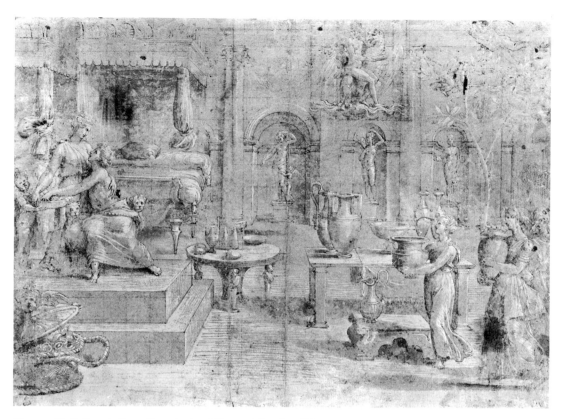

Fig. 1 G. F. Penni. *Scene from Ancient History.* Albertina, Vienna.

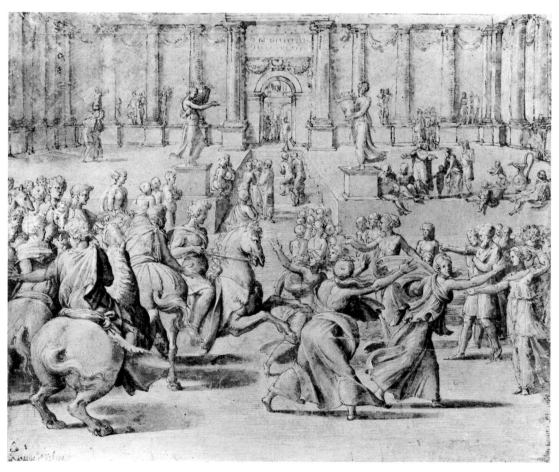

Fig. 2 G. F. Penni. *Scene from Ancient History.* Albertina, Vienna.

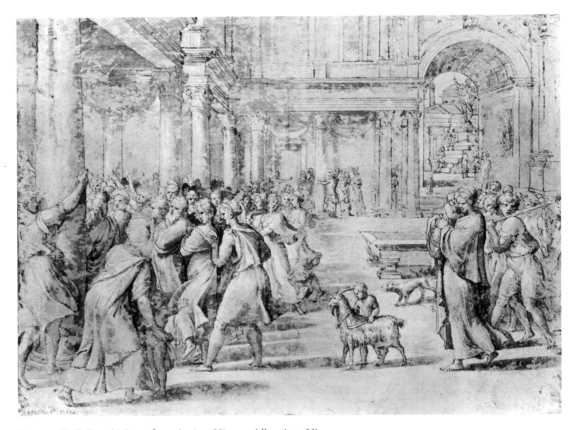

Fig. 3 G. F. Penni. *Scene from Ancient History*. Albertina, Vienna.

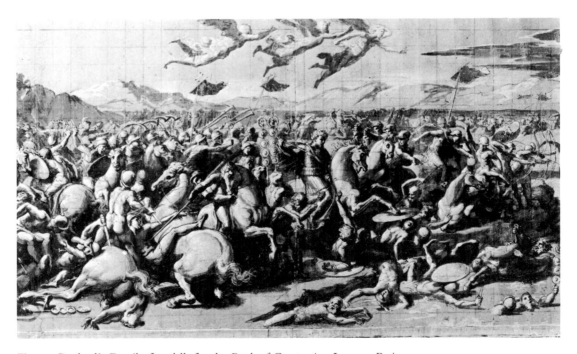

Fig. 4 Raphael?. Detail of *modello* for the *Battle of Constantine*. Louvre, Paris.

is already apparent in the Sala di Costantino in the Vatican (see Nos. 40 and 61), the decoration of which was begun by Raphael shortly before his death and then completed by Giulio. The flavor of Giulio's personality is so strong that it permeates even drawings that he produced in Raphael's studio during the master's lifetime (e.g. Nos. 56–59). As Konrad Oberhuber has demonstrated, these form a well-defined and consistent group.

Penni is the unknown quantity in the equation. His artistic personality has proved to be abnormally elusive. Vasari's account of him is significantly brief: he entered Raphael's studio when only a boy; there he acquired the nickname "il Fattore"; he preferred drawing to painting and made many finished drawings ("disegni finiti"); after the partnership with Giulio came to an end in 1524 he was clearly unable to make an independent career for himself, and when he followed Giulio to Mantua in the hope of resuming their association he was rebuffed. In recent years a number of drawings of the finished *modello* type that must have emanated from Raphael's studio have been attributed to Penni. They mostly reproduce compositions by Raphael himself, and their style can be defined only in terms of his; but they seem too weak and timid in handling to be by Raphael himself, and they contain hardly any *pentimenti* or other signs of creative struggle. The theoretical possibility that they are very early drawings by Giulio, or Perino or Polidoro dating from a period before the draughtsman's style was formed when he might have been wholly dominated by Raphael, is excluded by the existence of some by the same hand that must be products of Giulio's studio in the early 1520s (e.g. Nos. 53 and 61) and others that reveal the level of the draughtsman's unaided efforts (e.g. Nos. 52 and 55). Three drawings of subjects from ancient history in the Albertina (Figs. 1–3) were attributed to this hand by Philip Pouncey, who pointed out that they can hardly be much earlier than c. 1530, and that they have nothing to do with the well-defined mature styles of Giulio, Perino or Polidoro.

Everything that can be inferred from these drawings about the career and personality of the draughtsman conforms with Vasari's account of Penni. The attribution, though arrived at solely by process of elimination, remains on the whole a valid working hypothesis. Penni's nickname "il Fattore" might suggest that he was that indispensable member of any organization, the man who gets things done and is prepared to undertake the necessary drudgery. His apparent role in the studio has been neatly defined by John Shearman as "secretarial": we must imagine an assistant lacking creative talent but trained to act as a kind of artistic amanuensis, capable of interpreting the master's ideas and working them up into tidy and clearly intelligible *modelli* in a style closely based on his.

Recently, however, the homogeneity of this group of drawings has been questioned. The problem has not yet been ventilated in full, but it was touched on by Oberhuber apropos of the large and once greatly admired *modello* in the Louvre (Fig. 4) for the *Battle of Constantine* in the Sala di Costantino (*Raffaello architetto*, pp. 329 ff.) and by

Sylvia Ferino Pagden—who also refers to the oral opinion of John Shearman—apropos of the two Loggia *modelli* in the Uffizi (*Raffaello a Firenze*, exh. 1984, pp. 290 f.). There can be no doubt about Raphael's responsibility for the composition of the *Battle of Constantine* (see No. 40), but the *modello* has until recently been accepted as part of the Penni group. This view is challenged by Oberhuber, who argues in favor of the traditional attribution to Raphael; and after studying the drawing long and carefully and trying to see it as if for the first time, without any preconceived ideas, there does seem to be a rhythm and an intellectual control of the magnificently organized grouping of the figures that put it in an altogether higher class than such *modelli* as Nos. 49 and 50. The faces too are as expressive as they can be within the classical convention. In handling and facial psychology it seems impossible to dissociate the *modello* for the *Battle* from the one at Chatsworth for the *Allocution of Constantine* on another wall of the same room (No. 48). It is instructive to place the Louvre drawing alongside one for yet another detail of the Sala di Costantino decoration: the *modello*, also in the Louvre, for a niche containing one of the figures of historical Popes (Fig. 5), seems by comparison

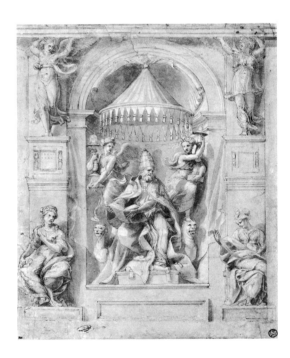

Fig. 5 G. F. Penni, after Raphael.
Modello for the Sala di Costantino.
Louvre, Paris.

dryly schematic and even technically different in such details as the blobby application of the white heightening, which in the other drawing is applied in a system of fine hatching with long thin parallel strokes.

The largest group of *modelli* is connected with the series of fifty-two biblical subjects, all but four taken from the Old Testament, painted by Raphael's assistants under his

supervision on the vault of the Vatican Loggia (see No. 43). Most, if not all, of the artists recorded as having been his studio assistants are mentioned by Vasari in connection with the Loggia: not only Giulio, Penni, Perino and Polidoro but also the more obscure Vincenzo Tamagni, Tommaso Vincidor and Pellegrino Munari, as well as Giovanni da Udine who was responsible for the Grotteschi. We are here concerned not with identifying the various hands responsible for the execution of the frescoes, but only with their design. There seems every reason for attributing this to Raphael himself. So fluent and inventive a draughtsman would hardly have entrusted his assistants, however well-trained, with the task of devising a complicated decorative commission for the Pope himself; and in fact it is noticeable that though the small scale of the Loggia frescoes and their distance from the floor make them not altogether easy to see, they have a consistent but never monotonous narrative clarity that makes the action in each one immediately intelligible, and that must be the product of a single intelligence. As Kenneth Clark put it, "all these beautiful inventions have an inexhaustible flow that can properly be described as Mozartian; and the imagination behind them can only be that of Raphael himself" (*Apollo*, c [1974], p. 258). It is not surprising that during the sixteenth and seventeenth centuries prints of this series of images were widely popular under the name of *Raphael's Bible*.

The two drawings for the Loggia with the best claim to be given to Raphael himself are the black chalk sketch in the Albertina (1983, no. 44; Oberhuber-Fischel 468) for three figures in the fresco of *David and Goliath*, one drawn from a *garzone di bottega* wearing contemporary dress, and the *modello* in the Louvre (Fig. 6; Louvre 1983, no.

Fig. 6 Raphael.
Moses Receiving the Tables of the Law.
Cabinet des Dessins, Musée du Louvre, Paris.

106; Oberhuber-Fischel 465) for *Moses Receiving the Tables of the Law*). This *modello* resembles most of the others in its technique of pen and brown wash over black chalk

heightened with white and squared in black chalk, but the penwork and the way of indicating clouds and landscape with the brush point are free and vigorous to the point of roughness, and there are *pentimenti* of the kind that suggest the hesitation of the creative thinker. Like the others, this *modello* agrees in all essentials with the fresco, but it does not have the insipidly overall accentless appearance of a "fair copy" drawing. Again it is difficult to disagree with Oberhuber's contention that the draughtsman is likely to have been Raphael himself.

Once the possibility of Raphael's authorship of one of the *modelli* is admitted, it becomes a theoretical possibility for all the others. These must be looked at critically again from this point of view. They can be placed roughly in some sort of descending order of merit, with the Louvre *Moses* at the top, but the gradations of quality are so subtle that it is very hard to determine the exact point at which the caesura between Raphael and Penni should be inserted. This introduction is not the place for an analysis of every drawing in the group; but of the five here exhibited, it could be argued that the British Museum *David and Bathsheba* (No. 44) goes very well with the Louvre *Moses*. Bathsheba's drapery is very like his, and there is also the same rapid, impatient, confident quality of penwork, especially evident in the way the architecture is dashed in freehand without any regard for correct perspective.

The *Isaac and Esau* in the Ashmolean Museum (No. 46) has, in contrast, all the appearance of a fair copy *modello*. It is very much more delicate, even dainty, in handling, but there are passages in it of great beauty—the sensitive drawing of the right hand of Isaac, for example, the play of alternate light and shade on the arms and hands of Jacob in the background—that if not by Raphael himself show his amanuensis drawing, as it were, at his dictation and so well able to interpret his intentions as to transcend, quite exceptionally, his own limitations of technique and personality. The Louvre *Battle of Constantine* is equally a fair copy *modello*, and in it there are some heads, especially in the right foreground, that are identical with Isaac's in structure, psychology and expression.

The Windsor *Division of the Promised Land* (No. 47), though it likewise corresponds exactly with the finished painting, has the appearance of a preliminary sketch. Robinson, an experienced and sensitive connoisseur, singled it out as the only Loggia drawing unquestionably by Raphael himself (in the 1860s he could not have known either the *David and Bathsheba* or the *Isaac and Esau*). Popham, on the other hand, catalogued it as "School of Raphael," with the comment "the mannerisms of drawing come very close indeed to Raphael himself, and I suspect that it is a copy of his original design. The drawing is much too sloppy to be actually by him." But it does not look like a copy, by which Popham presumably meant a line-for-line facsimile; and what he saw as "sloppiness" might be more charitably interpreted as impatient but masterly rapidity. An example of a composition sketch in pen and ink that is certainly by Raphael and

corresponds exactly with the final result is the study also at Windsor for an earlier work, the *Judgment of Zaleucus* in the Stanza della Segnatura (Popham 797 verso; Oberhuber-Fischel 419). The possibility that the *Division of the Land* drawing might be by the same draughtsman at a somewhat later stage and in a hastier and more impatient mood, is at least worth considering.

The *Expulsion from Paradise*, also at Windsor (No. 43) is, in the literal sense of the term, a shadow of its former self. An old photograph taken in the 1850s (repr. British Museum 1983, p. 238) shows that it was originally in the same technique as most of the Loggia *modelli*, of pen and wash heightened with white over black chalk. In the middle of the last century the apparent absence of studies for the Loggia frescoes demonstrably by Raphael himself gave rise to the ingenious suggestion that he provided preliminary sketches in black chalk which were handed over to an assistant to work up into finished *modelli*. The audacious experiment, implying an almost maniacal degree of self-confidence, in which the pen and wash was "cleaned off" to reveal the black chalk underdrawing supposedly by Raphael, does not seem to support the view that the drawing must necessarily have been the work of two hands. Whether Raphael was responsible for the underdrawing remains an open question. It certainly lacks the liveliness and sparkle of the Albertina *David and Goliath* sketch, but it could be argued that the two drawings represent different stages in the creative process. On the other hand, the strangely shaped dropped chin of the angel is a morphological deformity shared with the taller of the two figures (Rebecca) in the background of the Ashmolean *Isaac and Esau*. I prefer to make no comment on the fifth Loggia drawing in the exhibition, for *Lot and his Daughters Fleeing from Sodom* (No. 45), from the Ball State University Art Gallery at Muncie, Indiana, which I know only from the reproduction in Oberhuber-Fischel.

Having said as much, I have to admit that while arguments can be found in support of the attribution to Raphael of Nos. 43, 44, 46 and 47 when each is considered individually, these drawings reveal disturbing contrasts of technique and style and, apparently, purpose, when considered as a group. These disjointed remarks on the Raphael-Penni problem—disjointed because confined as far as possible to drawings included in this exhibition—are provisional and inconclusive. All that one can safely suggest at this stage is that our current view of Penni's personality is to some extent a negative one, erring on the side of over-inclusiveness; and, correspondingly, that our view of Raphael's development in his last years may be unduly restrictive.

I can point to no drawing certainly attributable to Perino del Vaga that can be connected with his activity in the Raphael studio, and to only one by Polidoro da Caravaggio: the small sketch of three draped figures, in the Wallace Collection, London, a non-lending institution (Ravelli 139; cf. also *Master Drawings*, xxiii–xxiv [1985–86], pp. 68 f.), which is a study for one of the monochrome scenes in the Loggia *basamento*. I

have chosen mainly early drawings by them datable in the 1520s in which the influence of Raphael is apparent, adding to them a few examples of their mature styles and that of Giulio Romano to demonstrate the course of their later development. The word "mature" seems hardly applicable to Penni, but one or two drawings included reveal him in a phase independent of the tutelage of Raphael or even of Giulio. The inclusion of three drawings by Baldassare Peruzzi, a slightly older contemporary of Raphael and as an independent master associated with him in Rome, made it necessary to enlarge the title of the exhibition from "Raphael and his Studio" to "Raphael and his Circle." Of the three drawings, one (No. 89) is connected with a project initiated by Raphael; No. 91, though probably very much later, still reflects a certain Raphaelesque influence; No. 90 reveals the decisive influence that Peruzzi exercised on Polidoro.

Certain names will be found repeatedly cited in this catalogue. Passavant, Robinson, Ruland, Crowe and Cavalcaselle, Fischel, Parker, Popham, Pouncey, Shearman, Oberhuber are some of those who in the course of the century and a half since the first edition of Passavant's *Raffael von Urbino* appeared in 1839 have contributed to the study of Raphael and his followers, and especially of their drawings. It is sometimes said that lengthy canvassing of the views of earlier critics is out of place in a catalogue, where all that is needed is a straightforward statement of the writer's own opinion. But not every problem is susceptible of a straightforward answer, and an opinion is often no more than a matter of opinion. Many problems are still unsettled. It seems arrogant to ignore the wisdom and experience of our predecessors; and when a satisfactory conclusion has been reached, there is surely an intrinsic interest in tracing the successive stages of the critical and intellectual process that led up to it.

The bibliography of Raphael is by no means limited to the names listed above. It is very extensive, and much of it is obsolete and of only antiquarian interest. An exhibition catalogue does not aspire to be a catalogue raisonné, so I have confined myself to giving references to the standard catalogues of Raphael's drawings and otherwise citing only such other publications as I found positively helpful. A great part of the present catalogue and its introduction is, inevitably, based on that of the British Museum exhibition of 1983, which was the joint work of myself and my former colleague Nicholas Turner, whose collaboration was invaluable and to whom I remain greatly indebted.

J. A. GERE

LENDERS TO THE EXHIBITION

The Visitors of the Ashmolean Museum, Oxford 4, 6, 7, 10, 16, 23, 31, 34, 40, 46, 61, 80

Ball State University Art Gallery, Muncie, Indiana 45

The Trustees of the British Museum, London 11, 12, 17, 18, 24, 32, 44, 50, 52, 68, 69, 71, 72, 81

The Duke of Devonshire and the Chatsworth Settlement Trustees, Chatsworth 20, 30, 33, 36, 37, 42, 48, 54, 55, 56, 57, 59, 63, 73, 89

Duke Roberto Ferretti, Montreal 5, 84

Isabella Stewart Gardner Museum, Boston, Massachusetts 41

The J. Paul Getty Museum, Malibu, California 14, 28, 39

The Armand Hammer Foundation, Los Angeles, California 25

Robert and Bertina Suida Manning, New York 86

Mr. Joseph F. McCrindle, Princeton, New Jersey 85

The Metropolitan Museum of Art, New York 8, 70, 78, 79

The National Gallery of Scotland, Edinburgh 35

Barbara Piasecka-Johnson, Princeton, New Jersey 38

The Pierpont Morgan Library, New York 1, 2, 29, 64, 65, 76, 77, 87, 90, 91

Mr. David E. Rust, Washington, D.C. 82

Vermeer Associates 88

The Victoria and Albert Museum, London 60

Her Majesty Queen Elizabeth II, Windsor Castle, The Royal Library 9, 13, 15, 19, 21, 22, 26, 27, 43, 47, 49, 51, 53, 58, 62, 75, 83

Private Collections, London and New York 3, 66, 67, 74

COLOR PLATES

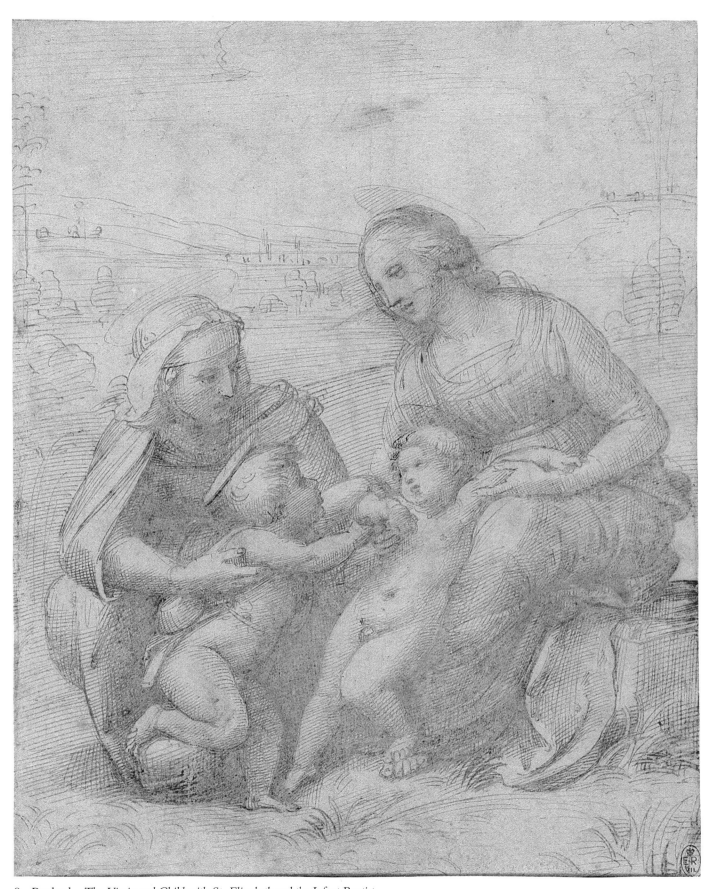

9 Raphael *The Virgin and Child with St. Elizabeth and the Infant Baptist*

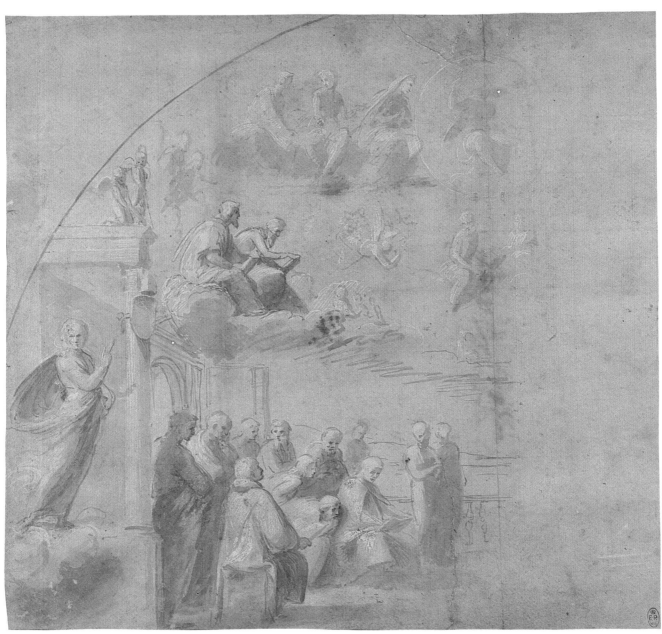

13 Raphael *Composition Study for the "Disputa"*

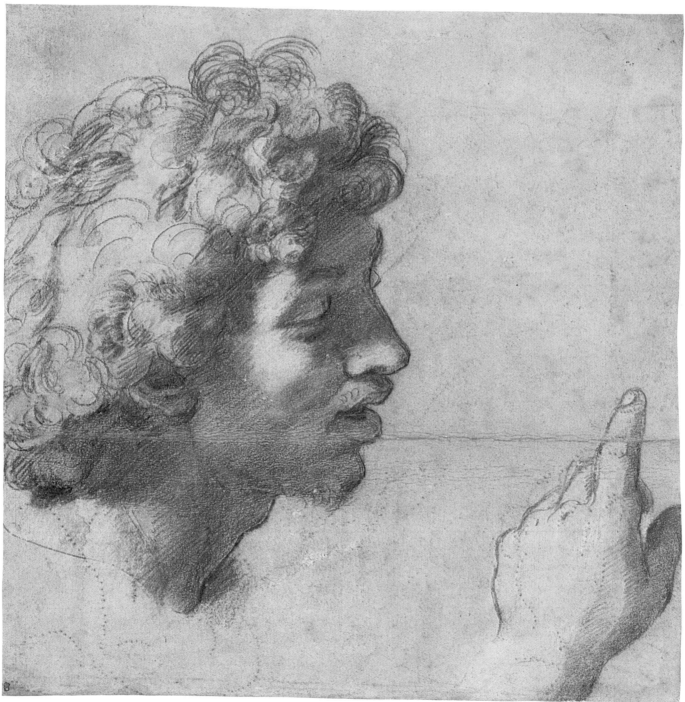

38 Raphael *Head of a Young Man with Curly Hair; a Left Hand*

Photograph: Courtesy of Christie's

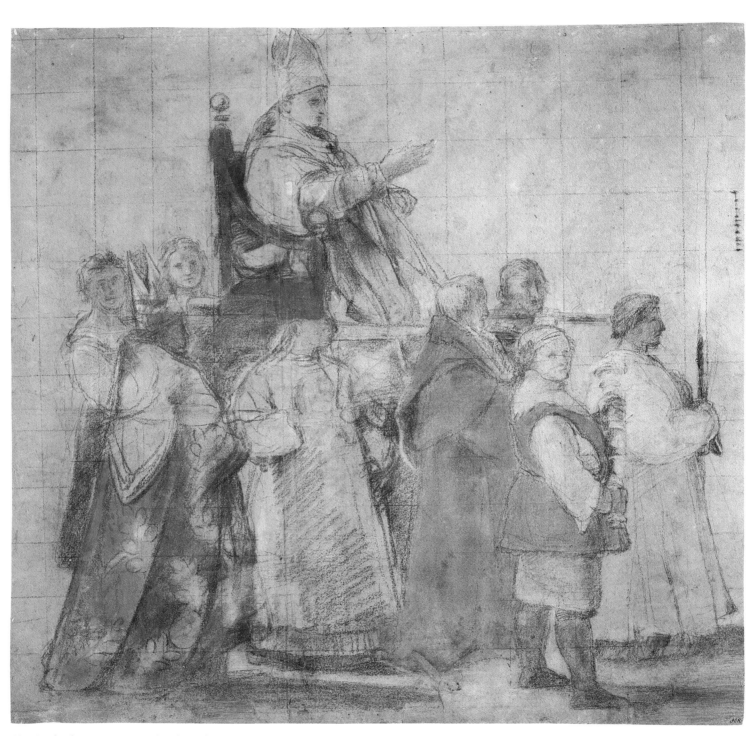

41 Raphael *A Pope Carried in the Sedia Gestatoria*

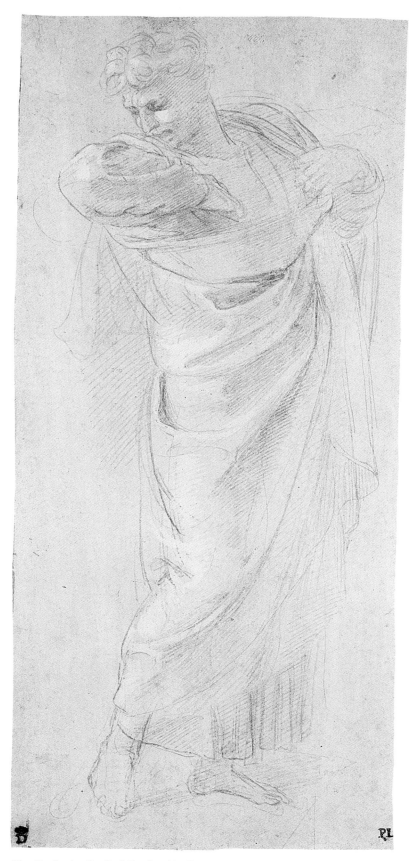

28 Raphael *St. Paul Rending his Garments*

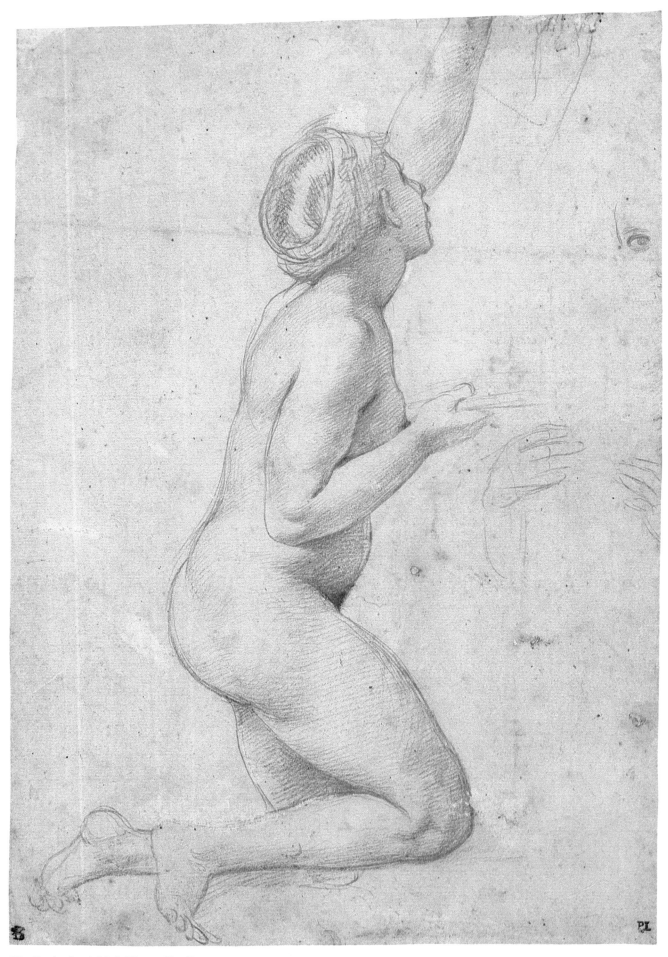

35 Raphael *A Nude Woman Kneeling*

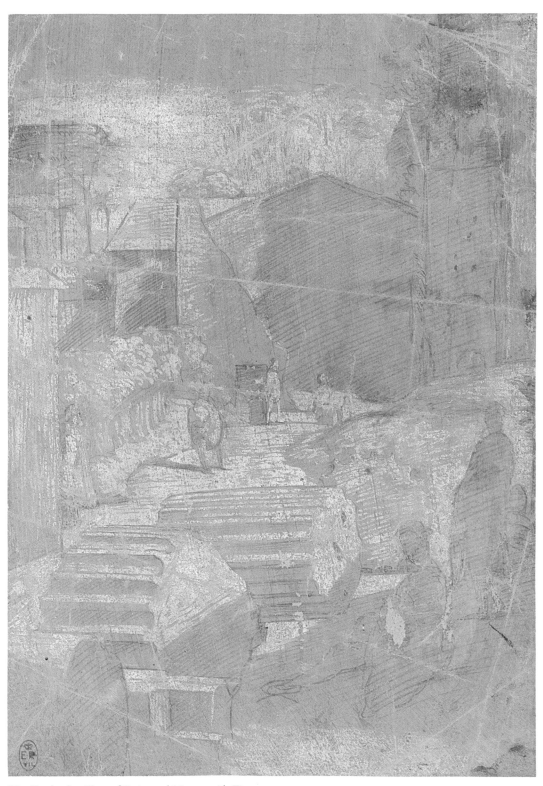

22 Raphael *View of Ruins and Houses with Figures*

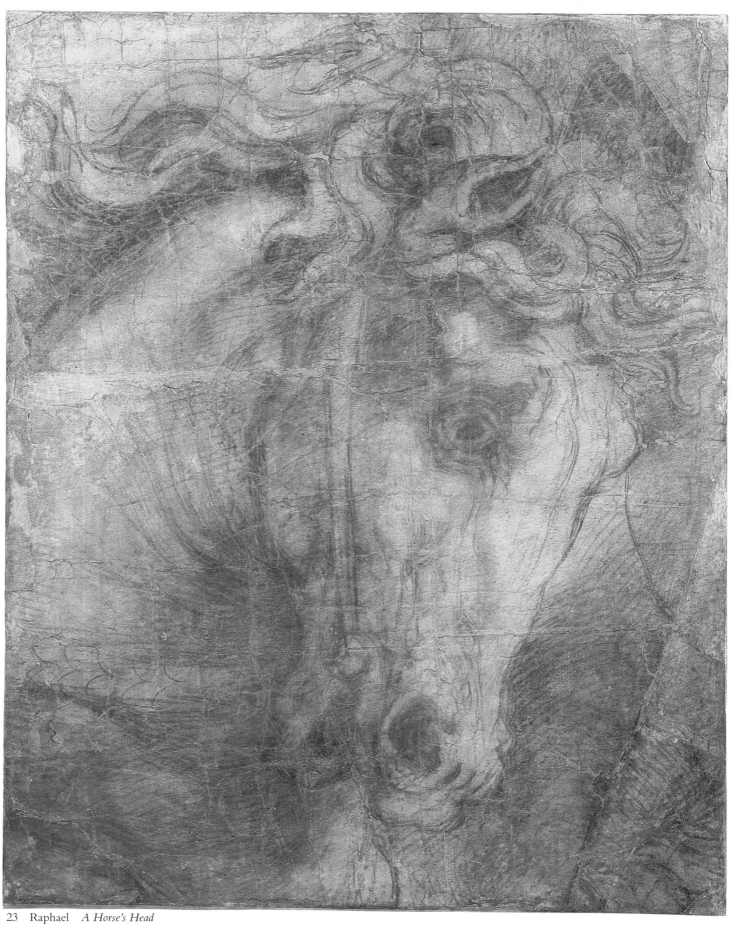

23 Raphael *A Horse's Head*

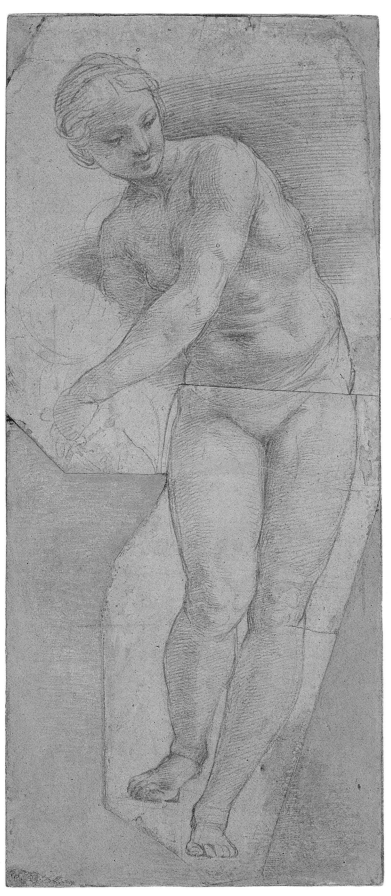

17 Raphael *Venus*

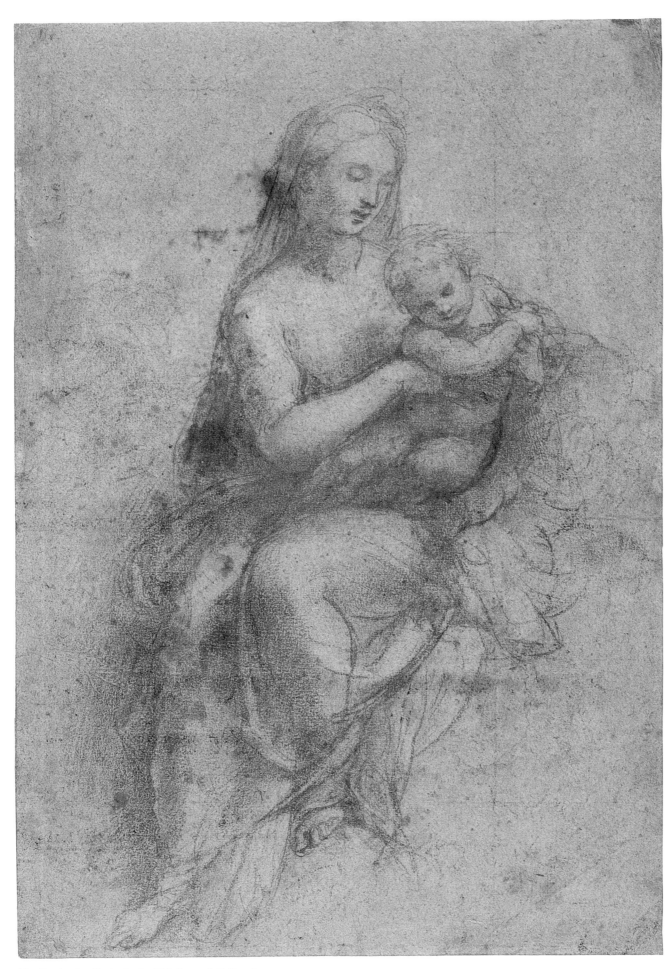

18 Raphael *Study for the "Madonna di Foligno"*

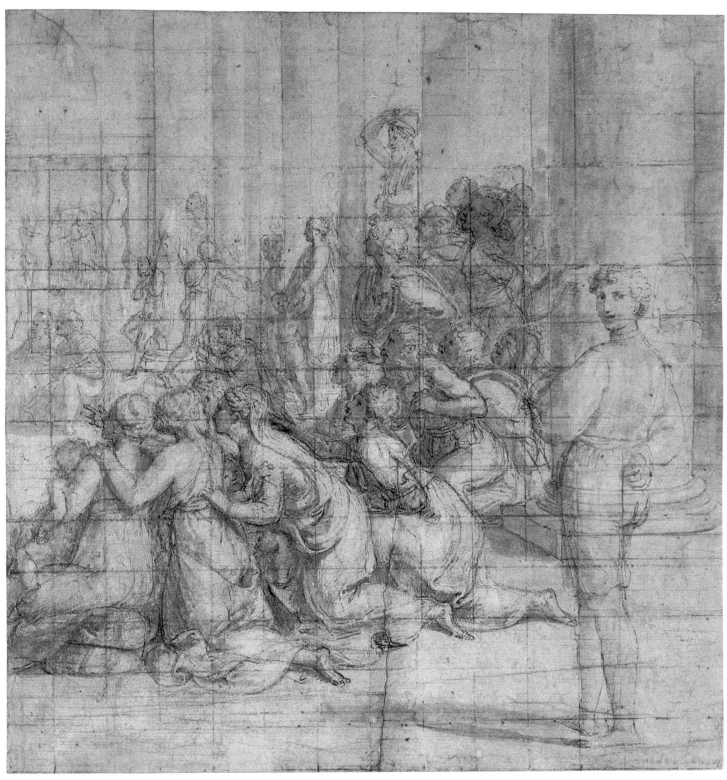

61 Giulio Romano *Part of a Composition of Figures in a Pillared Hall*

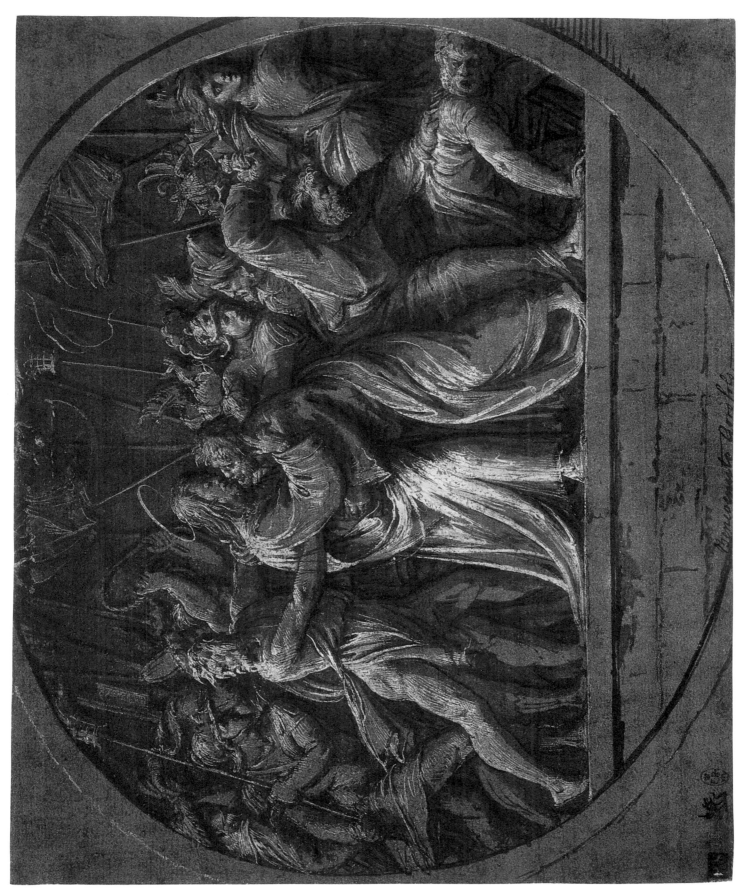

83 Polidoro da Caravaggio *The Betrayal of Christ*

LIST OF WORKS CITED IN ABBREVIATED FORM

Albertina 1983	*Graphische Sammlung Albertina: Raphael in der Albertina, aus Anlass des 500. Geburtstages des Künstlers* [catalogue by Erwin Mitsch], Vienna, 1983
Antaldi Inventory	*Catalogue of the Antaldi Collection, from the Original Manuscript of the Seventeenth Century, Now Deposited in the University Galleries, Oxford* in Robinson, *Oxford*, pp. 343 ff.
Autour de Raphaël	Musée du Louvre. *Autour de Raphaël: dessins et peintures du Musée du Louvre*, Paris, 1983–84
Bartsch	Adam Bartsch, *Le peintre graveur* (21 vols.), Vienna, 1803–21 (unless otherwise stated, references are to vol. xiv, containing Marcantonio and his two principal followers Agostino Veneziano and Marco da Ravenna)
Bean and Stampfle	Jacob Bean and Felice Stampfle, *Drawings from New York Collections*. Vol. i: *The Italian Renaissance*, The Metropolitan Museum of Art and The Pierpont Morgan Library, 1965–66
Bean and Turčić	Jacob Bean, with the assistance of Lawrence Turčić, *15th and 16th Century Italian Drawings in The Metropolitan Museum of Art*, New York, 1982
Bober and Rubinstein	Phyllis Pray Bober and Ruth Rubinstein, *Renaissance Artists and Antique Sculpture: A Handbook of Sources*, Oxford, n.d. [1985]
British Museum 1983	J. A. Gere and Nicholas Turner, *Drawings by Raphael from the Royal Library, the Ashmolean, the British Museum, Chatsworth and Other English Collections*, London, 1983
Chatsworth Catalogue	*Catalogue of Drawings in the Collection of the Duke of Devonshire*, 1929. Typescript. Compiled by Francis Thompson, then librarian at Chatsworth. A bound copy is in the library of the Department of Prints and Drawings in the British Museum
Crowe and Cavalcaselle	J. A. Crowe and G. B. Cavalcaselle, *Raphael: His Life and Works with Particular Reference to Recently Discovered Records and an Exhaustive Study of Extant Drawings and Pictures* (2 vols.), London, 1882
Dussler	Luitpold Dussler, *Raphael: A Critical Catalogue of his Pictures, Wall-Paintings and Tapestries*, London and New York, 1971
Fairfax Murray	*J. Pierpont Morgan Collection of Drawings by the Old Masters Formed by C. Fairfax Murray* (4 vols.), London, privately printed, 1905–12 (vol. i entitled *A Selection from the Collection of Drawings by the Old Masters Formed by C. Fairfax Murray*)
Fischel 1898	Oskar Fischel, *Raphaels Zeichnungen: Versuch einer Kritik der bisher veröffentlichen Blätter*, Strasburg, 1898
Fischel or Fischel, *Corpus*	Oskar Fischel, *Raphaels Zeichnungen* (8 parts, Berlin, 1913–41. For part 9, see Oberhuber-Fischel). References to "fig." are to illustrations in the fascicules of text

Fischel, *Umbrer*	Oskar Fischel, *Die Zeichnungen der Umbrer*, Berlin, 1917
Fischel 1948	Oskar Fischel, *Raphael*, translated from the German by Bernard Rackham (2 vols.), London, 1948
Freedberg	S. J. Freedberg, *Paintings of the High Renaissance in Rome and Florence* (2 vols.), Cambridge, Mass., 1961
Frerichs 1981	L. C. J. Frerichs, *Italiaanse Tekeningen ii: de 15^{de} en 16^{de} Eeuw*, exh. Amsterdam, Rijksprentenkabinet, Rijksmuseum, 1981
Frommel	Christoph Luitpold Frommel, *Baldassare Peruzzi als Maler und Zeichner* (Beiheft zum *Römischen Jahrbuch für Kunstgeschichte*, ii), Vienna-Munich, 1967–68
Gaudioso	F. M. Aliberti Gaudioso and E. Gaudioso, *Gli affreschi di Paolo III a Castel Sant' Angelo: progetto ed esecuzione*, exh. Rome, Museo Nazionale di Castel Sant' Angelo, 1981
Gere and Pouncey	J. A. Gere and Philip Pouncey, *Italian Drawings in the Department of Prints and Drawings in the British Museum: Artists Working in Rome c. 1550 to c. 1640*, London, 1983
Golzio	Vincenzo Golzio, *Raffaello nei documenti, nelle testimonianze dei contemporanei e nella letteratura del suo secolo*, Rome (Vatican City), 1936
Gronau 1902	Georg Gronau, *Aus Raphaels Florentiner Tagen*, Berlin, 1902
Hartt 1939	Frederick Hartt, "Drawings by Giulio Romano in the National Museum, Stockholm," in *Nationalmuseum Årsbok*, 1939, pp. 38 ff.
Hartt or Hartt, *Giulio*	Frederick Hartt, *Giulio Romano* (2 vols.), New Haven, 1958
Hirst 1961	Michael Hirst, "The Chigi Chapel in S. Maria della Pace," in *Journal of the Warburg and Courtauld Institutes*, xxiv (1961), pp. 161 ff.
K der K	Georg Gronau, *Raffael: des Meisters Gemälde in 275 Abbildungen (Klassiker der Kunst)*, Berlin-Leipzig, 1909
Knab-Mitsch-Oberhuber	Eckhart Knab, Erwin Mitsch, Konrad Oberhuber, unter Mitarbeit von Sylvia Ferino-Pagden, *Raphael: die Zeichnungen*, Stuttgart, 1983 (Veröffentlichungen der Albertina, Wien, nr. 19)
Lawrence Gallery	*A Catalogue of One Hundred Original Drawings by Raffaelle, Collected by Sir Thomas Lawrence*, Messrs Woodburn, London, 1836
Louvre 1983	*Raphaël dans les collections françaises*, exh. Paris, Grand Palais, 1983
Lugt	Frits Lugt, *Les marques de collections de dessins et d'estampes*, Amsterdam, 1921. Numbers followed by "a", "b", etc. are in the *Supplément*, The Hague, 1956
Marabottini	Alessandro Marabottini, *Polidoro da Caravaggio* (2 vols.), Rome, 1969
Mariette, *Crozat Gallery*	[P. J. Mariette], *Recueil d'estampes d'après les plus beaux tableaux et dessins, &c., qui sont en France*, Paris, 1729
Morelli 1893	"Ivan Lermolieff" (Gaetano Morelli), *Kunstkritische Studien über italienische Malerei: die Galerie zu Berlin*, Leipzig, 1893
Oberhuber 1962	Konrad Oberhuber, "Vorzeichnungen zu Raffaels Transfiguration," in *Jahrbuch der Preussischen Kunstsammlungen*, N.F. iv (1962), pp. 116 ff.
Oberhuber-Fischel	*Raphaels Zeichnungen, begründet von Oskar Fischel, fortgeführt von Konrad Oberhuber.* Part ix: *Entwürfe zu Werken Raffaels und seiner Schule im Vatican 1511/12 bis 1520*, Berlin, 1972

Parker	K. T. Parker, *Catalogue of the Collection of Drawings in the Ashmolean Museum*. Vol. ii: *The Italian Schools*, Oxford, 1956
Passavant 1839	J. D. Passavant, *Rafael von Urbino und sein Vater Giovanni Santi* (2 vols.), Leipzig, 1839
Passavant	J. D. Passavant, *Raphaël d'Urbin et son père Giovanni Santi, édition française refaite, corrigée et considérablement augmentée par l'auteur . . . revue et annotée par M. Paul Lacroix* (2 vols.), Paris, 1860. References are to the catalogue of drawings in vol. ii, pp. 399 ff.
Pluchart	Henry Pluchart, *Ville de Lille, Musée Wicar. Notice des dessins . . . exposés, précédée d'une introduction et du résumé de l'inventaire général*, Lille, 1889
Pope-Hennessy	John Pope-Hennessy, *Raphael*, London, n.d. [1970]
Popham 1930	A. E. Popham, *Italian Drawings Exhibited at the Royal Academy, Burlington House, London, 1930*, London, 1931
Popham, *Windsor*	A. E. Popham and Johannes Wilde [the latter being responsible only for the section of drawings by Michelangelo], *The Italian Drawings of the XV and XVI Centuries in the Collection of His Majesty the King at Windsor Castle*, London, 1949
Pouncey and Gere	Philip Pouncey and J. A. Gere, *Italian Drawings in the Department of Prints and Drawings in the British Museum; Raphael and his Circle* (2 vols.), London, 1962
Raffaello architetto	ed. C. L. Frommel, S. Ray, M. Tafuri, *Raffaello architetto*, Milan, 1984
Raffaello a Roma	*Biblioteca Hertziana, Musei Vaticani, Raffaello a Roma: il convegno di 1983*, ed. Christoph Luitpold Frommel and Matthias Winner, Rome, 1986
Ravelli	*Monumenta Bergomensia xlviii. Polidoro Caldara da Caravaggio*. Vol. i: *Disegni di Polidoro*. Vol. ii: *Copie da Polidoro. Studio e catalogo a cura di Lanfranco Ravelli. Edizione promossa dalla Banca Credito Bergamasco*, Bergamo, 1979
Robinson, or Robinson, *Oxford*	J. C. Robinson, *A Critical Account of the Drawings by Michel Angelo and Raffaello in the University Galleries, Oxford*, Oxford, 1870
Robinson, *Malcolm*	J. C. Robinson, *Descriptive Catalogue of Drawings by the Old Masters, Forming the Collection of John Malcolm of Poltalloch, Esq.*, London, privately printed, 2nd edition, 1876
Ruland	[Carl Ruland], *The Works of Raphael Santi da Urbino as Represented in the Raphael Collection in the Royal Library at Windsor Castle, Formed by H.R.H. The Prince Consort, 1853–1861, and Completed by Her Majesty Queen Victoria*, privately printed, 1876
Shearman 1961	John Shearman, "The Chigi Chapel in S. Maria del Popolo," in *Journal of the Warburg and Courtauld Institutes*, xxiv (1961), pp. 129 ff.
Shearman 1964	John Shearman, "Die Loggia der Psyche in der Villa Farnesina und die Probleme der letzten Phase von Raffaels graphischem Stil," in *Jahrbuch der Kunsthistorischen Sammlungen in Wien*, lx (1964), pp. 59 ff.
Shearman 1965	John Shearman, "Raphael's Unexecuted Projects for the Stanze," in *Walter Friedländer zum 90. Geburtstag*, Berlin, 1965, pp. 158 ff.

Shearman 1972	John Shearman, *Raphael's Cartoons in the Collection of Her Majesty The Queen, and the Tapestries for the Sistine Chapel*, London, 1972
Sirén 1917	Osvald Sirén, *Italienska handteckningar från 1400 och 1500-talen i Nationalmuseum*, Stockholm, 1917
Vasari	Giorgio Vasarai, *Le vite de' più eccellenti pittori, scultori ed architettori . . . con nuove annotazioni e commenti da Gaetano Milanesi* (9 vols.), Florence, 1878–85
Vasari Society	*The Vasari Society for the Reproduction of Drawings by Old Masters*, i to ix, London, 1905–15; 2nd series, i to xvi, 1920–35
Weigel	Rudolph Weigel, *Die Werke der Maler in ihren Handzeichnungen. Beschreibendes Verzeichniss der in Kupfer gestochenen, lithographirten und photographirten Facsimiles von Originalzeichnungen grosser Meister*, Leipzig, 1865

THE CATALOGUE

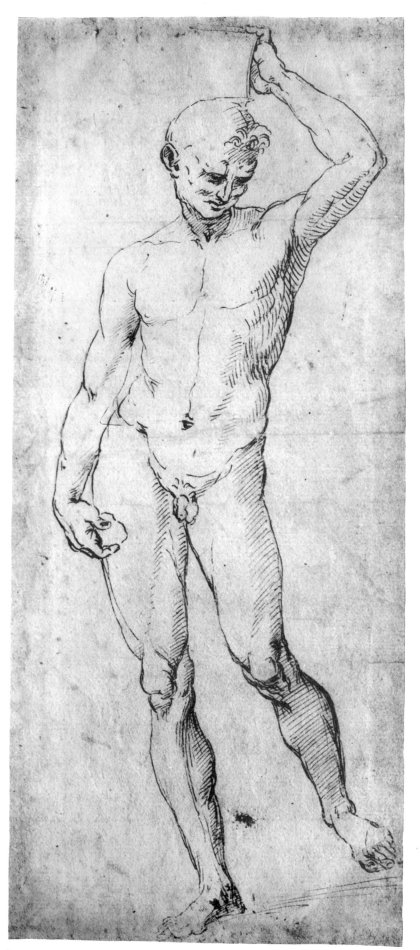

1

RAFFAELLO SANTI, CALLED RAPHAEL

URBINO 1483–1520 ROME

1 A Canephoros

Pen and brown ink. 323: 132 mm.
PROVENANCE: Charles Fairfax Murray; J. Pierpont Morgan.
LITERATURE: Fairfax Murray, i, no. 17.
The Pierpont Morgan Library I, 17

THE inner contour of the right upper arm and the contour of the chest on the same side seem to have been retouched in a darker ink. The traditional attribution was to Raphael. A. E. Popham and Philip Pouncey came independently to the opinion that this is an old copy of a lost early drawing by him (notes in The Pierpont Morgan Library records). There are certain features, however, such as the drawing of the head and the beauty of the facial expression, the shape of the hands and fingers, and the firm and very assured structure of the knees, that suggest that this may be an original drawing of the early Umbrian period, datable probably before 1500.

2 The Agony in the Garden

Pen and brown wash. The contours pricked for transfer and gone over with the stylus. Much faded and rubbed. 226: 265 mm.

PROVENANCE: Viti-Antaldi (according to Fairfax Murray, but it does not bear any of the Antaldi marks and nothing identifiable with it is listed in the Antaldi Inventory); Lord Leighton, P. R. A. (sale, Christie's, 1896, 11 June, lot 447); Charles Fairfax Murray; J. Pierpont Morgan.

LITERATURE: Fairfax Murray, i, no. 15; Fischel 66; Bean and Stampfle 48; Knab-Mitsch-Oberhuber 24.

The Pierpont Morgan Library I, 15

INSCRIBED on verso in ink: *Timoteo Viti*. A small panel painting by Raphael, now in the Metropolitan Museum of Art, corresponds exactly in scale with this drawing which served as cartoon for it, the outlines of the composition being transferred to the panel by means of the pricking.

The drawing is not mentioned by Passavant, Ruland or Crowe and Cavalcaselle (a fact that further discredits the supposed Viti-Antaldi provenance), but the description of it hanging in Frederick Leighton's dining room, in an account of the interior of his London house in about 1880 (*Beautiful Houses; Being a Description of Certain Well-Known Artistic Houses*, by Mrs. [Mary Eliza] Haweis, London, 1882, p. 9), establishes that he at least was aware of Raphael's authorship and of the connection with the painting, then in the collection of Baroness Burdett-Coutts. Nevertheless, it appeared in his posthumous sale in 1896 under the name of Timoteo Viti, to whom, in the late nineteenth century, a number of early drawings by Raphael were attributed in consequence of Morelli's erroneous supposition that he had been one of Raphael's masters.

The painting formed part of the predella of the altarpiece of *The Virgin and Child with the Infant Baptist and Sts. Peter and Paul and Catherine and Lucy* (the so-called *Pala Colonna*), now also in the Metropolitan Museum and generally dated c. 1505. Konrad Oberhuber has recently put forward a detailed case for an earlier dating, c. 1501–2. In his view the *Pala Colonna* is less mature in conception and execution and spatially and compositionally less developed than the *Madonna Ansidei* of 1505 (National Gallery, London) with which it is often grouped (*Metropolitan Museum Journal*, 1978, pp. 55 ff.).

In the cartoon the chalice is standing on the cliff before which Christ kneels, but in the painting it is carried towards him by a hovering angel. X-Ray examination has shown that this was an afterthought, and that the panel originally corresponded with the drawing in this detail.

3 The Betrothal of the Emperor Frederick III and Eleanor of Portugal

Pen and brown wash, heightened with white. Traces of underdrawing in black chalk. The sheet was at one time folded in four, which caused it to split along the folds. Old photographs show that the left and right halves were not realigned correctly when the four quarters were rejoined (probably in the seventeenth century, to judge from the watermark in the former backing paper). Though still badly rubbed and damaged, particularly on the right, its appearance has been much improved by its recent skillful restoration, in the course of which various fragments which had been used as patches were replaced in their original position. 272: 411 mm.

PROVENANCE: Baldeschi family, of Perugia; Count Contini, of Florence; Count Contini-Bonacossi, of Florence.

LITERATURE: Passavant 157; Ruland, p. 265, v, 3; Crowe and Cavalcaselle, i, p. 183; Fischel 65; Knab-Mitsch-Oberhuber 28.

Private Collection, New York

INSCRIBED in ink by the draughtsman, top left: *Questa è la quinta [st]oria de papa*.

A *modello* for one of the large frescoes in the library added to the north aisle of Siena Cathedral by Cardinal Francesco Todeschini Piccolomini. By a contract dated 29 June 1502, the Umbrian painter Bernardino Pintoricchio agreed to undertake the decoration, the main feature of which was to be ten scenes from the life of the Cardinal's uncle, Aeneas Sylvius Piccolomini, also a Cardinal and from 1458 to 1464 Pope Pius II, whose writings and collection of books the Piccolomini Library was designed to house. The related fresco—the fifth in the series, as the inscription on the drawing indicates—represents Aeneas Sylvius, who had been largely instrumental in arranging the Emperor's marriage, bringing the betrothed couple together. Their meeting took place on 7 March 1451 outside the Porta Camollia of Siena. The column erected in commemoration of the event is a conspicuous feature of the drawing as it is of the fresco, but the fresco also includes a view of Siena in the left background.

Some critical argument was provoked in the past by the discrepancy not only between the clause in the contract specifying that Pintorrichio himself was to make all the preparatory drawings and Vasari's statement that he was assisted in this by Raphael, but also between Vasari's slightly differing accounts of their collaboration in his lives of Pintoricchio and Raphael, in one of which he implied that Raphael produced all the preparatory drawings, and in the other that he was responsible for only some of them. Morelli and other late nineteenth-century critics also found it impossible to accept the possibility that Pintoricchio, in 1502 an established master of nearly forty, would have been willing to surrender to a twenty-year-old novice the task of making the designs for this important commission. The few surviving drawings connected with this project were traditionally given to Raphael, but the over-subtle hypercriticism of the Morellian

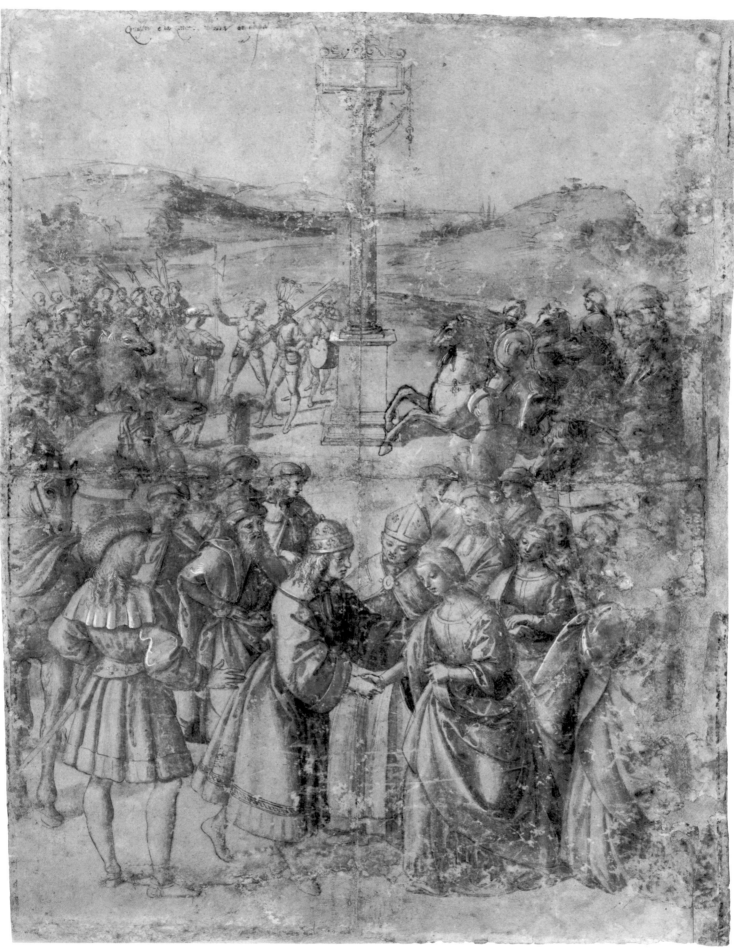

3

period discounted the testimony of Vasari and gave most of them to Pintoricchio. The critical balance was restored by Panofsky (*Repertorium für Kunstwissenschaft*, xxxvii [1915], pp. 267 ff.), who observed that "the older generation of scholars, though not yet equipped with the sharp tools of modern stylistic analysis, were nevertheless guided by an extremely reliable instinct when it came to judging artistic questions; and they took their stand throughout on the basis of the tradition established by Vasari." Robinson's summing up of the problem is an example: "The question has been much debated, as to whether Raffaello were the actual inventor of the elaborate compositions in question, or whether he only worked them into shape from rough sketches and ideas furnished to him by Pinturicchio. The writer's opinion is that Raffaello was the master spirit, the real inventor, and that Pinturicchio, who, in fact, seems to have been of a practical turn, gladly availed himself of the superior powers of his young assistant as a simple matter of business. Such co-operation being customary at that day, when painters and sculptors, regarding themselves as workmen, were exempt from the undue self-appreciation, which modern ideas of the exalted nature of the artistic vocation have created" (*Oxford*, p. 127).

All four known studies for the Piccolomini Library frescoes are undoubtedly by Raphael. In addition to the present drawing and No. 4, there is another *modello*, for the first fresco in the series, *The Departure of Aeneas Sylvius for the Council of Basle*, and a pen and ink sketch for a group of horsemen in the same composition, both in the Uffizi (Fischel 62 and 60). In his study of Raphael's early stylistic development, apropos of the suggested redating of the *Colonna Madonna* (*Metropolitan Museum Bulletin*, 1978, p. 84), Konrad Oberhuber analyzed the style of the two *modelli* and reached the conclusion that the Uffizi sheet is so much more advanced in its sense of space and plasticity that it must be considerably later than the one in New York, probably by as much as a year. It is true that from the point of view of technique the Uffizi drawing does seem more developed; but—though admittedly we know nothing about the way Pintoricchio set about the planning and execution of the Library project—it also seems, on the face of it, surprising to find the design for the first fresco of the series produced as much as a year later than the design for the fifth. Raphael can have had no part in the execution of the paintings, and it is perhaps more likely, as Cara Denison has argued (*European Drawings, 1375–1825* [in The Pierpont Morgan Library], 1981, no. 13), that he would have made the designs for the whole series at about the same time. It may be that his development was even more rapid than has been supposed.

4 Four Studies of a Young Man Holding a Halberd RECTO. Two Studies of a *Putto* Holding a Shield VERSO.

Metalpoint on slate-gray prepared paper. 213: 223 mm.

PROVENANCE: William Young Ottley (sale, London, T. Philipe, 1814, 6 June etc., lot 1219); Sir Thomas Lawrence (Lugt 2445); Samuel Woodburn.

LITERATURE: W. Y. Ottley, *The Italian School of Design*, 1823, p. 46; *Lawrence Gallery* 5; Passavant 530; Robinson 14; Ruland, p. 264, iii, 4; Crowe and Cavalcaselle, i, p. 184; Fischel 63/64; Parker 510; British Museum 1983, no. 29; Knab-Mitsch-Oberhuber 62/63.

Ashmolean Museum P II 510

THREE of the four figures on the recto occur in the group in the center background of Pintoricchio's fresco of *Frederick III Bestowing the Poet's Crown on Aeneas Sylvius Piccolomini*, in the Piccolomini Library in Siena (see No. 3). The man in the center of the group of three in the drawing corresponds in pose with the figure in the central position in the painted group. There is a *pentimento* for his right arm, which in the painting is in the alternative, outstretched position. The figure with his legs apart on the left of the group of three and the one standing by himself with his legs crossed on the right of the sheet also occur in the painting, but transposed so that they are respectively to the right and left of the central figure. The figure on the right of the group of three in the drawing does not appear at all. In the fresco the figures are wearing elaborate historical costume; in the drawing, apart from the suggestion of headgear, their dress is the everyday one of Raphael's period.

All the earlier critics, from Ottley onwards, accepted the traditional view that these are preparatory studies by Raphael for the Piccolomini Library fresco. Morelli, however (1893, pp. 247 ff.), disregarded the testimony of Vasari about the nature of Raphael's collaboration with Pintoricchio and dismissed as "absurd" the possibility that an older and well-established master would have entrusted a novice with the design of even a subordinate group of figures. He sought to reconcile this view with his belief in the traditional attribution of the drawing by the farfetched assumption that Raphael happened to be in the studio when Pintoricchio was drawing the group from a model, and amused himself by making these sketches. In 1907 A. von Beckerath proposed an attribution to Pintoricchio (*Repertorium für Kunstwissenschaft*, xxx, pp. 293 ff.). Fischel rejected Raphael's authorship in his *Corpus* (1913) on the grounds that "the drawing is careless and the contours repetitive," and in his *Zeichnungen der Umbrer* of 1917 (no. 119) gave it without qualification to Pintoricchio; but in the posthumously compiled catalogue raisonné of 1948, which presumably represents his latest opinion, what seems to be this drawing is listed as by Raphael.

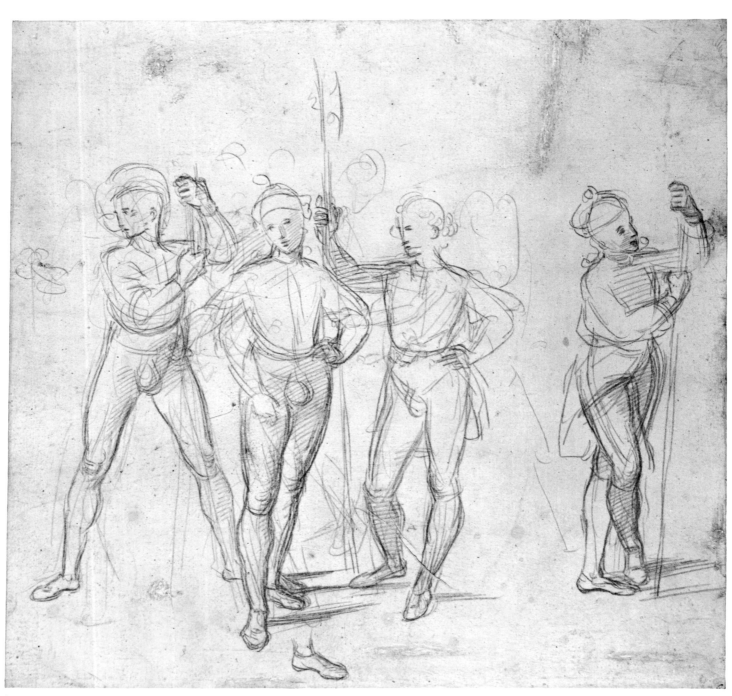

4

Parker followed the traditional attribution, which had been reaffirmed by Popham (1930, no. 120). His suggested explanation of the loose and apparently perfunctory handling was that the figures were not studied from a model but "from memory, with reminiscences of Signorelli." Fischel had already observed the close general resemblance between these figures and some of those in Signorelli's Monte Oliveto frescoes; but if Raphael had made these sketches out of his head, he would hardly have dwelt so carefully on details of everyday dress that have no counterpart either in Signorelli's figures or in those in the Piccolomini Library painting. This is surely a rapid sketch from a studio assistant made for the purpose of establishing the essentials of four different poses, three of which would later have been combined, with others, in a study for the group in its final form.

The studies on the verso are for the *putti* holding escutcheons with the coat-of-arms of the Piccolomini at the base of the pilasters in the Library.

4 verso

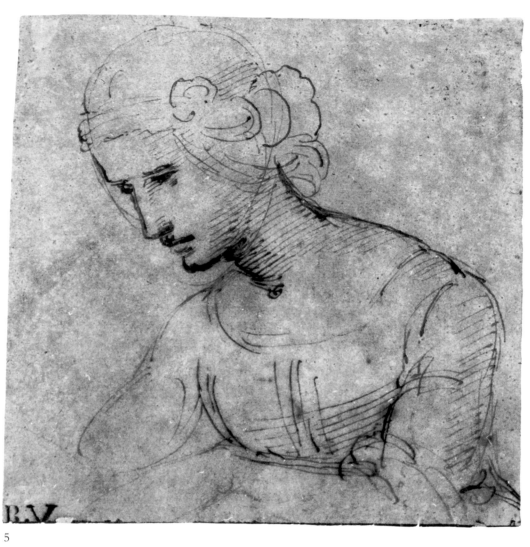

5

5 Head and Shoulders of a Young Woman

Pen and brown ink. 139: 136 mm.

PROVENANCE: Antaldi (Lugt 2245).

Montreal, Duke Roberto Ferretti

THOUGH this drawing cannot be identified in the Antaldi Inventory, there seems to be no reason to doubt the authenticity of the Antaldi mark (the initials R. V., standing for *Raffaello Vrbinas*) or the attribution to Raphael. It must be from the Florentine period, and is evidently a study for the Virgin holding the Child and looking down towards him. A similarly shaped head, narrow and elongated and with a long nose, can be seen in the sheet of studies at Chatsworth for the *Madonna im Grünen* (Fischel 117), and the angle of the head and neck and the turn of the body parallelled in other studies for Florentine Madonnas (e.g. Fischel 111 and 139).

6 Seven Nude Men Fighting for Possession of a Standard

Pen and brown ink over black chalk. The outlines pricked. 274: 421 mm.

PROVENANCE: Antaldi (according to the *Lawrence Gallery* catalogue: perhaps no. 2 in the Inventory, "una battaglia di figure ignude, fatto con penna grossa"); William Young Ottley (sale, London, T. Philipe, 1814, 6 June, etc., lot 1775★★); Sir Thomas Lawrence (Lugt 2445); Samuel Woodburn.

LITERATURE: W. Y. Ottley, *The Italian School of Design*, 1823, pp. 49 f.; *Lawrence Gallery* 65; Passavant 533; Robinson 102; Ruland, p. 166, viii, 1; Crowe and Cavalcaselle, ii, p. 265; Fischel 193; Parker 537; British Museum 1983, no. 50; Knab-Mitsch-Oberhuber 236.

Ashmolean Museum P II 537

TWO similar but less deliberately drawn compositions are sketched on either side of another sheet in the Ashmolean Museum (P II 538; Fischel 194/195). Both include the motif of the binding of a captive. Most of the nineteenth-century critics, including Robinson, Crowe and Cavalcaselle and Ruland, explained them as discarded studies for the *Battle of Ostia* in the Stanza dell' Incendio (decorated 1515–17), a conspicuous feature of which is the binding of a group of prisoners. As far back as 1823, however, Ottley had published No. 6 with the comment that Raphael was seeking to emulate Leonardo da Vinci's *Battle of the Standard* which he had seen in Florence, and that the drawing must date from about 1506—that is, from the middle of his Florentine period. This view was followed by Passavant, and is now generally accepted, though Gronau (1902, p. 42), Fischel and Parker propose a slightly later dating, c. 1508–9, in the period of transition between Florence and Rome. But whether Raphael made these

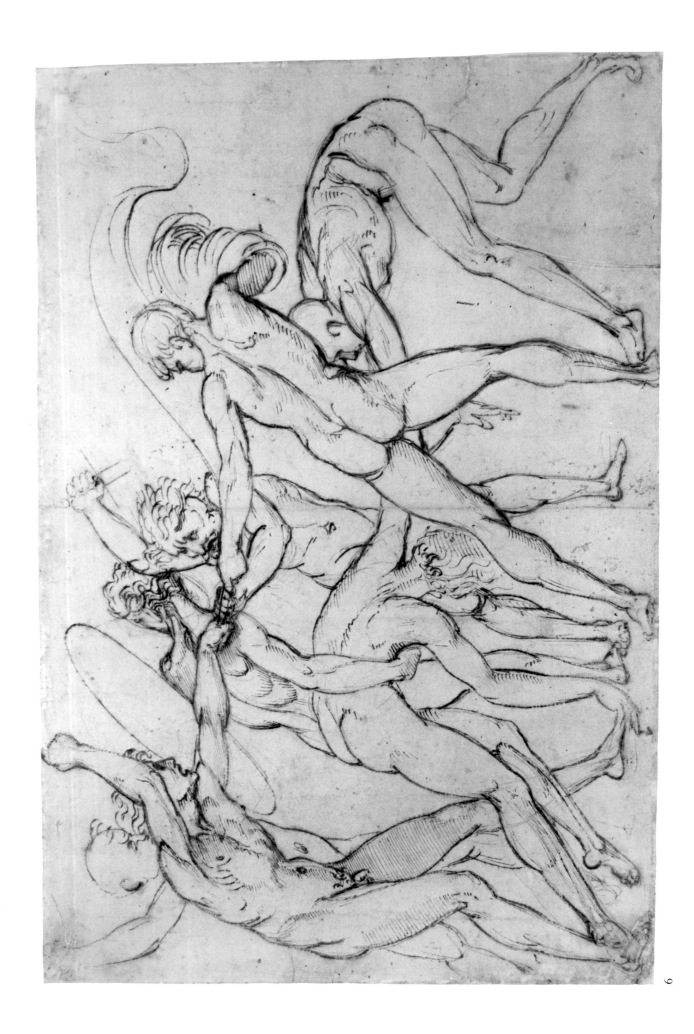

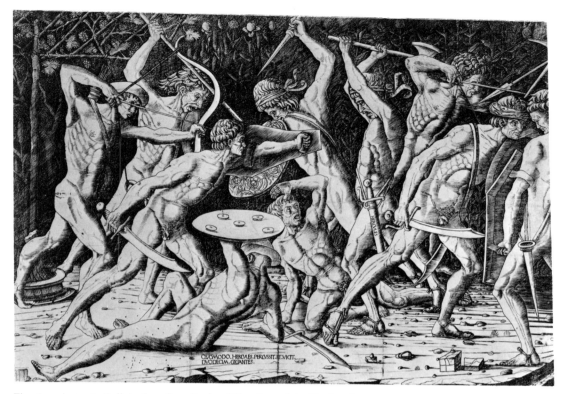

Fig. 6a Antonio Pollaiuolo, after. *Battle of Hercules and the Twelve Giants*. Engraving. B. xiii, 203, 3.

drawings in Florence or in Rome, the underlying inspiration is the Florentine tradition of the heroic nude in action. The closest parallel is not so much the *Battle of the Standard*, in which the figures are on horseback, nor even Michelangelo's *Bathers*, as the earlier (c. 1470) engravings of the *Battle of Naked Men* by Antonio Pollaiuolo and the *Battle of Hercules and the Twelve Giants* after him (Fig. 6a).

The purpose of Raphael's frieze-shaped drawings of fighting nude men is still a matter of conjecture. The pricked contours of No. 6 show that he intended to carry the design a stage further, and to carry it further on the same small scale: if he had wanted to repeat the composition on a larger scale, the drawing would have been squared for enlargement. The size of the sheet would have been suitable for an engraving, and in some drawings made by Raphael for the purpose of being engraved (e. g. the study for the *Massacre of the Innocents* in the British Museum and the two for the *Quos Ego* at Chatsworth: cf. under No. 19, and British Museum 1983, nos. 124 and 125) the contours are pricked. Fischel's suggested explanation of the pricking, that a pendant of the same composition in reverse was contemplated, hardly does justice to Raphael's power of invention.

It has been suggested that the drawing is reworked by a later hand which went over and strengthened the contours. The contours have certainly been gone over, but there is no reason to doubt that this was the work of Raphael himself, who must for some reason have wanted to emphasize the linear rhythm of the composition.

7 The Virgin and Child with the Infant Baptist

Brush drawing in brown, over leadpoint and/or stylus underdrawing. Touches of (oxidized) white heightening, particularly on the Child's face and the Virgin's right shoulder. The separate sketch in the left-hand corner in red chalk. 219: 180 mm.

PROVENANCE: Antaldi (Lugt 2445: perhaps no. 60 in the Inventory: *Una Madonna in quarto di foglio reale, col Bambino e S. Gio. disegno fatto d'acquerella med^mo Raffaelle*). The annotation *venduto* indicates that this is one of the drawings bought by Crozat in 1714); Pierre Crozat (?); Sir Thomas Lawrence (Lugt 2445); Samuel Woodburn.

LITERATURE: *Lawrence Gallery* 32; Passavant 481; Robinson 33; Ruland, p. 59, x, 5; Crowe and Cavalcaselle, i, pp. 263 f.; Fischel 118; Parker 518; British Museum 1983, no. 55; Knab-Mitsch-Oberhuber 123.

Ashmolean Museum P II 518

A STUDY for the *Madonna im Grünen* (*Madonna of the Meadow*) in the Kunsthistorisches Museum in Vienna, a painting inscribed with an indistinctly written date which might be 1505 or 1506. The composition is a variant of the *Madonna del Cardellino* (Uffizi) and the *Belle Jardinière* (Louvre), and is probably the first in the sequence (see Dussler, pp. 20 and 22).

In this drawing and in the closely related study in the Metropolitan Museum (No. 8), the grouping of the figures has reached its final form. The figure of the Virgin cannot exactly be described as clothed, but neither is it a study from the nude: Raphael's principal concern at this point seems to have been to define the fall of the light on the group. This is an early example of his use of the brush point for drawing (for another, see the early sketch for the *Disputa*, No. 13). Passavant was misled by the unfamiliar technique and unusual appearance of the drawing into declaring that the wash, though beautiful in itself, was the work of a later hand. Fischel (1898, no. 58) at first followed Morelli (*Kunstchronik*, 1891–92, p. 527, no. 17) in rejecting the drawing altogether as either a copy or a forgery. In his *Corpus*, however, he accepted it. Robinson and Crowe and Cavalcaselle had accepted it without question, and Robinson made some pertinent observations on "the peculiar shading ('bistrage')," a technique "probably suggested by the method of sketching or 'laying in' tempera pictures on the absorbent white gesso grounds, or of fresco painting on the wet intonaco . . . Regular even tints could only be obtained by repeated strokes dexterously laid side by side, or by cross hatchings, flat washing with thin aqueous pigments being very difficult, from the fact that every touch on such absorbent surfaces immediately sinks in as if on blotting-paper."

The slight and partly trimmed away red chalk sketch in the top left corner was drawn after the other study on the sheet. It differs in showing the Virgin's shoulders parallel to the picture plane and her right hand brought up to hold the Infant Christ's right shoulder, a motif that does not occur elsewhere in Raphael's work.

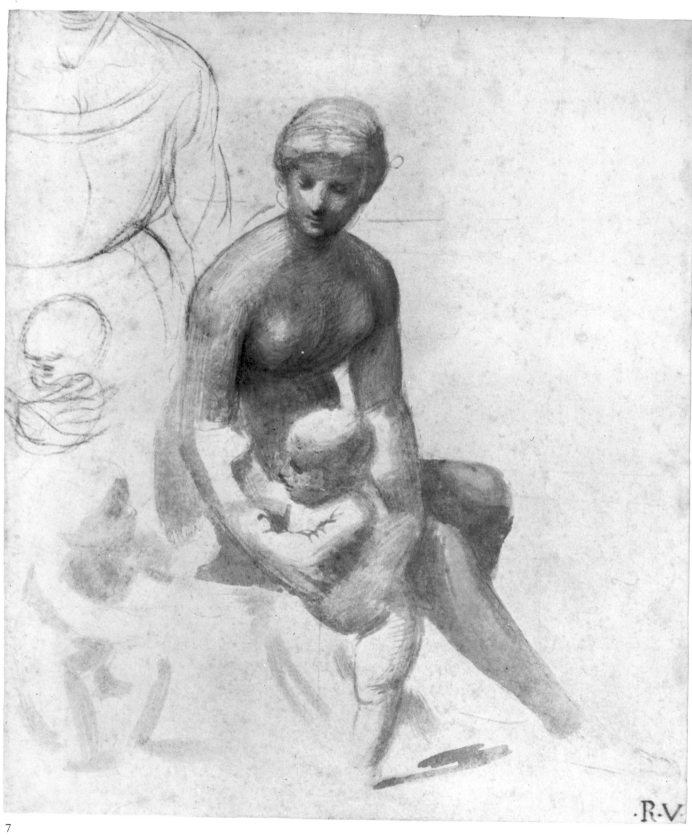

7

8 The Virgin and Child with the Infant Baptist RECTO. Study of a Nude Man VERSO.

Red chalk (recto). Pen and brown ink (verso). Somewhat stained and abraded. 224: 159 mm.

PROVENANCE: Herman ten Kate Hermansz. (sale, Amsterdam, 1732, 16 June, portfolio H, no. 31); Antonie Rutgers (sale, Amsterdam, 1778, 1 December, lot 268); Cornelis Ploos van Amstel (Lugt 2034: sale, Amsterdam, 1800, 3 March, portfolio EEE, no. 3); George Hibbert (sale, London, Christie's, 1833, 12 June, lot 169); Samuel Rogers (sale, London, Christie's, 1856, 6 May, lot 950); T. Birchall (in his collection by 1857, when he lent the drawing to the Manchester Art Treasures Exhibition); his brother-in-law, Richard Rainshaw Rothwell; the latter's great-nephew, J. W. Rothwell (sale, London, Sotheby's, 1964, 11 March, lot 150).

LITERATURE: Passavant 454; Crowe and Cavalcaselle, i, p. 264; Bean and Stampfle 49; Bean and Turčić 210; Knab-Mitsch-Oberhuber 124.

The Metropolitan Museum of Art, Rogers Fund 64.47

INSCRIBED on recto in ink in a sixteenth-century hand, in lower left corner *1519* (or *1509*) and in lower right corner *Raf. d'U*; on verso, in another sixteenth-century hand, apparently in the same ink as the drawing and probably by the draughtsman: *Carte di d[i]segno 6* . . . (the rest illegible). The figures inscribed in the lower left corner of the verso refer to the location of the drawing in the ten Kate Collection.

The separate studies above on the recto are of the Baptist's right arm and the drapery on the Virgin's right hip.

The recto drawing is a study for the *Madonna im Grünen* (*Madonna of the Meadow*) of 1505 or 1506. It must have followed very closely upon No. 7 (q. v.), and is the last in the sequence of surviving preparatory drawings. The main group of figures is on the same scale in both drawings, and the outlines of one may have been traced from the other. The New York drawing corresponds very closely with the painting, except that there the Virgin is wearing a heavy mantle which covers her left arm from shoulder to wrist. This is one of the earliest examples of Raphael's use of red chalk, which was to become his preferred medium after he went to Rome.

The figure on the verso was misinterpreted by Crowe and Cavalcaselle as "a Prometheus, lying on his back with his elbows thrown back, so that he rests on his forearms." Jacob Bean (*Metropolitan Museum of Art Bulletin*, Summer 1964, pp. 1 ff.) was the first to observe that the sheet should be looked at upright, and that this is a drawing from a model so posed that his body is sagging forward, supported by the cords faintly indicated in the drawing round his elbows and forearms. Bean also pointed out the close connection with a pen and ink drawing in the Louvre of a full-length figure in exactly the same position, either by Raphael himself or an old copy of a lost drawing by him (Fischel 183; Louvre 1983, no. 130), which Fischel had suggested might be a study for one of the crucified thieves in a *Crucifixion* or a *Descent from the Cross*. In handling the Louvre drawing is drier and more schematic; as Bean suggests, it (or the

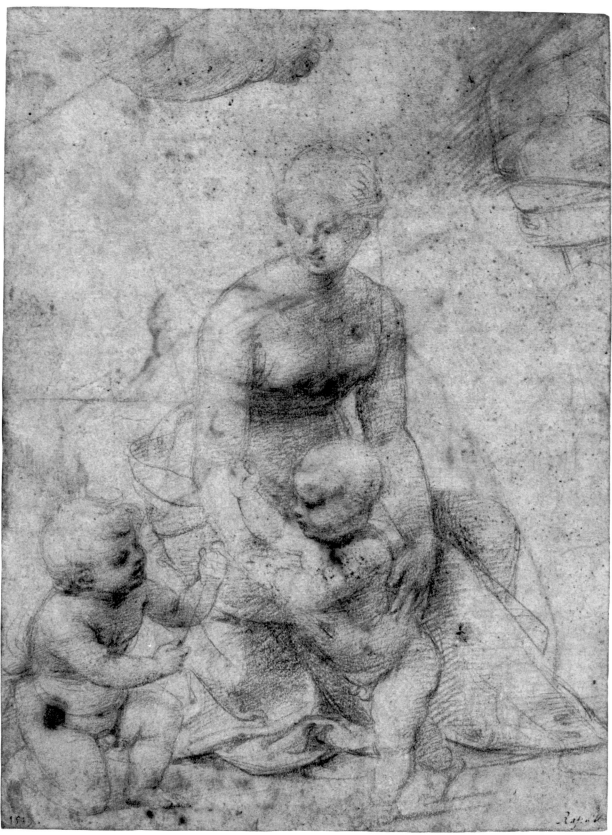

8

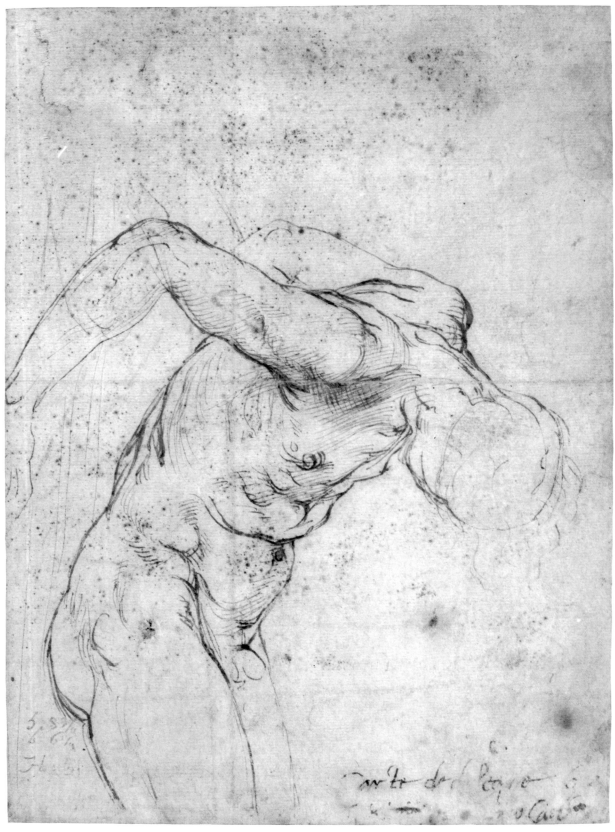

8 verso

lost original) was probably not drawn directly from life. Raphael was experimenting with the theme of the *Descent from the Cross* at about the time of the *Madonna im Grünen*: a study in the Albertina (Fischel 182; Albertina 1983, no. 10) for the central group in the composition engraved by Marcantonio (Bartsch 32) is on the same sheet as a drawing for one of the predella panels of the Borghese *Entombment* of 1507. Marcantonio's engraving does not include the thieves, but it seems very likely that studies for one of them were made in the same connection.

9 The Virgin and Child with St. Elizabeth and the Infant Baptist

Pen and brown ink. 234: 180 mm.

PROVENANCE: Bonfiglioli family of Bologna; purchased with the rest of the Bonfiglioli Collection by Procuratore Zaccaria Sagredo of Venice, 1727/28; Consul Joseph Smith (d. 1770); purchased for King George III, 1773.

LITERATURE: Passavant 427; Ruland, p. 82, xlv, 4; Crowe and Cavalcaselle, i, pp. 298 ff.; Fischel 130; Popham, *Windsor*, no. 790; British Museum 1983, no. 58; Knab-Mitsch-Oberhuber 244.

Windsor, Royal Library 12738

LISTED by Passavant and Ruland as a study for a composition known from an old copy of a lost drawing in the Louvre (Fischel 131); two paintings, neither from Raphael's own hand, one of which is in the Swedish Royal Collection at Drottningholm Castle and the other formerly in that of Mr. Charles T. Yerkes of New York (David Brown, *Raphael and America*, Washington, 1983, fig. 19); and at least five engravings, none datable earlier than the seventeenth century. Crowe and Cavalcaselle described the Windsor drawing as a study for an apparently never executed variant of the *Madonna Canigiani* (Munich) of about 1505–7; Fischel, followed by Popham, considered it and the lost original of the Louvre copy to be preliminary studies for the *Madonna Canigiani* itself. In that composition St. Elizabeth kneels on both knees with her body more erect and turned in profile to the right. The contour of her back and upper arm balances the contour of the Virgin's figure, and their heads are on a level. The group is thus pyramidal in outline, an effect enhanced by the addition of a standing St. Joseph behind the two kneeling figures.

Raphael's habit of allowing a whole sequence of related ideas to germinate simultaneously in his mind and develop out of one another is exemplified by the sheet of sketches of the *Virgin and Child* in the British Museum (No. 12). It is an open question, whether the Windsor drawing and the lost original of the Louvre copy are to be considered as stages in the evolution of the *Madonna Canigiani*, or whether Crowe and Cavalcaselle

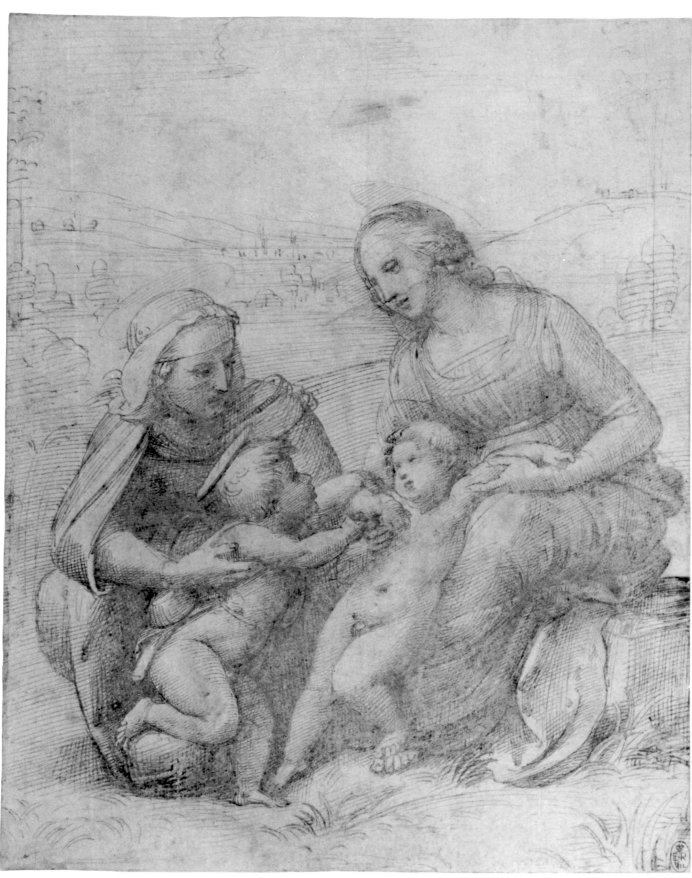

9

were right in supposing that an independent variant of the composition had been contemplated. No such painting is recorded, but the Windsor drawing has the appearance of a *modello* rather than a preliminary sketch. The careful degree of finish, the technique of elaborate crosshatching, the absence of *pentimenti*, and the indication of the landscape background, all suggest that the composition had crystallized in Raphael's mind beyond the point when he would have embarked on the fairly radical recasting necessary to produce the Canigiani solution. He used exactly the same carefully finished technique of fine crosshatching in pen and ink in the study at Chantilly (Fischel 119) for the *Belle Jardinière* of 1507, in which the group comes very close to its final form, and also in the *modello* at Lille (Pluchart 458; Fischel 161; Louvre 1983, no. 54), datable c. 1507, for Domenico Alfani's *Holy Family* now in the Perugia Gallery. Fischel's view that this technique indicates later reworking by another hand can only be described as an inexplicable aberration. In No. 9 he could see Raphael's hand only in the landscape background.

10 Study for an *Entombment* (sometimes known as *The Death of Adonis*) RECTO. Adam and Eve: *The Temptation* VERSO.

Pen and brown ink. Some roughly drawn black chalk underdrawing in the legs of Adam on the verso. 265: 330 mm.

PROVENANCE: Antaldi (no. 25/26 in the Inventory); Pierre Crozat; Pierre-Jean Mariette (Lugt 2097: sale, Paris, 1775–76, part of lot 692); comte de St. Morys; Henry Fuseli (both according to *Lawrence Gallery*); Sir Thomas Lawrence (Lugt 2445); Samuel Woodburn.

LITERATURE: Mariette, *Crozat Gallery*, no. 42; W. Y. Ottley, *The Italian School of Design*, 1823, p. 54; *Lawrence Gallery* 30; Passavant 462; Robinson 44; Ruland, p. 22, no. 25; Crowe and Cavalcaselle, i, p. 316; Fischel 200/201; Parker 539; British Museum 1983, no. 75; Knab-Mitsch-Oberhuber 210/211.

Ashmolean Museum P II 539

T HE title, "The Death of Adonis," by which this drawing is usually known, was not given to it until after it entered the Crozat Collection in 1714. The composition is, in fact, derived from a group of figures found in essentially the same form on Antique sarcophagi representing not the death of Adonis but the body of Meleager being borne to the funeral pyre. The confusion between Meleager and Adonis no doubt arose because each was a huntsman in whose legend a wild boar plays an important part. Meleager and the huntress Atalanta between them killed the Calydonian boar, a feat that led, indirectly, to Meleager's death. Adonis was killed by a boar, but his body is never shown carried in this way.

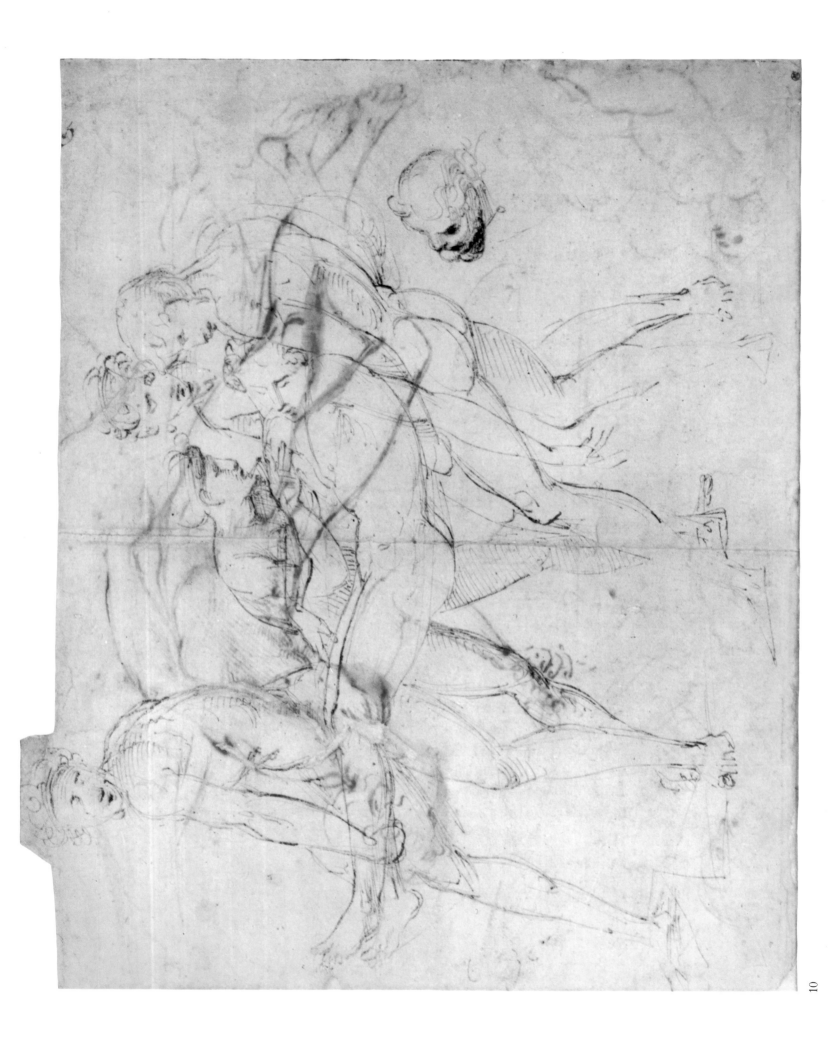

In the Antaldi Inventory the subject is given as "quattro figure, che portono un Christo morto." How the alternative title became attached to the drawing is not recorded. Mariette did not take it very seriously: "C'est le nom qu'on a donné à ce dessein fait à la plume dans lequel Raphaël a peut-être eû intention de representer Jesus Christ porté dans le tombeau. Quoiqu'il en soit, il est postérieur a celuy dont on vient de faire la description." The drawing previously described is the early study for the Borghese *Entombment*, now in the British Museum (No. 11). Ottley repeated the title "The Death of Adonis" without comment and without reference to Mariette's suggestion that the drawing might be a study for an *Entombment*. Passavant, on the other hand, described it as a study for an *Entombment*, but without reference to the Borghese painting. Ruland and Crowe and Cavalcaselle had no doubt about its connection with that particular painting. Robinson, Fischel and Parker were all noncommittal about the subject, and inclined, like Mariette, to rule out the possibility of a connection with the Borghese painting on the grounds that the drawing is more developed in style than studies certainly for it.

Comparison of No. 10 with the Antique prototypes and with the Borghese painting and the studies related to it, reveals a number of features that cumulatively tend to the conclusion that Raphael made this drawing with an *Entombment* in mind. In the center of the group in many of the sarcophagus reliefs a bearded man stands on the far side of the body, supporting its further arm and leaning forward to peer into its face. The corresponding figure in the drawing is a young woman, who in her action, and her position relative to the other figures, resembles the Magdalen in the painting. The Magdalen appears in reverse, but in exactly the same pose and with her face similarly in profile, in the *modello* for the painting in the Uffizi (Fischel 175).

The faint strokes proceeding horizontally from the left hand of the right-hand bearer and the clenching of the hand itself indicate that the drawing resembles the painting and differs from all the Antique prototypes in showing the body carried on a sheet. The sheet appears more clearly in a variant of the drawing by an anonymous amateur draughtsman, the so-called Calligraphic Forger, who was active in the seventeenth century and is known to have copied drawings in the Antaldi Collection (repr. *Burlington Magazine*, li [1927], opp. p. 26), in which the Magdalen figure and her companion immediately to the right are plainly represented as female.

Though No. 10 resembles the Antique reliefs and differs from the Borghese painting in showing the body carried feet first—both Robinson and Fischel attached particular significance to this discrepancy—it differs from the reliefs and resembles the painting in showing it carried from right to left: that is, towards the place occupied by the tomb in the painting.

The step on the left which supports the right foot of the left-hand bearer in No. 10 has no counterpart in any of the Antique reliefs, but its position corresponds with the

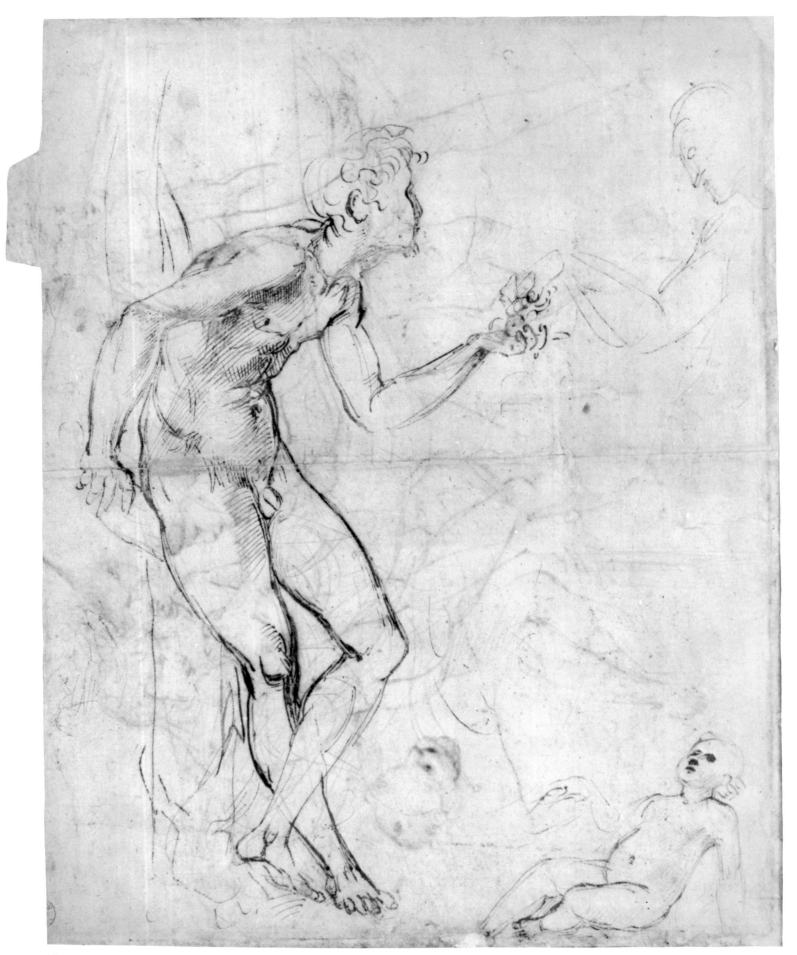

10 verso

lower step of the threshold of the tomb in the painting, on which the left foot of the left-hand bearer is supported.

If the early composition study for the *Entombment* (No. 11) is imagined in reverse and without the figure of the kneeling Virgin, it can be seen as a transitional stage between the Meleager drawing and the eventual solution. The poses of the right-hand bearer in No. 10 and in the reversed No. 11 are even identical.

That the motif of the dead Meleager was considered appropriate to adapt to an *Entombment* at the time when Raphael was planning the Borghese picture is shown by the existence of two similarly inspired groups by Signorelli, both datable in the very first years of the sixteenth century: one in the background of the *Lamentation* in the Brizio Chapel in Orvieto Cathedral (where, significantly, it is represented as a relief on a sarcophagus front), the other in the background of the Borgo San Sepolcro *Crucifixion* (both details repr. Knab-Mitsch-Oberhuber, figs. 90–91). Crowe and Cavalcaselle even took the view that Raphael conceived the Meleager drawing under the inspiration of the Orvieto fresco (an opinion followed by Fischel, cf. also *Old Master Drawings*, xiii [1938/39], p. 50); but there are features peculiar to the drawing, notably the Magdalen figure, that suggest direct knowledge of an Antique prototype. (It may also be added, for what it is worth, that the name of the patron who commissioned the *Entombment* was Atalanta Baglione, and that she did so to commemorate her son, who had died by violence; the theme of the dead Meleager may thus have held a particular significance for her.)

It is true, as Mariette was the first to argue, that the Meleager drawing does seem more developed in style than the early *Entombment* study, No. 11; but the conclusion that this stylistic contrast must imply a difference of date depends on the proposition that an artist's development invariably follows a straightforward line. Crowe and Cavalcaselle say, apropos of this argument, "we shall observe that in drawings made about this time for the predella of the 'Entombment,' the same power and sweep of contour were displayed, and Raphael performed the feat which we find so frequently repeated, of making sketches of the utmost diversity in style for one and the same picture."

A more serious obstacle in the way of dating the Meleager drawing c. 1506, before Raphael had moved to Rome, is the existence of the drawing of the *Temptation* on the other side of the sheet. The composition, known in its complete form only from an engraving by Marcantonio (Bartsch 1), resembles the fresco of the subject on the vault of the Stanza della Segnatura in format and in the symmetrical placing of the figures of Adam and Eve. The figures themselves are entirely different, but Marcantonio is known to have based many of his engravings on discarded studies by Raphael, and the possibility cannot be excluded that the verso drawing is an early idea for the Segnatura vault and thus datable some years after the inception of the *Entombment*. On the other hand, it does not follow, because drawings are on the front and back of the same sheet,

that they were necessarily made at the same time.

The reclining child in the lower right corner of the verso has no connection with the group of Adam and Eve. Fischel pointed out (*Old Master Drawings*, xiii [1938/39], p. 51) that it is a sketch from memory of the sleeping Christ in a *Virgin and Child*, by Giovanni Bellini now in the Isabella Stewart Gardner Museum in Boston; and that the motif is repeated, in reverse, in a painting by Raphael's father, Giovanni Santi, in the National Gallery in London (*ibid.*, fig. 8).

The "faintly discernible sketch of a torso with the thigh bent outwards, derived perhaps from an Antique Psyche and Cupid," which Fischel (*ibid.*, p. 50) saw near the left knee of Adam, is the lower part of the right-hand bearer in the group on the other side of the sheet, showing through the paper.

11 Composition Study for the Borghese *Entombment* RECTO. Three Sketches of a Corpse in a Winding Sheet, One Showing it Carried by a Man; a Group of Three Seated Nude Children VERSO.

Pen and brown ink. 213: 320 mm.

PROVENANCE: Antaldi (Lugt 2445: nos. 27/28 in the Inventory); Pierre Crozat (sale, Paris, 1741, 10 April, etc., lot 109); M. Nourri, Conseiller au Grand Conseil (sale, Paris, 1785, 24 Feb., etc., lot 266); J. A. Julien de Parme (anon. sale, London, T. Philipe, 1801, 25 April, lot 106); G. Hibbert (sale, Christie's, 1833, 12 June, lot 174); Samuel Rogers (sale, Christie's, 1856, 6 May, lot 951); T. Birchall (in his collection by 1857, when he lent the drawing to the Manchester Art Treasures Exhibition); his brother-in-law Richard Rainshaw Rothwell; the latter's great-nephew, F. R. Rothwell (sale, Sotheby's, 1963, 21 Oct., lot 63).

LITERATURE: Mariette, *Crozat Gallery*, no. 41; Passavant 453; Ruland, p. 22, no. 24; Crowe and Cavalcaselle, i, pp. 310 f.; Fischel 170; Gere and Pouncey 361 (Appendix I); British Museum 1983, no. 77; Knab-Mitsch-Oberhuber 196/197.

British Museum 1963–12–16–1

AFTER being seen and described by Crowe and Cavalcaselle, this drawing was lost to sight until its reappearance in the London saleroom in 1963. The plate in Fischel's *Corpus* is a reproduction in reverse of the etching in the Crozat Gallery.

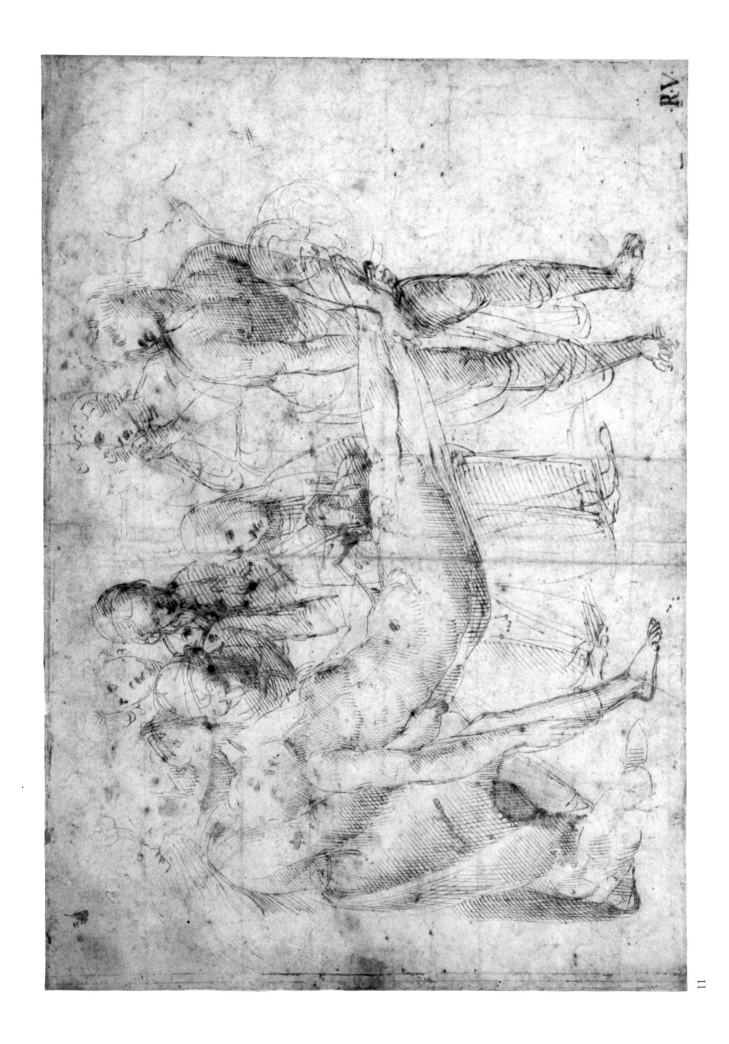

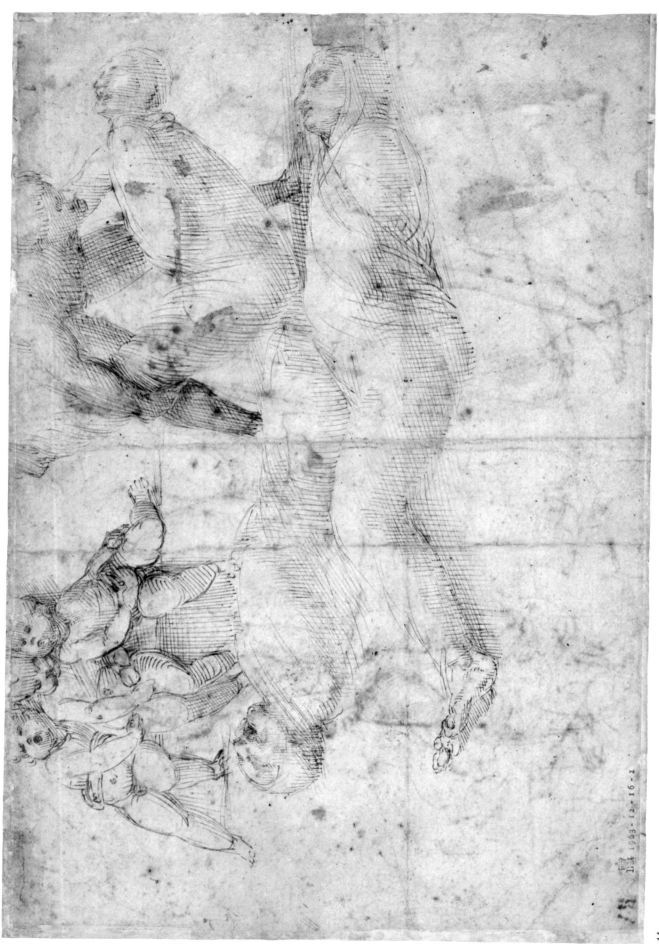

11 verso

Raphael's altarpiece of the *Entombment* (Fig. 11a) dated 1507, was commissioned for the chapel of the Baglioni family in the church of S. Francesco in Perugia. By 1608 it

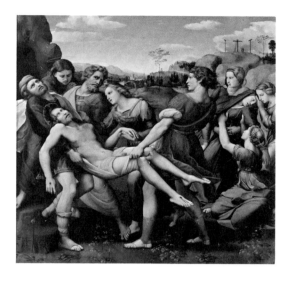

Fig. 11a Raphael. *The Entombment.*
Borghese Gallery, Rome.

had been acquired by Pope Paul V, who gave it to his nephew, Cardinal Scipione Borghese. It still hangs in the Villa Borghese in Rome, from where it derives the name by which it is generally known. Robinson was the first critic to put forward (*Oxford*, pp. 154 ff.) the convincing suggestion that Raphael had originally intended that his altarpiece should represent, not the *Entombment*, but the *Lamentation* for which there are composition studies at Oxford (Parker 529; Fischel 164) and in the Louvre (3865; Fischel 168), and which was derived from an altarpiece by his master Perugino formerly in the church of S. Chiara in Florence and now in the Palazzo Pitti.

The present drawing is the earliest known surviving study for the second phase of the design in which the *Entombment* superseded the *Lamentation*, and it shows that the point of departure for the *Entombment* was a Meleager sarcophagus (see No. 10). At this stage the composition was conceived as a single compact group, but in the final painting the Virgin and the Holy Women constitute a separate group on the right. The Virgin's central position in the drawing and her kneeling posture are vestiges of the original *Lamentation*.

The studies on the verso were evidently drawn from nature and include one of a man staggering under the weight of a corpse. They show the trouble that Raphael took to achieve verisimilitude. The group of three children can have no connection with the *Entombment*. The motif could be imagined at the foot of the Virgin's throne in a *Sacra Conversazione*, and it has been suggested that this is an early idea for a detail of the *Madonna del Baldacchino* (Florence, Palazzo Pitti), a painting of about the same date as the *Entombment*, in which two naked child angels stand in front of the high step of the throne.

12 Studies of the Virgin and Child

Pen and brown ink. Traces of underdrawing in red chalk. 254: 184 mm.

PROVENANCE: Arthur Pond (inscribed on verso: *Pond's sale 1759*); Rev. C. M. Cracherode (Lugt 606 followed by date *1786* on verso), by whom bequeathed in 1799.

LITERATURE: Ruland, p. 71, no. 10; Crowe and Cavalcaselle, i, pp. 272 and 347; Fischel 109; Pouncey and Gere 19; British Museum 1983, no. 84; Knab-Mitsch-Oberhuber 161.

British Museum Ff. 1–36

THE motif of the Child straddling the Virgin's knee in the lower of the two larger studies is derived, in reverse, from Michelangelo's marble *tondo* at Burlington House, a work datable about 1505. Raphael's sketch is a study for the *Bridgewater Madonna* (Duke of Sutherland: on loan to the National Gallery of Scotland) which resembles it closely in the diagonal line of the Child's body and extended left leg and exactly in the angle and expression of his head; but in the painting his right leg is on the other side of the Virgin's knee, so that he is reclining on her lap. The sketch immediately above resembles the *Colonna Madonna* (Berlin) except for the position of the Virgin's legs, which are turned the other way. The Child in the top left corner resembles those in the *Madonna del Granduca* (Florence, Palazzo Pitti) and the *Small Cowper Madonna* (Washington), while the close embrace with heads touching in the sketch to the right is paralleled in the *Tempi Madonna* (Munich).

With the possible exception of the *Bridgewater Madonna*, which some critics place at the beginning of Raphael's Roman period (c. 1509), all the paintings mentioned above come from the later part of his stay in Florence. His late Florentine–early Roman Madonnas are a series of closely linked variations on the motif of a woman with a child. This sheet of studies, clearly all drawn at the same time, throws a revealing light on his method of working, for it shows that these solutions were not arrived at one after the other, but that they took shape simultaneously; and whether or not the *Bridgewater Madonna* was painted in Rome, the existence of a sketch for it on this sheet establishes that it had come close to its final form before Raphael left Florence.

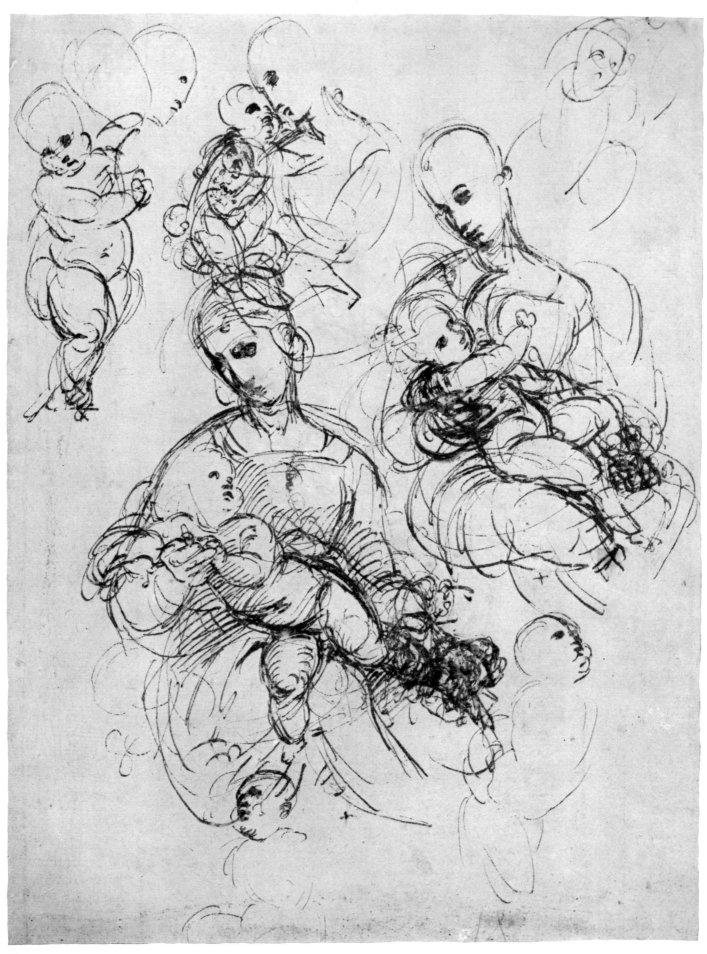

12

13　Composition Study for the Left-Hand Side of the *Disputa*

Brush drawing in brown wash, heightened with white, over stylus. 250: 285 mm.

PROVENANCE: King George III.

LITERATURE: Passavant 429; Ruland, p. 180, no. 69; Robinson, under no. 60; Crowe and Cavalcaselle, ii, p. 29; Fischel 258; Popham, *Windsor*, no. 794; British Museum 1983, no. 85; Knab-Mitsch-Oberhuber 278.

Windsor, Royal Library 12732

I<small>N</small> 1508 Pope Julius II invited Raphael, who was then in Florence, to come to Rome to undertake the decoration of the apartment on the second floor of the Vatican Palace that he had chosen for his own occupation. This consists principally of the Sala di Costantino, approached from the loggia overlooking the Cortile di San Damaso, and three smaller intercommunicating rooms leading out of it on the far side: successively the Stanza d'Eliodoro, the Stanza della Segnatura, and the Stanza dell'Incendio. Julius had begun by entrusting the decoration of the apartment to a number of artists including Sodoma, Lotto, Peruzzi and Raphael's master Perugino; it is characteristic of his ruthless genius as a patron that once satisfied with Raphael's ability he gave him absolute responsibility, with discretion to replace as much of his predecessors' work as he thought necessary. It was also characteristically tactful of Raphael to leave undisturbed Perugino's ceiling in the Stanza dell'Incendio and part of Sodoma's in the Stanza della Segnatura (see No. 15), and to include portraits of both artists in the *School of Athens*.

Before the end of 1508 Raphael had begun work in the Stanza della Segnatura. This name implies the official function connected with the administration of justice for which the room was used later in the century, but originally it seems to have been intended as the Pope's private library. This purpose is suggested by the subject of the four principal frescoes on the walls. Three of them symbolize what were then regarded as the main departments of learning: *Theology* by the so-called *Disputa* (or *Dispute of the Sacrament*); *Philosophy* (in the general sense of humane as opposed to theological studies) by the *School of Athens*; *Jurisprudence* by the three *Judicial Virtues* on one window wall and the smaller scenes below representing acts of justice or lawgiving. Imaginative literature is symbolized by *Parnassus* on the opposite wall, in which the classical and modern poets are assembled round the group of Apollo and the Muses.

More composition studies for the *Disputa* happen to have survived than for the other paintings in this room. They illustrate the laborious process of trial and error by which Raphael arrived at the eventual solution, in which the composition is divided horizontally into two distinct zones separated by an uninterrupted strip of sky. The upper zone consists of a concave cloud platform supporting on either side the figures of six seated

saints or patriarchs. In the center is the Holy Ghost, above which is Christ enthroned flanked by the Virgin and the Baptist, and above him God the Father attended by angels hovering in a curved formation which echoes the shape of the cloud platform. In the center of the lower zone is an altar bearing a monstrance, and on either side a crowd of theologians engaged in argument and discussion. The limitation of the human mind in attempting to grasp the mystery of the Faith is reflected in the contrast between their irregular grouping and agitated gestures and the symmetrical serenity of the figures in the upper zone.

The Windsor drawing should be studied in conjunction with two others, one in Oxford (Parker 542; Fischel 259), the other also at Windsor (Popham 795; Fischel 261), in which the figures respectively in the upper and lower zones are sketched together with their counterparts on the right-hand side. The cloud platform supports only four figures—presumably the Evangelists—in pairs at each end. On a cloud on the same level in the center is a third pair, identified by their attributes as Peter and Paul, and above them is Christ, on either side of whom are three figures, including the Virgin.

No. 13 shows that Raphael began by trying to make the lower part more manageable by reducing its width and exactly defining its depth. The disputing figures are on a terrace bounded on the far side by a balustrade and at either end by an E-shaped architectural screen, the entablature of which is supported by single columns standing on the extremities of the high *basamento*. Raphael seems to have introduced this *basamento* to counterbalance the upper part of the doorway which encroaches on the picture area on the opposite side. In the final solution its place is occupied by a waist-high balustrade, and the doorway itself is raised to the same height by the imposition of a *trompe l'oeil* parapet. (This expedient was found unnecessary in the *School of Athens* on the opposite wall, in which the doorway on one side is not balanced by any simulated architectural feature.)

Raphael did not all at once arrive at a satisfactory solution for the center of the lower part. The altar bearing the monstrance, which is the focus of attention for the disputing figures in the fresco, was not introduced until a later stage. The isolated pair of figures standing immediately to the left of the center line in No. 13 would have been balanced by a similar pair, and the center left open to reveal the balustrade. In the other sketch at Windsor these pairs of figures are omitted and the seated theologians and their companions brought closer together, with the balustrade still visible between them. Which of these two otherwise identical solutions is the earlier is an open question. It may be significant that the pairs of figures flanking the central opening persist beyond the sketch stage, since they recur in an old copy in the Louvre (Fischel 262/263) of a carefully worked out design for the left-hand side which comes closer to the final result.

In his treatment of two complex groups of figures pressing agitatedly forward towards a central point in the lower part of the *Disputa*, and even in some individual

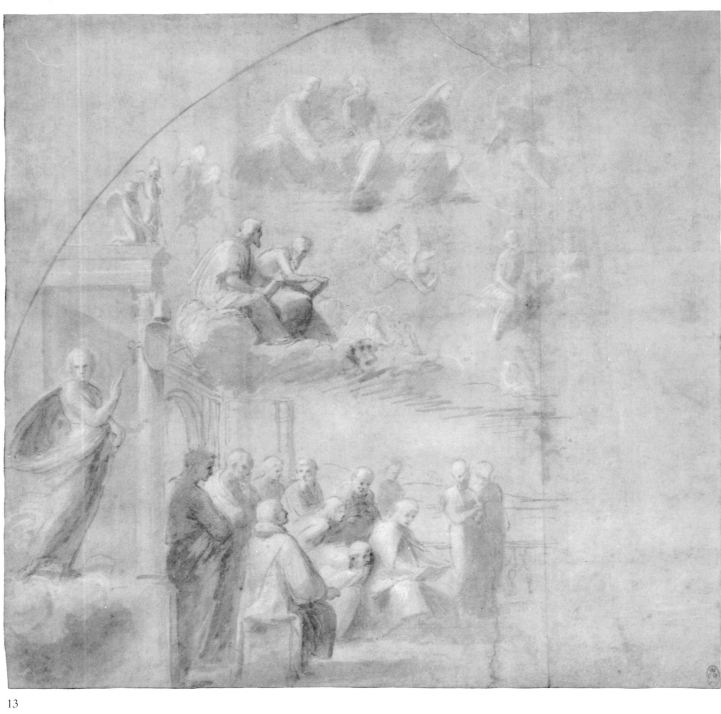

13

poses, Raphael was clearly inspired by Leonardo da Vinci's unfinished *Adoration of the Magi*, which he would have seen in Florence. A striking feature of Leonardo's composition is the pair of mysterious figures on either side of the foreground: on the left an old man lost in thought and on the right a young man who gestures towards the Virgin and Child while gazing obliquely outwards. From the latter Raphael derived the Leonardesque stance and gesture of the angel in the foreground of the Windsor drawing (his supernatural nature is shown by his standing on a cloud) who looks towards the spectator and points upward to indicate the Divine Mystery.

In the final solution the architectural element was abandoned, but the young man immediately to the right of the balustrade in the left foreground (a vestige of the architecture), though no longer a supernatural figure retains the outward gaze and the Leonardesque gesture.

14 Study for a Group of Figures in the *Disputa* RECTO. Studies for Figures in the *Disputa* VERSO.

Pen and brown ink. 311: 210 mm.

PROVENANCE: Jonathan Richardson, jun. (Lugt 2170); Sir Joshua Reynolds (Lugt 2364); S. J. Loyd, 1st Lord Overstone; his daughter, Lady Wantage; A. T. Loyd of Lockinge House; Christopher Loyd.

LITERATURE: C. L. Loyd, *The Loyd Collection of Paintings and Drawings*, London, 1967, no. 116; Fischel 271/270; British Museum 1983, no. 89; Knab-Mitsch-Oberhuber 291/292.

Malibu, The J. Paul Getty Museum 84.GA.920

FIRST published by A. G. B. Russell (*Vasari Society*, 2nd series, v[1924], no. 6), who had come upon the drawing, unattributed, in an album at Lockinge House. He rightly dated it at the beginning of Raphael's Roman period, c. 1509–11, but made no suggestion about its purpose. It was left to Fischel, who already knew the recto from an old copy in the Louvre, to fit it into the sequence of studies for the *Disputa* (*Burlington Magazine*, xlvii [1925], pp. 175 ff.). The man walking forward to the right in the recto group is a discarded idea for the conspicuous figure—the so-called "philosopher"—who in the painting stands with his back to the spectator in the center of the group to the left of the altar. The seated figure summarily sketched on the right corresponds in position with St. Gregory, the nearer of the two enthroned Fathers of the Church on that side. (The strangely shaped head, which might be mistaken for a helmet with a conical visor, is a characteristic abbreviation of the profile of an upturned face and chin.) The standing figure in a monastic habit and his interlocutor on the right are retained in the fresco (the latter having been given a mitre) but placed further back and to the left. Behind and immediately to the left of the "philosopher" Raphael substituted a pair of mitred figures, both turned to the right.

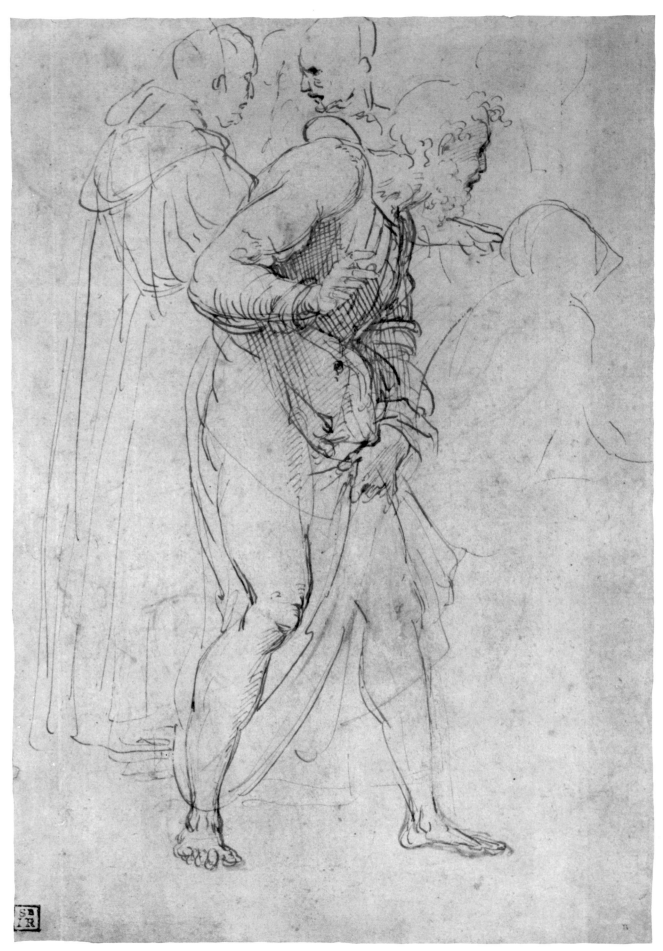

14

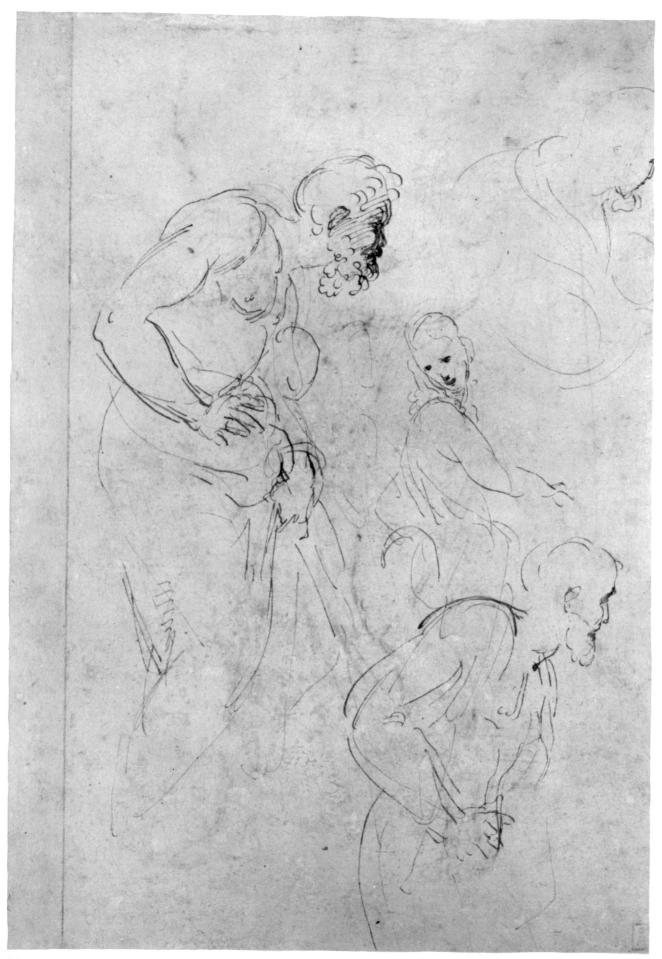

14 verso

On the verso are three rougher sketches for the principal figure, two of them with a slightly different position for the right arm. The study in the center of the sheet is for the "Leonardesque youth" in the left foreground of the *Disputa* (see No. 13), with his right arm pointing downwards.

15 *Poetry*: Study for a Detail of the Vault of the Stanza della Segnatura

Black chalk over stylus. Squared in black chalk. 360: 227 mm.

PROVENANCE: King Charles I (in King George III's "Inventory A" described as "from Kensington": i.e. from the old Royal collection said to have been formed by Charles I, found in about 1730 "in the Buroe in His Majestys Great Closset at Kensington Palace." See Popham, *Windsor*, p. 11).

LITERATURE: Ruland, p. 195, ii, 7; Crowe and Cavalcaselle, ii, pp. 22 and 25; Fischel 228; Popham, *Windsor*, no. 792; British Museum 1983, no. 110; Knab-Mitsch-Oberhuber 334.

Windsor, Royal Library 12734

THIS study for one of the roundels on the vault of the Stanza della Segnatura is very close to the figure as painted, the principal difference being that in the drawing the upper part is unclothed.

The vault is partitioned in a complex arrangement of alternate roundels and rectangular spaces surrounding a central octagon. The four roundels contain figures of *Theology*, *Philosophy*, *Justice* and *Poetry*, each of which is related to the theme of the fresco on the wall below (*Poetry* being above *Parnassus*), while the subject of each of the four rectangular frescoes is thematically related to the roundels on either side of it.

The four roundels and the four rectangular scenes are by Raphael, but the partitioning of the vault was devised by Sodoma, who was also responsible for the subsidiary paintings in the central octagon and in the spaces between the roundels. These are vestiges of the original decoration completed not long before Raphael's arrival. Since, for obvious practical reasons, the ceiling is usually the first part of any room to be decorated, it has been generally assumed that the vault of the Stanza della Segnatura was the first task undertaken by Raphael after he came to Rome. But Pope-Hennessy (p. 148) argues, firstly, that Julius II would hardly have allowed an entirely untried painter to begin work by drastically altering a ceiling decoration that had only just been completed; and, secondly, that the studies for the vault paintings reveal a greater degree of maturity and assurance than those for the *Disputa* (e. g., No. 13). The substitution of Raphael's ceiling paintings for Sodoma's is therefore likely to date from some years later, probably c. 1511, when the completion of the wall frescoes had revealed the stylistic incompatibility of Sodoma's ceiling.

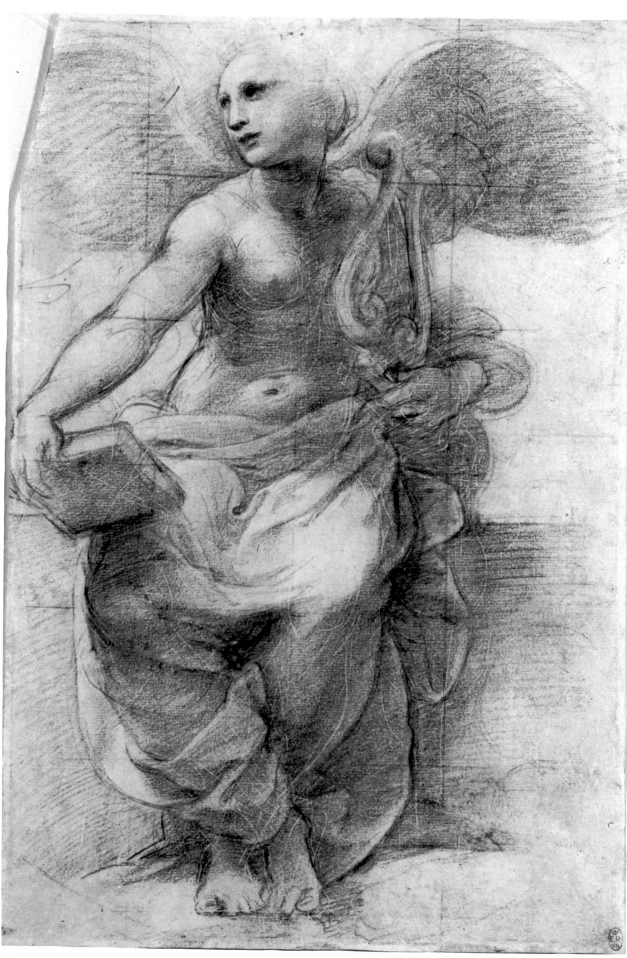

15

16 Melpomene: Study for the *Parnassus* RECTO.
Virgil: Study for the *Parnassus* VERSO.

Pen and brown ink. Faint underdrawing in lead point on the verso; what appears to be similar underdrawing on the recto is the verso drawing showing through. 330: 219 mm.

PROVENANCE: Jean-Baptiste-Joseph Wicar; William Young Ottley (sale, London, T. Philipe, 1814, 6 June etc., lot 1210); Sir Thomas Lawrence (Lugt 2445); Samuel Woodburn.

LITERATURE: W. Y. Ottley, *The Italian School of Design*, 1823, pp. 52 f.; *Lawrence Gallery* 66; Passavant 511; Robinson 69; Ruland, p. 187, 76 and 80; Crowe and Cavalcaselle, ii, p. 86; Fischel 249/248; Parker 541; British Museum 1983, no. 104; Knab-Mitsch-Oberhuber 374/370.

Ashmolean Museum P II 541

T HE recto drawing is a study for the Muse identified as Melpomene, the Muse of Tragedy by the tragic mask in her hand, who stands on the left of the group surrounding Apollo in the center background of the fresco of *Parnassus* in the Stanza della Segnatura in the Vatican.

The most obvious difference between this study and the figure in the painting is that there the face is turned towards the spectator. In the lost composition study engraved by Marcantonio (Bartsch 247; Pope-Hennessy, fig. 83) this figure is looking backwards over her right shoulder, as in the drawing; in the other lost study known from a copy in the Ashmolean Museum (Parker 639; Fischel, fig. 221; Pope-Hennessy, fig. 84), the head is in an intermediate position, turned three-quarters to left. As Parker suggested, Raphael no doubt abandoned the first position, beautiful though it is, when he realized that the backward turn of the head would repeat the position of the head of Virgil whose traditional role in the *Divina Commedia* is indicated by his looking back towards Dante as if encouraging him to follow.

Exactly how the figure in the drawing is standing is unclear. Her weight is not supported on either leg: Crowe and Cavalcaselle describe her as seeming "hardly to touch the earth" and Parker as "floating downwards." The explanation is provided by an old copy, also in the Ashmolean Museum (Parker 465), of a Raphaelesque drawing of the hovering figure of *Victory* in the spandrel to the left of the arch on the east side of the Arch of Titus (Fig. 16a). Raphael based his Melpomene on this Antique prototype, just as he based the seated Muse next to her on the Vatican *Ariadne*. Fischel and Parker explain the curved shape on which the legs of the figure in the drawing seem to be supported as the outline of the legs of the seated Muse. These occupy the same position in the painting, but the curve is too regular and must in fact be the contour of the arch which forms one side of the spandrel.

Even in the painting the Antique model is not completely assimilated. Melpomene is one of a group of static figures, but her raised right foot and fluttering dress suggest that she is moving. Both anomalies are vestiges of the figure in the spandrel. Crowe

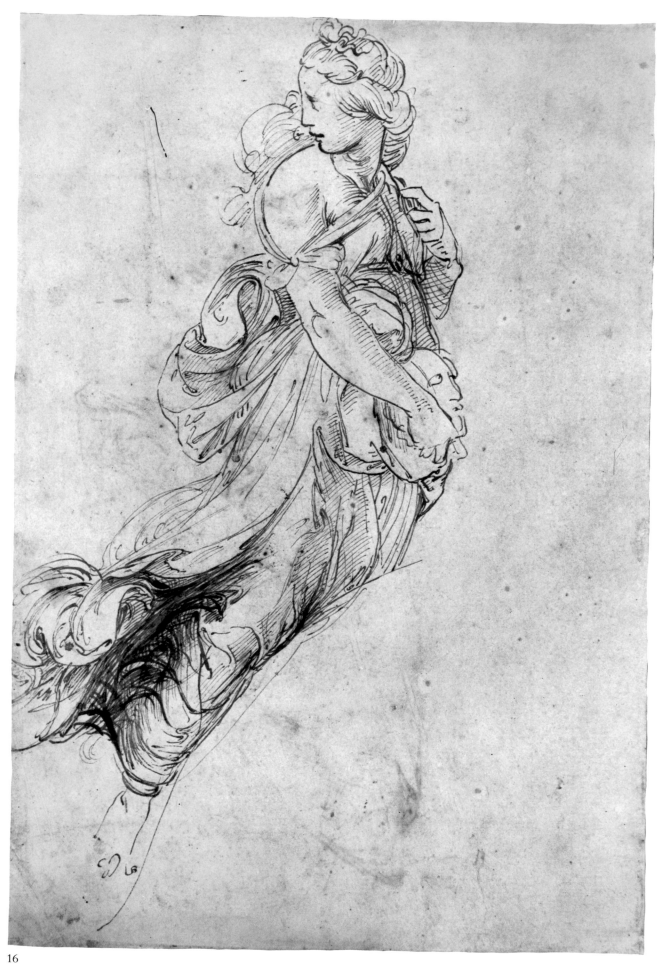

16

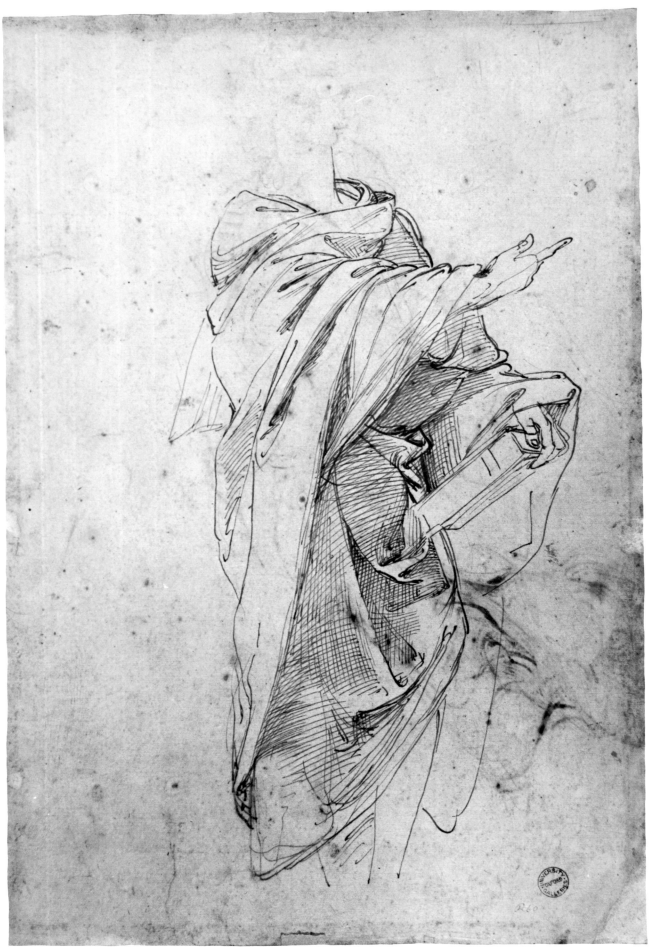

16 verso

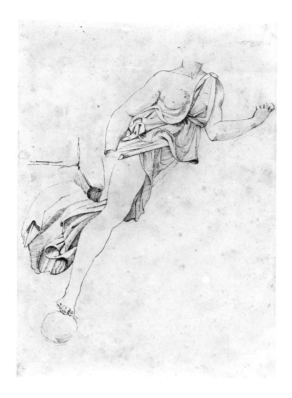

Fig. 16a Raphael School. *A Victory*:
Copy of spandrel relief from the *Arch of Titus*.
Ashmolean Museum, Oxford.

and Cavalcaselle noticed the fluttering drapery, but explain it, rather lamely, as caused by a gust of wind "which plays with the folds of her vestment, but leaves her neighbor's tunic untouched."

An old copy of the recto in the Uffizi (1220 E) was treasured by Nicolas Poussin, according to an inscription in a seventeenth-century hand, probably that of the collector, Sebastiano Resta: *Nel Parnasso in Vaticano. Era questo foglio carissimo a Monsù Pussino. L'hebbi dal Sigr Pietro Santi Scolᵒ di Monsù Lamer suo discepolo 1699.* "Monsù Lamer" is presumably Poussin's studio assistant, Jean Lemaire.

The drawing on the verso is for the complete figure of Virgil, who in the fresco stands immediately to the left of Melpomene with his body largely obscured by her dress and by the figure of Homer. The effect of the drawing has been accidentally distorted by the fortuitous placing of the head of the recto figure, which shows through the paper and gives the impresssion that the head of the verso figure is in profile to right on an unduly long neck. The stroke apparently indicating the front of the neck is in fact the back of the neck of the verso figure: the bearded head, turned to look backward over its right shoulder so that it is in profile to left, is faintly but completely drawn in lead point.

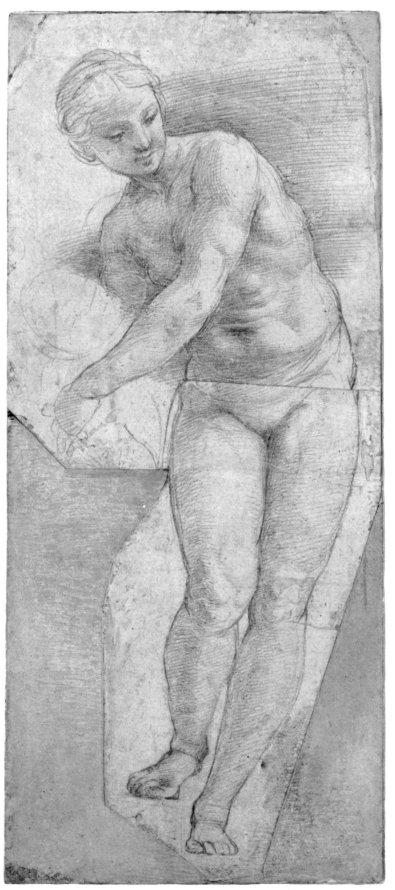

17

17 Venus

Metalpoint on two pieces of pink prepared paper, the lower overlapping the other by about 25 mm. Irregularly trimmed. Maximum measurements: 238: 100 mm.

PROVENANCE: José de Madrazo; Sir Charles Robinson (both according to Robinson); John Malcolm of Poltalloch.

LITERATURE: Ruland, p. 127, ii, 2; Robinson, *Malcolm*, no. 190; Fischel, p. 328, n. (wrongly stated to be reproduced in part viii of his *Corpus*); Pouncey and Gere 27; British Museum 1983, no. 115; Knab-Mitsch-Oberhuber 358.

British Museum 1895–9–15–629

THE addition of the overlapping sheet, which is trimmed along the contour of the upper part of the leg, was made by the draughtsman in order to modify the pose. The previous position of the right hip is indicated by the line to the left of the trimmed contour. There is also a *pentimento* for the right shoulder.

The figure corresponds very closely, in the same direction, with an engraving by Marcantonio (Bartsch 311) of Venus in a niche, reaching down to embrace the head of Cupid who stands on a low plinth to the left. The position of his head is indicated in the drawing by the roughly drawn circular outline above her left forearm. The engraving is one of a pair and its pendant, of *Apollo* (Bartsch 335), must have been derived from a lost study for the statue represented in a niche on the left-hand side of the *School of Athens*. In the niche on the other side is a statue of Minerva, whose presence in the *School of Athens* is as suitable as that of Venus would be inappropriate. The *Venus and Cupid* group cannot be connected with any known or recorded work; it is not impossible that Raphael designed it on purpose to be engraved, in the belief that *Apollo and Venus* would make a more attractive pair than *Apollo and Minerva*.

The drawing must date from Raphael's first years in Rome. The pink metalpoint ground is paralleled in studies for the *School of Athens* in the Stanza della Segnatura, (begun 1508–9), and in the "Pink Sketchbook" group datable at about the same time (see Fischel, *Burlington Magazine*, lxxiv [1939], pp. 181 ff.). Pen and ink sketches of a standing *Apollo* and a standing *Venus* in the Uffizi (Fischel 264) and at Lille (Fischel 266) seem to be derived from the "Leonardesque youth" in the left foreground of the *Disputa*, another fresco in the Stanza della Segnatura (see No. 13).

18 The Virgin and Child: Study for the *Madonna di Foligno*

Black chalk on greenish-gray paper. The halo behind the Virgin's head drawn with the stylus. Traces of squaring in black chalk. 402: 268 mm.

PROVENANCE: Jean-Baptiste-Joseph Wicar (according to the *Lawrence Gallery* catalogue); Sir Thomas Lawrence (Lugt 2445); King William II of Holland (sale, The Hague, 1850, 12 August, lot 39); Henry Vaughan, by whom bequeathed.

LITERATURE: *Lawrence Gallery* 49; Passavant, p. 538, *hhh*; Ruland, p. 73, no. 10; Crowe and Cavalcaselle, ii, p. 167; Fischel 370; Pouncey and Gere 25; British Museum 1983, no. 120; Knab-Mitsch-Oberhuber 427.

British Museum 1900-8-24-107

THE group corresponds very closely with the upper part of the altarpiece in the Vatican Gallery of *The Virgin and Child Adored by the Baptist, St. Jerome, St. Francis and the Donor, Sigismondo de'Conti*, commissioned by the last-named for the High Altar of the church of S. Maria in Aracoeli in Rome and probably completed not long before his death in February 1512. In 1565 his descendants moved the painting to a church in the Umbrian city of Foligno, from which it derives the name by which it is generally known. Removed to Paris after the Treaty of Campo Formio in 1797, it was restored in 1815 but placed in the Vatican.

In the painting, the group of the Virgin and Child is surrounded by a circular glory and not the almond-shaped *mandorla* indicated in the drawing. The position of the Child's legs is also different. The irregular contour below his left thigh in the drawing is either a cushion or an alternative placing of the leg. But in spite of these differences, which though slight are unmistakable signs of creative thinking, and the squaring—to say nothing of the very high quality of the drawing itself—Raphael's authorship has not in the past been universally accepted. Passavant, for example, dismissed it as a copy of a lost drawing, and Crowe and Cavalcaselle as a copy of an engraving by Marcantonio (Bartsch 47), which, though possibly based on a discarded study for the *Madonna di Foligno*, differs from the drawing in almost every detail. On the other hand, when Sidney Colvin published it in 1906 (*Vasari Society*, i, no. 7) it was with the emphatic, and entirely just, comment, "the touch and sentiment of the Virgin's head seem thoroughly Raphael's and not those of any imitator; and the suggestion of modelling in her shoulder and arm is very sensitive and full of beauty."

The earlier critics were no doubt disconcerted by the superficially unfamiliar appearance of the drawing. This is the only known instance of Raphael's use of the Venetian *sfumato* technique of black chalk on *carta azzurra*—a shortlived technical experiment that may reflect the phase, in about 1512, when he was briefly in close contact with the Venetian painter Sebastiano del Piombo.

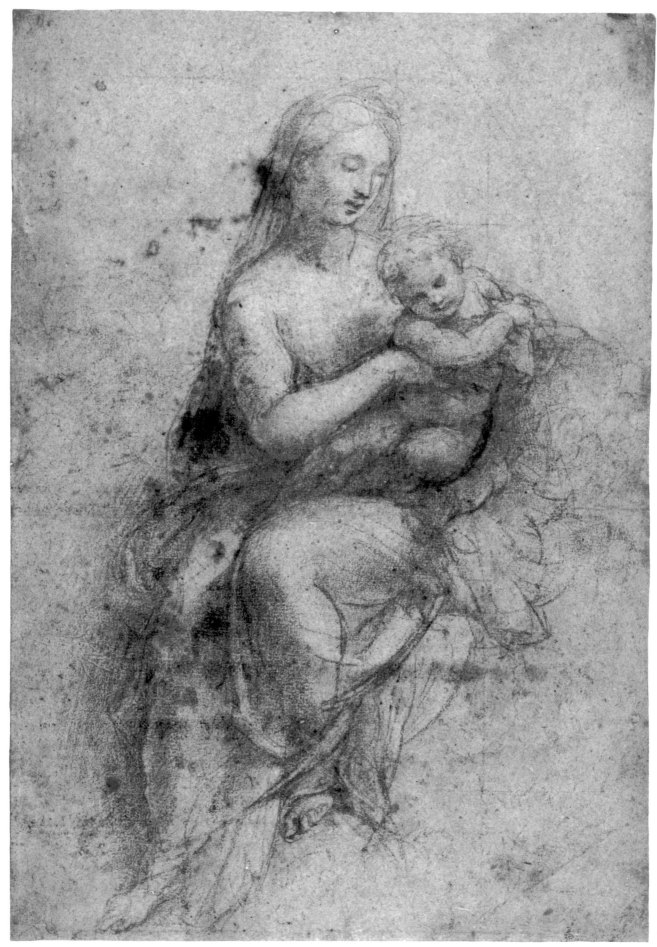

18

19 The Massacre of the Innocents RECTO.
Design for a Circular Dish VERSO.

Red chalk, over black chalk and stylus (recto); pen and brown ink (verso). 248: 411 mm.

PROVENANCE: Bonfiglioli family, of Bologna; purchased with the rest of the Bonfiglioli Collection by Procuratore Zaccaria Sagredo of Venice, 1727/28; Consul Joseph Smith (d. 1770); purchased for King George III, 1773.

LITERATURE: Passavant 421; Ruland, p. 35, ix, 7; Crowe and Cavalcaselle, ii, p. 119; Fischel 234; Popham, *Windsor*, no. 793; British Museum 1983, no. 123; Knab-Mitsch-Oberhuber 341.

Windsor, Royal Library 12737

RAPHAEL's principal works in Rome were on the walls of the Pope's private apartments in the Vatican, access to which was limited to a relatively small number of privileged persons. Engravings provided the best means of making his work known to a wider public, and in Marcantonio Raimondi he found the ideal interpreter and disseminator. Marcantonio, who was one of the earliest reproductive (as distinct from original) engravers, devised an effective all-purpose technique of regular hatching and cross-hatching into which to translate Raphael's forms. Many of his prints and those of his followers, Agostino Veneziano and Marco da Ravenna, reproduce discarded studies by Raphael made in connection with other projects, and are often of historical importance as preserving intermediate stages in the working out of a composition. Occasionally, however, Raphael seems to have made designs especially to be engraved; one of these was the *Massacre of the Innocents*, which is known in its final form only from Marcantonio's engraving (Bartsch 18).

The *Massacre of the Innocents* is one of Raphael's most complex and most tightly organized figural compositions, and it has often been remarked that it reflects the impact on him of Michelangelo's *Bathers*, the only completed section of the cartoon for the fresco of the *Battle of Cascina* intended for the Palazzo della Signoria, which caused an enormous artistic sensation in Florence at the time when Raphael was there. The *Massacre* resembles the *Bathers* in being primarily a virtuoso display of skill in the representation of the human figure in every conceivable pose and gesture. The *Bathers* hardly suggest an episode in a battle; similarly, the *Massacre of the Innocents* has been, so to speak, "defused" and emptied of all the elements of pity and terror that are naturally—and, one would have supposed, inextricably—associated with the subject. In Kenneth Clark's words, "the beautiful poses of Herod's executioners bear no more relation to their brutal intentions than if they were ballet dancers."

Studies for figures in the *Massacre of the Innocents* are on two sheets in the Albertina (Fischel 231/232 and 236/237), on the other side of which are studies for the vault of

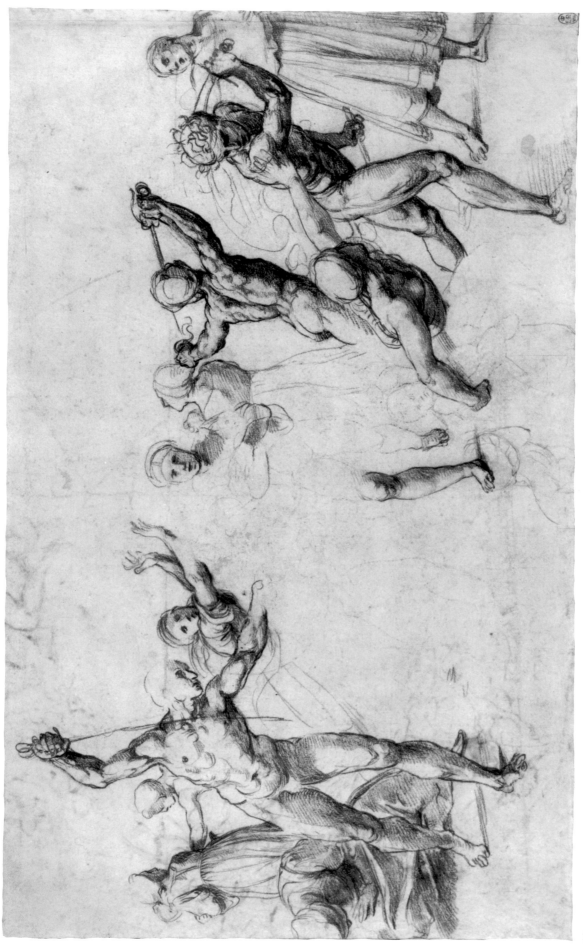

19 verso

the Stanza della Segnatura. It seems reasonable on grounds of style to date the *Massacre of the Innocents* at about the same time, c. 1511 (see No. 15).

The surviving drawings are evidence of the trouble that Raphael took over the composition, and the importance he attached to his collaboration with Marcantonio. The dotted contour visible here and there in the black chalk underdrawing of the Windsor study shows that the outlines were traced through from another sheet by pouncing (a method of transferring a design from one sheet to another by outlining the contours with a series of prick holes, through which a dark powder, or "pounce," was blown or dusted to make a dotted contour on the sheet below). The first sheet may have been the pen and ink drawing in the British Museum (Pouncey and Gere 21; Fig. 19a), in which the contours are pricked for transfer and the figures, though the mothers as well as the executioners are naked, correspond in size with those in No. 19.

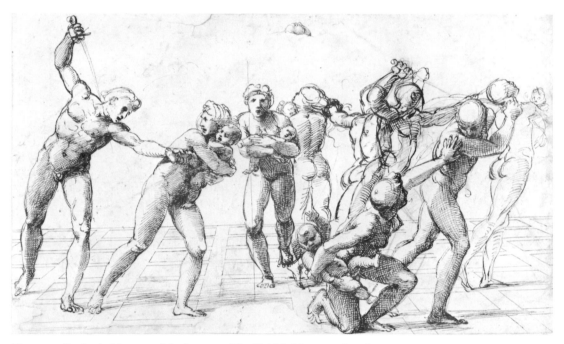

Fig. 19a Raphael. *Massacre of the Innocents*. The British Museum, London.

No. 19, so far as it goes, agrees exactly with the print. The British Museum drawing also corresponds very closely with the engraving, the principal difference (apart from the nudity of the mothers) being a pair of figures in the right background, an executioner brandishing a sword in one hand and with the other grasping the hair of a fleeing mother. These figures are evidently an afterthought: it was only they that were first sketched in red chalk, and the executioner is drawn over another figure. Raphael abandoned this solution for the right background before going on to the next stage of the

design, for these are the only figures not pricked for transfer to another sheet; but his reluctance ever to waste anything is demonstrated by their reappearance as a sea-centaur and sea-nymph in the border of the design for a circular dish of No. 19 verso. On 10 November 1510, just when Raphael was probably working on the *Massacre of the Innocents*, the goldsmith Cesare Rossetti acknowledged a payment on account from Raphael's patron, Agostino Chigi, for two bronze *tondi*, each about four *palmi* (about three feet) in diameter, to be decorated in relief "cum pluribus floribus" after designs to be supplied by Raphael (Golzio, pp. 22 f.). Though the document specifies a decoration of flowers rather than sea-monsters, the possibility that No. 19 verso was made in connection with this commission cannot be excluded. In any case, the design was almost certainly meant to be realized in bronze. There is no evidence that Raphael ever made designs on purpose for the decoration of maiolica. Compositions and details of compositions by him are often found on maiolica—so much so that in the past it was sometimes known as "Raphael ware"—but these are always taken from engravings.

20 One of the Marble Horses of the Quirinal

Red chalk, over stylus. The measurements added in pen and brown ink. 218: 278 mm.
PROVENANCE: Sir Peter Lely (Lugt 2092); William, 2nd Duke of Devonshire (Lugt 718).
LITERATURE: British Museum 1983, no. 127; Knab-Mitsch-Oberhuber 531.
Chatsworth 657

B Y a brief of Pope Leo X, dated 27 August 1515, Raphael was officially authorized to inspect and purchase all antiquities discovered in Rome itself and within a radius of ten miles from the city. His interest in Antique art and its powerful effect on his creative imagination was already apparent even before he settled in Rome (cf. No. 10). It is thus surprising that the present drawing is unusual—one might even go so far as to say unique—in being an accurate and carefully measured copy by him of a piece of Antique sculpture. Though this drawing has been in the Devonshire Collection since the eighteenth century, and under the name of Raphael, it has been completely ignored in the Raphael literature—even escaping the fine-meshed net of Ruland, who on the whole missed very little. In recent years, the present compiler, John Shearman, and James Byam Shaw have independently expressed their belief in Raphael's authorship. No. 20 was first published by Byam Shaw in the catalogue of the exhibition of Chatsworth drawings circulated in the United States in 1969/70.

The horse is one of those in the famous colossal group usually known as "The Horse-Tamers," but probably in fact representing Castor and Pollux, which has stood on the Quirinal Hill in Rome since ancient times. The monument, which in the late

eighteenth century was regrouped round an obelisk brought from elsewhere, is probably a Roman replica of a Greek original of the fifth or sixth century B. C. The horse copied by Raphael is the one inscribed OPVS PRAXITELIS; the copy shows it as it was in the early sixteenth century, with most of the left foreleg missing.

In the opinon of Arnold Nesselrath (*Burlington Magazine*, cxxiv [1982], p. 357), the measurements are not inscribed in Raphael's hand. It does indeed seem likely that he would have delegated to an assistant the mechanical task of measuring the statue.

21 The Virgin and Child with St. Elizabeth and a Female Saint: Study for the *Madonna dell'Impannata*

Metalpoint, heightened with white, on pale brown prepared paper. 210: 145 mm.

PROVENANCE: Bonfiglioli family, of Bologna; purchased with the rest of the Bonfiglioli Collection by Procuratore Zaccaria Sagredo of Venice, 1727/28; Consul Joseph Smith (d. 1770); purchased for King George III, 1773.

LITERATURE: Passavant 426; Ruland, p. 81, xli, 4; Crowe and Cavalcaselle, ii, p. 171; Fischel 373; Popham, *Windsor*, no. 800; British Museum 1983, no. 135; Knab-Mitsch-Oberhuber 425.

Windsor, Royal Library 12742

THE drawing corresponds very closely with the principal group in the *Madonna dell'Impannata* (Florence, Palazzo Pitti), a painting generally agreed to have been executed on Raphael's design by one of his studio assistants, probably G. F. Penni, in about 1513–14. The female saint usually identified as St. Catherine, who is lightly sketched on the left of the group in the drawing, in the painting rests her right hand on St. Elizabeth's shoulder and is leaning so far forward that their heads are almost touching. With her left forefinger she touches the Infant Christ, who turns his head to look up at her.

In the drawing the composition seems to be complete in itself, but in the painting it is enlarged to include a seated figure of the youthful Baptist in the right foreground, and above him and behind the Virgin's left shoulder a window with the blind ("impannata") which gives the picture its name. X-Ray photography has revealed that the place of the Baptist was originally occupied by a half-length figure of St. Joseph seated in profile to the left, and behind him a youthful head which can only be the Baptist's (see *Bollettino dell'arte*, xxxi [1938], pp. 495 ff.). Studies by Raphael, also in metalpoint, on a sheet at Berlin (Fischel 374), include one for the Infant Christ and another for the Baptist; both are as in the painting and establish that Raphael was responsible for the alteration.

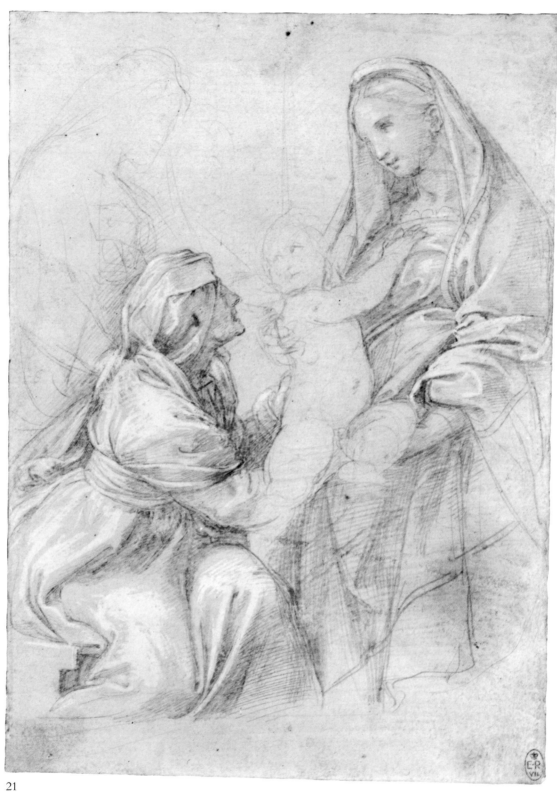

21

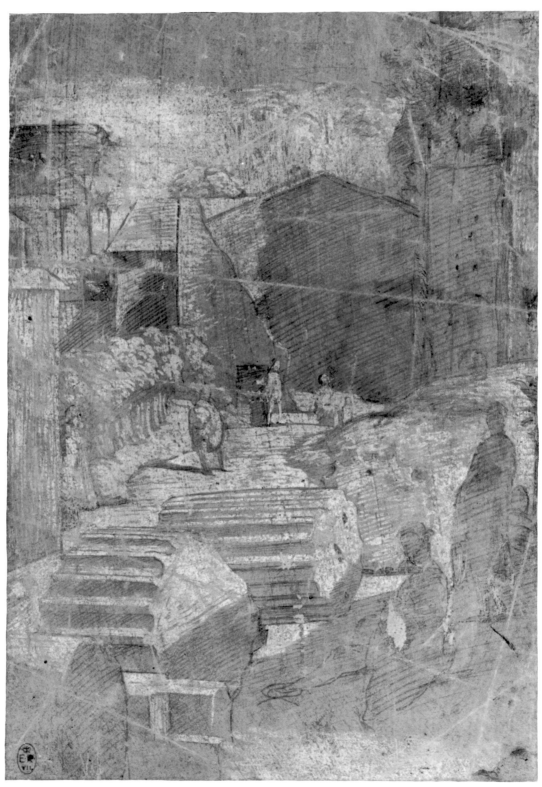

22

22 View of Ruins and Houses with Figures

Metalpoint, heightened with white, on pale buff prepared paper. Somewhat rubbed. 210: 141 mm.

PROVENANCE: Presumably in the royal collection by the time of King George III, but not traced by Popham in any of the old inventories.

LITERATURE: Popham, *Windsor*, no. 801; Ravelli 6; British Museum 1983, no. 139; Knab-Mitsch-Oberhuber 450.

Windsor, Royal Library 0117

T HE drawing bore no traditional attribution. Owen Morshead, Librarian at Windsor Castle 1926–58, was the first to observe its close correspondence, in reverse, with the landscape background in the so-called *Morbetto*, a composition of figures either dead or dying of plague known from an engraving by Marcantonio inscribed INV. RAP. VR (Bartsch 417; Fig. 22a). The correspondence is close but not

Fig. 22a Marcantonio Raimondi, after Raphael. *The Plague*. Engraving. B. xiv, 417.

exact: the figures seen in silhouette in the right foreground of the drawing and the two foremost drums of the fallen column do not appear in the engraving, and a dead horse occupies the place of the solitary figure standing in the roadway. No date is inscribed on the engraving, but the composition is generally placed in the period around 1512–13, largely on the basis of its resemblance to the *Freeing of Peter* in the Stanza d'Eliodoro; for reasons concerned with the apparent course of Marcantonio's technical development, the engraving may be somewhat later, c. 1515–16 (see *The Engravings of Marcantonio Raimondi*, catalogue by Innis H. Shoemaker, exh. University of Kansas, Lawrence, and University of North Carolina, Chapel Hill, 1981, no. 31).

Kenneth Clark, who first published the drawing (*Vasari Society*, 2nd series, xii [1931], no. 6), doubted whether it was necessarily made on purpose for the engraved composition: Raphael could have adapted a landscape sketch made for some other purpose, or possibly for no purpose at all. The way in which the composition is fitted into the rectangle certainly tends to support the view that it was conceived as an independent entity complete in itself. Clark's suggestion that the scene represented is in the neighborhood of the Forum of Trajan may well be correct, though it finds no absolute confirmation in any of the views of that part of Rome published by Hermann Egger in his *Römische Veduten* (Vienna, 1932).

Very few landscape drawings by Raphael are known. The detailed pen and ink view of Perugia in the background of the very early drawing of *St. Jerome in a Landscape* in the Ashmolean Museum (Parker 34, as Circle of Perugino; British Museum 1983, no. 19) is one; another, later, example is the slight sketch at Weimar, also in pen, of an imaginary landscape with a Colosseum-like ruin (Knab-Mitsch-Oberhuber 251). Neither resembles the Windsor landscape at all closely, and the question must arise, whether Raphael's name would necessarily come to mind if the drawing were considered without knowledge of its connection with the *Morbetto*. It would be difficult to find parallels for the caricatural treatment of the grotesquely obese figure in the middle distance, or, at the other extreme, for the mannered elongation of those in the right foreground, reduced as they are to almost abstract terms and silhouetted against the light. On the other hand, it is impossible to suggest a convincing alternative attribution. The probable fairly early date of the *Morbetto* composition limits the number of possibilities if (as seems likely) the drawing is anterior to it. There is no reason for invoking the names of Giulio Romano or G. F. Penni, the two studio assistants who might in theory have made such a drawing at that time; nor does Ravelli's suggestion that No. 22 is a derivation from the *Morbetto* by Polidoro da Caravaggio seem at all convincing. In the end we have to fall back on the proposition of the incalculability of creative genius (as opposed to creative talent), and the possibility that an artist of Raphael's calibre is always capable of springing a surprise.

Some measure of external argument in favor of Raphael's authorship is provided by

the physical nature of the drawing. Fischel, who accepted the attribution without question, included it in his "buff-grounded silverpoint sketchbook" group (cf. *Burlington Magazine*, lxxvii [1939], p. 182), another of which, the study for the *Madonna dell'Impannata* of c. 1513–14, also, and perhaps significantly, at Windsor (No. 21), is on a sheet of exactly the same height and only fractionally smaller width.

23 A Horse's Head

Black chalk. Somewhat rubbed and damaged. The outlines pricked for transfer. The sheet is composed of a number of pieces of paper: the lower right corner seems to have been made up of fragments taken from elsewhere in the cartoon. 682: 533 mm.

PROVENANCE: Francesco Massini ? (a "gentilhuomo di Cesena," who according to Vasari [iv, p. 346] owned "alcuni pezzi del detto cartone che fece Raffaello per questa istoria d'Eliodoro"); Cardinal Albani (purchased by Ottley from the Palazzo Albani Collection in Rome in 1801); William Young Ottley (sale, London, T. Philipe, 1814, 6 June, etc., lot 1689); Sir Thomas Lawrence; Samuel Woodburn.

LITERATURE: *Lawrence Gallery* 74; Passavant 513; Ruland, p. 201, 40; Robinson 86; Crowe and Cavalcaselle, ii, p. 240; Parker 556; Oberhuber-Fischel 402; British Museum 1983, no. 144; Knab-Mitsch–Oberhuber 433.

Ashmolean Museum P II 556

A FRAGMENT of the cartoon for the fresco of the *Expulsion of Heliodorus from the Temple* in the Stanza d'Eliodoro in the Vatican, which was probably painted in 1512: it includes a portrait of Pope Julius II, who died in February 1513. The head is that of the horse ridden by the avenging angel, in the right foreground. Thanks to the kind cooperation of Professor Fabrizio Mancinelli of the Pontifical Museums and Galleries, it was possible recently for Isabelle Frink and Sylvia Ferino Pagden to place a full-size photograph of the cartoon fragment over that detail of the fresco. The contours of both heads correspond exactly, but the horse's mane in the fresco has none of the quality of the drawing—a quality that invites comparison with the black chalk studies of the rhythmic patterns of water and hair by Leonardo da Vinci. Over the centuries Raphael's paintings in the Vatican have endured many vicissitudes, and the inferiority of the painted head does not necessarily imply the intervention of a studio assistant.

23

24 A Sibyl RECTO.
Drapery of a Seated Figure, with One Foot
Supported on a Vase VERSO.

Red chalk over stylus. 262: 167 mm.

PROVENANCE: Jonathan Richardson, sen. (Lugt 2183); bought at the Richardson sale in 1746
by the 2nd Duke of Rutland; bought from the 8th Duke of Rutland c. 1907 by Messrs. Wilden-
stein, from whom bought by H. M. Calmann.

LITERATURE: A. E. Popham, *British Museum Quarterly*, xix (1954), p. 10; Pouncey and Gere 36;
British Museum 1983, no. 152; Knab-Mitsch-Oberhuber 393/392.

British Museum 1953–10–10–1

A STUDY for one of the Sybils painted by Raphael on the wall surrounding the
Chigi Chapel in the church of S. Maria della Pace in Rome. The altar is in a
shallow round-headed niche in the wall of the nave. On either side of the arch
Raphael painted a pair of Sibyls with attendant angels. The upper part of the wall is
separated by a heavy entablature from the area containing the Sibyls and consists of a
lunette divided vertically by a window on either side of which is a pair of Prophets,
one sitting and one standing (see No. 25).

The present drawing, unknown until its appearance on the London art market in
1953, is a study for the Sibyl immediately to the right of the arch. She is sometimes
identified as the Phrygian, but as L. Ettlinger has pointed out (*Journal of the Warburg
and Courtauld Institutes*, xxiv [1961], p. 322), there is no real basis for the identification.
(The only one of the four who can convincingly be identified is the elderly Sibyl on
the extreme right, who is clearly the Cumaean: she resembles Michelangelo's *Cumaean
Sibyl* on the Sistine ceiling, and the tablet next to her is inscribed *iam nova progenies*, the
utterance given to this Sibyl by Virgil, *Ecl.* iv, 7). No. 24 corresponds in all essentials
with the figure as painted, from which it differs only in such details as the elevation of
the left knee, the angle of the right arm, and the position of the right hand. In the fresco
the hand rests on the arch, but in the drawing it is supported on a rectangular object
which could be the end of a thick table top: if so, this suggests that the drawing was
made from a living model posed in the studio. Sketched very lightly to the right, with
some *pentimenti*, are a head and an extended arm. The angular profile and indication of
the headdress identify this as an indication of the Cumaean Sibyl, who occupies the
same position in the fresco.

An earlier study for the so-called Phrygian Sibyl in the Ashmolean Museum (Parker
562; British Museum 1983, no. 151) differs from the final result in the position of the
head, shoulders and arms. In his catalogue, Parker said of the then newly discovered
British Museum study that "the handling is rather coarse and defective, but whether

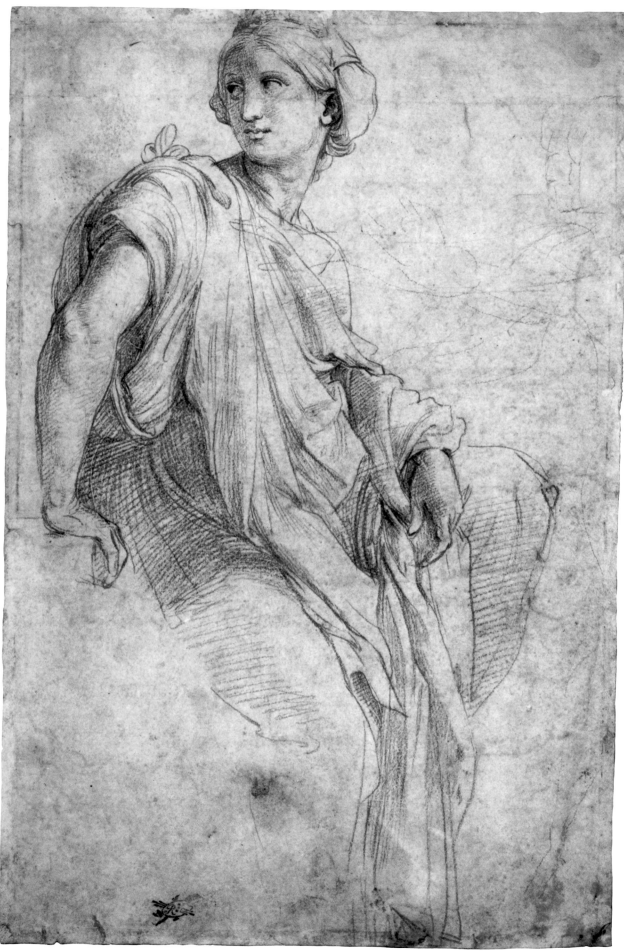

24

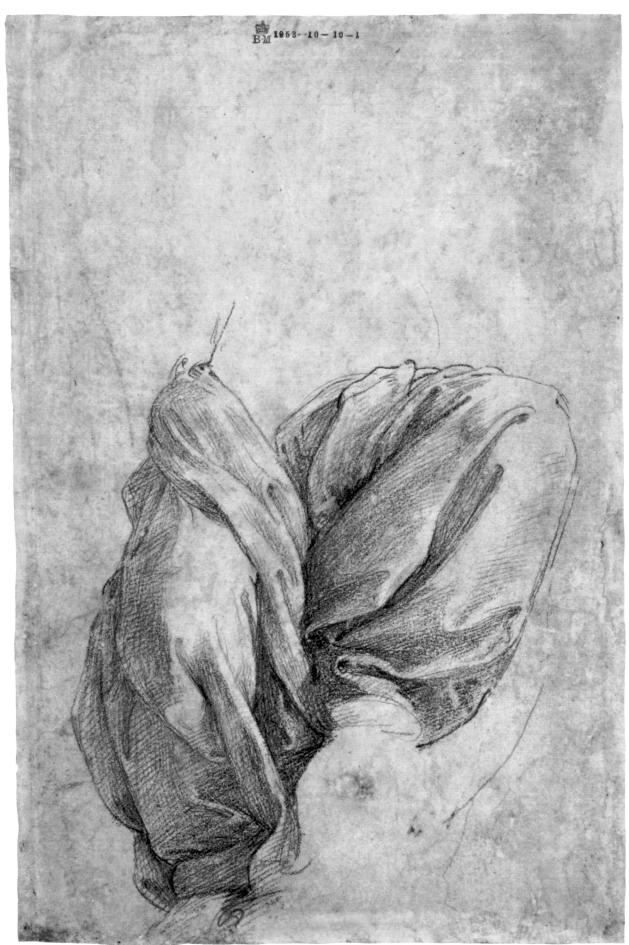

BM 1953-10-10-1

24 verso

the drawing is by a scholar of Raphael, a copy, or a retouched original remains problematical." These strictures are surely too severe: it is impossible to see any sign of retouching, or of any other hand than Raphael's. No. 24 is perhaps less attractive than the other, and in such passages as the left shoulder and hand seems somewhat harder and more schematic; but the concept of "attractiveness" is not one that should be applied to the judgment of Raphael's drawings. Raphael practiced a strict economy of effort, which sometimes led him to concentrate on the part of a drawing that particularly interested him and pay only perfunctory attention to the rest. In No. 24 his concern was above all with the head and the right arm and shoulder.

The drawing on the verso, of the draped legs of a seated figure with the left knee raised and the foot supported on a vase, is probably for the Cumaean Sibyl: the vase is in the same place in relation to the painted figure, but there the legs are crossed so that the right foot is supported on it.

There is no documentary evidence for the date of the S. Maria della Pace frescoes, but critics are agreed in placing them in the same period as the Stanza d'Eliodoro (1511–14). John Shearman was the first to observe (cf. Hirst 1961, p. 168) that a very rough sketch in black chalk for one of the pairs of Prophets is on the same sheet in the Ashmolean Museum as a study, also in black chalk, for a figure in the *Expulsion of Heliodorus* (Parker 557; Oberhuber-Fischel 399). Another rough sketch in pen and ink, identified by Hirst (1961, p. 167, n. 33) as for the Prophets and Sibyls on the right-hand side of the chapel, also in the Ashmolean Museum, is on the verso of a metalpoint study for a group in the *School of Athens* (Parker 553; verso repr. British Museum 1983, no. 149).

25 The Prophet Hosea and the Prophet Jonah

Pen and brown wash, heightened with white, over black chalk and stylus. Squared under the drawing in stylus, and over it in red chalk. 269: 198 mm.

PROVENANCE: Jonathan Richardson, jun. (Lugt 2170. In *An Account of Some of the Statues, Bas-reliefs, Drawings and Pictures in Italy, &c., with Remarks by Mr. Richardson, Sen. and Jun.*, 1722, p. 104, the younger Richardson states that his father "has also the drawing of one of the Prophets on this side," but the reference is not necessarily to this drawing); Pierre-Jean Mariette (Lugt 2097); Henry Constantine Jennings (Lugt 2771); "R. P. Knight, Esq., M. P. " (so inscribed on the facsimile engraving in C. M. Metz's *Imitations of Ancient and Modern Drawings*, 1798. The reference must be to the connoisseur and collector Richard Payne Knight, who sat in Parliament from 1780 to 1806, and who bequeathed his large collection of drawings to the British Museum in 1824. How this important sheet became separated from the rest is not recorded); baron Henri de Triqueti (Lugt 1304); E. Calando (Lugt 837: in his sale, Paris, 1899, 11–12 December); with Messrs. Colnaghi, London, c. 1965; Major S. V. Christie-Miller.

LITERATURE: Ruland, p. 271, iii, 4; Knab-Mitsch-Oberhuber 390.

Los Angeles, The Armand Hammer Foundation

A *modello* for the pair of Prophets on the left of the window in the lunette above the Chigi Chapel in S. Maria della Pace (see No. 24). It corresponds very closely with the figures as executed, except that in the fresco the lower part of the angel's body and his legs are draped, and the seated Prophet (Hosea) inclines his head very slightly to the left. The double system of squaring, like that on No. 41, shows that the figures had been enlarged from a smaller sketch and were themselves destined for further enlargement, perhaps in the full-scale cartoon which would have been the final stage of the preparatory process.

The omission of the Prophets in the lunette from much of the standard Raphael literature, including even the volume in the *Klassiker der Kunst* series (they are, however, reproduced by Dussler on pl. 154a), is due to the confused and ambiguous nature of Vasari's account (iv, pp. 340 and 495), which has thrown doubt on Raphael's responsibility not only for the execution of this part of the decoration but even for its design. But whether or not the painting of the lunette was carried out by Raphael's friend and associate Timoteo Viti, as Vasari seems to imply (see Hirst 1961, p. 167, n. 33), the evidence of preparatory drawings establishes that the entire scheme of decoration, and the conception and design of all the figures, were the work of Raphael.

No. 25 disappeared from sight after the Calando sale in 1899, but even before then it had not been widely known. Passavant (p. 142), for example, knew of it only from the facsimile engraving by Metz, and Crowe and Cavalcaselle (ii, p. 216) only from Passavant's reference. Fischel reproduced an old photograph with his letter appealing for information about lost Raphael drawings (*Burlington Magazine*, xx [1911–12], p. 299, no. 9). His emphatic attribution of the drawing to Giulio Romano, and his com-

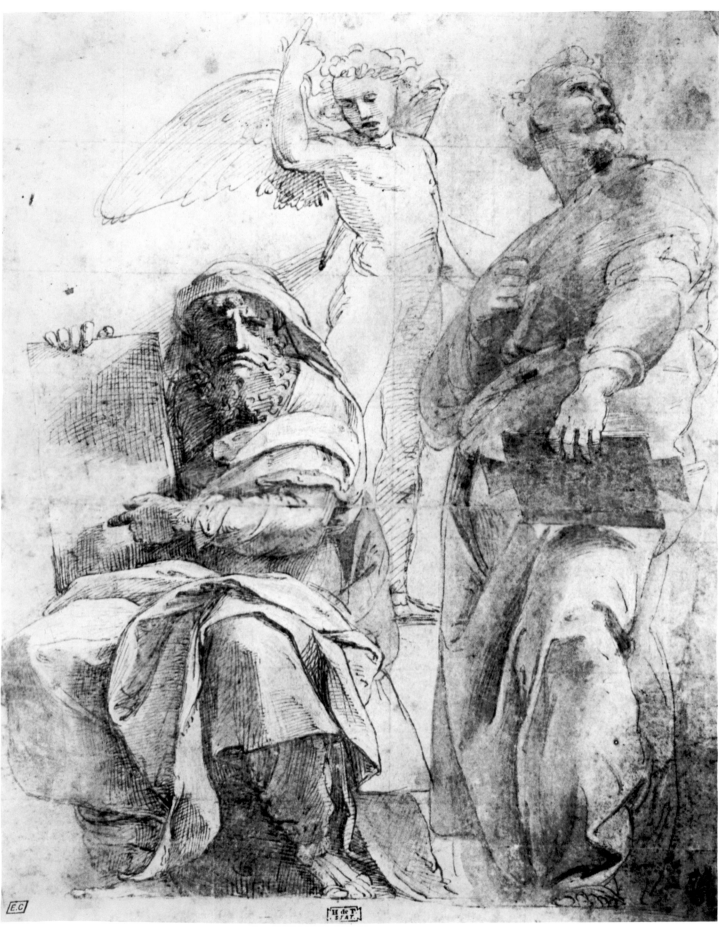

ment that in it "one is conscious of the classical relationship of pupil to master, as of Van Dyck to Rubens—greatness of form and the emptiness of heart of the pupil" (1948, pp. 182 and 364) was based only on the photograph. The drawing reappeared in Paris in about 1965, when its importance as an undoubted work by Raphael was recognized by James Byam Shaw. His view was subsequently endorsed by K. T. Parker and Konrad Oberhuber. The latter was the first in recent years to publish the drawing, in the catalogue of the exhibition *The Armand Hammer Collection*, Los Angeles, 1971, no. 61.

26 "Feed My Sheep": Christ's Charge to Peter

Offset of a drawing in red chalk over stylus. 257: 375 mm.

PROVENANCE: King George III. (Possibly, as Popham suggested, to be identified with the "Feed my Sheep, an excellent Design of Raffaelle; Sketch Red Ch. manner of the Baptism my Father has" which the younger Jonathan Richardson saw in the Bonfiglioli Palace in Bologna [*An Account of Some of the Statues . . . in Italy*, 1722, p. 31]. A large part of the Bonfiglioli Collection passed, via Zaccaria Sagredo, into the possession of Consul Joseph Smith, whose collection was bought en bloc for the King in 1773.)

LITERATURE: Passavant 425; Ruland, p. 245, 12; Crowe and Cavalcaselle, ii, p. 289; Popham, *Windsor*, no. 802; Shearman 1972, p. 96; Oberhuber-Fischel 441; British Museum 1983, no. 155; Knab-Mitsch-Oberhuber 513.

Windsor, Royal Library 12751

AN offset of a study for one of the ten cartoons commissioned from Raphael by Leo X, for a series of tapestries intended to be hung round the lower part of the walls of the Sistine Chapel on ceremonial occasions. Seven of the cartoons have been in the English royal collection since 1623, and in 1865 were placed in the South Kensington (later Victoria and Albert) Museum on indefinite loan. The exact date when Raphael received the tapestry commission is not recorded, but he received a payment on account on 15 June 1515 and a final payment on 20 December 1516.

The frescoes round the upper part of the side walls of the chapel, painted by Botticelli, Domenico Ghirlandaio and others, illustrate the history of mankind under the Old Covenant, as revealed to Moses, and under the New Covenant, as revealed by Christ. Michelangelo's ceiling, completed in 1512, illustrates its history before the Old Covenant. The tapestries continued the theme by illustrating the dissemination of the word of the New Covenant by the Apostles Peter and Paul (see Shearman 1972, p. 25, for a reconstruction of their original placing).

The Windsor sheet is an offset: that is, a mirror image of a drawing made by damping and pressing it against another sheet of paper. The cartoons and the studies for them are in the opposite direction to the tapestries, since these were woven from the back.

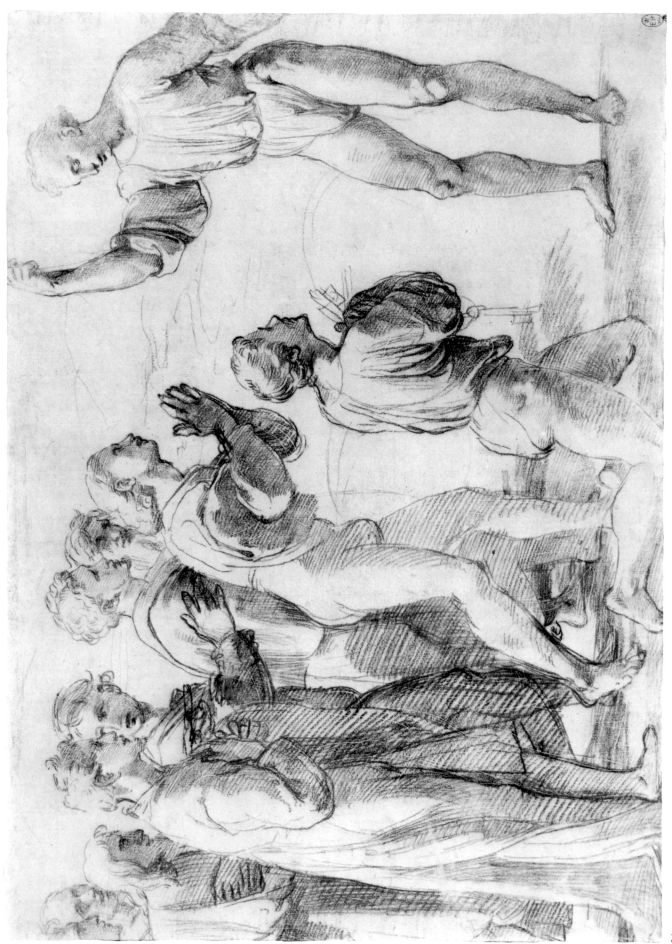

The offset, of an early study drawn from studio assistants posed in everyday dress, was presumably made by Raphael himself in order to gauge the effect of his design in the direction in which it would finally appear. He was very conscious of the importance of direction and designed the cartoons to take into account the fact that the human eye normally reads a composition from left to right.

The claim that the offset was corrected and worked up by Raphael is without foundation: the texture and color of the chalk are uniform; there is no trace of right-handed hatching, as there would have been if the drawing had been reworked; and the offset corresponds, line for line, with what is left of the original. This survives in the form of three fragments: one, corresponding with the figure posing for Christ, in the Louvre (3854), and two, including between them the heads of all eight standing figures in the offset, formerly in the collection of Mr. John Gaines and now in that of Mr. Ian Woodner (Gaines sale, Sotheby's, New York, 1986, 17 November, lot 8. All three repr. Oberhuber-Fischel 442–4 and Shearman 1972, figs. 46, 48 and 49). The Louvre fragment is irregularly trimmed on the right, and in two places the trimming has impinged on the drawing itself which has been carefully made up. The lower right-hand area of the sheet must have been damaged in such a way that only part of it could be salvaged, perhaps by the splashing on to it of some liquid which would explain the irregular but apparently deliberate nature of the trimming.

The final stage of the design is represented by a squared *modello*, also in the Louvre, in pen and wash heightened with white (Oberhuber-Fischel 445; Shearman 1972, fig. 51), which agrees with the cartoon and differs from the offset in the gesture of Christ's left arm, which points down towards the kneeling St. Peter, and in the introduction of an additional figure on the far side of the youthful disciple (St. John ?) who advances behind St. Peter with his hands joined. It also includes the disciple on the extreme right of the group, who has probably been trimmed away from the offset. The Louvre *modello* has been doubted, notably by Pope-Hennessy (p. 163), who sees it as a comparatively weak studio product in which Raphael's hand is apparent only in the indication of the landscape background; but Oberhuber and Shearman are surely right in claiming it for Raphael himself.

27 The Blinding of Elymas

Metalpoint and brown wash, heightened with white and touched with pen and brown ink, over perspective diagram ruled with the stylus, on gray prepared paper. 270: 355 mm.

PROVENANCE: "bought at Rome" for King George III (Windsor Inventory A). A drawing of this subject, attributed to Raphael, was in the collection of Queen Christina of Sweden in Rome (see catalogue of the Queen Christina Exhibition, Stockholm, 1966, no. 1090), where it was seen in 1688 by the Swedish collector Nicodemus Tessin. He does not describe the technique or the dimensions, but quotes a Latin inscription on the drawing which differs in some respects from the one on the Windsor drawing; but this could be explained by its having been transcribed from memory. It is not impossible, therefore, that Queen Christina's drawing is the one now at Windsor. If so, the earlier provenance would be: Joachim von Sandrart? (see J. Q. van Regteren Altena, *Les dessins italiens de la Reine Christine de Suède*, Stockholm, 1966, pp. 13f.); Queen Christina; Cardinal Azzolino; Don Livio Odescalchi (see *Master Drawings*, iii [1965], pp. 383 ff.).

LITERATURE: Ruland, p. 250, vii, 13; Crowe and Cavalcaselle, ii, p. 302; Popham, *Windsor*, no. 803; Shearman 1972, p. 102; Oberhuber-Fischel 448; British Museum 1983, no. 158; Knab-Mitsch-Oberhuber 524.

Windsor, Royal Library 12750

THE inscription on the base of the throne is exactly the same as the one in the same position in the tapestry cartoon (see No. 26) for which this drawing is a study: L. SERGIVS PAVLLVS ASIAE PROCOSS. CHRISTIANAM FIDEM AMPLEC-TITVR. SAVLI PREDICATIONE. There is surely no reason to doubt that Raphael himself inscribed the words on the drawing: the lettering seems fully compatible with his elegant Italic handwriting, of which there are many examples.

The subject is the conversion to Christianity of the Roman Procurator of Cyprus, Sergius Paulus, who had invited Paul and Barnabas to explain the faith to him. The "false prophet" or "sorcerer" Elymas tried to controvert them, whereupon Paul struck him blind: and the Procurator "when he saw what was done, believed" (*Acts*, xiii, 6–12).

The drawing corresponds so closely with the cartoon, both in the placing of the figures and in the details of the architectural background, that the earlier critics had dismissed it as a copy, at best a product of the Raphael studio perhaps made for the engraving by Agostino Veneziano (Bartsch 43) with which it exactly corresponds. But though this could well have been the drawing used by the engraver, it is unlikely to have been made especially for that purpose. Except when Raphael did produce a design especially to be engraved, as in the case of the *Massacre of the Innocents* (see No. 19), his usual practice seems to have been to supply Marcantonio and his followers with drawings already made in connection with other projects.

Popham was the first to reaffirm the traditional attribution to Raphael himself. This opinion was followed by Konrad Oberhuber and John Shearman, with the reservation that the drawing may have been retouched here and there and the penwork added by a later hand. The sheet is not in pristine condition, but the present compiler, at least,

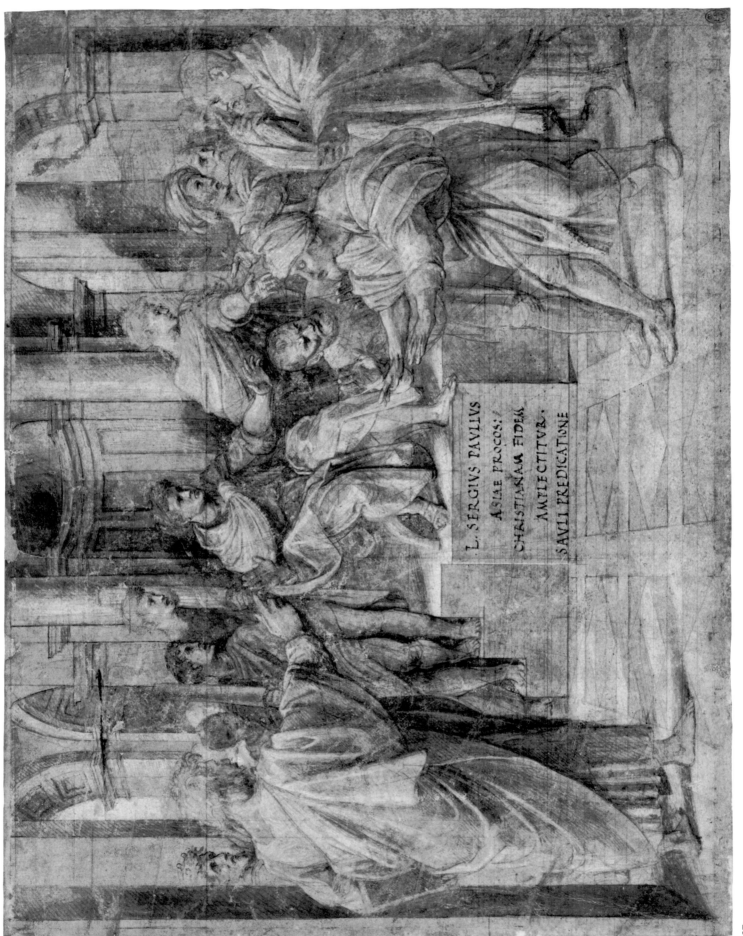

L. SERGIVS PAVLVS
ASIAE PROCOS:/
CHRISTIANAM FIDEM
AMPLECTITVR.
SAVLI PREDICATIONE

27

finds it impossible to see any passages of unmistakable retouching; and the precision and economy with which some of the faces, notably those of the bearded man to the left of Elymas and of the upper of the two lictors, have been accented and animated by a few rapid but unerringly placed pen strokes, seem characteristic of Raphael himself at his most masterly.

Exactly where this drawing fits into the sequence of studies that would have led up to the final design is not altogether clear. To judge from its careful finish and its correspondence with the composition as executed, it could be explained as the *modello* that must have preceded the full-scale cartoon, were it not that in Raphael's normal studio procedure—in so far as this can be inferred from the evidence of drawings—such a *modello* would have been squared for enlargement. What might be interpreted as the remains of squaring is in fact the complicated grid of ruled lines defining the perspective and serving as the framework of the composition; the drawing may represent a stage of the design when that particular aspect was uppermost in Raphael's mind.

The symmetrical placing of the figures against a symmetrically designed architectural background might have seemed almost insipidly regular if it had not been counterbalanced by the off-center perspective emphasized by the pattern of the pavement. If the lines of the pattern are produced they converge at a point above the Procurator's right hand, and the level of this vanishing point has been indicated on the drawing by a horizontal ruled line. In the tapestry, this subtly contrived asymmetry is in its turn offset by the addition of a square pier on the right (it would be on the left of the drawing and the cartoon, both of which are in the reverse direction to the tapestry), which shifts the vanishing point to the center of the whole composition. Shearman (p. 36) suggests that the purpose of this blank area in the tapestry was to provide a place where the papal throne and baldacchino would not obscure part of the figural narrative. According to his reconstruction of the order of the tapestries in the Sistine Chapel, the throne would have been placed in front of this part of the *Blinding of Elymas*.

28 St. Paul Rending his Garments

Metalpoint, heightened with white, on gray prepared paper. 228: 103 mm.

PROVENANCE: Sir Peter Lely (Lugt 2092); William, 2nd Duke of Devonshire (Lugt 718); Chatsworth 730 (sale, Christie's, 1984, 3 July, lot 40).

LITERATURE: Passavant 563; Ruland, p. 251, 8; Crowe and Cavalcaselle, ii, p. 306; Shearman 1972, p. 104; Oberhuber-Fischel 449; British Museum 1983, no. 157; Knab-Mitsch-Oberhuber 525.

Malibu, The J. Paul Getty Museum 84.GG.919

THE figure occurs on the left of the tapestry cartoon of *The Sacrifice at Lystra* (see No. 26). St. Paul is rending his garments in anger at the intention of the people of Lystra to offer a sacrifice to him and his companion St. Barnabas. The two Apostles had just performed a miracle of healing, which led the townspeople to believe that they were the Gods Mercury and Jupiter "in the likeness of men" (*Acts*, xiv, 6–8).

The drawing corresponds very closely with the figure in the cartoon. The apparent omission from the cartoon of the fold of drapery falling over the back is adduced by Shearman as an example of Raphael's readiness to sacrifice realism to aesthetic effect: it would have been confused with the drapery of St. Barnabas who stands immediately behind St. Paul wearing a robe of exactly the same shade of pink shot with yellow. The fold can in fact be seen in the cartoon, hanging well below the figure's waist; but it is certainly difficult to distinguish from St. Barnabas's robe, and its eventual omission from the tapestry shows that Raphael did find the visual ambiguity disturbing.

Though the drapery was probably arranged on a live model, the head is already idealized and, apart from the absence of the beard, closely resembles the head of the figure in the cartoon; and, as Sydney Freedberg puts it (1961, p. 274), the figure "is developed in poetic eloquence of pose in a way more artificial than direct observation of a model would permit."

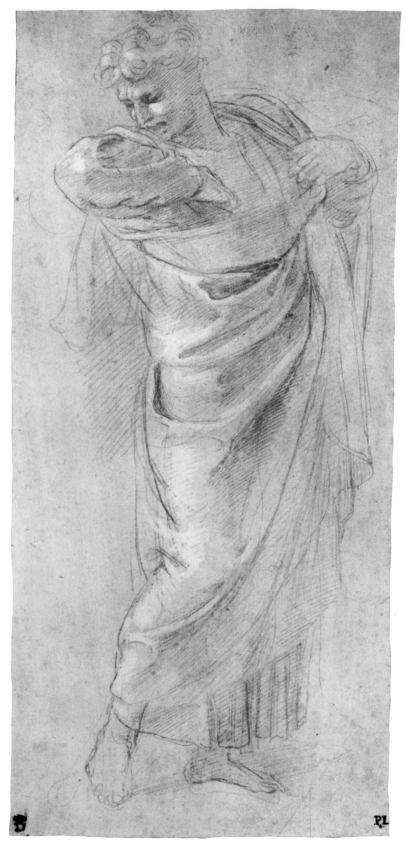

28

29 "Il Terremoto" (The Earthquake)

Metalpoint, heightened with white, on gray prepared paper. Some stains at top. Below the figure a horizontal ruled stylus line. Circular: 108 mm.

PROVENANCE: Jonathan Richardson, sen. (Lugt 2183); Sir Joshua Reynolds (Lugt 2364); in the middle of the nineteenth century, according to Ruland, "in the royal collection at Dresden"; Janos Scholz.

LITERATURE: Shearman 1972, pp. 104–5; Oberhuber-Fischel 450.

The Pierpont Morgan Library, Janos Scholz Collection 1977.45

THIS half-figure occupies the lower part of the high, narrow tapestry (see No. 26) of *St. Paul in Prison at Philippi*. It personifies the earthquake which by destroying the prison enabled St. Paul to escape (*Acts*, xvi, 26). The drawing is in reverse to the tapestry, and would thus have been in the same direction as the lost cartoon.

The motif is an adaptation of the half-figure personifying the sky (*Ouranos* or *Coelus*) which supports the figure of Jupiter in the top right-hand corner of a much copied Antique relief of the *Judgment of Paris* in the Villa Medici (M. Cagiano de Azvedo, *Le antichità di Villa Medici*, Rome, 1951, no. 54; Bober and Rubinstein 119). In the relief, the figure holds the cloth symbolizing the vault of heaven with his arms extended to either side; in the drawing, though he still holds the cloth, his arms are held out in front of him and are curved slightly inwards; in the tapestry the cloth is omitted, but the arms (if imagined reversed, as they would have been in the cartoon) are in exactly the same position as in the drawing. In view of the difference between the Antique original and the drawing, and the exact correspondence, apart from the omission of the cloth, between the drawing and the figure as it would have appeared in the cartoon, it seems perverse to doubt that the drawing was purposely made as a study for the cartoon. Raphael used the same motif in his *Judgment of Paris* engraved by Marcantonio (Bartsch 245), which is a very free adaption of the Villa Medici relief, but there the figure's arms are extended even more widely than they are in the relief.

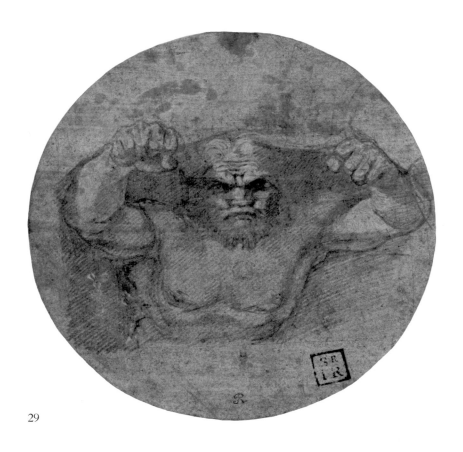

29

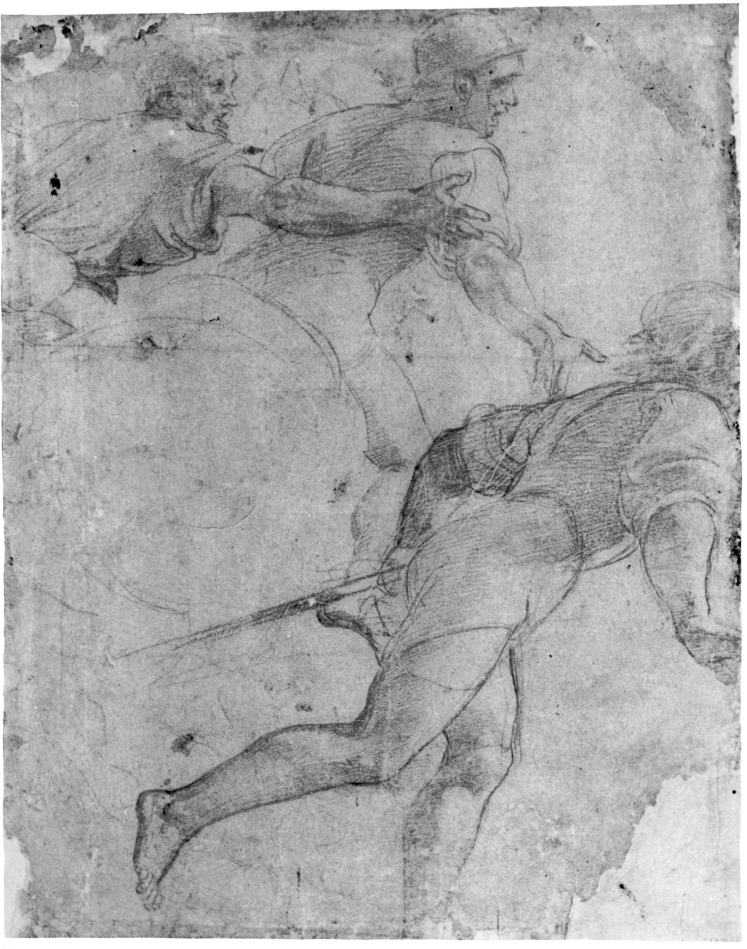

30 A Soldier Running to the Right, and Two Others on Horseback

Red chalk over stylus. The edges tattered and three of the corners torn away. 316: 245 mm.

PROVENANCE: Dukes of Devonshire.

LITERATURE: Ruland, p. 249, 5; Crowe and Cavalcaselle, ii, p. 281; Fischel 1898, no. 252; Shearman 1972, pp. 101 f.; Oberhuber-Fischel 447; British Museum 1983, no. 156.

Chatsworth 905

T HE same group of figures occurs, in the reverse direction, on the right-hand side of the tapestry of *The Conversion of St. Paul* (see No. 26). It must thus have been in the same direction as the cartoon, which has disappeared but which would have resembled the others in being in reverse to the tapestry.

The traditional attribution of the drawing to Raphael was accepted by Ruland and by Crowe and Cavalcaselle, but Fischel in his 1898 volume followed Dollmayr in giving it to Penni. It is not always clear how accurately the catalogue of Raphael's work compiled from Fischel's notes by Otto Kurz and appended to his posthumously published monograph of 1948 reflects the latest state of his opinion, but the view there unequivocally expressed is that, apart from Nos. 26 and 28, all the known surviving studies for the tapestry cartoons are products of the studio. Popham seems to have been the first critic in modern times to believe in the traditional attribution of No. 30 (his opinion is quoted in the catalogue of the 1953 exhibition of *Drawings by Old Masters* at the Royal Academy, London, under no. 57), and in this he has been followed by Konrad Oberhuber and by John Shearman.

The question has been confused by the existence of a deceptively similar version, also in red chalk, in the Teyler Museum in Haarlem (Oberhuber-Fischel, fig. 133; Shearman 1972, fig. 64). The resemblance is so close that one of the drawings, at least, must be a copy; but either if considered in isolation might plausibly be attributed to Raphael himself. The Haarlem drawing has been claimed as the original, but both Oberhuber and Shearman are firmly of the opinion that the Chatsworth version is by Raphael himself, and that the other is a copy of it. Shearman pointed out that the essential difference is the presence on the Chatsworth sheet, but not the other, of the preliminary underdrawing in stylus which is so often a feature of Raphael's chalk studies (e. g. No. 26), and which is here handled with a freedom and decision entirely characteristic of him.

31 Back View of a Nude Man Sitting on a Stone and Separate Studies of his Head and Left Arm RECTO. Sketches for a *Resurrection* VERSO.

Black chalk (recto); pen and brown ink (verso). 345: 265 mm.

PROVENANCE: Sir Peter Lely (Lugt 2092); Sir Joshua Reynolds (Lugt 2364); William Young Ottley (sale, London, T. Philipe, 1814, 6 June etc., lot 1771); Sir Thomas Lawrence (Lugt 2445); Samuel Woodburn.

LITERATURE: Passavant 520; Robinson 136; Ruland, p. 40, xxi, 5; Fischel 390/389; Parker 559; British Museum 1983, no. 166; Knab-Mitsch-Oberhuber 477/475.

Ashmolean Museum P II 559

THE drawings on both sides are studies for a composition of the *Resurrection*, a rough sketch for the complete lower part of which is also in the Ashmolean Museum (Parker 558; Fischel 388; Fig. 31a). A study for the whole composition in the Musée Bonnat at Bayonne (Bean 132; Fischel 387; Fig. 31b) shows that it was

Fig. 31a Raphael. *Design for the Lower Portion of a Composition of the Resurrection.* Ashmolean Museum, Oxford.

Fig. 31b Raphael. Sketch for a *Resurrection*. Musée Bonnat, Bayonne.

to have been a large-scale painting with an arched top—evidently an altarpiece. No such painting by Raphael is known and no commission for one is recorded, but Michael Hirst (1961) has convincingly demonstrated that the projected altarpiece was intended for the Chigi Chapel in the church of S. Maria della Pace in Rome. He pointed out that the tablets and scrolls which are such conspicuous adjuncts to the figures of Sibyls and

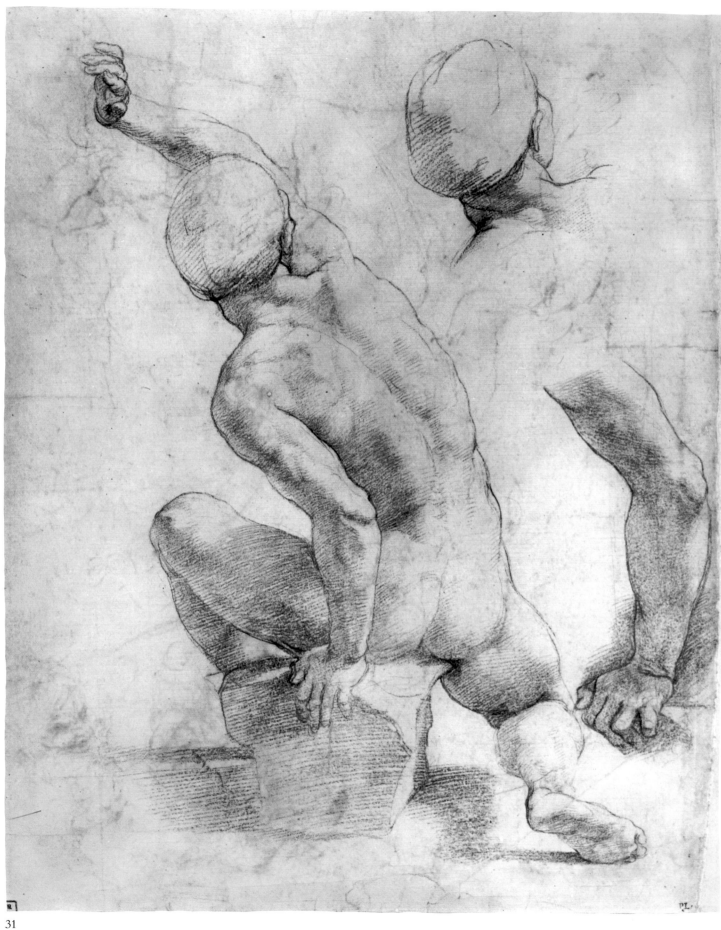

31

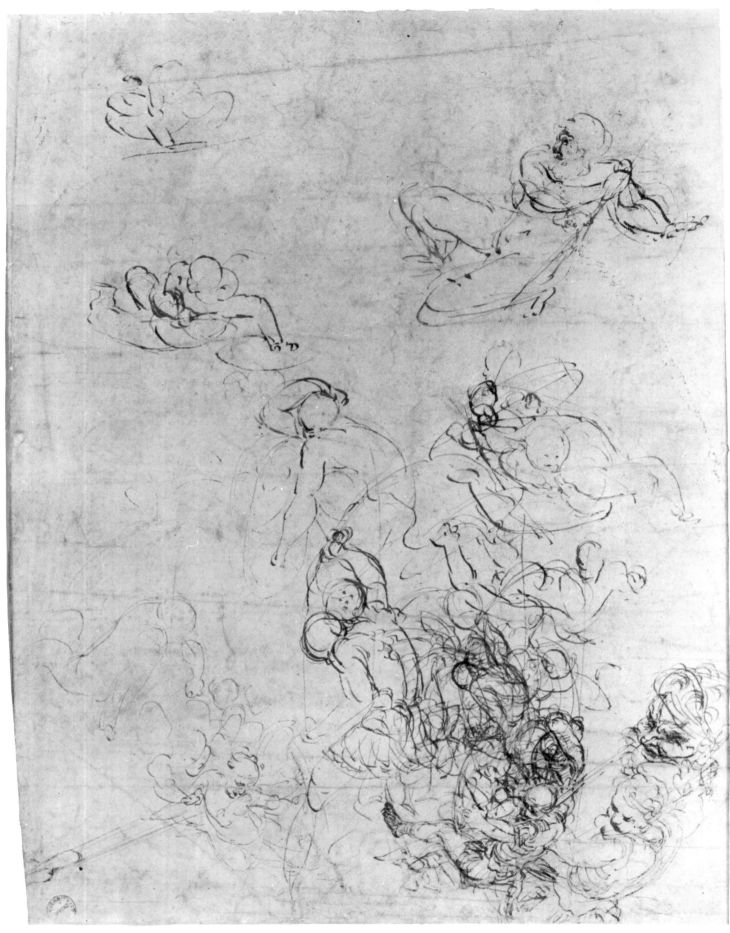

31 verso

Prophets on the wall surrounding the chapel niche (see No. 24) are all inscribed with texts relating to the *Resurrection*, and that each of the Prophets foretold that event; but that the significance of these allusions cannot be appreciated except in the context of a representation of the subject, and that the only space for such a representation would have been above the altar. An altarpiece was planned in Raphael's lifetime (and thus presumably by Raphael) since a posthumous payment, for a frame "per la tavola d'altar che andava alla pace," is recorded on behalf of the owner of the chapel and Raphael's patron, Agostino Chigi, who died less than a week after he did. A few months later, Raphael's rival, Sebastiano del Piombo, is reported as claiming that the commission had been given to him; and in the contract dated 1 August 1530 by which he undertook to paint the altarpiece, discovered by Hirst in the Chigi archives, the subject is specified as the *Resurrection*.

The recto of the present sheet and Nos. 32 and 33 belong to a group of highly finished figure studies in black chalk, which Robinson and Ruland were the first, independently, to observe are for soldiers guarding the tomb in a *Resurrection*, suddenly awakened and dazzled by the supernatural light emanating from the Risen Christ. Previously they had been explained as discarded studies either for the *Battle of Ostia* in the Stanza dell'Incendio or for the Sala di Costantino. Of the others, one is in the Ashmolean Museum (Parker 560; Fischel 391; British Museum 1983, no. 171) and two are at Windsor (Popham 798 and 799; Fischel 392 and 393; British Museum 1983, nos. 168 and 170); what may be a seventh is at Besançon (2301, as Primaticcio; Gernsheim photo 12137) and a pen and ink drawing of the same figure, apparently also by Raphael (Fischel 395a, fig. 309; Knab-Mitsch-Oberhuber 357), is on the verso of the study in Frankfurt for *Justinian Receiving the Pandects* in the Stanza della Segnatura.

Raphael would hardly have gone to the trouble of making detailed studies of this kind before the design of the whole composition had been finally determined, but no record of the definitive solution has survived. Three of the single figures of which there are studies, including No. 31 recto, correspond with figures in the Ashmolean sketch for the lower part, but only one (Fischel 393) has a counterpart in the complete composition study at Bayonne. From this it might be concluded that the Oxford sketch represents a later stage in the working-out of the design, but probably not the final one since it includes no figures corresponding with Nos. 32 and 33 or with Fischel 392. A further piece of evidence in any attempt to reconstruct the composition is the engraving by the Master HFE discussed under No. 32. Hirst suggests that something of the effect of Raphael's *Resurrection*, in whatever form it finally took, might be reflected in the altarpiece of the subject painted in about 1519 by his friend and fellow-Urbinate Girolamo Genga for the oratory of St. Catherine of Siena in Rome (Fig. 31c), in which the scene is represented at night with dramatic contrasts of light and shade. If Raphael had had a night scene in mind, the effect might also have been not unlike *The Freeing*

Fig. 31c Girolamo Genga.
Altarpiece of the Resurrection.
S. Caterina da Siena, Rome.

of Peter in the Stanza d'Eliodoro, in which, it has often been noted, the dazzled guard on the left is in the same pose, in reverse, as Fischel 393.

On the verso of No. 31, Raphael seems to have begun by jotting down in summary graphic shorthand some nine or ten possible poses for single figures of soldiers. The two in the top left corner of the sheet are close to Fischel 391. Next to them, on the right, is a kneeling man leaning backwards, holding a spear in his right hand and supporting his weight on his left knee and outstretched left arm; in the backward slant of his body he resembles the soldier seated on the plinth of the tomb in the Bayonne sketch. In the center of the sheet is another kneeling figure crouching forward with his right knee raised, steadying himself with his downstretched left arm and with the other arm shielding his face. To the right is a seated figure holding his shield above his head with his right hand. His pose resembles the lower of the two in the top left corner, but is even closer to one in the right foreground of the Bayonne sketch. Below him, partly obscured by the more heavily drawn group of smaller-scale figures, is one looking downwards over his left shoulder and shading his face with a shield held out with both arms extended to his right, together with another, very slight, indication of a pose resembling the upper of the two in the top left corner. In the lower left corner are the head and part of the shaft of a spear and two half figures. Comparison with the Bayonne sketch suggests that these last are for the angels surrounding the Risen Christ in the upper part of the composition. Above them is a very summary sketch of a man seated on the ground with his legs to the left and his body turned away from the spectator. His head is pillowed on his left arm and his right arm is stretched downwards.

In the lower right corner Raphael then combined three or four figures in a sketch for the group in the right foreground. The resulting tangle of lines is not altogether easy to make out; but a sketch of this kind, in which ideas have come rushing to the point

of the draughtsman's pen faster than he can clearly express them, takes us close to the heart of the mystery of artistic creation. In the forefront of the group is a soldier sitting on the ground and falling backwards with his left leg in the air, and on the right, on a larger scale, separate studies of his body and head. Above him, close to the vertical line indicating the right edge of the composition, is the upper part of a seated figure holding his arms over his head in the same position as the figure in No. 32. To the left, repeated on a larger scale just outside the group with an alternative position for the head, is a standing man in profile to left, stepping forward with his left leg. His left arm is lowered and his right arm raised to grasp in both hands the pliant staff of a banner bent backwards in the wind so violently that he has to lean forward to take the strain. In the catalogue of his sale in 1814, Ottley pointed out that the pose of this figure is the same as that of Marcantonio's *Standard Bearer* (Fig. 31d). Marcantonio's engravings were often based

Fig. 31d Marcantonio Raimondi.
Standard Bearer.
Engraving. B. xiv, 481.

on studies by Raphael originally made for other purposes, and the apparently meaningless and somewhat unsatisfactory isolation of the figure in the engraving might be explained on the hypothesis that he had made use of a separate drawing of it. This might have been one of the group of finished studies in black chalk. If so, the figure with the banner is likely to have been retained in the final design.

32 A Nude Man Seated on the Ground Holding his Arms Round his Head; an Alternative Position for his Right Leg

Black chalk. 293: 327 mm., including a strip added to the top in order to enable the right arm to be completed. The style of this addition is characteristic of Mariette.

PROVENANCE: Pierre-Jean Mariette (Lugt 2097: probably part of lot 699 in his sale, Paris 1775–76); Uvedale Price (sale, Sotheby's, 1854, 4 May, lot 179).

LITERATURE: Ruland, p. 321, lviii, 1; Fischel 395; Pouncey and Gere 34; British Museum 1983, no. 172; Knab-Mitsch-Oberhuber 482.

British Museum 1854–5–13–11

THE drawing is still on Mariette's gray-blue mat, the inscription on which, *Tabulae quae in Palatio Vaticano Victoriam de Saracenis in Ostiensi littore reportatam, exprimit, inserviendum, Raphael Sanzio Urbin., Circa ann. 1517*, shows that he connected it with the *Battle of Ostia* in the Stanza dell'Incendio. Fischel was the first to group it with the other studies in black chalk for figures in a *Resurrection* (see No. 31). For some reason Ruland had not included it with them, but relegated it to the section of his catalogue headed "General Studies," though with the comment "perhaps for the Resurrection"; and Robinson—surprisingly, in view of the fact that it had been acquired by the British Museum sixteen years before the publication of his Oxford catalogue—omitted it altogether from his list of *Resurrection* studies (*Oxford*, pp. 275 f.) A figure holding its

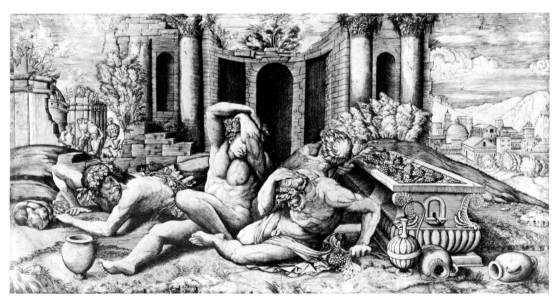

Fig. 32a Master HFE. *Bacchanal*. Engraving. B. xv, 464, 5.

71. RAFFAELLE

32

arms in much the same position (the legs are not visible) can be seen in the rough sketch for the group of soldiers in the right foreground of No. 31 verso. Fischel pointed out (*Jahrbuch der Preussischen Kunstsammlungen*, xlvi [1925], p. 191) that in an engraving of a *Bacchanal* by the Monogrammist HFE (Fig. 32a), in which four nude men are sprawling on the ground beside a sarcophagus filled with grapes, the central figure corresponds exactly in the same direction with No. 32, with the right leg in the alternative position given in the drawing, and the two on the right correspond, in reverse, with the foremost figures of the three in No. 33. No counterpart to the fourth figure exists among the surviving studies, but it is tempting to suppose that the engraving may preserve Raphael's solution for part of the composition. The two figures who are shielding their eyes are doing so as if dazzled by light coming from the direction of the sarcophagus.

33 Three Reclining Nude Men

Black chalk. 233: 364 mm.

PROVENANCE: Nicolaes Flinck (Lugt 959); William, 2nd Duke of Devonshire, who purchased the Flinck Collection in 1723.

LITERATURE: Fischel 394; British Museum 1983, no. 169; Knab-Mitsch-Oberhuber 478.

Chatsworth 20

THE omission of this drawing from the earlier Raphael literature (Passavant, Ruland, Robinson, etc.) is explained by the fact that it was not until 1925 that it was recognized, by Fischel, as one of the group of studies by Raphael for figures in the lower part of a *Resurrection*. Previously it had been attributed to Michelangelo. The figure in the forefront and the one whose head and shoulders are visible behind him occur in reverse, together with two other figures, one being the seated man for which No. 32 (q. v.) is a study, in the engraving by the Monogrammist HFE which may have been based on Raphael's design for a group of figures in the *Resurrection*.

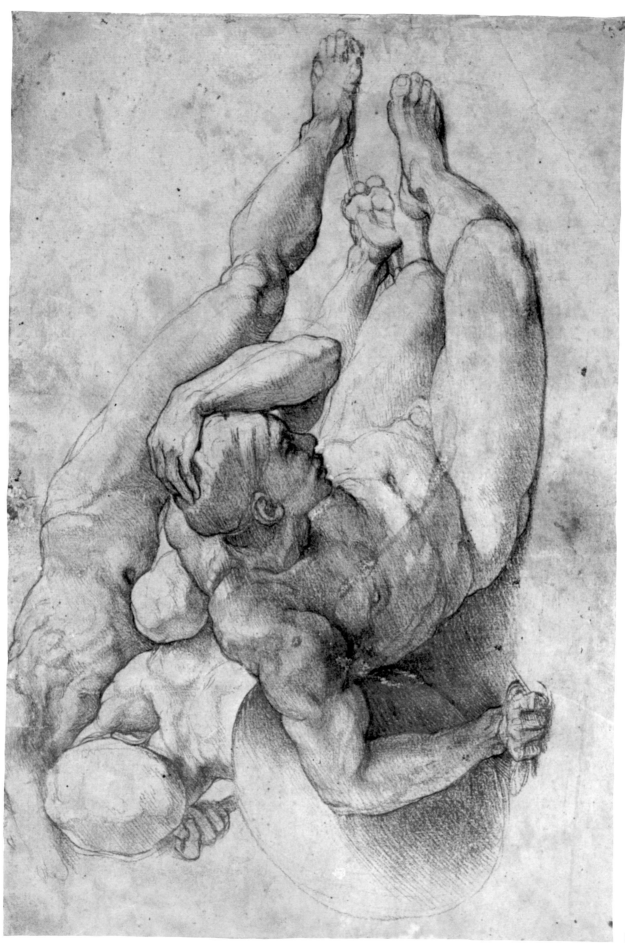

33

34 Venus and Psyche: Sketch for a Pendentive in the Loggia of the Farnesina

Pen and brown ink over red chalk. 105: 80 mm.

PROVENANCE: Cardinal Santa Croce? (see below) Borghese (according to *Lawrence Gallery* catalogue); William Young Ottley? (perhaps lot 1211 in his sale, London, T. Philipe, 1814, 6 June etc.: "a free pen sketch for the story of Cupid and Psyche in the little Farnese"); Sir Thomas Lawrence (Lugt 2445); Samuel Woodburn.

LITERATURE: Robinson 10(3); Ruland, p. 282, 33; Crowe and Cavalcaselle, ii, p. 419; Parker 655; British Museum 1983, no. 159; Knab-Mitsch-Oberhuber 542.

Ashmolean Museum P II 655

INSCRIBED in ink, lower right: RAFAELO. Similar inscriptions in small capitals have been attributed to a Cardinal Santa Croce (see *Musée du Louvre: dessins de Taddeo et Federico Zuccaro*, 1969, under no. 13).

The Villa Farnesina, as it is now called, was built by Agostino Chigi, the banker and financial adviser of Julius II and Leo X, and apart from these two Popes Raphael's chief patron. The decoration of the ground floor loggia with subjects from the legend of Cupid and Psyche was carried out by Raphael with the help of assistants, and completed by the end of 1518.

In the center of the vault are two large figure compositions, the *Council of the Gods* and the *Wedding Feast of Cupid and Psyche*, which simulate a tapestry awning. The deeply coved sides of the vault are pierced by fourteen lunettes, two at either end and five on either side, those on the outer wall forming the upper part of the arched openings giving on to the garden. The lunettes are almost contiguous and divide the coving into a series of triangular pendentives which alternate with the inverted triangles formed by the intersection of the lunettes with the coving. These spaces are edged with garlands of leaves with fruit and flowers, which form the framework of the illusionistic arbor apparently supporting the central awning, behind which the figures in the pendentives and subsidiary vaults are seen a background of blue sky.

The pendentives illustrate episodes from the legend of Psyche involving the Olympian Gods; in the subsidiary vaults are *amoretti* holding emblems of the Gods represented in the pendentives; the lunettes were never painted, but there is good reason for supposing that Raphael included these in his scheme and had made designs for them which were never carried out (see No. 35).

Robinson, Ruland and Crowe and Cavalcaselle agreed in recognizing No. 34, in which there are numerous *pentimenti*, as Raphael's first sketch for the pendentive of *Psyche Presenting the Vase to Venus*. (The reference is to one of several ordeals by which she was punished for her temerity in loving Cupid: Venus made her fetch a flask of water from the river Styx, and to descend a second time to the infernal regions to bring

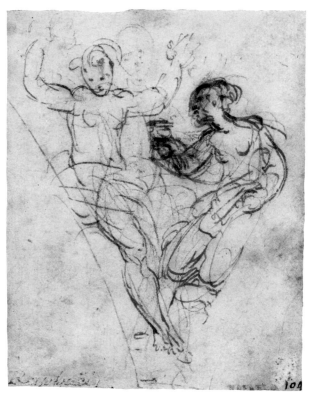

34

back some of the ointment by which Proserpine preserved her beauty.) Fischel at one time dismissed it as a copy "in the manner of Guido Reni" (1898, no. 270), but later he too accepted it (1948, pp. 184 and 366). This, and possibly also a sheet of rapid pen jottings in the Wallraf-Richartz Museum in Cologne (Oberhuber-Fischel, fig. 58), are the only surviving sketches for the Farnesina Loggia. All the other known preparatory drawings are carefully finished figure studies in red chalk, some now attributed to Raphael himself and others to his assistants Giulio Romano and Penni. On the problem of attribution critical opinion is far from unanimous, but it is generally agreed that the finished study in the Louvre for the *Venus and Psyche* group is by Raphael (Fig. 34a).

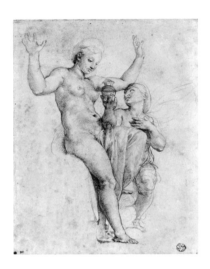

Fig. 34a
Raphael. *Venus and Psyche*.
Cabinet des Dessins, Musée du Louvre, Paris.

Shearman's convincing analysis of the relationship between the sketch and the group as painted (1964, pp. 81 f.) disposes of any possibility that the former might be a rough jotting from memory by some later hand. The pose of Venus in both is much the same, but Psyche's is entirely different; Shearman pointed out that the group in the sketch is

Fig. 34b
Raphael, copy after. *Prophets and Sibyls*: Detail of the pair of sibyls
to the right of the arch in lower part of old copy of lost Raphael
design for Chigi Chapel in S. Maria della Pace, Rome.
National Museum, Stockholm.

a variation of a discarded solution for the pair of Sibyls to the right of the arch of the Chigi Chapel in S. Maria della Pace (see No. 24), known from an old copy in Stockholm (Fig. 34b). In the final result, the pose of Venus (apart from the way she holds her arms) is still close to that of the left-hand Sibyl; but Psyche in no way resembles the right-hand Sibyl, being instead adapted from the angel accompanying St. Matthew in an engraving by Agostino Veneziano which presumably reproduces a composition by Raphael (Fig. 34c).

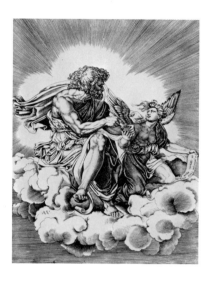

Fig. 34c
Agostino Veneziano, after Raphael.
St. Matthew. Engraving.

35 A Nude Woman Kneeling, with her Left Arm Raised: Study for a Figure in a Composition of *Psyche Attired by the Graces* (?)

Red chalk. Traces of stylus underdrawing. 279: 187 mm.

PROVENANCE: William, 2nd Duke of Devonshire (Lugt 718); Chatsworth 56.

LITERATURE: Ruland, p. 320, lv, 1; Crowe and Cavalcaselle, ii, p. 262; British Museum 1983, no. 161; Knab-Mitsch-Oberhuber 548.

Edinburgh, The National Gallery of Scotland D. 5145

THE traditional attribution to Raphael seems never to have been doubted. No such figure occurs in any known work by him, and various suggestions about the purpose of this study have been made: for example, that it might have been for a discarded figure in the foreground either of the *Fire in the Borgo* in the Stanza dell'Incendio (Crowe and Cavalcaselle) or of the *Miracle of Bolsena* in the Stanza d'Eliodoro (Fischel 1898, no. 197 and 1948, p. 104). Adolfo Venturi (*Raffaello*, 1920, p. 196) and Popham (*Vasari Society*, 2nd series, vi [1925], no. 8) observed independently that the style is closest to that of the red chalk figure studies for the Psyche Loggia of the Farnesina (see No. 34). Raphael would hardly have gone to the trouble of making a careful study of this kind before working out the whole composition in detail, so if this is a study for the Farnesina it would have been for some part of the decoration that was projected but never carried out. In fact, the cycle in the Loggia is incomplete since none of Psyche's adventures on Earth is included. John Shearman (1964, pp. 66 f.) observed that some of the figures in the pendentives are pointing in the direction of the lunettes and that their gestures are meaningless when the lunettes are blank, and argued that the missing episodes were to have been represented there. He went on to point out that a kneeling figure in a pose resembling, in reverse, that in the Edinburgh study, occurs in an engraving by Giulio Bonasone of a seated woman being attired by three handmaidens, another of whom resembles, also in reverse, a red chalk drawing of a standing nude woman on the verso of a study for the pendentive of *Jupiter Embracing Cupid*, in the Louvre (MI 1120, repr. *Autour de Raphaël*, p. 25 and Shearman, op. cit., p. 69. The recto of the Louvre sheet has been attributed to Giulio Romano, but the verso seems to be by Raphael himself).

Shearman's suggestion that Bonasone's engraving repeats, in reverse and in a considerably garbled form, a composition by Raphael probably intended for one of the lunettes, is confirmed by the recent discovery in the Rome Print Room, in an album of drawings by members of the Alberti family, active in Rome in the second half of the sixteenth century, of a pen sketch of the same group, in reverse to the engraving,

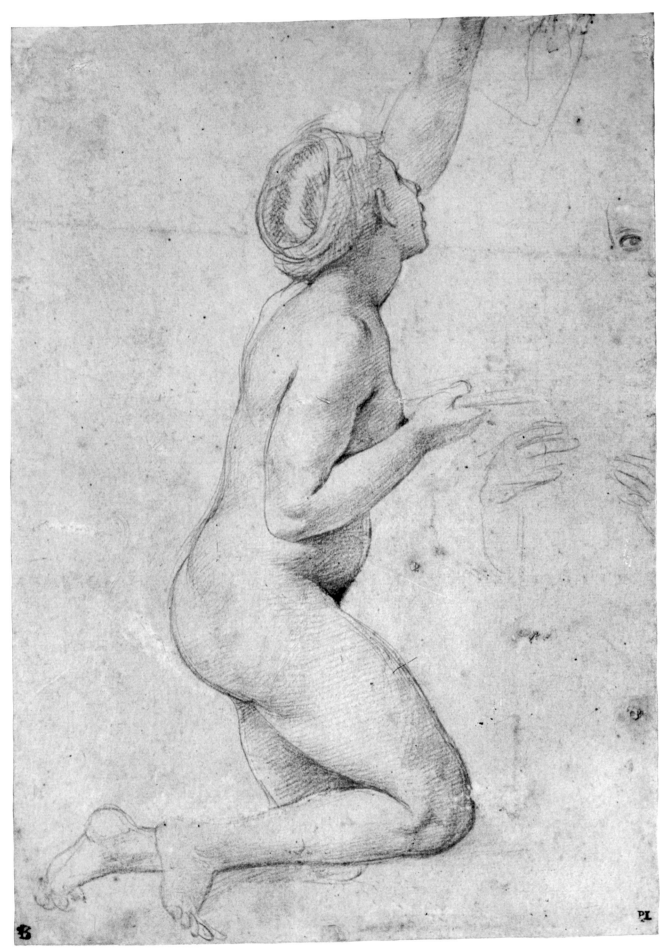

35

in which the Edinburgh and Louvre figures appear exactly as in the drawings and in the same direction (Fig. 35a; F. N. 2983). The contour of the group in the Alberti copy

Fig. 35a Alberto Alberti. *The Toilet of Psyche*. Istituto Nazionale per la Grafica, Rome.

suggests that it was designed to fit into a lunette, which would have been the one on the left of the pendentive in which Cupid looks towards the three Graces and points downwards to the left. If so the subject of the scene intended for the lunette would be *Psyche Attired by the Graces*.

On the right of the sheet is a sketch of a face and two hands. In the catalogue of the British Museum exhibition of 1983 it was suggested that these might belong to the third handmaiden (or Grace) who is arranging Psyche's hair. The sketch may well have been made with such a figure in mind, but the action of the figure in the Alberti copy is different.

36 Neoptolemus Taking Andromache into Captivity after the Fall of Troy

Pen and brown ink. 262: 408 mm.

PROVENANCE: William, 2nd Duke of Devonshire (Lugt 718).

LITERATURE: Passavant 569; Ruland, p. 130, xvi, 1; Crowe and Cavalcaselle, ii, p. 548; Oberhuber-Fischel, pp. 56 f.; British Museum 1983, no. 165; Knab-Mitsch-Oberhuber 586.

Chatsworth 903

THE usual interpretation of the subject as the *Rape of Helen* can hardly be correct. The incident represented follows the sacking of a city from which the victors are departing by boat with their spoils, together with a young woman who is weeping and clearly reluctant to accompany them. Hartt (*Giulio*, p. 51) and Professor Hugh Lloyd-Jones (orally) have independently put forward the more convincing suggestion that she is Andromache, widow of the Trojan prince Hector, and the young man escorting her Neoptolemus, the son of Achilles, to whom she was given as a slave as part of his share of the spoils of Troy.

Fig. 36a Marcantonio Raimondi. *The Rape of Helen.* Engraving. B. xiv, 209.

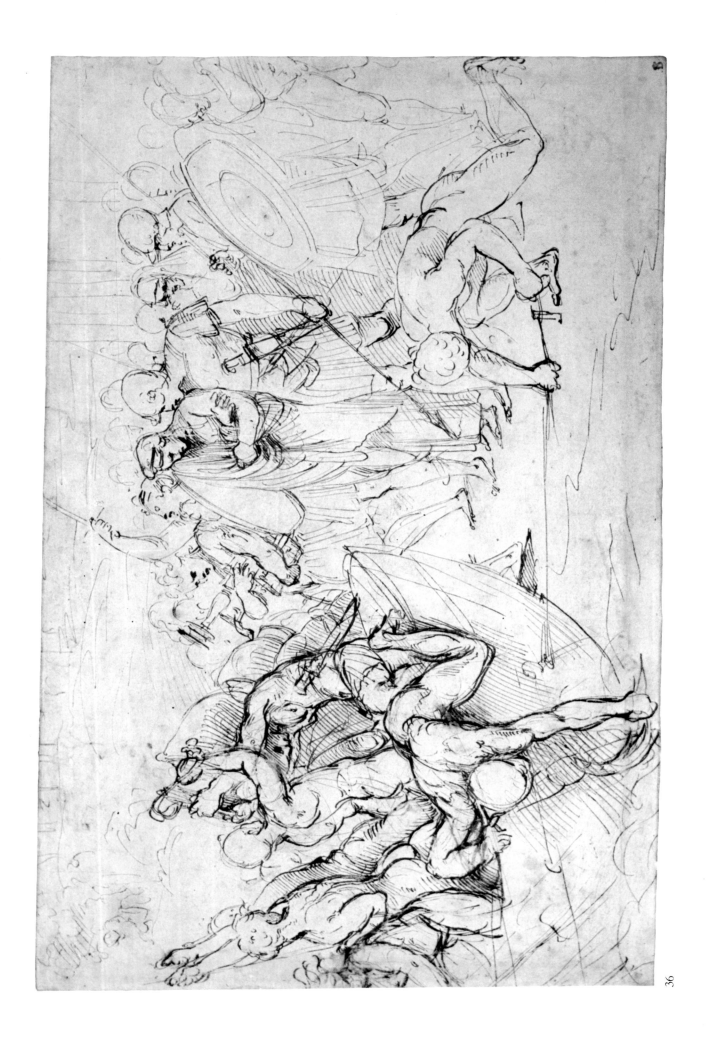

36

Critical opinion of this drawing has varied. Passavant and Ruland accepted the traditional attribution to Raphael himself; Crowe and Cavalcaselle were noncommittal; Hartt attributed it to Giulio Romano, at a time when he was most under Raphael's influence; for Popham (MS note in the Chatsworth catalogue) it was "best explained as an old facsimile of a genuine Raphael drawing"; Oberhuber, on the other hand, describes it as one of the finest pen drawings of Raphael's latest period, c. 1516–19. The view expressed in the British Museum 1983 exhibition catalogue, that the composition must be by Raphael but that the drawing itself might be Penni, is perhaps somewhat overcautious: the drawing remains on the borderline, but is very close to the Raphael end of the Raphael-Penni spectrum. Oberhuber's reaffirmation of the traditional attribution may well be correct.

The purpose of the drawing is unknown. The subject might have been intended as either an alternative or a pendant to the *Rape of Helen* engraved by Marcantonio (Bartsch 209), which it resembles in format and scale and in the general disposition of the figures (Fig. 36a).

37 The Transfiguration

Red chalk over stylus. Squared in red chalk. 246: 350 mm.

PROVENANCE: William, 2nd Duke of Devonshire (Lugt 718)

LITERATURE: Ruland, p. 30, 85; British Museum 1983, no. 174.

Chatsworth 904

ASTUDY for the upper part of the large altarpiece of the *Transfiguration*, commissioned by Cardinal Giulio de'Medici (later Pope Clement VII) for the cathedral at Narbonne in southern France, of which diocese he had become bishop in 1515. The exact date of the commission is not recorded, but it was probably towards the end of 1516. The earliest reference to it is in a letter dated 17 January 1517 addressed to Michelangelo by Raphael's hostile rival Sebastiano del Piombo, whose equally large altarpiece of the *Raising of Lazarus*, now in the National Gallery in London, had been commissioned at about the same time, by the same patron and for the same place. In another letter, dated 2 July 1518, Sebastiano informed Michelangelo that Raphael had not yet begun his painting, and when Raphael died in April 1520 it was still unfinished. It was completed by Giulio Romano, but never reached Narbonne. Instead, it was placed in the church of S. Pietro in Montorio in Rome, and is now in the Vatican Gallery.

Oberhuber (1962, pp. 116 ff.) has shown, from the evidence of drawings, that Raphael's first intention had been to represent only the miracle of the Transfiguration. A studio drawing in the Albertina (1983, no. 70), which must be either a *modello* for the whole composition or a copy of one, is made up (apart from the half-figure of God the Father) of exactly the same elements as the Chatsworth study. Christ stands prominently in the center, with the three chosen disciples, Peter, James and John, kneeling in front of him. On either side of him are the hovering figures of Moses and Elijah, and on the extreme right of the two kneeling deacons who appear on the left in the Chatsworth drawing, and who have been variously identified as St. Lawrence and St. Julian, in compliment to the patron's father and uncle, Lorenzo and Giuliano de'Medici; or as St. Felicianus and St. Agapitus, whose martyrdom is celebrated on the liturgical feast of the Transfiguration; or as St. Justus and St. Pastor, the patron saints of Narbonne. The upper part is occupied by a half-figure of God the Father, emerging from clouds and surrounded by a glory of angels.

Except that the figures are naked, No. 37 corresponds in all essentials with the upper part of the revised design as eventually carried out, in which the lower part of the panel is occupied by the group of disciples who had not been chosen to accompany Christ and who therefore remained at the foot of the mountain, trying without success to heal the demoniac boy who was later healed by Christ himself after his descent. It has been argued that the two episodes are not factually connected in the Gospel narrative, and

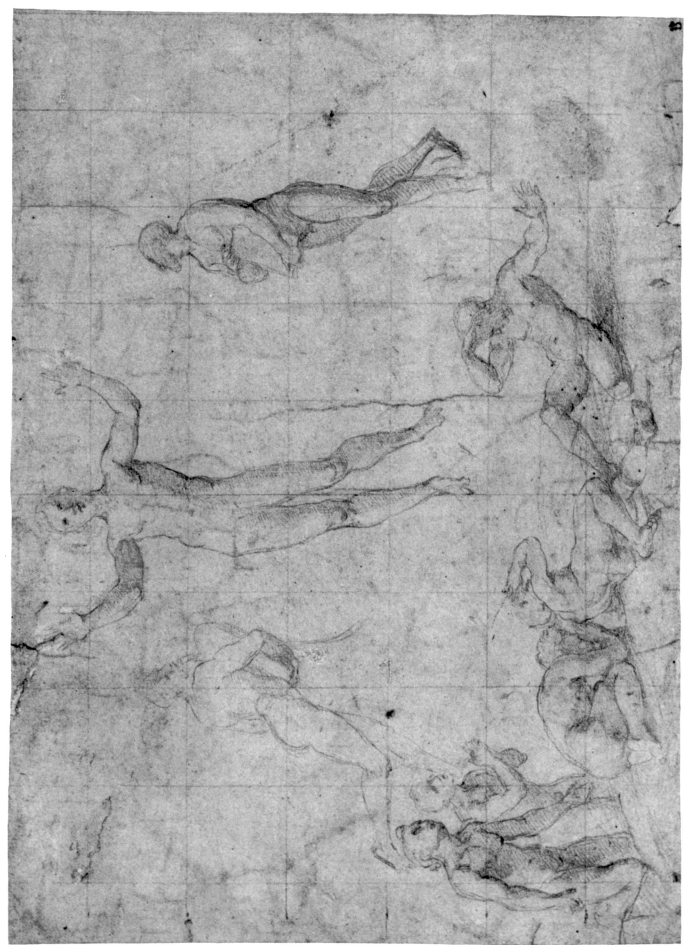

37

that Raphael would hardly have ventured to combine them in this way unless he had been instructed to do so by his patron. A number of ingenious explanations of a symbolic nature have been suggested for what appears to some critics to be an iconographical anomaly (see, for example, Dussler, p. 53 and Sylvia Ferino Pagden in *Raffaello a Roma*, pp. 24 ff.); but it is clearly implied in the accounts given by Matthew (xvii) and Mark (ix), that the disciples had tried to heal the boy while the Transfiguration was taking place on the summit of the mountain. In the words of Crowe and Cavalcaselle "the two incidents thus combined have the sanction of scripture, and Raphael cannot be accused of caprice in attempting to unite them in one composition."

By simultaneously commissioning two altarpieces of equal size and importance for the same church, Giulio de'Medici had deliberately provoked a confrontation between two bitterly hostile factions: Raphael was placed in direct competition not only with Sebastiano del Piombo but also with Sebastiano's friend and supporter Michelangelo, who was known to be providing him with practical assistance in the form of drawings. Raphael seems not to have started work on his altarpiece until Sebastiano's was well advanced; and it may well be, as Sylvia Ferino Pagden and others have suggested, that the motive for the change of plan was an aesthetic one, inspired by dissatisfaction with the essentially static nature of the conventional early solution and by the need to devise a more dramatic treatment of the subject that could hold its own with Sebastiano's *Lazarus*.

In spite of its evident connection with the painting and its unmistakable character as a squared working drawing, and though it has been in the well-known and much studied Devonshire Collection under the name of Raphael since the eighteenth century, No. 37 has received surprisingly little critical attention. It was omitted altogether by Passavant, and though listed by Ruland as a study by Raphael for the *Transfiguration* is not mentioned by Crowe and Cavalcaselle nor included by Fischel in his 1898 volume. Later (1948, p. 367), Fischel attributed it to Penni. Oberhuber (1962, pp. 127 ff.) was the first critic to argue, emphatically and convincingly, in favor of the traditional attribution to Raphael, who must have made many working drawings of this rather dry and diagrammatic type which have not survived.

38 Head of a Young Man with Curly Hair; a Left Hand

Black chalk, over dotted (pounced through) underdrawing. 363: 346 mm.

PROVENANCE: William, 2nd Duke of Devonshire (Lugt 718); Chatsworth 66 (sale, Christie's, 1984, 3 July, lot 39).

LITERATURE: Ruland, p. 29, 76; Crowe and Cavalcaselle, ii, pp. 310 and 489; British Museum 1983, no. 177.

Princeton, New Jersey, Barbara Piasecka-Johnson

A STUDY for the head and left hand of the disciple pointing upwards in the center of the group in the lower part of the *Transfiguration* (see No. 37). The place of such drawings in the sequence of preparatory studies, first defined by Fischel (*Burlington Magazine*, lxxi [1937], pp. 167 ff.), is evidence of the laborious care with which Raphael worked out every detail of a composition before he began to paint it. Fischel had observed that these drawings, and others like them, are on exactly the same scale as the corresponding details in the painting and that there are in all of them traces of dotted underdrawing which must have been pounced through (see No. 19) from another sheet on which the outlines had been pricked for transfer. He concluded that they had been traced through from the finished cartoon of the whole composition, to enable the artist to make full-scale studies of any details that he wanted to realize with particular care, and he invented the term "auxiliary cartoon" to describe drawings of this type. Comparison with the finished painting shows that Raphael was still prepared to modify his ideas even at the eleventh hour. The disciple in the center of the painting, for example, looks older, his beard and moustache are very much more luxuriant, and the shape of his nose has been altered; but the fall of light across both heads is exactly as in the drawing. Raphael's use of the auxiliary cartoon goes back to a very early stage of his career, when he was still working in Umbria: drawings of exactly the same kind for heads in the Vatican *Coronation of the Virgin* of c. 1502–3 are at Windsor (Popham 788) and in the British Museum (Pouncey and Gere 5).

Altogether six auxiliary cartoons for the *Transfiguration* are known, corresponding with seven of the nine heads in the group of disciples. Of the remaining five, one is still at Chatsworth (67; British Museum 1983, no. 178), two are in the British Museum (Pouncey and Gere 37 and 38), one, of the heads and hands of two contiguous figures, is in the Ashmolean Museum (Parker 568), and one is in the Albertina (Cat. iii, 1932, no. 79; 1983, no. 45). Ruland listed all six as studies for the *Transfiguration*, by Raphael. It is thus all the more surprising to find Crowe and Cavalcaselle describing No. 38 and Chatsworth 67 as studies for the tapestry cartoon of *St. Paul in Athens*, though with the comment that the latter drawing may "also have been intended for the *Transfiguration*."

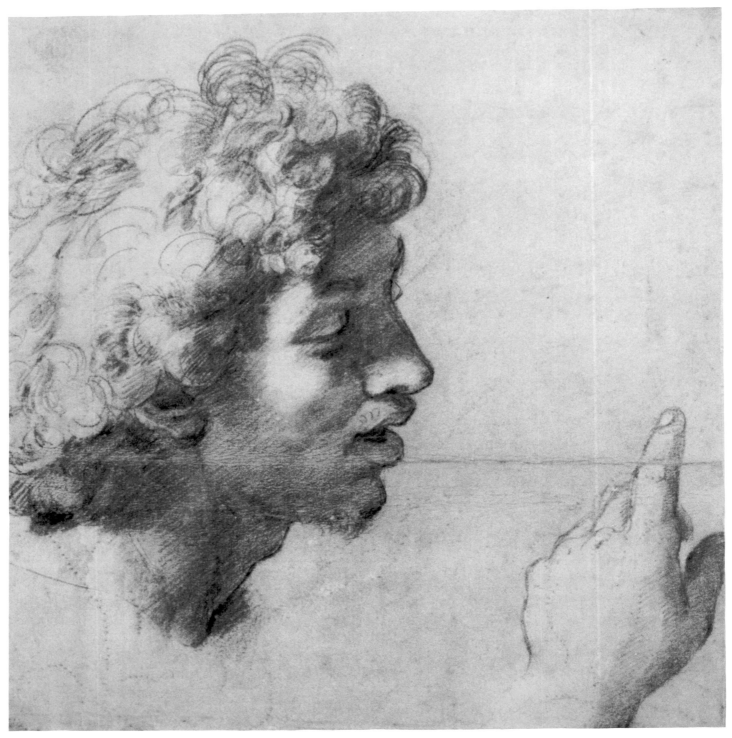

38

Photograph by Marek Bulaj

Their reference elsewhere to No. 38 as a study for another of the cartoons, the *Sacrifice at Lystra*, may be no more than a slip, though the head of St. Barnabas on the extreme left of that cartoon resembles the drawing as closely as does the head in the other cartoon that they do connect with it. They attributed both drawings to Penni, but accepted as by Raphael the larger of the two in the British Museum (Pouncey and Gere 37), for the head of St. Andrew in the foreground, and the sheet with two heads in the Ashmolean. Fischel (1898) accepted the latter as by Raphael, but attributed the other five to Penni. Later (*Burlington Magazine*, ut cit. and 1948, p. 367) he extended the attribution to Raphael to include the British Museum *St. Andrew*, but did not repeat his orally expressed opinion, quoted in the Albertina catalogue of 1932, that the head in that collection is also by Raphael. No. 38 and Chatsworth 67 were reproduced for the first time, and the case for Raphael's authorship convincingly argued, by Frederick Hartt (*Art Bulletin*, xxvi [1944], p. 87). The traditional view that all six are by Raphael was simultaneously reaffirmed by Pouncey and Gere and by Oberhuber (1962, pp. 142 ff.), and is now generally accepted. Pope-Hennessy, indeed, declares, of No. 38, "with its masterly command of the lighting of the softly modelled features, this is one of the finest drawings Raphael made."

The *Transfiguration* was unfinished when Raphael died, and had to be completed by his chief studio assistant, Giulio Romano. The upper part and the group of disciples on the left of the lower part, seem to be largely the work of Raphael himself. The group on the right, of the possessed boy and his father and mother, is evidently executed by another hand, which has every appearance of being Giulio's. The existence of auxiliary cartoons by Raphael himself for so many of the heads implies that the full-scale cartoon had been completed according to his design, and that this design must have included the lower right-hand group in the form in which it was carried out, however much it may have been superficially transformed by Giulio.

39 Christ in Glory

Black chalk and gray wash, heightened with white, on gray-washed paper. 225: 179 mm., including two strips added on either side.

PROVENANCE: Pierre Crozat? ("l'Etude de la figure du Christ du tableau des cinq saints" was part of lot 105 in his sale, Paris, 1741); Cornelis Ploos van Amstel; M. Verstegh; Thomas Dimsdale (all according to the *Lawrence Gallery* catalogue. Not identifiable in the Ploos van Amstel sale catalogue, Amsterdam, 1800, 2 March etc.); Sir Thomas Lawrence (Lugt 2445); King William II of Holland (sale, The Hague, 1850, 12 August, lot 55); his son-in-law the Grand Duke Carl Alexander of Saxe-Weimar; the Weimar Museum, 1919; anonymous sale, of a "Continental Collection," Christie's, 1982, 9 December, lot 17.

LITERATURE: *Lawrence Gallery* 56; Passavant, p. 536 r; Ruland, p. 49, viii, 5; Fischel 1898, no. 362; Paul Joannides, *The Drawings of Raphael*, 1983, no. 456; Knab-Mitsch-Oberhuber 618.

Malibu, The J. Paul Getty Museum 82.GG.139

Inscribed in ink, lower right, in an eighteenth- or nineteenth-century hand: *Raphaello da Urbino fe*. This figure of Christ blessing occurs, flanked by those of the Virgin and St. John the Baptist, in the upper part of the composition known as *The Five Saints*, which exists in the form of an engraving by Marcantonio (Bartsch 113), a *modello* drawing in the Louvre (3867; *Raphaël dans les collections françaises*, 1983, no. 117; Knab-Mitsch-Oberhuber, fig. 151), and a painting in the Parma Gallery (K der K 209). The lower part of the composition is occupied by a standing figure of St. Paul and a kneeling St. Catherine of Alexandria.

Neither the Louvre drawing nor the painting is by Raphael. The drawing is attributed to Giulio Romano by Knab-Mitsch-Oberhuber and to Penni by Joannides (op. cit., no. 457); the painting is now generally accepted as an early work by Giulio. The connection between No. 39 and the *Five Saints* was observed by Passavant. He and Ruland accepted without question the traditional attribution to Raphael. Fischel, on the other hand, with the hypercriticism characteristic of the late nineteenth century, gave the drawing to Giulio. The original attribution has been accepted by all later critics. It does not necessarily follow that Raphael himself was responsible for the composition as a whole. As Paul Joannides suggests, this is more likely to be a pastiche of Raphaelesque elements put together in the studio after his death. He points out that the position of the arms echoes that of the Christ in the *Transfiguration* (see No. 37), but that the pose of the figure is a "reworking" of the Christ in the *Disputa*.

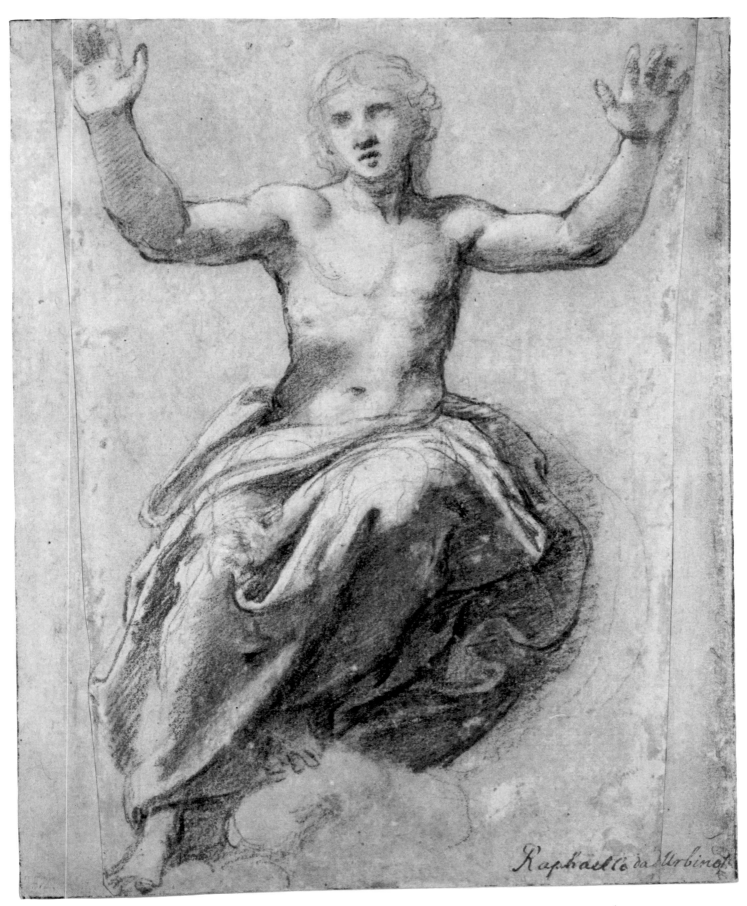

Raphaello da Urbino

39

40 Two Studies of a Nude Man RECTO.
Two Studies of an Elderly Man Seated in an
Attitude of Meditation VERSO.

Black chalk, heightened with white. Some stylus underdrawing (recto); black chalk (verso).
257: 362 mm.

PROVENANCE: Duke of Alva (according to *Lawrence Gallery* catalogue); Sir Thomas Lawrence;
Samuel Woodburn.

LITERATURE: *Lawrence Gallery* 98; Passavant 519; Robinson 143; Ruland, p. 236, 17; Crowe
and Cavalcaselle, ii, p. 455; Parker 569; Oberhuber-Fischel 487/488; British Museum 1983, no.
181; Knab-Mitsch-Oberhuber 592/593.

Ashmolean Museum P II 569

THE studies on the recto, drawn from a model wearing a loincloth and with his hair tied up as in the life studies for the *Resurrection* (see Nos. 31–33) in which the same model may even have been used, are for two figures struggling in the water in the right foreground of the *Battle of Constantine* in the Sala di Costantino in the Vatican. In the painting their relative position is transposed, the study on the left of the sheet being for the soldier pulling himself into the boat, the other for his partly submerged companion who is clasping him round the waist. These studies are closer to the corresponding figures in the squared *modello* for the whole composition, in the Louvre (Oberhuber-Fischel 485), in which they are likewise naked: in the fresco, the figure climbing into the boat is wearing a helmet and a suit of mail.

The fresco of Constantine's victory over Maxentius at the Battle of the Milvian Bridge is the largest of the four scenes from his life in the Sala di Costantino, and was the source of inspiration for the great Baroque battle scenes of the seventeenth century by Pietro da Cortona, Charles Lebrun and others. The decoration of the walls of the Sala (the coved and painted vault was not added until the 1580s) was well under way before Raphael's death, since a payment for scaffolding there is recorded in October 1519 (see Shearman 1965, p. 178). It was completed by his assistants and heirs, Giulio Romano and Giovanni Francesco Penni. Though almost everything that we now see in the room has been either reinterpreted and transformed, or wholly designed, by Giulio, the scheme of the decoration was certainly devised by Raphael (see No. 60). Two of the four historical scenes, the *Baptism of Constantine* and the *Donation of Constantine* (see No. 61), belong to the later phase when the decoration was resumed after the election of Clement VII in 1523; the *Allocution of Constantine* (see No. 4) and the *Battle* belong to the first, Raphaelesque, phase. Though both were clearly executed by Giulio, the problem is to determine the extent of Raphael's responsibility for their design. Vasari says that "le invenzioni e gli schizzi delle storie" were partly by him; and as John

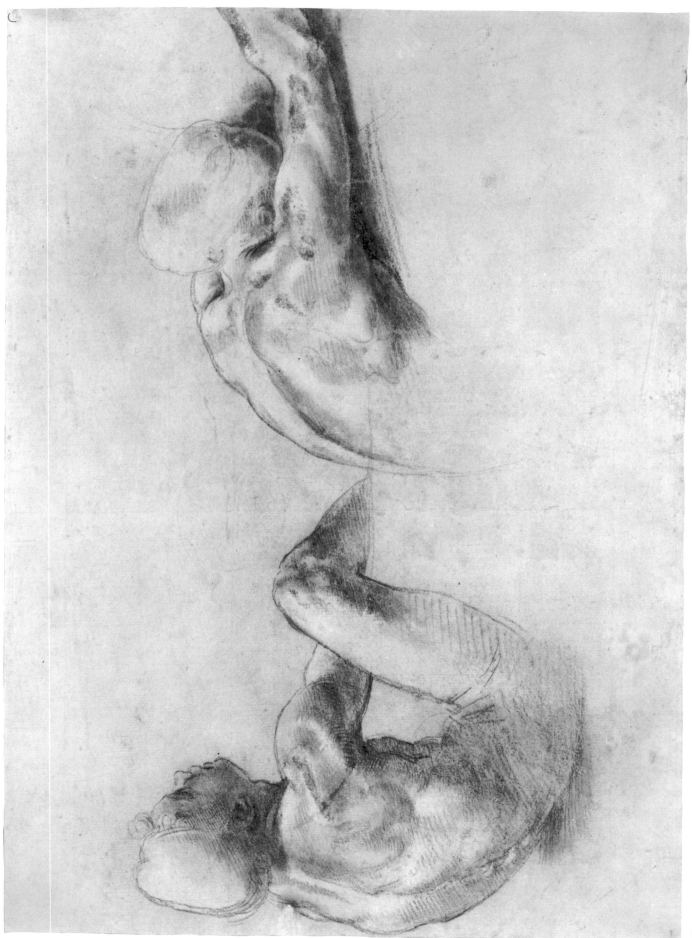

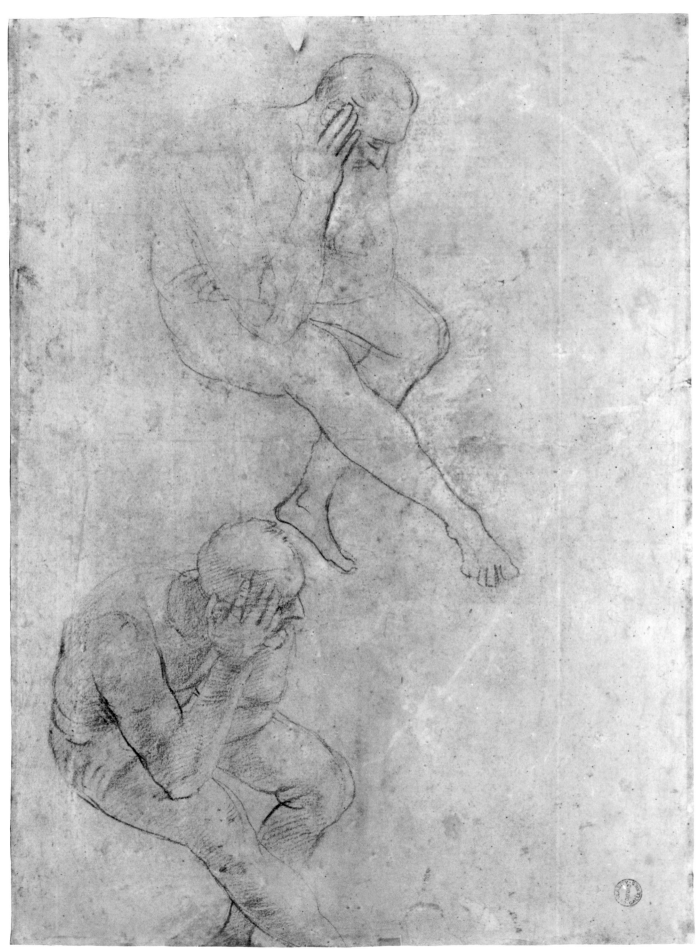

40 verso

Shearman pointed out, in the case of the *Battle* we have the explicit testimony of his friend, and first biographer, Paolo Giovio: "his last work was the battle in which Maxentius was defeated, begun in the larger dining hall and completed by his followers after his death."

Raphael himself may have been responsible for the *modello* of the *Battle* in the Louvre (see p. 15), and the Ashmolean drawing is another piece of evidence, of crucial importance. Its connection with the *Battle* had already been noted by Passavant, and he, Ruland, Robinson and Crowe and Cavalcaselle all accepted without question the traditional attribution to Raphael. In the hypercritical 1890s, however, Morelli, Dollmayr and Fischel successively gave it to Giulio, an opinion later shared by Hartt and, apparently, maintained by Fischel (cf. 1948, p. 367). The attribution to Giulio was emphatically rejected by Kenneth Clark (*Vasari Society*, 2nd series, xiii [1932], no. 5) and Parker, both of whom, and also Dussler (p. 88), were strongly inclined to give the drawing to Raphael. Parker drew attention to the resemblance between these figures and the black chalk studies for the *Resurrection*. The attribution to Raphael was accepted without qualification by Shearman (1965, p. 179) and by Konrad Oberhuber, and in the British Museum catalogue of 1983.

This is a problem of attribution that can be decided only by the internal evidence of style and quality. By these criteria, Giulio can surely be ruled out. The delicacy and breadth with which the structure of the knee of the left-hand figure is rendered, the beautiful suggestion of the fall of light across it, and the subtle element of pathos that the draughtsman has imparted to the features, are surely beyond his powers (and, *a fortiori*, Penni's). Detailed studies of individual figures in the poses in which they finally appear would not have been made until the composition had reached its definitive form; so if these studies are by Raphael—and no alternative attribution is in the least convincing—it follows that he was responsible for the composition. Giulio's intervention as executant has inevitably modified Raphael's conception, but he seems not to have taken the same liberties as he did with Raphael's design for the *Allocution*. He must have seen that any attempt to alter a composition so complex and so tightly woven as the *Battle* could lead only to disaster.

The studies on the verso are also evidently drawn from life. Their purpose is unknown, and there seems to be no reason for connecting them with the Sala di Costantino. Robinson, who discovered them when the sheet was lifted from its old backing, and Oberhuber are surely right in attributing them to Raphael.

41 A Pope Carried in the Sedia Gestatoria, with his Retinue

Black, yellow and red chalk. Squared twice in pen, one system of squaring under the drawing, the other over it. 398: 404 mm.

PROVENANCE: William Russell (Lugt 2648: sale, Christie's, 1884, 10–12 Dec., lot 457); Sir Charles Robinson (Lugt 1433: sale, Christie's, 1902, 12–14 May, lot 295); Mrs. John Gardner.

LITERATURE: G. F. Waagen, *Galleries and Cabinets of Art in Great Britain . . . visited in 1854 and 1856, and now for the first time described, . . . forming a supplemental volume to the Treasures of Art in Great Britain*, 1857, p. 187; Ruland, p. 200, 29; Grosvenor Gallery, Winter Exhibition, London, 1877, no. 613; Crowe and Cavalcaselle, ii, p. 140, n.; Corporation Art Gallery (Guildhall) Exhibition, London, 1895, Gallery ii, no. 95; R. van N. Hadley, *Drawings: Isabella Stewart Gardner Museum, Boston*, 1968, no. 8; Oberhuber-Fischel 490; R. Quednau, *Die Sala di Costantino*, Hildesheim and New York, 1979, pp. 464 ff.

Boston, Isabella Stewart Gardner Museum 2.4093

THE group of figures resembles in general disposition, and corresponds exactly in some details with (though the underlying style of the two drawings is wholly different) the left-hand side of a composition known from a highly finished *modello* drawing traditionally attributed to Giulio Romano, formerly in the Lichtenstein Collection and acquired in 1948 by the Rijksmuseum in Amsterdam (1948.368: Frerichs 1981, no. 77; Hartt, fig. 542; Oberhuber-Fischel, fig. 234). Two rapid pen sketches by Giulio, one in the Louvre, for the left-hand half (3874; *Autour de Raphaël*, no. 35), the other, for the right-hand group, in the Nationalmuseum, Stockholm (329/330; Sirén 1917, no. 316), correspond exactly, so far as they go, with the *modello*. They seem to be halves of the same sheet, and are reproduced together by Hartt, 1939, p. 39 and 1958, fig. 85, and by Oberhuber-Fischel, figs. 232 and 233.

In the complete composition, the Pope's gesture is directed towards a group of men with horses, some of whom carry Roman standards. The most conspicuous figures in the right-hand group are a man in Roman armor kneeling in the foreground, and in the background a woman descending a flight of steps and turning towards the Pope and his entourage.

Before their connection with the Stockholm fragment and the *modello* was observed, the Louvre fragment and the Gardner drawing were necessarily considered in isolation. Waagen described the Gardner drawing as a study by Raphael for the somewhat similar group on the left in the *Expulsion of Heliodorus* in the Stanza d'Eliodoro, a work datable 1511–12 in which the bearded Pope—a portrait of Julius II—is also being carried in from the left in the sedia gestatoria. In this opinion he was followed by Ruland, who pointed out the connection with the Louvre sketch which he likewise attributed to Raphael. Crowe and Cavalcaselle, with their usual acuteness, rejected Raphael's author-

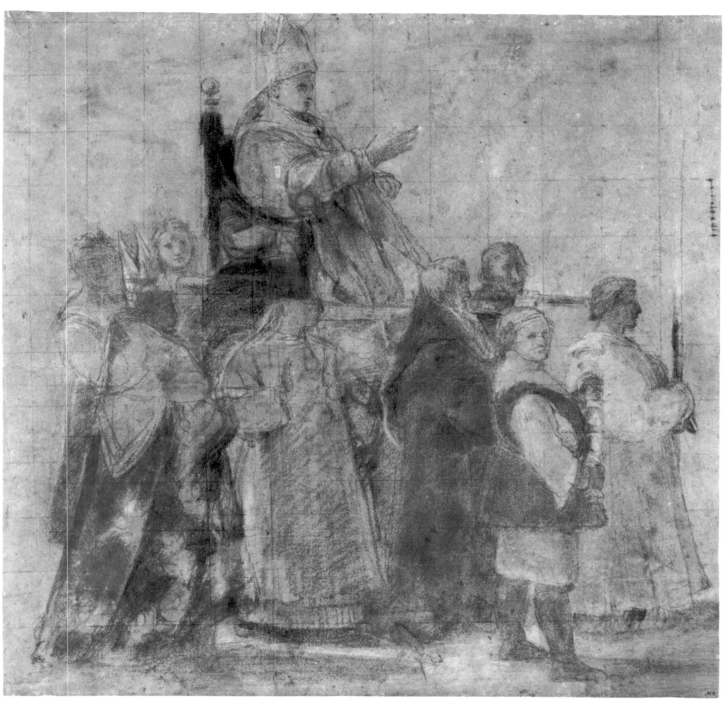

41

ship of the sketch (and *a fortiori* the connection with the *Expulsion of Heliodorus*) which seemed to them unduly evolved in style—or as they put it, "too modern for Raphael." They suggested no alternative attribution, but described the sketch as having been copied from nature by "the rapid and experienced hand [of] a clever draughtsman." It would have been interesting to have had their opinion of the Gardner drawing, but they had not seen it and do no more than allude to it in passing. Robinson's opinion of it is presumably expressed in the catalogue of the Guildhall exhibition of 1895, when it was still in his possession, where it is described as a study by Raphael for two of the frescoes in the Vatican Stanze, "adopted with many variations partly in the Heliodorus and partly in the Saracens at Ostia." (In the *Battle of Ostia* in the Stanza dell'Incendio, a somewhat later work, datable c. 1515, the Pope, though likewise on the left of the composition, is not carried in the sedia gestatoria but is enthroned on a kind of plinth or pedestal.) The drawing then drops completely out of the Raphael literature for more than seventy years, until its publication by Rollin Hadley in 1968 and Konrad Oberhuber in 1972.

Sirén, who rightly accepted the traditional attribution of the Stockholm fragment to Giulio, was the first to observe its connection with the Louvre sheet. He does not refer to the Gardner drawing, but the "old copy of the entire composition" which he mentions as being in the Lichtenstein Collection is presumably the *modello* now in Amsterdam. Though he heads his catalogue entry with the title "Attila before the Walls of Rome"— the subject of another fresco in the Stanza d'Eliodoro—in the entry itself he seems to hint at the possibility of its being a discarded project for the Sala di Costantino, the decoration of which was carried out after Raphael's death by Giulio Romano and G. F. Penni (see No. 47).

This suggestion was taken up by Hartt (1939), who pointed out the significance of the mitre worn by the principal figure in the Louvre sketch (as in the Gardner drawing, which he does not mention). The sedia gestatoria is a means of conveyance used exclusively by the Pope, and in the *modello* the personage so conveyed is indeed wearing the papal tiara or triple crown. This did not in fact become part of the pontifical regalia before the ninth century, but according to the tradition repeated in Bartolomeo Platina's *Lives of the Popes*, five editions of which appeared between 1479 and 1518, the Emperor Constantine, having been converted to Christianity by Pope Sylvester I (A.D. 314–335), bestowed on him and his successors the privilege of wearing a diadem of gold set with gems; "but this Sylvester declined, as unbefitting a person dedicated to religion, preferring to wear a Phrygian mitre." If the mitred Pope is Sylvester, the figure kneeling in the foreground must be Constantine, and the woman in the background either his wife, the Empress Fausta, or his mother, St. Helena.

Whether Giulio himself (or, as Philip Pouncey was inclined to think, Penni) was responsible for the execution of the *modello*, its style leaves no doubt that Giulio was

responsible for its invention. It corresponds with the Gardner drawing only in the form of the sedia gestatoria and in the figures and placing of the Pope himself and the macebearer and the crucifer at the head of the procession. Otherwise there is no close resemblance: the Pope's entourage in the *modello* consists not of robed ecclesiastics but of Swiss Guards in *Landsknecht* costume, and the composition as a whole reveals another and very different creative personality. Its agitated and spatially incoherent conception is in contrast to the lucid and harmonious simplicity of the Gardner drawing and the clarity with which the relation of the ample, dignified forms to one another and to the picture area is defined. The restless effect of the *modello* is enhanced by the oblique movement of the papal group; in the other, the direction of the carrying-poles of the sedia and the relative positions of the mitred figure on the left of the group and the macebearer emphasize that the movement is exactly parallel to the picture plane. In the Gardner drawing the monumental figure of the mitred ecclesiastic serves as the cornerstone of the group, anchoring it firmly within the well-defined limits of the picture area; the corresponding figure in the *modello* destroys the integrity of the picture area by seeming to stride inwards from a point outside it—a device that serves to increase the sense of spatial ambiguity. The Gardner drawing also differs from the *modello* in the psychologically convincing characterization of some of the faces. There may even be some truth in the comment in the catalogue of the 1877 Grosvenor Gallery exhibition, "supposed to contain several portraits among the bearers." The cleanshaven face of the Pope is also very striking, though if this was intended as a portrait of Leo X, he has been unrecognizably flattered.

Giulio can be excluded as a possible author of the Gardner drawing, as can Penni, to whom Fischel attributed it in 1937 on the basis of a photograph. It is clear from Fischel's pronouncements on the subject that he failed to form any positive conception of Penni's artistic personality, and that he saw him in negative terms simply as a "wastepaper basket" in which conveniently to dispose of any Raphaelesque drawing not assignable to Raphael himself or to Giulio; the drawing is quite unlike anything even in the large group perhaps over-attributed in recent years to Penni. More recently, critics have tended to revert to the traditional attribution to Raphael himself. It should be emphasized that this opinion is not reached merely by process of elimination: *pentimenti* and other signs of creative struggle rule out any possibility that this is a tidied-up repetition produced by a studio assistant, while the very high quality and the artistic personality revealed are entirely consonant with Raphael's authorship. Hadley summarizes the first detailed argument in favor of the attribution, put forward by Rosamond Mack in an unpublished study. He also quotes the favorable opinion of Oberhuber, later amplified in Oberhuber-Fischel. The loose, impressionistic handling of the chalk is comparable with that in such late Raphael drawings as the study in the Albertina for the *Spasimo di Sicilia* in the Prado, a work datable 1516–17 (234; Oberhuber-Fischel, fig. 65; Albertina

1983, no. 41), and there is a general resemblance, both in the figures themselves and in their grouping, to another composition of a papal ceremony, *The Oath of Leo III* in the Stanza dell'Incendio, also datable 1516–17. The technique is most unusual for Raphael, but it can be paralleled in the portrait head of an unidentified ecclesiastic in the collection of the Earl of Pembroke at Wilton (Oberhuber-Fischel, fig. 70; British Museum 1983, no. 141), which is executed in a combination of black, red and white chalk.

The suggestion that the Amsterdam *modello* is a discarded project by Giulio for one of the historical scenes in the Sala di Costantino seems very plausible; and it seems reasonable to suppose, as Mrs. Mack and Oberhuber have done, that the Gardner drawing is a study by Raphael for the same project, later adapted and transformed by Giulio in accordance with the mannerist style which he developed after his master's death. To judge from the format of the composition and the direction of the lighting, the scene would have been intended for the space between the windows eventually occupied by the *Donation of Constantine*. Whether it also represents the *Donation* may be questioned. In the fresco, the ceremony is taking place inside a pillared hall, in which Constantine kneels before the enthroned Pope and hands him the document ceding to the Papacy supremacy over Rome and the surrounding territory. No such formal solemnity appears in the *modello*, the subject of which seems to be the more general one of Constantine submitting to the authority of the Pope—the subject, it may be noted, of one of the small grisailles below the *Donation*, represented in a much simplified form, reduced to the two principal figures.

More recently the problem has been discussed by Rolf Quednau, who argues that even if the Gardner drawing is by Raphael (he is clearly doubtful, but refrains from expressing a definite opinion without having seen the drawing itself) it can hardly be a project for the Sala di Costantino, since documentary evidence establishes that at the time of Raphael's death the *Donation of Constantine*—or whatever subject is represented in the Amsterdam *modello*—was not part of the iconographic program. The document in question is one of a series of letters written by Sebastiano del Piombo in Rome to Michelangelo in Florence in the course of the six months following Raphael's death. Sebastiano had been an adherent of Michelangelo and a declared enemy of Raphael and his followers. In his letters he described his efforts to secure the Sala di Costantino commission for himself by holding out the possibility that Michelangelo might provide the designs for it as he had done for the Borgherini *Flagellation* and the altarpiece of the *Raising of Lazarus*. In a letter of 6 September 1520 he tried to arouse Michelangelo's interest by describing the subjects of the four historical scenes to be painted in the Sala. Two of these four subjects, the *Allocution* and the *Battle*, were carried out, the former probably and the latter certainly after designs by Raphael (see Nos. 40 and 48); but instead of the *Baptism* and the *Donation*, the other two were to have been, according to Sebastiano, a scene of prisoners brought before Constantine and another of the prepa-

rations for the massacre of children commanded by Constantine in the hope that his leprosy might be healed by bathing in their blood.

Quednau suggested (*Raffaello a Roma*, p. 248, n. 5) that a Raphaelesque pen drawing in the British Museum (Gere and Pouncey 363, as Penni), the graphic style of which he describes as being "very close to Raphael," is probably connected with the composition of prisoners before Constantine. The drawing is a variation on the Antique theme of *Clementia*, as treated on a sarcophagus in the Vatican Belvedere and in the Antonine reliefs on the Arch of Constantine and in the Palazzo dei Conservatori (Bober and Rubinstein, nos. 160–3). Many of the features adduced in support of the connection with the Sala di Costantino, such as the Roman standards and armor, occur in these Antique prototypes; but one that does tend to support Quednau's suggestion is that the enthroned figure is wearing a crown—an unthinkable adornment of a Roman emperor of the classical period.

It is hard to believe that the *Massacre of Children* could have been seriously considered as an appropriate subject for one of the historical scenes in the Sala di Costantino. It is true that Constantine relented at the last moment, to be rewarded by a miraculous vision of Sts. Peter and Paul and the eventual healing of his leprosy; but "the preparation of the fire [for heating] the blood of the children to make a bath for Constantine, in which were to be shown many mothers, and little children, and executioners to slaughter them" would have shown him in an inappropriately unregenerate light. But even if we take Sebastiano's letter at its face value and assume that the four subjects described by him were being seriously considered, and if the British Museum drawing could be demonstrated to be connected with the project and by Raphael himself (but even in the light of the new enlarged conception of Raphael's late style the attribution is hard to accept), it does not follow that other subjects were never contemplated; and it is surely inconceivable that whoever devised the iconographic program for the decoration of one of the most important public or semi-public rooms in the Pope's own palace should never have at any stage contemplated the theme—particularly significant in that setting—of Constantine's relationship with the Papacy. The surviving evidence is surely insufficient to compel us to reject the theory that the Gardner drawing is in some way connected with the decoration of the Sala di Costantino.

Quednau is no doubt right in seeing the Gardner drawing as a faithful representation from life of the everyday sight of the Pope being carried in procession to say Mass (an occasion on which, incidentally, he would have worn a mitre rather than the tiara), but it does not follow that the drawing is merely a record of the spectacle made as an end in itself. Raphael was not one of those artists who drew for the sake of drawing. His overburdened and highly organized life obliged him to practice a rigid economy of time and effort. It is broadly true to say that after he came to artistic maturity he never made a drawing except as an aid to the realization of a pictorial idea. That this was so in the

present case is established by the double system of squaring, once underneath the drawing and once, very much more faintly, over it. As Oberhuber observed, the drawing must represent an intermediate stage in the planning of a composition: enlarged and elaborated from an earlier study, perhaps a sketch of the whole composition, and itself destined for repetition, perhaps in the *modello* that would have preceded the final full-size cartoon.

RAPHAEL?

42 Head of Pope Leo X

Black chalk. The outlines indented. 337: 268 mm. Maximum measurements of the original sheet, the lower corners of which are cut and the upper part irregularly torn so as to affect part of the forehead on the left; later remounted on a rectangular sheet measuring 480: 299 mm.

PROVENANCE: Padre Resta (see below); William, 2nd Duke of Devonshire (Lugt 718).

LITERATURE: B. Berenson, *The Drawings of the Florentine Painters*, 1903 and 1938, no. 2477; Oberhuber-Fischel 482; British Museum 1983, no. 183.

Chatsworth 38

INSCRIBED on old backing sheet in ink, in the hand of the late seventeenth-century collector Padre Sebastiano Resta: *Ritratto di Leone X° Michelangelo Buonaroti*. Passavant was the first to observe the connection with Raphael. This is one of the few drawings at Chatsworth singled out for mention in his *Tour of a German Artist in England* (1836, ii, p. 145), with the words "here ascribed to Michael Angelo, although from one of Raphael's own paintings." The old attribution seems nevertheless to have been retained, for in 1899 (*Jahrbuch der königlich Preussischen Kunstsammlungen*, xx, p. 209) Wickhoff gave the drawing to Sebastiano del Piombo, then believed to have been Michelangelo's stylistic *alter ego* and as such responsible for many drawings tradition-

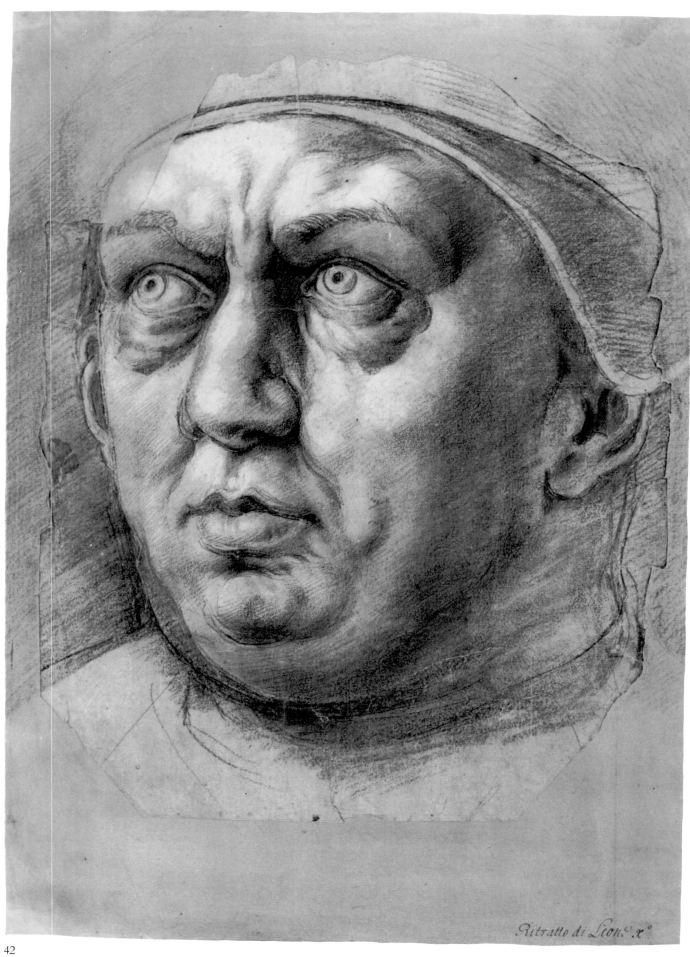

Ritratto di Leon.^e x.^o

42

ally—and, as most critics now believe, correctly—attributed to Michelangelo. This attribution was accepted by Berenson in the first (1903) edition of his *Florentine Drawings*[1], but in 1935 (*Bollettino d'arte*, xxviii, p. 484) Fischel spelt out in full what Passavant must have observed a hundred years before, that the head corresponds with that of the figure of *Pope Clement I*, who is represented, with the features of Leo X, above the doorway to the right of the *Allocution of Constantine* in the Sala di Costantino (see No. 47). In his second edition (1938) Berenson abandoned the attribution to Sebastiano in favor of one, not to Giulio Romano to whom Fischel had attributed the drawing, but to Raphael himself, with the comment: "it was used by Giulio for the head of Clement I; it has shrivelled in the process, the conception being far too overpowering for Giulio, and the execution too direct." John Shearman (1972, p. 61) took the same view, describing this head as "the most intensely realized (and the last) of all Raphael's portraits of Leo."

Konrad Oberhuber, on the other hand, followed Fischel without hesitation, citing, as unmistakably characteristic of Giulio, "the strained expression; the emphasis on separate features such as brows, eyes, cheeks, nose and chin; the tendency of the modelling to dwell on the plasticity of individual details rather than of the head as a whole; the hard but expressive quality of the line; and the irregular distribution of the light." Hartt (p. 51) supported the attribution to Giulio by a comparison with the heads in the cartoon of the *Lapidation of St. Stephen* (Vatican; Hartt, figs. 102–3 and 106–7), an independent work by Giulio datable not long after Raphael's death; but these seem looser and less well-controlled and with less grasp of the underlying form than the Chatsworth head. A more convincing comparison might be with the head of the horseman in the fragment of the cartoon for the *Battle of Constantine* (Milan, Ambrosiana; Hartt, fig. 81).

The drawing thus poses a nice problem in connoisseurship. The technical arguments in favor of Giulio are difficult to gainsay. On the other hand, the draughtsman was clearly a most gifted portraitist, and it would also be difficult to point to another portrait by Giulio that has anything of the power and psychological insight of this head. A contrasting example of his style as a portrait draughtsman, at the same period and on very much the same scale, is the "auxiliary cartoon" (see No. 38) in the British Museum for another head in the Sala di Costantino, that of the figure standing behind Constantine in the *Allocution of Constantine* (Pouncey and Gere 72; Oberhuber-Fischel 484b; British Museum 1983, no. 198). In this drawing the form is expressed in terms not of plastic

1. The attribution to Sebastiano was repeated by the present compiler in a review of the Arts Council Exhibition of Chatsworth drawings in 1949 (*Burlington Magazine*, xci, p. 170), influenced by Fischel's suggestion that the head of another one of the figures of historical Popes in the Sala di Costantino—that of *Urban I*—had been repainted by Sebastiano (*Illustrazione Vaticana*, viii [1937], pp. 923 ff.). The drawing was no. 6 in the exhibition catalogue by A. E. Popham, who attributed it to Giulio.

mass but of outline, and unlike the Chatsworth head it reveals very clearly the personality of Giulio as we know it in his later work. It is always possible—in theory, at least—that Giulio was put on his mettle and inspired to an unusual pitch of creativity by the challenge of doing justice to Leo's alarmingly formidable personality. On the other hand, our knowledge of Raphael's later development is not so complete as to enable the possibility that this drawing is by him to be entirely excluded.

Exactly how the drawing is related to the head in the fresco is not clear. The black chalk technique, the incised contours, and the over-lifesize scale all show that this is a fragment of a cartoon. Fischel had no doubt that this was so, and went to considerable trouble to obtain the measurements of the head in the fresco. He claimed that the two heads correspond exactly in scale, but the measurements that he gives for the painted head are significantly larger. Oberhuber accounted for the discrepancy by quoting the explanation supposedly given by Berenson, that the paper had shrunk; but there is no reason why the paper of a cartoon should shrink in size, and Berenson was clearly using the word "shrivelled" in a figurative sense, to describe the inferiority of the painted head.

43 Adam and Eve Expelled from Paradise

Black chalk, heightened with white. Squared in black chalk. Some traces of the former brown wash are visible. The surface of the drawing has suffered from the mid-nineteenth-century "restoration." 243: 278 mm.

PROVENANCE: King George III

LITERATURE: Passavant 418; Ruland, p. 214, vii, 6 and 7; Crowe and Cavalcaselle, ii, p. 503; Popham, *Windsor*, no. 806; Oberhuber-Fischel 457; British Museum 1983, no. 191; Knab-Mitsch-Oberhuber 582.

Windsor, Royal Library 12729

THE three figures correspond exactly with the group in the fresco in the second vault of the Vatican Loggia. The Loggia, which leads out of the Sala di Costantino and overlooks the Cortile di S. Damaso, is divided into thirteen sections, each with a separate vault decorated with four small-scale frescoes of biblical subjects, those in the first twelve illustrating the Old Testament and those in the thirteenth four scenes from the life of Christ. These fifty-two compositions form the so-called *Raphael's Bible*, well known from the many series of engravings published in the sixteenth and seventeenth centuries. The decoration of the Loggia can be dated between the early months of 1518 and May 1519.

Though Vasari names most of the artists recorded as members of Raphael's studio as having been involved in the decoration of the Loggia, he attributes specific frescoes

only to Giulio Romano and Perino del Vaga. But however many hands were responsible for the execution, the homogeneity and narrative intelligence and clarity of the series as a whole suggests that their "invention" was due to a single mind; and that mind can only have been Raphael's. Raphael must have made preliminary sketches of some sort for them, but the only one certainly attributable to him is the black chalk study in the Albertina for figures in *David and Goliath* (178; 1983, no. 44; Oberhuber-Fischel 468). Otherwise, the surviving drawings are squared *modelli*, almost all in the same technique of pen and brown wash heightened with white. It is clear, from the original appearance of the drawing of the *Expulsion from Paradise* as recorded in the facsimile engraving in C. M. Metz's *Imitations of Ancient and Modern Drawings* of 1798 (Weigel 6344) and the photograph in the Thurston Thompson publication of 1857 of the Raphael drawings in the royal collection (repr. British Museum 1983, p. 238), that it was a *modello* in the same technique and of exactly the same type. In his 1876 catalogue Ruland included a photograph of the drawing in its original "unrestored" state, and another of it as it now is with the comment "showing the first sketch, in black chalk, by Raphael's own hand." It seems likely, therefore, that it was he who in order to explain the absence of preliminary studies by Raphael for the Loggia frescoes evolved the theory that the *modelli* are, in the most literal sense of the term, works of collaboration, in which a rapid sketch in chalk by Raphael was worked up and elaborated by an assistant; and that his confidence in it was such that he was able to persuade the then Librarian at Windsor to allow the drawing to be "cleaned."

Passavant, who knew the drawing in its original state, accepted the traditional attribution to Raphael himself. Some later nineteenth-century critics, including Morelli, followed Ruland in seeing Raphael's hand in the black chalk underdrawing; others, including Fischel (1898) and Dollmayr, dismissed it as a copy. Crowe and Cavalcaselle (presumably on the basis of a photograph of the drawing in its present state, since they give the medium as "black and white watercolor"), describe it as "a counterpart of the fresco . . . taken from it with squares by Giulio." Fischel (1948, p. 367) came to accept Ruland's general thesis, for he cited the British Museum study for *Jacob's Dream* in the sixth bay of the Loggia (Pouncey and Gere 65) as an example of one "over a preliminary drawing by Raphael," an opinion which Konrad Oberhuber is inclined to follow. Oberhuber emphatically accepted it in the case of the Windsor *Expulsion* drawing (1962, p. 59), and in this view he was followed by Dussler (p. 89). Later, however, he modified his position, admitting that the black chalk underdrawing could be by Penni, but that if so, comparison with the altogether less expressive fresco suggests that he must have been closely following a sketch of some sort by Raphael. Popham catalogued the drawing under the general heading "School of Raphael," but was inclined to give it to Penni. The attribution to Penni was repeated by Pouncey and Gere (under no. 65).

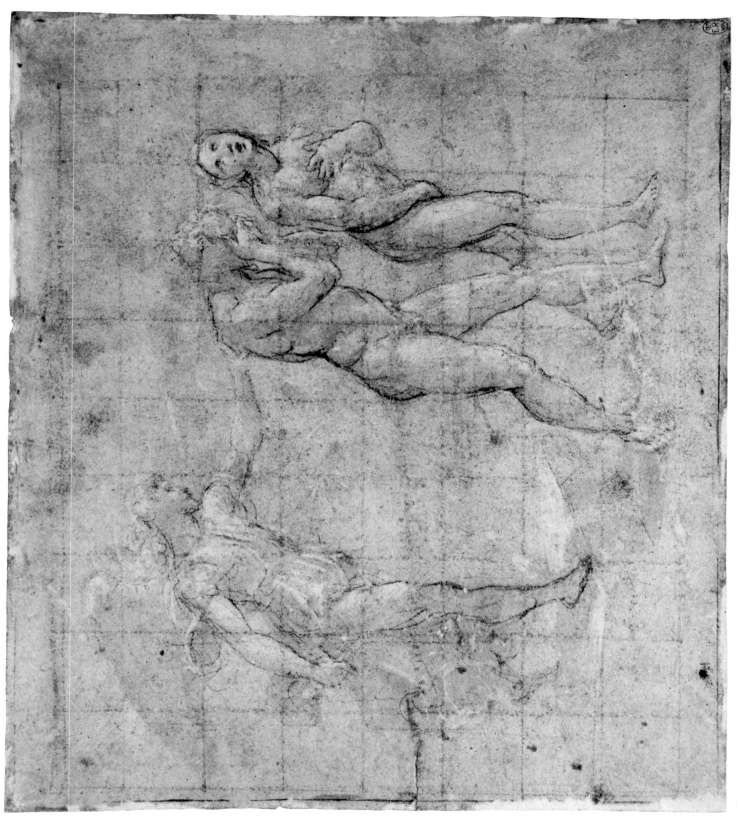

There is no evidence to show, nor has it ever been suggested, that Raphael had recourse to this unusually intimate method of collaboration on any other occasion. The onus of proof rests on those who support this ingenious but—it is also possible perhaps to feel—somewhat farfetched theory. They must be able to demonstrate that the under-drawing is beyond any question characteristic of Raphael, and of Raphael alone. The condition of the Windsor sheet makes it difficult to judge, but it could be argued that such a drawing would not have been beyond the powers of a competent and well-trained draughtsman imbued with Raphael's style and accustomed to following his thoughts and interpreting them in his idiom. See p. 15.

44 David and Bathsheba

Pen and brown wash over black chalk, heightened with white. Squared in black chalk. 215: 267 mm.

PROVENANCE: John Barnard? (what may be his collector's mark, Lugt 1419, is crossed out in lower left corner); Ralph Willett; F. J. Duroveray (both according to *Lawrence Gallery* catalogue); Sir Thomas Lawrence (Lugt 2445); King William II of Holland (sale, The Hague, 1850, 12 August, lot 56); Samuel Woodburn (sale, Christie's, 1860, 7 June, lot 724); Dr. Radford; Miss Kate Radford, by whom presented to the British Museum in 1900.

LITERATURE: *Lawrence Gallery* 88; Passavant, ii, p. 535, *l*; Ruland, p. 224, xliv, 4; Pouncey and Gere 66; Oberhuber-Fischel 469; British Museum 1983, no. 194.

British Museum 1900–6–11–2

INSCRIBED in ink along lower edge: *RAPHAEL*, and so attributed when in the Lawrence Collection. The drawing corresponds in almost every detail with the fresco in the eleventh vault of the Vatican Loggia, except that the central horizontal section of the structure on which Bathsheba is sitting is not decorated with a frieze, and that the composition has an arched top like the frescoes in the fourth and tenth vaults but unlike those in the eleventh.

Neither Passavant nor Ruland had seen the drawing itself, and between 1860 and 1900 it was lost to sight in a private collection. It was first published in 1962 by Pouncey and Gere as one of the group of Raphaelesque drawings that they attributed to Penni, an opinion then shared by Konrad Oberhuber. Sydney Freedberg (p. 415) attributed it "unequivocally" to Perino del Vaga. The attribution to Penni was maintained in the catalogue of the British Museum exhibition in 1983, though Nicholas Turner was inclined to demur and to wonder whether the drawing might not after all prove to be by Raphael himself. Reconsideration of the whole "Penni" group suggests that this possibility cannot be altogether dismissed (see pp. 15 ff.).

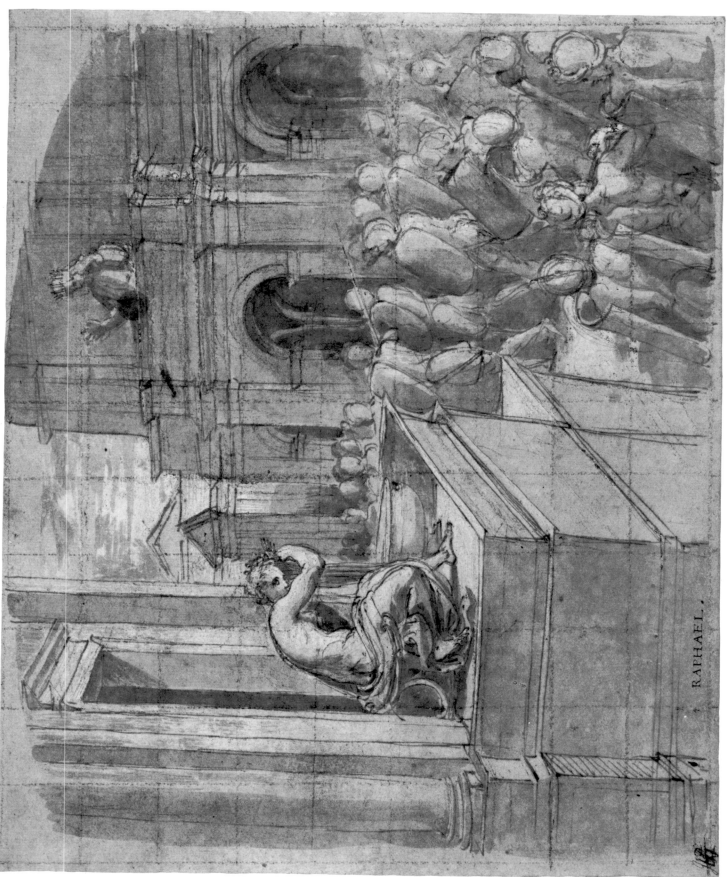

RAPHAEL.

44

45 Lot and his Daughters Escaping from Sodom

Pen and brown wash, heightened with white, over black chalk. Squared in black chalk. 223: 275 mm.

PROVENANCE: Joachim von Sandrart?; Queen Christina of Sweden; Cardinal Azzolino; Don Livio Odescalchi (see provenance of No. 27); Pierre Crozat (sale, Paris, 1741, part of lot 124); Pierre-Jean Mariette (sale, Paris, 1775–76, lot 689); Antonie Rutgers (according to Oberhuber, sale, Amsterdam, 1778, 1 December, lot 452); Ralph Willett; F. J. Duroveray; Thomas Dimsdale (all according to *Lawrence Gallery* catalogue. According to Oberhuber, the drawing was lot 499 in a sale of Willett's drawings on 13 July 1803); Sir Thomas Lawrence (Lugt 2445); King William II of Holland (sale, The Hague, 1850, 12 August, lot 69); Samuel Woodburn (sale, Christie's, 1860, 7 June, lot 720, bt "Farrer"); Emile Galichon (Lugt 856: sale, Paris, 1875, 10 May, lot 144, bt "Armand"); William H. Thompson of Indianapolis, whose collection of Italian paintings and drawings was given to the Ball State Teachers College in about 1940.

LITERATURE: *Lawrence Gallery* 83; Passavant, under no. 136 and p. 534, *e*; Ruland, p. 216, xvi, 4; Crowe and Cavalcaselle, ii, p. 508; Fischel 1898, no. 220; Pouncey and Gere, p. 51; Oberhuber-Fischel 459.

Muncie, Indiana, Ball State University Art Gallery

THE drawing, numbered in ink in the lower right corner *37*, is on a nineteenth-century French mat on which has been stuck the cartouche cut out of Mariette's gray-blue mat, with the inscription: *Egressus Lot e Sodoma. RAPHAEL URB. DELINEABAT in Xystis Vaticanis depingendum. Fuit olim S^{mae} Christinae Reg^{ae} Suedae, deinde Dom^{ni} P. Crozat, nunc penès P.J.Mariette, 1741*. As Mariette says, it corresponds with the fresco in the fourth vault of the Vatican Loggia.

The attribution to Raphael himself was maintained in the *Lawrence Gallery* catalogue, and was accepted by Ruland. Passavant was the first to doubt it, and he has been followed by all subsequent critics: Fischel dismissed the drawing as a copy (presumably of the fresco); Crowe and Cavalcaselle attributed it to Giulio Romano; Morelli (*Kunstchronik*, N. F. iii [1891/92], p. 489, no. 107) to Perino del Vaga; Pouncey and Gere and Oberhuber to Penni. The only critic to discuss the drawing in detail is Oberhuber, who pointed out that there are *pentimenti* for the head of Lot's wife and for the right arm of the figure on the extreme left of the composition. The present compiler knows the drawing only from photographs. It is clearly one of the group now generally attributed to Penni that is in need of reconsideration.

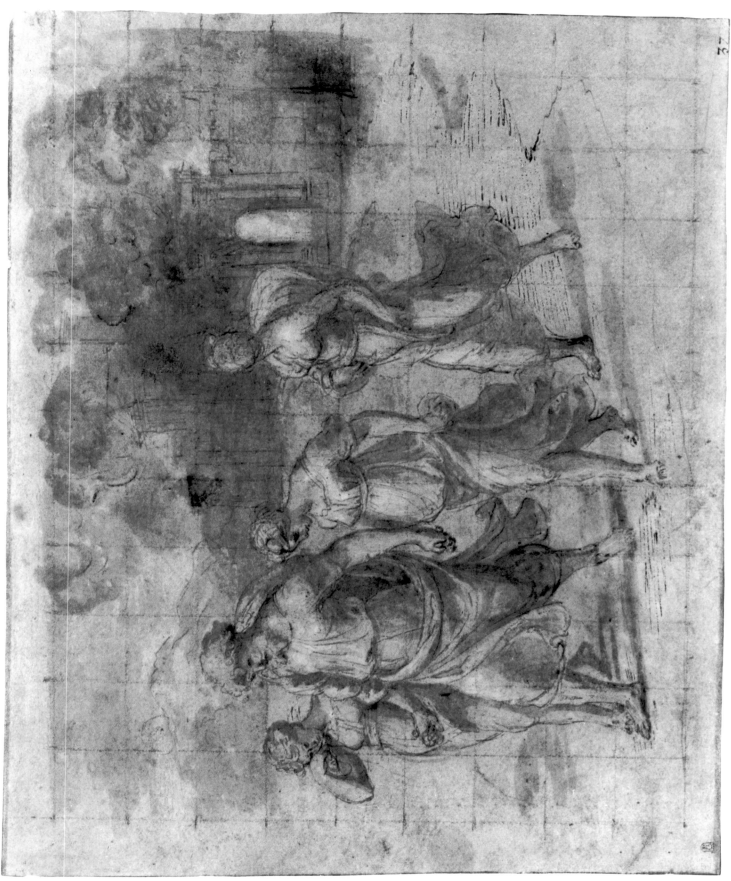

46 Esau Claiming Isaac's Blessing

Pen and brown wash, heightened with white. Squared in black chalk. 254: 283 mm.

PROVENANCE: Joachim von Sandrart?; Queen Christina of Sweden; Cardinal Azzolino; Don Livio Odescalchi (see provenance of No. 27); Pierre Crozat (sale, Paris, 1741, part of lot 124); Pierre-Jean Mariette (sale, Paris, 1775–76, lot 690); Messrs. Ascher and Welker, by whom presented to the Ashmolean Museum in 1936.

LITERATURE: Parker 574; Pouncey and Gere, p. 51; Oberhuber-Fischel 459b; British Museum 1983, no. 192.

Ashmolean Museum P II 574

THE sheet is on Mariette's gray-blue mat, with the inscription: *Essaü benedictionem Isaac deprecatur. RAPHAEL URBIN. DELINEABAT in Xystis Vaticanis depingendum. Fuit olim S.^{mae} Christinae Reg. Suedae et postea D^{ni} P. Crozat nunc penès P.J.Mariette 1741.* The drawing itself is inscribed in ink, lower right: *Rafael Urbin* followed, in another hand, by *38.*

As Mariette recognized, the drawing is a study for the fresco in the fifth vault of the Vatican Loggia. It corresponds with the painting in every detail. For the ruse by which Jacob tricked his father Isaac into giving his paternal blessing to him instead of to his elder brother Esau, see *Genesis*, xxvii.

The references supposedly given to this drawing by Passavant and Ruland are ambiguous, and it is clear that neither had seen it. It had been lost to sight since the Mariette sale in 1775–76 until 1936 when it was acquired by the Ashmolean Museum. Parker was the first to publish it, under the heading "School of Raphael" with the comment that "the style and technique are definitely those of a close contemporary scholar of Raphael, and the squaring seems to indicate that the drawing played some part in the preparation of the working cartoon. It is not incompatible with the other drawings tentatively assigned to Penni." His tentative attribution to Penni was followed, without qualification, by Pouncey and Gere and later by Oberhuber. But see p. 15.

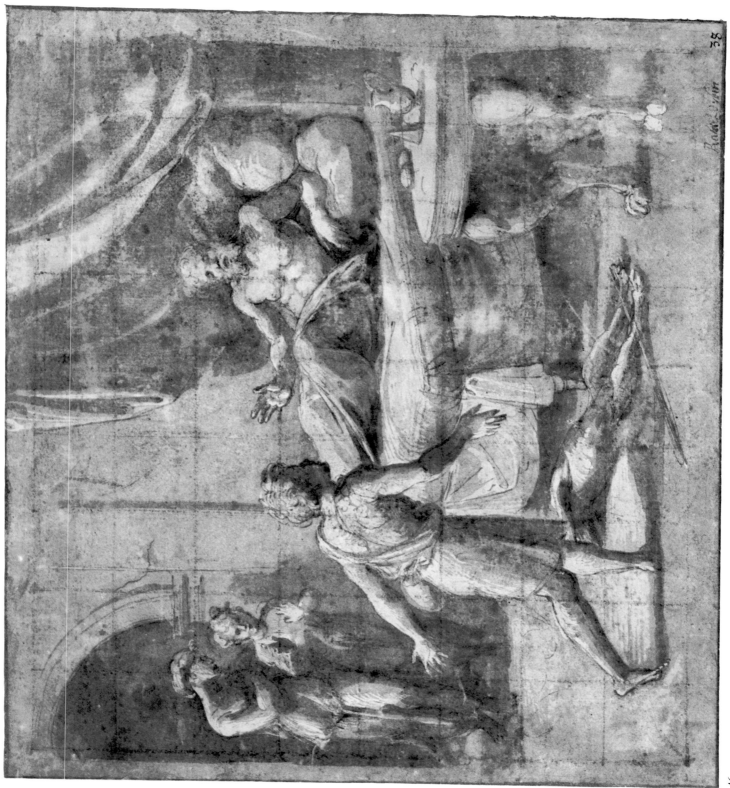

47 The Division of the Promised Land

Pen and brown ink. Squared in black chalk. 203: 297 mm.

PROVENANCE: King George III (Inventory A, p. 50).

LITERATURE: Passavant 420; Ruland, p. 223, xl, 6; Robinson, *Oxford*, pp. 360 f.; Crowe and Cavalcaselle, ii, p. 521; Popham, *Windsor*, no. 807; Pouncey and Gere, p. 51; Oberhuber-Fischel 467; British Museum 1983, no. 193.

Windsor, Royal Library 12728

THE drawing corresponds in all essentials with the fresco in the tenth vault of the Vatican Loggia, which represents Joshua and the High Priest Eleazar supervising the drawing of the lots by which the Promised Land was to be divided among the tribes of Israel (*Joshua*, xiv).

Passavant and Ruland attributed it to Raphael himself, the former with the comment "très beau dessin plein de vigueur"; and in his excursus on the Loggia frescoes Robinson, who did not know Nos. 44 and 46, singled it out as the only design for a complete composition "unquestionably" by Raphael himself. Crowe and Cavalcaselle, on the other hand, gave it to Giulio Romano, as also, by implication, did Fischel (1898, no. 232), when he attributed it to the Raphael follower responsible for the Louvre drawing of a Pope in the sedia gestatoria, now generally agreed to be by Giulio (see No. 41). Popham confined himself to the comment "the mannerisms of drawing come very close indeed to Raphael himself, and I suspect it is a copy of his original design for the subject. The drawing is much too sloppy to be actually by him," and went on to attribute it to the hand responsible for the pen and ink drawing in the British Museum connected with the *Baptism* in the thirteenth vault (Pouncey and Gere 67). Both drawings were attributed to Penni by Pouncey and Gere and, subsequently, by Konrad Oberhuber, who went further than Popham by suggesting that the Windsor drawing was worked up from a pen and ink sketch by Raphael. There are, admittedly, a few *pentimenti*, but close examination has not revealed (to the eye of the present compiler, at least) any sign of the intervention of another hand.

The attribution to Giulio was no doubt suggested by a certain linear emphasis particularly evident in the figure of the nude boy in the center foreground; but the resemblance to the sedia gestatoria sketch in the Louvre is a superficial one, limited to the similarity of technique. The attribution to Penni should also be reconsidered (see p. 15).

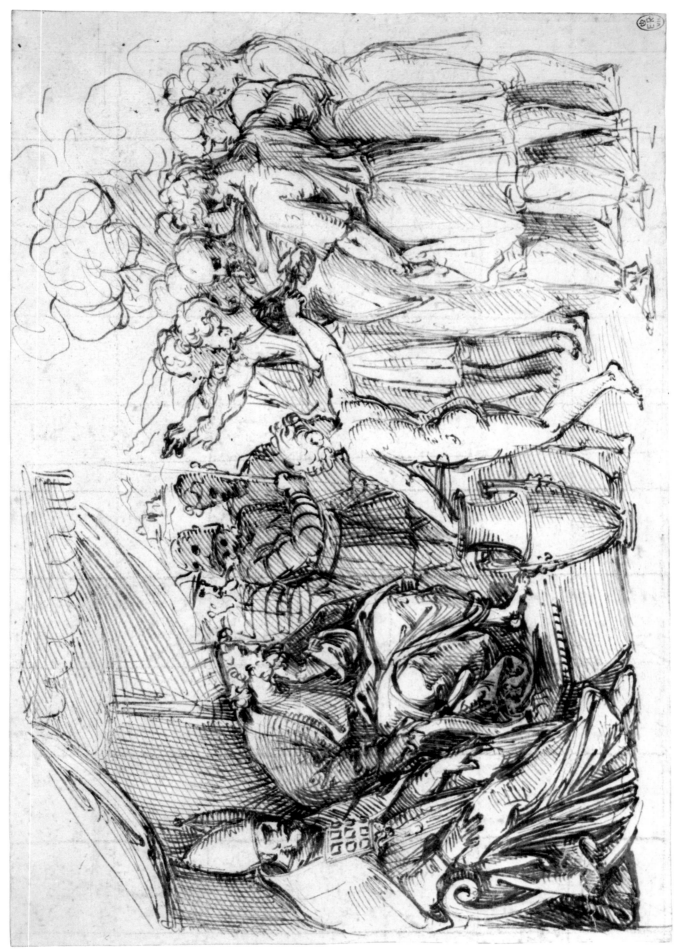

48 The Allocution of Constantine

Pen and brown wash, heightened with white. Squared in black chalk. 232: 415 mm.

PROVENANCE: Sir Peter Lely (Lugt 2092); J. van Bergestein; Nicolaes Flinck (acquired after Bergestein's death in 1704: see under Lugt 2092); acquired in 1723, with the rest of the Flinck collection, by William, 2nd Duke of Devonshire (Lugt 718).

LITERATURE: Ruland, p. 235, i, 4; Pouncey and Gere, p. 51; Oberhuber-Fischel 483; British Museum 1983, no. 197.

Chatsworth 175

A STUDY for the fresco in the Sala di Costantino in the Vatican, executed after Raphael's death by Giulio Romano and Giovanni Francesco Penni and their assistants (see No. 41). The finished painting differs considerably from the drawing: Constantine and his companion on the podium and the group of soldiers immediately to the right which occupies the center of the composition correspond with the drawing in all essentials; but the soldier pointing upwards in the extreme left foreground has been replaced by two page boys guarding the helmets of Constantine and his companion, and the group in the right foreground is relegated to the far distance and its place taken by the grotesque figure of a dwarf trying on a helmet. The miraculous apparition of the Cross in the sky, which in the fresco is the focus of attention, does not appear in the drawing: either the sheet has been trimmed or—perhaps more likely— the draughtsman was concerning himself only with the figural part of the composition.

This drawing was the sensation of the sale of Sir Peter Lely's collection in 1688. The account by his executor, Roger North, who was responsible for organizing the sale, is well known but will bear repeating (*The Autobiography of the Hon. Roger North*, ed. Augustus Jessopp, 1887, p. 200): "I shall give only one instance to show the prodigious value set upon some of these papers. There was half a sheet that Raphael had drawn upon with umber and white, that we call washed and heightened, a tumult of a Roman soldiery, and Caesar upon a *suggestum* with officers appeasing them. This was rallied at first, and some said 6d, knowing what it would come to; but then £10, £30, £50, and my quarrelsome lord [unidentified] bid £70, and Sonnius £100 for it, and had it. The lord held up his eyes and hands to heaven, and prayed to God he might never eat bread cheaper. There is no play, spectacle, shew or entertainment that ever I saw where people's souls were so engaged in expectation and surprise as at the sale of that drawing. Some painters said they would go a hundred miles to see such another. Whereby one may perceive how much opinion is predominant in the estimate of things. If all the good and evil in the world that depend on mere fancy and opinion were retrenched, little business would be left for mankind to be diverted with; but Providence hath so ordered it that as children they shall not want baubles to pass their time innocently with."

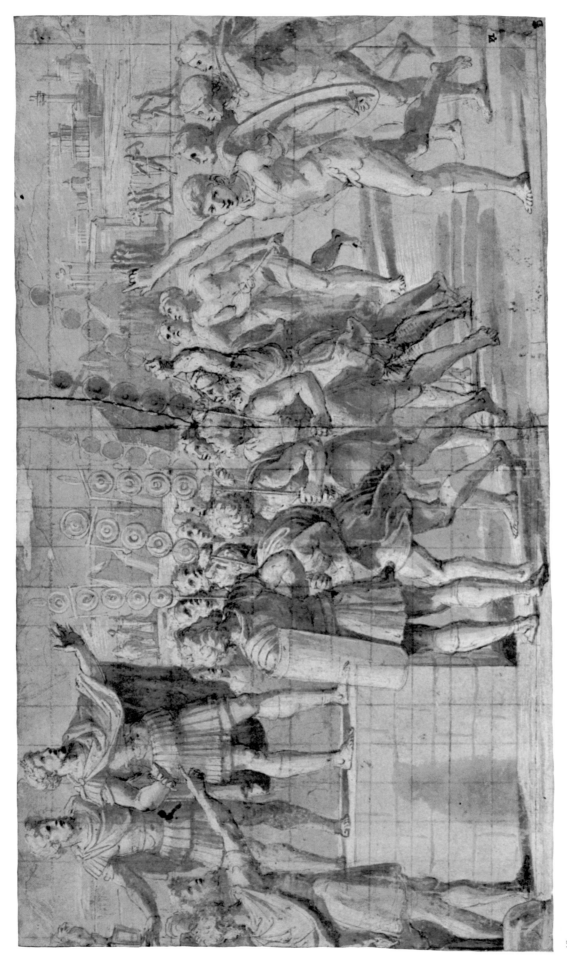

Later generations did not agree with this early estimate of the drawing. Ruland was the last critic to accept the attribution to Raphael, which by the end of the century had been unanimously rejected: Morelli, for example, gave the drawing to Perino del Vaga, while Fischel (1898, no. 206) dismissed it as a copy. It was not discussed by Hartt (1957). The attribution to Penni, first put forward by Pouncey and Gere, was followed by Konrad Oberhuber and in the catalogue of the British Museum exhibition of 1983. Oberhuber's analysis of the differences between the drawing and the eventual painting led him to the conclusion that the draughtsman was faithfully repeating a design by Raphael. In the coherence and lucidity of the grouping and the clarity of the spatial organization he saw a parallel to the *Battle of Ostia* in the Stanza dell'Incendio—a composition of a somewhat similar subject, not much earlier in date, and which also reflects knowledge of the reliefs on Trajan's Column. Recent reconsideration of the "Penni" group in the light of the possibility, which Oberhuber was the first to put forward, that the Louvre *modello* for the *Battle of Constantine* is not by Penni but by Raphael, suggests the same conclusion in the case of the *modello* for the *Allocution* (see p. xx).

The qualities singled out by Oberhuber in the *modello* as characteristic of Raphael's thinking have evaporated in the painting, where his design was transformed by Giulio in accordance with his fundamental anti-classical bias. Giulio was prepared to take considerable liberties with Raphael's *Allocution* but not with his design for the *Battle*, having no doubt realized that that composition was so tightly woven and so complex that no modification or addition would be possible.

GIOVANNI FRANCESCO PENNI

FLORENCE 1496–c. 1536

49 The Miraculous Draught of Fishes: The Calling of Peter

Pen and brown wash over black chalk; heightened with white. 203: 340 mm.

PROVENANCE: King Charles I (in King George III's Inventory A said to have been "found in an Old Bureau at Kensington which contained part of the collection of King Charles the first where also was preserved the volume of Leonardo da Vinci").

LITERATURE: Passavant 423 (1839, no. 289); Ruland, p. 243, no. 8; Crowe and Cavalcaselle, ii, p. 275; Popham, *Windsor*, no. 808; Pouncey and Gere, p. 56; Oberhuber-Fischel 440; Shearman 1972, pp. 94 f.; British Museum 1983, no. 187.

Windsor, Royal Library 12749

INSCRIBED in ink on verso, in a contemporary hand: *siculo*. The drawing corresponds very closely with the principal group in the tapestry cartoon (see No. 26). In the cartoon there are fish in the boats and three standing cranes in the right foreground, the group in the right-hand boat has been made more compact by moving the reclining oarsman closer to the other figures, and the oar lying between the feet of St. Andrew standing in the other boat is omitted. In these differences the drawing corresponds with the chiaroscuro woodcut by Ugo da Carpi (Bartsch xii, 13), for which, as Ruland suggested, it may have been used.

The oar lying on the left-hand boat is a survival from an earlier solution preserved in two drawings on the recto and verso of a sheet in the Albertina (Fig. 49a–b), in which St. Andrew is using it to propel the boat. In the recto drawing the boats are in the background and the foreground is occupied by a group of figures belonging to the crowd which had gathered by the lake to hear Christ preaching. As Konrad Oberhuber observed, the action of St. Andrew is appropriate when, as there, the boat is out in deep water; but once close inshore, as the boat is in the Windsor drawing and in the cartoon, it is no less appropriate for him to drop his oar and turn towards Christ with his hands spread in a gesture of amazement. The sketch on the verso of the Albertina sheet resembles the final result in showing the boats occupying the whole composition, but in it the action of St. Andrew is unaltered. It must therefore represent a transitional phase of the design; and that a creative imagination is at work is further shown by the presence of *pentimenti*, especially for the head. There are also *pentimenti* in the Windsor

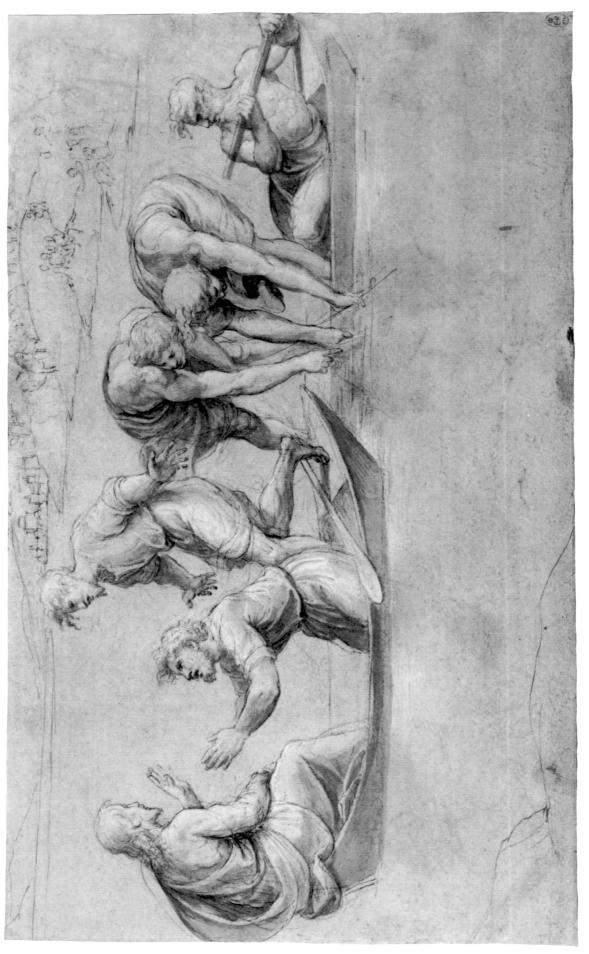

49

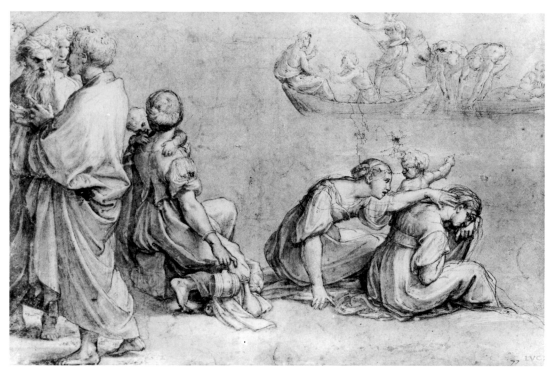

Fig. 49a Giulio Romano. *The Miraculous Draught of the Fishes*. Albertina, Vienna.

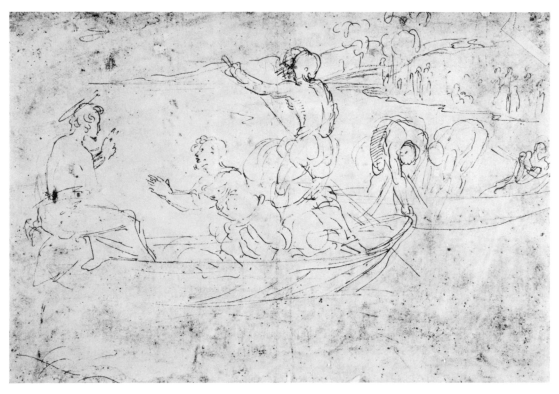

Fig. 49b Giulio Romano. *The Miraculous Draught of the Fishes* (verso). Albertina, Vienna.

drawing for his draperies and those of Christ. John Shearman pointed out that their correspondence with the same details in the group on the recto of the Albertina sheet establishes that this was the point of departure for the Windsor study.

In his first edition Passavant described the Windsor drawing as so extensively gone over by a clumsy hand that no conclusion about its authorship was possible. In his second he made no reference to the supposed retouching, and accepted the traditional attribution to Raphael. In this he was followed by Ruland. Crowe and Cavalcaselle were the first to express doubt. They suggested that the drawing might be by Penni, a view to which Popham, implicitly, subscribed with his observation that it is certainly by the same hand as the British Museum *Dormition and Coronation of the Virgin* (No. 50), which he was then inclined to give not to Penni but to Perino del Vaga. No. 49 is one of the group of neatly delicate but weak fair copies of designs by Raphael which all the evidence suggests are by Penni, the attribution to whom was followed by Pouncey and Gere, Shearman and Oberhuber. The significance of the verso inscription is obscure, but if it does refer to the very minor Umbrian painter Jacopo Siculo (cf. Shearman 1961, p. 157), it cannot be taken seriously as an attribution.

Both sides of the Albertina sheet were attributed to Giulio Romano by Oberhuber and by Shearman, and to Penni by Sydney Freedberg (p. 294). Erwin Mitsch (Albertina 1983) gave the recto to Giulio and the verso to Raphael himself. Paul Joannides (*The Drawings of Raphael*, 1983, no. 356) came independently to the same conclusion about the verso, but gave the recto to Penni. In a review of the Albertina exhibition (*Giornale dell'arte*, no. 6, Nov. 1983, p. 9) Oberhuber concurred with the view that the verso is by Raphael. The drawing on the recto seems, on the face of it, to be a first idea for the cartoon; but, as Shearman observed, it is surprising, in view of the historical significance of the subject for the Papacy, to find the Calling of Peter relegated to the background and subordinated to "the coincidental and trivial activities of the crowd from whom Christ has departed." It might also be added that this proto-mannerist treatment of the subject is in contrast to the narrative simplicity and directness of the eventual cartoon, and indeed of the whole series. Shearman went on to point out that figures in the foreground group have been lightly sketched in black chalk but not completed, whereas the group of figures in the boats has almost attained its final form. He suggested, as one possible explanation, that the composition might be a variant of the cartoon design produced for some other purpose by Raphael with Giulio's assistance. They could, for the sake of argument, have had an engraving in mind. The composition was engraved twice later in the century: once by Battista Franco (Bartsch xvi, p. 124, 14) and in an anonymous engraving of poor quality which has in the past been attributed to Antonio Fantuzzi (not in Bartsch; F. Herbet, *Les graveurs de l'école de Fontainebleau*, p. 85, no. 81).

50 The Dormition and Coronation of the Virgin

Pen and brown wash, heightened with white. Traces of underdrawing in black chalk. 379: 260 mm.

PROVENANCE: "from the Borghese Palace, Rome" (according to *Lawrence Gallery* catalogue); Sir Thomas Lawrence (Lugt 2445); King William II of Holland (sale, The Hague, 1850, 12 August, lot 73); Samuel Woodburn (sale, London, Christie's, 1860, 13 June, lot 1347).

LITERATURE: *Lawrence Gallery* 40; Passavant, p. 539, *ll*; Ruland, p. 106, iii, 4; Fischel 1898, no. 352 and under *Corpus* 384; Pouncey and Gere 68; British Museum 1983, no. 185.

British Museum 1860–6–16–84

THE "Dormition of the Virgin," the title given to a representation of her deathbed, is a reference to the belief that she did not die in the physical sense, but that her body was miraculously translated to Heaven in the Assumption.

In December 1505 Raphael contracted with the nuns of the convent of Monteluce, near Perugia, to paint for them an altarpiece that was to resemble in size, color, degree of finish and number of figures ("perfectione, proportione, qualità et conditione . . . et omne de colore et figure numero") and, implicitly, in subject, the *Coronation of the Virgin* by Domenico Ghirlandaio then in the church of S. Girolamo at Narni. Ghirlandaio's *Coronation* followed a standard Umbrian pattern much favored by the Observant branch of the Franciscan Order, to which the Monteluce convent belonged: it is an arched panel, with the Coronation taking place in the upper part and a group of about twenty kneeling saints below. In 1516 a fresh agreement with the nuns was negotiated, but the painting had still not been begun when Raphael died four years later. In 1523 a renewed approach was made to his heirs, Giulio Romano and Giovanni Francesco Penni, and it was they who jointly executed the altarpiece which in June 1525 the nuns finally received. The Monteluce *Coronation*, now in the Vatican Gallery, is in the most literal sense of the term a joint work, for it is made up of two separate panels by two different hands: the upper part, of the Coronation of the Virgin, is clearly by Giulio; the lower, no less clearly by Penni, represents the Apostles gathered round the Virgin's empty sarcophagus, as in the earlier Vatican *Coronation*. The same motif is also found in the lower part of an *Assumption of the Virgin*.

John Shearman (1961, pp. 149 ff.), having convincingly demonstrated that the altarpiece which Raphael may be presumed to have intended for the Chigi Chapel in S. Maria del Popolo could only have been an *Assumption*, put forward the ingenious hypothesis that this altarpiece was in fact carried out by Penni after Raphael's death, on Raphael's design, but was rejected by the heirs of Agostino Chigi; and that after Giulio's departure from Rome in the autumn of 1524, his partner confected an altarpiece for

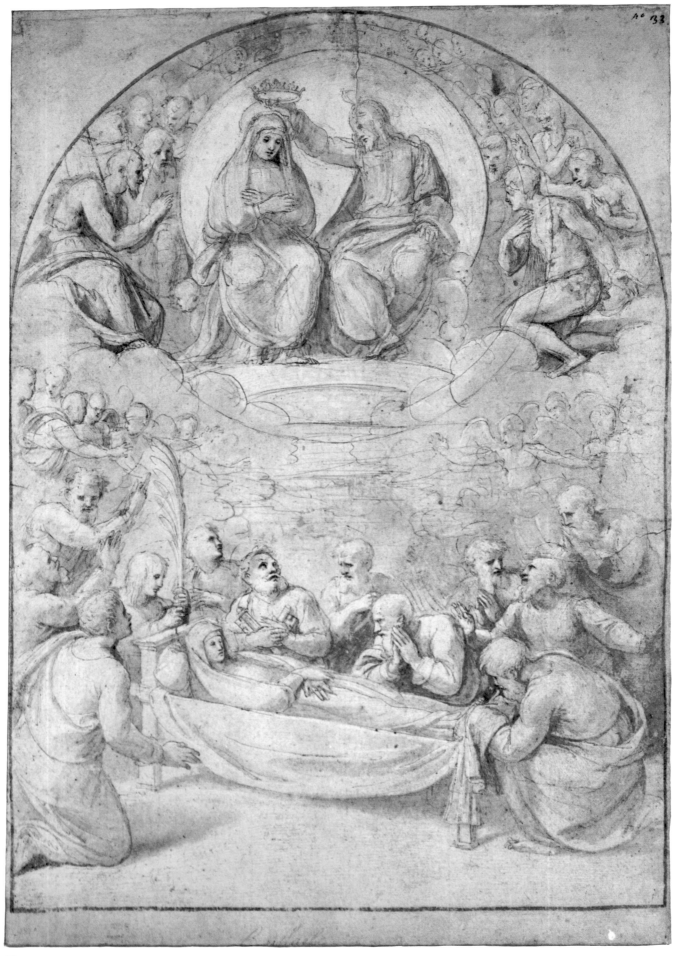

50

Monteluce by attaching the upper part of the *Coronation of the Virgin* which, on Shearman's hypothesis, Giulio had begun for Monteluce but had had to leave unfinished, with the lower part of the hypothetical *Assumption* originally intended for the Chigi Chapel.

The drawing of the *Dormition and Coronation of the Virgin* was accepted as by Raphael himself when in the Lawrence Collection. Passavant was the first to suggest that it might be connected with the Monteluce commission. In the first edition of his monograph (1839, no. 363) it is listed as a study by Raphael himself for the painting. In his second edition, however, he described it as a product of the studio, and dismissed the possibility of a connection with the painting on the *a priori* grounds that only the master would have made preparatory studies for it. Ruland listed it as by Raphael himself, under the heading "supposed to be for Monteluce." Fischel (1898) repeated the suggestion, but attributed the drawing itself to Penni.

No. 50 is certainly not from the hand of Raphael himself: the execution unmistakably reveals the neat but colorless personality of the draughtsman who has been identified as Penni. But the conception and grouping of the figures are far beyond his unaided capabilities, and there seems every reason for supposing that this drawing, like so many others of the Penni group, is a fair copy of a *concetto* by Raphael. In some features, notably the circular Glory enclosing the figures of Christ and the Virgin, and the gap in the figures below revealing the distant landscape, the composition resembles the *Madonna di Foligno* of about 1511–12 (see No. 18), and it seems reasonable to date it at about the same time.

The *Coronation of the Virgin* for Monteluce is the only recorded commission with which this design might conceivably be connected; and since Raphael seems rarely, if ever, to have made designs without some definite purpose in mind, the suggestion cannot be lightly dismissed. In shape and proportion of height to width the composition exactly corresponds with the altarpiece by Ghirlandaio which Raphael had been required to take as his model, and very closely with the altarpiece eventually produced for Monteluce. It is true that iconographically the drawing differs from the Ghirlandaio altarpiece, in which the lower part of the composition is occupied by a crowd of kneeling saints; but, as Umberto Gnoli pointed out (*Bollettino d'arte*, xi [1917], p. 138, n. 5), that type of *Coronation* seems to have been developed from another, of which there are also a number of examples in Umbria, in which the lower part of the panel is occupied by the Dormition of the Virgin. By about 1511 or 1512—the probable date of the drawing—the Ghirlandaio pattern must have come to seem impossibly old-fashioned. Raphael might well have suggested an alternative treatment of the subject equally acceptable to Umbrian tradition and thus to the conservative taste of his patrons.

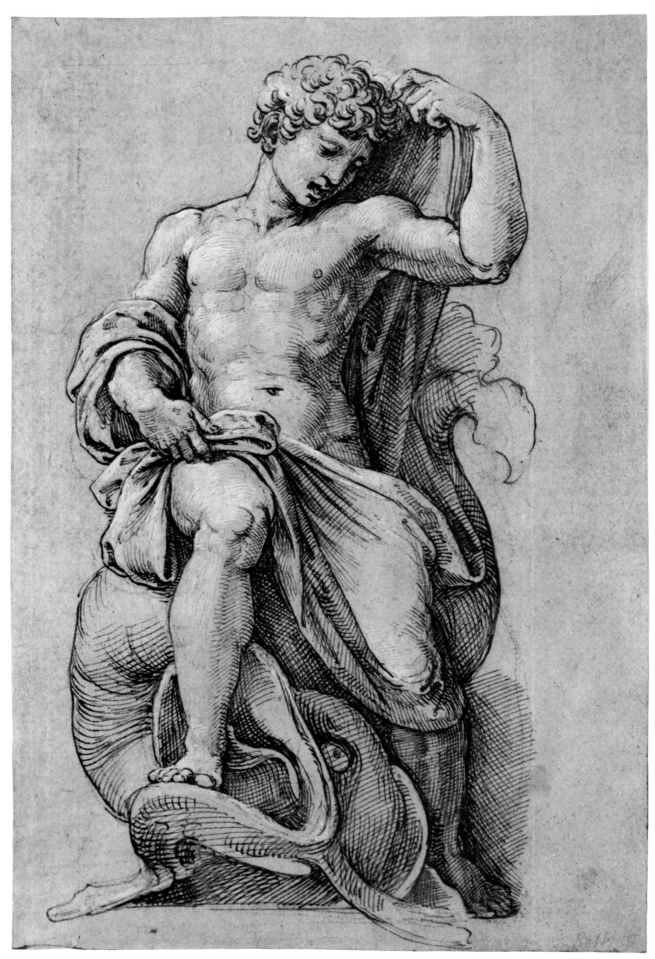

51

51 Jonah RECTO.
Sketches of a Standing Woman, a Head, Hands, etc. VERSO.

Pen and brown ink, heightened with white, over black chalk (recto); black chalk, touched with pen and ink (verso). 305: 200 mm.

PROVENANCE: King George III.

LITERATURE: Passavant, ii, p. 494, s; Ruland, p. 308, ii, 6; Crowe and Cavalcaselle, ii, p. 342; Popham, *Windsor*, no. 811; Oberhuber-Fischel, pp. 43 ff.; Knab-Mitsch-Oberhuber 544.

Windsor, Royal Library 0804

THE drawing is connected with the marble statue of *Jonah* by the Florentine sculptor Lorenzo di Lodovico Lotti, usually called Lorenzetto (1490–1541), in the Chigi Chapel in the church of S. Maria del Popolo in Rome. Raphael was the architect of the chapel and devised a scheme for its decoration which in the event was not completely carried out. This scheme included four statues of Prophets in niches. Those of *Daniel* and *Habbakuk* are by Bernini, added when the chapel was completed in the middle of the seventeenth century; but *Jonah* and *Elijah* are by Lorenzetto, who according to Vasari was "aiutato dal giudizio di Raffaello." It is generally agreed that *Jonah*, at least, follows a design by Raphael, which presumably attained its final form not later than 1519, since an identical figure is represented in one of the stucco roundels in the Vatican Loggia, the decoration of which was begun early in 1518 and completed by May 1519.

Ruland listed No. 51 as a study by Raphael for the statue. Passavant and Crowe and Cavalcaselle, on the other hand, thought it a copy of the statue. This is the one thing it cannot be, for, as Popham was the first to observe, there are differences in the angle of the head and body and in the drapery: in the statue the left leg is bare and above the drapery, the right thigh is almost wholly covered, and there is no fold of drapery round the right forearm. There is also a *pentimento* in the drawing for the position of the left arm, and what may be another near the lower part of the left leg.

Popham attributed to the same hand the Windsor *Tarquin and Lucretia* (No. 53) and also "probably" the *Division of the Promised Land* in the same collection (No. 47). Konrad Oberhuber at first accepted this implied attribution to Penni, and argued, from the character of the underdrawing, the *pentimenti*, etc., that this must be either a preliminary study for the statue or a copy of one. He suggested three possible explanations—that the drawing is an exact old facsimile of a lost drawing by Raphael in which the copyist has even included the *pentimenti*; or that it is by an assistant using rough sketches by Raphael; or that Raphael himself contributed the black chalk underdrawing which was then worked up and elaborated by an assistant—but after discussing the arguments for

51 verso

and against each solution he concluded that "perhaps the truth, as so often, lies somewhere between the three possibilities." Later (*Raffaello a Roma*, p. 202) he resolved the problem by attributing the drawing to Raphael himself, accounting for the unfamiliar technique by its being a design for sculpture.

Popham's comment, that No. 51 "does not look like a sculptor's drawing," raises the question of whether there is such a thing as a recognizable "sculptor's drawing." It would be rash to express any kind of generalization, especially when the supposed draughtsman was not a sculptor; but it may be legitimate to wonder whether the busy and overburdened Raphael would necessarily have designed a piece of sculpture in this laborious—not to say labored—technique, and also to wonder how far it would have been possible for Lorenzetto to interpret such a design in three-dimensional terms. One might have expected Raphael, accustomed as he was to collaborating with assistants capable of interpreting his intentions, to have jotted down the essentials of the pose and then gone on to elaborate it in the form of a clay or wax model. His sketches for a figure of *Cupid Bending his Bow* on a sheet in the Ashmolean Museum (P II 536; Fischel 205) include two of the same pose seen from front and back, which might suggest that he had a three-dimensional figure in mind; and in 1516 he is recorded as having made a clay model of a child which was being executed in marble by a professional sculptor (see Crowe and Cavalcaselle, ii, p. 342).

To the present writer, at least, Popham's attribution of No. 51 to the hand responsible for the *Tarquin and Lucretia* seems more convincing than the attribution to Raphael. An estimate of quality is ultimately a matter of opinion, and he can only express his own view that everything about this drawing—its labored technique, its generally "overall" appearance and lack of accent, the area of cast shadow by the left leg—reinforce the impression that it is a copy of something. The differences between drawing and statue are too subtle and too intelligent to be modifications introduced by the copyist, who must presumably have had in front of him, in some form or other, an alternative design by Raphael. The purpose of such a drawing is a matter of speculation. Oberhuber claimed that there are traces of squaring in black chalk and in stylus. The presence of squaring would suggest that the figure was to have been repeated on a plane surface rather than in three-dimensional form, but careful scrutiny has not revealed it: vertical framing lines enclose the figure on either side, but no ruled lines are visible at right angles to them.

The black chalk sketches on the verso are too slight and fragmentary for any definite conclusion about their authorship to be drawn. Oberhuber attributed them to Raphael on the strength of the resemblance that he saw between them and studies for the Psyche Loggia of the Farnesina (see No. 34). Popham had observed that the pose of the full-length woman resembles, in reverse, that of Psyche in one of the series of engravings of the legend of Psyche by the Master of the Die (Bartsch xv, p. 213, 40). In another

of the same series (Bartsch 41) Psyche appears in a very similar pose. Some of this series are based on the frescoes in the Psyche Loggia, but there is no reason to suppose that Raphael himself was in any way responsible for the design of the others. The most that can be said is that they are Raphaelesque, by an artist imbued with Raphael's manner. The suggestion that the standing figure might be a study for the adulteress in Lorenzetto's bronze frieze of *The Woman Taken in Adultery*, also in the Chigi Chapel (J. Pope-Hennessy, *High Renaissance and Baroque Sculpture*, 1963, fig. 79) was plainly inspired by the purpose (or derivation) of the drawing on the other side of the sheet: beyond the fact that both figures are standing in profile, they differ in every possible respect.

52 The Toilet of Venus

Pen and brown ink. 233: 208 mm.

PROVENANCE: Henry Reveley (sale, London, Christie's, 1852, 11 May, lot 99); Sir Charles Robinson (inscribed by him on verso: *J. C. Robinson 1859*); John Malcolm of Poltalloch.

LITERATURE: Ruland, p. 127, iii; Robinson, *Malcolm*, no. 191; *Guide* [by Sidney Colvin] *to an Exhibition of Drawings and Engravings by the Old Masters, principally from the Malcolm Collection*, London, British Museum, 1895, no. 108; Pouncey and Gere 69; British Museum 1983, no. 201.

British Museum 1895–9–15–630

INSCRIBED on verso, in black chalk: . . . *aeli fecit*. The traditional attribution to Raphael was accepted by Ruland, Robinson and Colvin. As long ago as 1897, however, it was rejected by Charles Loeser on grounds of quality (*Archivio storico d'arte*, 2nd series, iii [1897], p. 348). His alternative attribution to G. F. Penni, though apparently arrived at largely by process of elimination, was followed by Pouncey and Gere. In the light of the current enlarged conception of Raphael's late drawing style, all attributions of drawings to the Raphael studio, and especially to Penni, have to be reconsidered very critically and as far as possible without being affected by preconceived ideas. But in this drawing, though the handling of the pen is admittedly Raphaelesque, the underlying personality still seems trivial and unintelligent. Raphael could never have produced a composition so incoherent and without feeling for the relationship of figures in space, and so lacking in "fundamental brainwork" as to include the *amorino* balanced, in defiance of the law of gravity, on one edge of a tall basket. The taste revealed in the clumsy turned legs of the couch and the grotesquely tall and ungainly vase can be exactly matched in the three drawings of subjects from ancient history in the Albertina. These show Penni in a phase when the influence of Raphael had entirely worn off and the possibility of his authorship would never even momentarily be considered. No. 52, though superficially still Raphaelesque in appearance and evidently earlier, must likewise be an independent composition. The Raphaelesque handling is parallelled in the drawing for the *Baptism* in the Vatican Loggia, also in the British Museum (Pouncey and Gere 67; Oberhuber-Fischel 470).

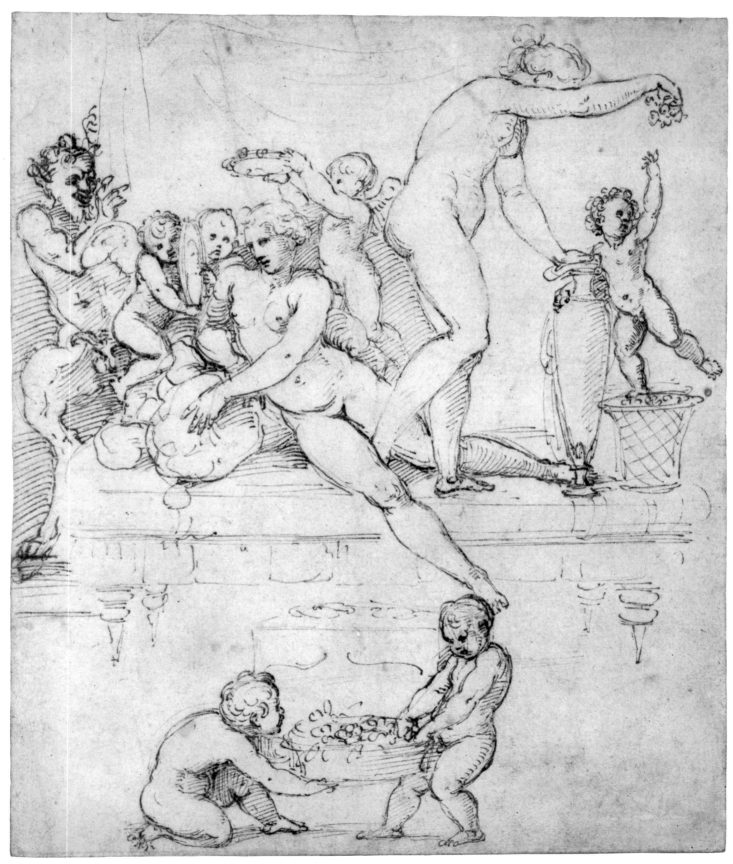

53 Tarquin and Lucretia

Pen and brown ink, heightened with white, over black chalk. 251: 168 mm.

PROVENANCE: King George III.

LITERATURE: Passavant, p. 494, *t.*; Ruland, p. 163, i, 3; Popham, *Windsor*, no. 812; Oberhuber-Fischel, p. 41; British Museum 1983, no. 202.

Windsor, Royal Library 0506

INSCRIBED on verso in ink: *Polidoro*. The drawing corresponds very closely and in the same direction with the left-hand half of an engraving by Agostino Veneziano (Bartsch 208), inscribed *Raphael Urb. Inv.* and dated 1524. (According to Bartsch, there is an earlier state dated 1523; he also lists a later reworking by Enea Vico, his xv, p. 287, 15.) The correspondence is close but by no means exact. There are enough differences, notably in the arrangement of the canopy and in such details as the shape of the legs of the couch and the absence in the engraving of the pair of sandals on the stool, to establish that the drawing cannot be a copy of the engraving but that it must have served as basis for it. The right-hand half of the engraved composition shows the room in detail, empty but for a man running forward at the back and a pair of copulating dogs in the foreground. In the drawing the composition seems to be complete in itself; its effect is much diminished by this addition, which was presumably an afterthought, perhaps by the engraver.

The inscription attributing the design to Raphael cannot be taken literally, but it does suggest that the design emanated from his immediate circle. In his first edition (1839, no. 301) Passavant listed the drawing as by Raphael himself, but in his second he attributed it to Giulio Romano "in the period when he was still trying to imitate his master." Ruland included it as "ascribed to Polidoro?" Popham catalogued it as "School of Raphael," by the same hand as the drawing of *Jonah* (No. 51) and one of the *Birth of the Virgin* at Stockholm (Sirén 1917, no. 353, repr.; another, apparently better version in the Bibliothèque Royale in Brussels, repr. by J. C. J. Bierens de Haan, *L'Oeuvre gravé de Cornelis Cort*, The Hague, 1948, pl. 6), and probably also the study for *The Distribution of the Promised Land* (No. 47). Konrad Oberhuber attributed all these drawings to Penni, an opinion later revised in the case of the *Jonah*. But whether or not the *Jonah* is by Raphael himself, as Oberhuber now contends, that attribution is out of the question for the *Tarquin and Lucretia* drawing, which unmistakably reveals the personality of the draughtsman of the Penni group.

Some drawings of this group (e.g. Nos. 52 and 55, and another, of the *Feast of the Gods*, in the École des Beaux-Arts in Paris, repr. Oberhuber-Fischel, fig. 44) have every appearance of being the draughtsman's unaided efforts. In the *Tarquin* drawing the

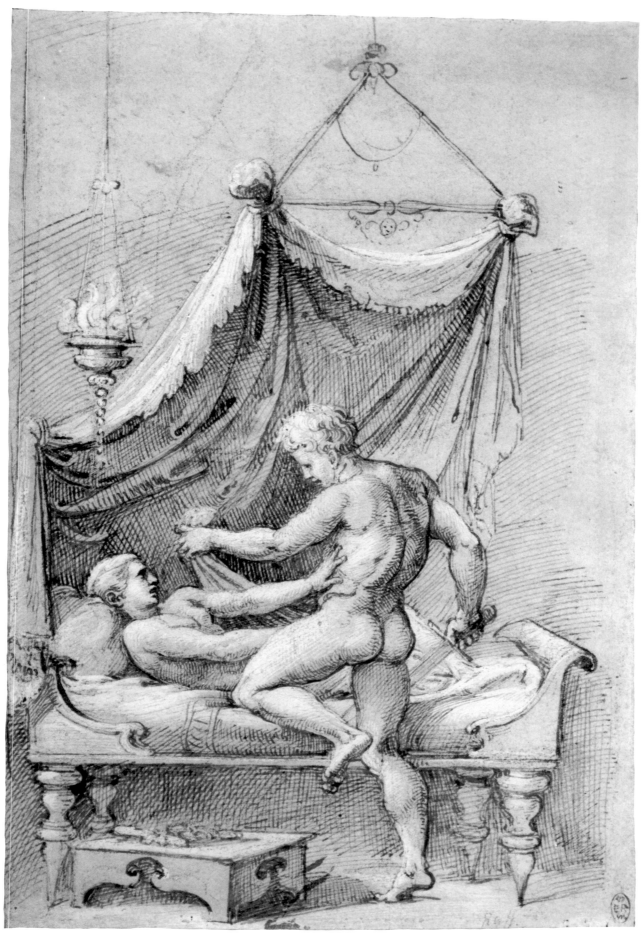

53

quality of the composition is altogether superior. The erotic flavor (suggestive of the more explicit "Aretine postures"), the rubbery musculature of Tarquin and the facial type of Lucretia, combine to suggest the possibility that it may have been based on a design by Giulio. After Raphael's death in 1520 Giulio and Penni jointly inherited the business of his studio and were in partnership until Giulio's departure for Mantua in the autumn of 1524. There is nothing inherently improbable in the suggestion that he may, on occasion, have performed the same "secretarial" function for Giulio as he had done for Raphael.

54 Design for a Tomb

Pen and brown wash. 549: 420 mm.

PROVENANCE: Dukes of Devonshire.

LITERATURE: Ruland, p. 301, d, iii; E. Lechevallier-Chevignard, *Gazette des Beaux-Arts*, 2nd series, xv (1877), pp. 482 f.; Oberhuber-Fischel, pp. 40 ff.; K. Oberhuber and H. Burns, in *Raffaello architetto*, pp. 429 ff. and no. 3.4.5.

Chatsworth 125

INSCRIBED in pen, lower right, in an early hand: *Di Rafael d'Urbino*. As "School of Raphael" at Chatsworth, and placed by Ruland in his apocryphal section of "ascribed" drawings. Fischel (1898, no. 644) denied that it had any connection with him. Popham was the first to associate it with the "Penni" group, which he then (c. 1945) believed were very early drawings by Perino del Vaga. Philip Pouncey's attribution to Penni was followed by Konrad Oberhuber.

Lechevallier-Chevignard published No. 54 in conjunction with a design in the Louvre (1420, as Peruzzi) for a monument surmounted by an equestrian statue, and suggested that both were projects by Raphael for the tomb of Francesco Gonzaga, Marquis of Mantua (d. 29 March 1519) for which he is recorded as having supplied a drawing in June 1519. Konrad Oberhuber and Howard Burns agree that the Louvre drawing is by Raphael, and that it very probably is a design for the Gonzaga monument; but they reject Raphael's authorship of the other design, which they see as a pedantic and antiquarianizing combination of Raphaelesque motifs with others taken from the Antique, assembled according to the conventional pattern of the Florentine quattrocento tomb—a pattern which had already become old-fashioned by c. 1520, the apparent date of the Chatsworth drawing. Arnold Nesselrath has pointed out that the pair of figures reclining on the sarcophagus is derived from an Antique sarcophagus now in the Museo Torlonia but in the early sixteenth century in the Palazzo Savelli, details of which are copied on two pages of the Raphaelesque *Fossombrone Sketchbook*.

That the design of the Chatsworth tomb is not by Raphael is established by a sheet in the Louvre (622, as Perino del Vaga), on which are two rapid drawings of the same composition which have every indication of being preparatory sketches (Fig. 54a). On the verso are three rough sketches of Antique sarcophagi. The drawings on this sheet are certainly not by Raphael; nor are they by Perino del Vaga, to whom they were traditionally attributed; nor do they seem to be by Penni, who was certainly responsible for the fair copy *modello* at Chatsworth. The mount of the Louvre drawing is annotated by Philip Pouncey "tout près de Peruzzi." He now rejects the possibility of its being from Peruzzi's own hand, but maintains that there is a flavor of old-fashioned and rather provincial archaeological pedantry about the design that makes it more reasonable to associate it with him than with any of the other artists in Raphael's circle.

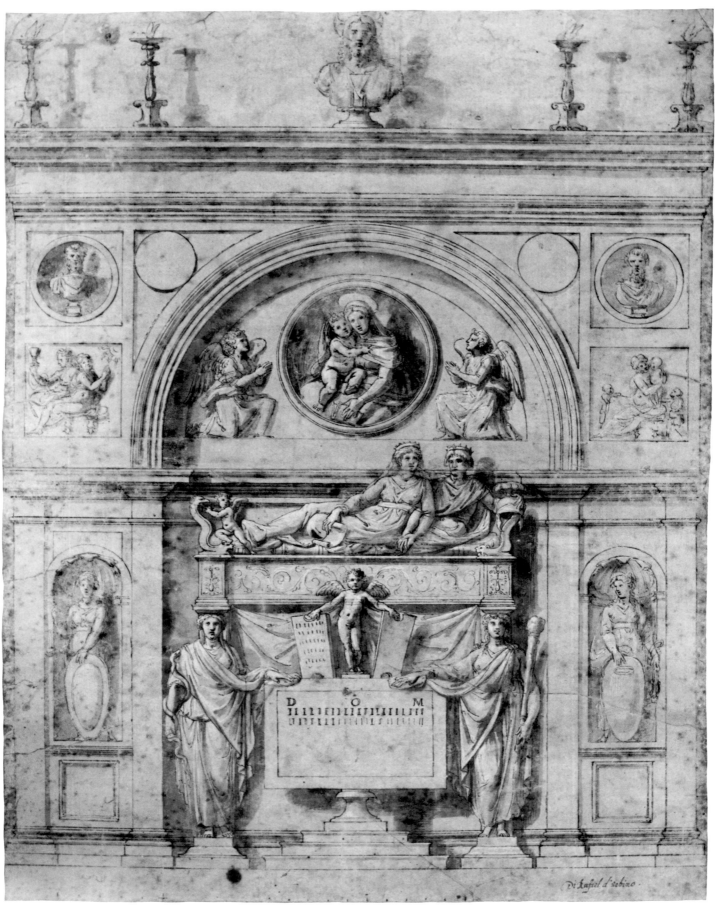

Di Rafael d'ibino.

54

There seems to be no compelling evidence either for or against Lechevallier-Chevignard's suggestion that this might have been an alternative solution for the Gonzaga monument "surtout consacré aux vertus conjugales et aux sentiments pieux," and incorporating an effigy of Francesco Gonzaga's widow Isabella d'Este.

Fig. 54a Italian. Early 16th Century. *Design for a Tomb*. Cabinet des Dessins, Musée du Louvre, Paris.

55 A Composition of Nude Figures, with a Prisoner Brought before an Enthroned Emperor or King

Pen and brown ink, heightened with white, on a greenish-washed ground. 395: 287 mm.

PROVENANCE: unidentified mark, probably of a late seventeenth- or early eighteenth-century English collector (Lugt 2908); Nicola Francesco Haym (Lugt 1972); William, 2nd Duke of Devonshire (Lugt 718).

LITERATURE: Oberhuber-Fischel, p. 42.

Chatsworth 392

THE traditional attribution was to the Bolognese painter and draughtsman Bartolomeo Passarotti (1529–1592), whose numerous drawings are executed in pen and ink in a superficially rather similar technique of coarse hatching and cross-hatching. The attribution to Penni, first suggested by Philip Pouncey in a note in the Chatsworth catalogue, was followed by Konrad Oberhuber. Like No. 52, this is clearly an independent effort at composition, and likely therefore to date from the period after Raphael's death. It is perhaps worth recalling (see No. 41) that in September 1520 "Prisoners before the Emperor Constantine" was apparently being considered as the subject of one of the four historical scenes in the Sala di Costantino, the decoration of which had been begun by Raphael and was being continued by his heirs, Giulio Romano and Penni. As things turned out, the subject is not represented anywhere in the Sala di Costantino. If this drawing was made in that connection—and it must be emphasized that the basis for the suggestion is nothing more than the similarity of subject—its format shows that it would have been a study for one of the small grisailles in the *basamento*.

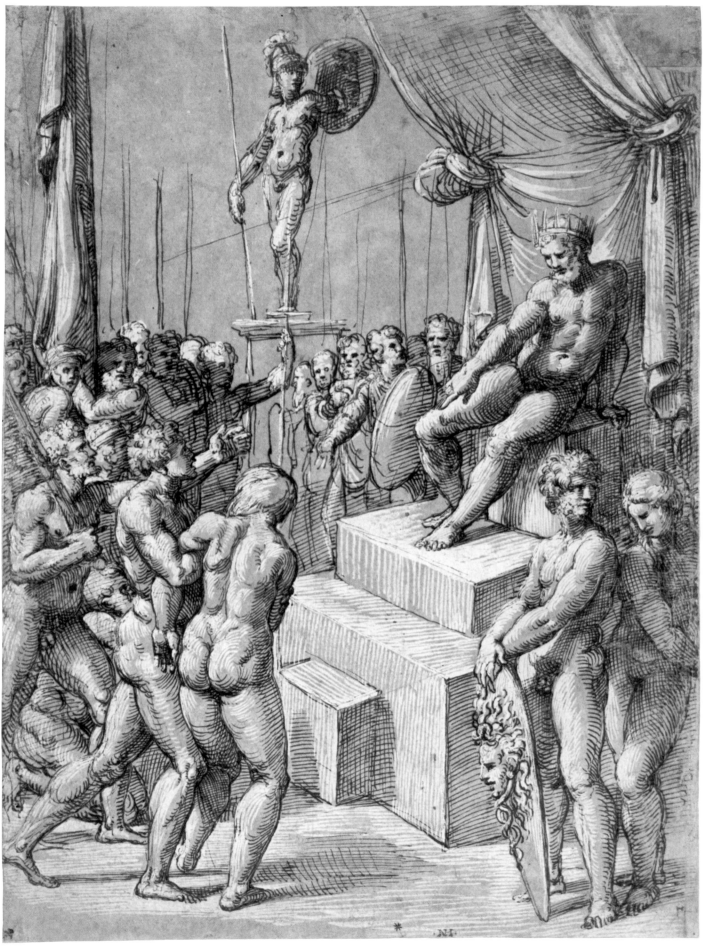

55

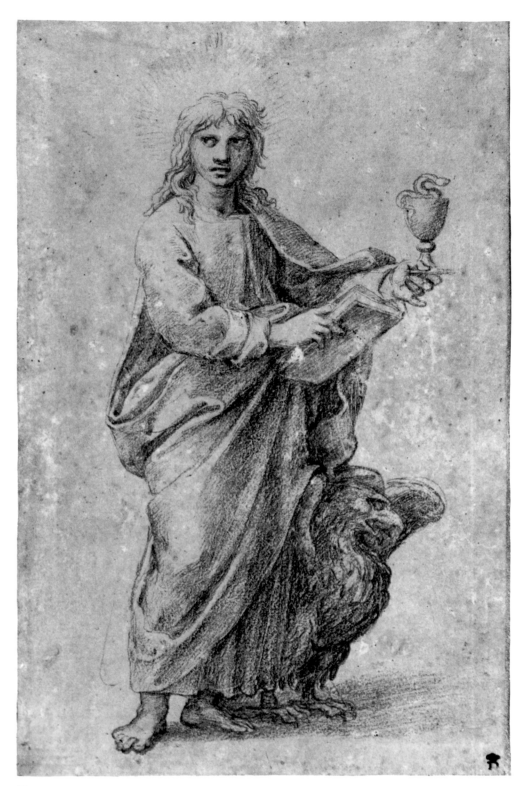

56

GIULIO PIPPI, CALLED GIULIO ROMANO

ROME c. 1499–1546 MANTUA

56 St. John the Evangelist

Red chalk over stylus. 206: 130 mm.

PROVENANCE: William, 2nd Duke of Devonshire (Lugt 718).

LITERATURE: Passavant, p. 165; Ruland, p. 233; Fischel 1898, nos. 459, 466 and 468; Popham, *Windsor*, under no. 810; Shearman 1964, p. 87; Oberhuber-Fischel, pp. 31 f.

Chatsworth 74

ONE of a series of drawings of the Twelve Apostles traditionally attributed to Raphael, all at Chatsworth, which correspond in reverse with a series of engravings by Marco Dente da Ravenna (Bartsch 65–76. The thirteenth engraving of the series, Bartsch 64, is of Christ). The references given above are to the series as a whole.

Passavant supposed that the Chatsworth Apostles were copies of the "Apostoli di chiaroscuro, grandi quanto il vivo" which Raphael, according to Vasari, painted in the Sala dei Palafrenieri in the Vatican (that is, the room leading out of the Sala di Costantino on the south side), which he mistakenly thought had been totally destroyed in the 1550s (see Pouncey and Gere, under no. 63). Ruland fell into the same error, and described the Chatsworth drawings as Raphael's studies for these paintings. Fischel, who does not mention the Sala dei Palafrenieri, thought that the drawings were made especially for the engraver. In a later note, in the Chatsworth catalogue, he argued that "the experimental lines, in which the draughtsman is clearly feeling his way towards the right solution" showed that they are not copies after the engravings and suggested that the draughtsman might have been Marcantonio, then believed to be the engraver (see Oberhuber-Fischel, p. 31, n. 86). In another note in the catalogue, Popham was inclined to accept this suggestion, but in his Windsor catalogue he referred to the Chatsworth drawings apropos of another red chalk drawing, of the group of *Venus and Cupid* in Cardinal Bibbiena's Bathroom (Oberhuber-Fischel 454), describing them as "copies from Raphael compositions . . . extremely delicate, almost dainty, in touch, very near to Raphael himself in style, but without his decisiveness." More recently, both John Shearman and Konrad Oberhuber have attributed them to Guilio Romano, and this does seem to be the right solution. Oberhuber dates them c. 1514–15 on the grounds of their resemblance to the "new idealized conception of the Apostles that Raphael had

evolved in the tapestry cartoons. They are clearly the work of a young artist, and show how Giulio began. The uncertain placing of the figures on the paper, and the impression that they give of being preconceived and not freely developed, suggest, as one would expect, that they derive from designs by Raphael. The exaggerated but at the same time meaningless expression of the heads, the shadowed eyes, the wild hair, the unsubstantiality of the bodies, and the sharpness and hardness of the folds of drapery, are all characteristic of Giulio."

57 The Holy Family with St. Anne

Pen and brown wash, heightened with white. Corners cut. Maximum measurements: 206: 288 mm.

PROVENANCE: Sir Peter Lely (Lugt 2092); William, 2nd Duke of Devonshire (Lugt 718).

LITERATURE: Ruland, p. 100, x, 1; Fischel 1898, no. 408; S. Arthur Strong, *Reproductions in Facsimile of Drawings by the Old Masters in the Collection of the Earl of Pembroke and Montgomery at Wilton House*, 1900, under no. 19; *Drawings by Old Masters*, exh. Royal Academy, London, 1953 (catalogue by K. T. Parker and J. Byam Shaw), no. 67; Giles Robertson, *Vincenzo Catena*, 1954, pp. 57 f.; A. E. Popham, *Drawings from Chatsworth*, exh. Washington, etc. 1962/63, no. 63.

Chatsworth 90

THE same group of figures, with St. Joseph about to teach the Infant Christ to walk with the help of a go-cart, is repeated in a painting in the Dresden Gallery by Raphael's Venetian contemporary Vincenzo Catena (Robertson, pl. 27) which has at various times been attributed to Perugino, Sassoferrato (after a design by Raphael) and Andrea del Sarto. The existence of this painting for a time misled critics into disregarding the traditional attribution of the drawing to Raphael; Ruland, for example, gave it to Sarto and Fischel dismissed it as a copy after Catena.

Strong was the first to reaffirm the Raphaelesque character of the composition, apropos of another drawing of it, formerly at Wilton House, which to judge from his facsimile reproduction is inferior in quality to the Chatsworth version and evidently a copy of it. He catalogued the Wilton version under the heading "Roman School," but with the comment that "the type of the heads and shape of the extremities are those of Giulio Romano." He later became librarian at Chatsworth, and was presumably responsible for reclassifying the version there as "attributed to Giulio Romano." Parker and Byam Shaw gave it without qualification to Giulio, but added that Popham believed it to be by Perino del Vaga. Popham later catalogued it as "School of Raphael" with the comment that it "must have been made in the immediate entourage of Raphael, if not by the master himself," mentioning Perino along with Giulio and Penni only as one of the alternative attributions that had been suggested. The attribution to Giulio is by far

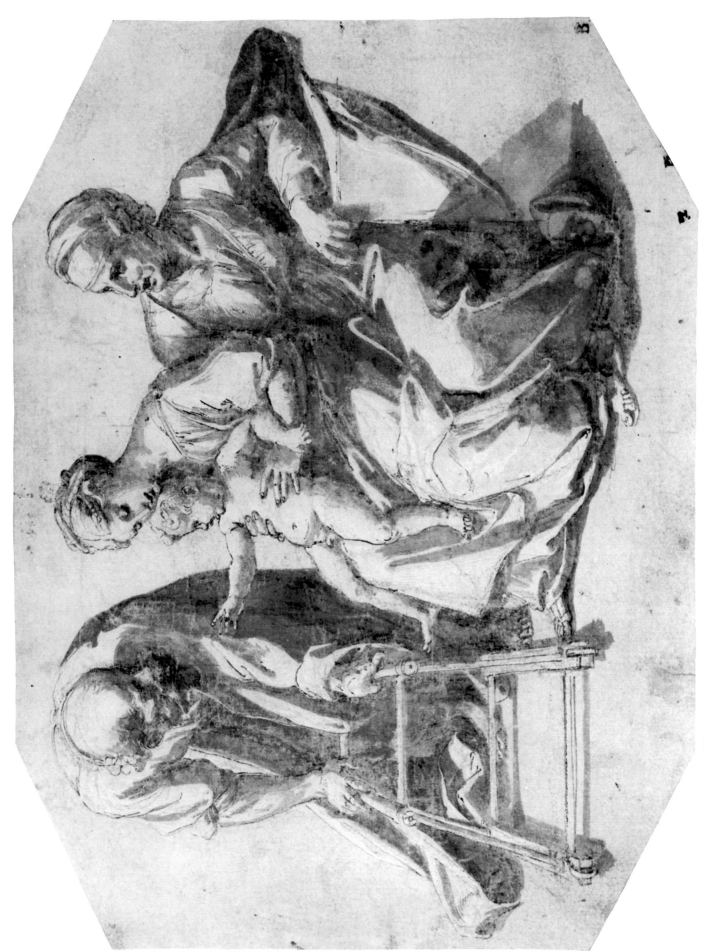

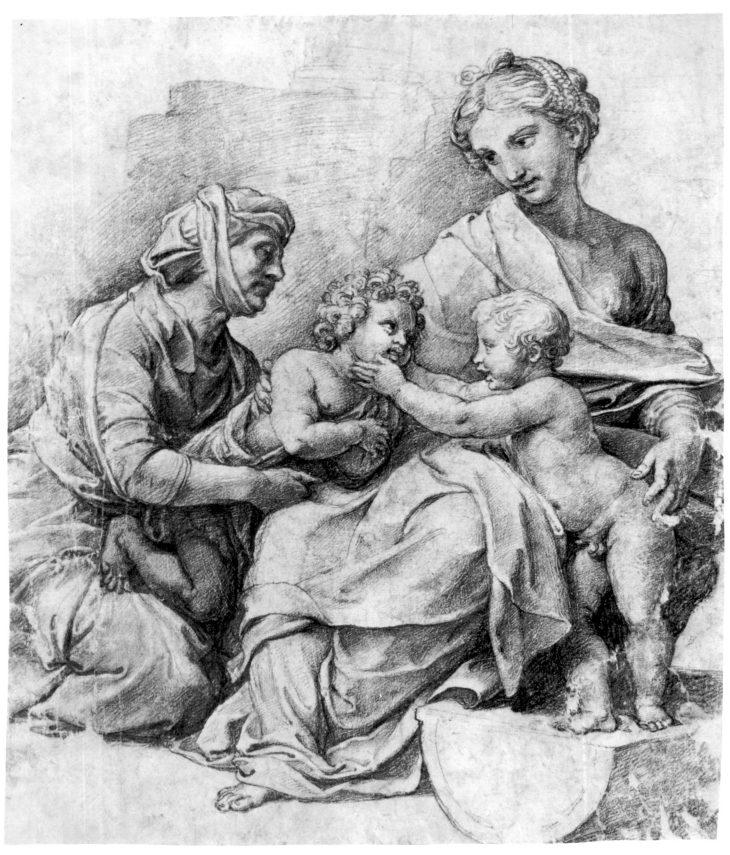

58

the most plausible: his personality seems positively evident in such details as the facial type of the Virgin and the springy, wiry contour which bounds the Child's body. The drawing can hardly be by Raphael himself, as Popham hinted, but it may well reproduce a composition by him. As Strong observed, the composition is "the work of a powerful designer, to whom no problem of form or attitude presents the slightest difficulty."

The group of the Virgin and Child is repeated in a painting of *The Virgin and Child with Donors* by Lorenzo Lotto, formerly in the W. R. Hearst Collection in New York (B. Berenson, *Lorenzo Lotto*, 1956, pl. 143).

58 The Virgin and Child with St. Elizabeth and the Infant Baptist

Red chalk, over stylus underdrawing. Rubbed and damaged, especially on either side. 268: 222 mm.

PROVENANCE: King George III (Inventory A: *Raffaello d'Urbino e Scuola 27*).

LITERATURE: Passavant, p. 493, *f*; Ruland, p. 80, xxxix, 6; Crowe and Cavalcaselle, ii, p. 553; Fischel 379a; Popham, *Windsor*, no. 833; Oberhuber-Fischel, pp. 30 ff.; British Museum 1983, no. 200.

Windsor, Royal Library 12740

THE drawing corresponds very closely, but not exactly, with the *Small Holy Family* in the Louvre (K der K 163; Dussler, fig. 106), so called to distinguish it from the larger *Madonna of Francis I* in the same collection. The painting is one of a group of variations on the theme of the Holy Family which include the *Madonna of the Oak-Tree*, the *Madonna della Rosa* and the *Perla* (all in the Prado), and the *Madonna del Divino Amore* (Naples), produced in the Raphael studio in the years immediately before his death and to all appearances based on *concetti* by him.

In the painting, the upper part of the Baptist's body is moved further round to the left, so that his right shoulder is less prominent and more of his back is showing; his right elbow is lowered so that it rests on St. Elizabeth's right hand; he is wearing his cloak of camel's hair; the Virgin's right hand is not placed on his back; she wears a piece of drapery over her left shoulder. The correspondence is otherwise exact, and extends even to the folds in the drapery. As Fischel pointed out, there are *pentimenti* where the chalk drawing has diverged from the preliminary stylus sketch, in the Baptist's leg and in the profile of St. Elizabeth.

Ruland listed the Windsor drawing as by Raphael himself. Passavant, Crowe and Cavalcaselle (who describe it as in silverpoint, presumably by confusion with No. 21, the study for the earlier *Madonna dell'Impannata* in the same collection), and Fischel

(1898, no. 327) dismissed it as a copy of the painting. Subsequently, however, in his *Corpus*, Fischel took careful note of the differences from the painting and also the *pentimenti*. He described the drawing as "uninteresting and phlegmatic" ("temperamentlos"), and grouped it with a number of others, including the Uffizi studies for the *Madonna of Francis I* of 1518 (Fischel 377/378), all of which he was inclined to give to Giulio Romano. Later (1948, p. 366) he described the Windsor drawing as "near to Giulio." Popham nevertheless explained it as "a copy from the painting . . . a careful and sensitive drawing in the style of many after the Farnesina frescoes at Chatsworth and elsewhere," and Dussler (p. 50) as "a contemporary copy, with variations, taken from the painting."

The differences between drawing and painting are surely too subtle and too intelligent to have been introduced by a copyist, however sensitive; if this is a copy of anything, it can only be of a lost drawing. In fact, there is no reason to doubt that it is a study for the painting, or, to be quite exact, a *modello*; not by Raphael, though he must have provided the preliminary sketch, but by Giulio, as Fischel had suggested and as Konrad Oberhuber emphatically maintains. The facial types and the rather labored handling seem as characteristic of him as they are uncharacteristic of Raphael. As an example of Giulio's use of the technique, the drawing provides a useful criterion for assessing other red chalk drawings datable in Raphael's last years that hang in the balance between him and Giulio.

59 A Nude Man Sprawling on the Ground, Holding an Oval Shield; a Separate Study of his Right Foot

Black chalk, with touches of white heightening. 221: 302 mm.

PROVENANCE: William, 2nd Duke of Devonshire (Lugt 718).

LITERATURE: Ruland, p. 236, 19; Crowe and Cavalcaselle, ii, p. 455; Oberhuber-Fischel 486; British Museum 1983, no. 182; Knab-Mitsch-Oberhuber 593.

Chatsworth 59

INSCRIBED in ink in the lower left corner, in an early hand: *Raphael*. Like No. 40, this is a study from the model for one of the soldiers in the water in the right foreground of the *Battle of Constantine*. In the painting he is wearing a coat of mail and holds a dagger in his right hand. Ruland accepted the traditional attribution to Raphael. Crowe and Cavalcaselle, on the other hand, found it "not acceptable as the genuine outcome of the master's pencil" and seem to think it a copy of a lost drawing

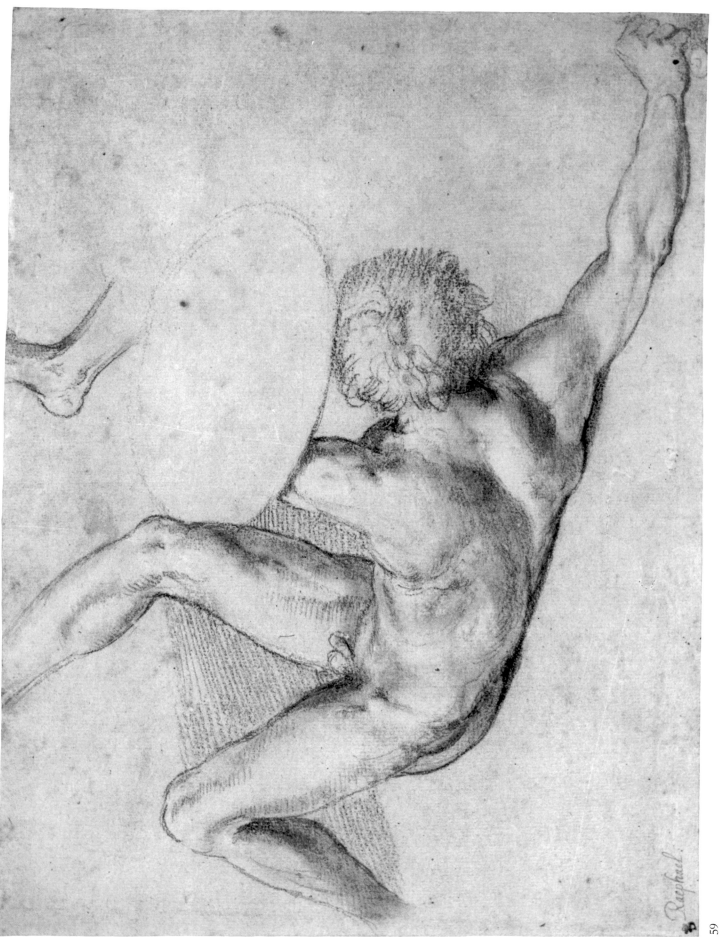

Raphael.

59

by him. The views of the later nineteenth-century critics varied: Morelli considered it an original drawing by Raphael himself which had been retouched by a later hand, Dollmayr gave it to Giulio, and Fischel to Penni. In his discussion of No. 40 Parker compared the two drawings and was emphatic in seeing a distinction between them. John Shearman (1965, p. 179) made the same distinction, and attributed No. 40 to Raphael and No. 59 to Giulio. Oberhuber gave both drawings to Raphael. The catalogue of the British Museum exhibition agreed with Parker and Shearman, that the two drawings are probably not by the same hand: in No. 59 "which Parker justly compared with the figure studies for the *Resurrection* (Nos. 32 and 33), the musculature of the backs . . . is rendered by a sequence of delicate tonal modulations. In no. 182 (the Chatsworth study), it seems to us that the form of the body lacks organic unity, and that it is crudely broken up into over-emphatic areas of light and dark. It seems to be the work of a less subtle draughtsman, having many of the characteristics of Giulio." The juxtaposition of the two drawings in the British Museum exhibition of 1983 did not dispel this impression.

60 An Enthroned Pope Attended by Child Angels, with a Female Figure Holding a Book and a Thunderbolt

Pen and brown wash. Maximum measurements of sheet irregularly trimmed on the right: 299: 244 mm.

PROVENANCE: Sir Peter Lely (Lugt 2093 partly cut away at bottom of sheet); Sir Thomas Lawrence; Samuel Woodburn (said to have been bought for the Museum at the Lawrence-Woodburn Sale in 1860, but not identifiable in sale catalogue).

LITERATURE: Oberhuber-Fischel, pp. 26 f.; Peter Ward-Jackson, *Victoria and Albert Museum Catalogues. Italian Drawings, Volume One: 14th–16th Century*, 1979, no. 155.

Victoria and Albert Museum 2269

DISCOVERED among the anonymous Italian drawings by Peter Ward-Jackson, who observed the connection with the fresco on the extreme right of the north wall of the Sala di Costantino in the Vatican. The four scenes from the history of Constantine—the *Allocution*, the *Battle*, the *Baptism* and the *Donation*—are represented as feigned tapestries occupying the center of each wall, with on either side the figure of a Pope who played a significant role in the early history of the Church. Except on the north wall, where the windows have made the available space too narrow, each Pope is enthroned under a canopy in a round-headed niche flanked symmetrically by pairs of seated female figures symbolizing Virtues and other abstract qualities and

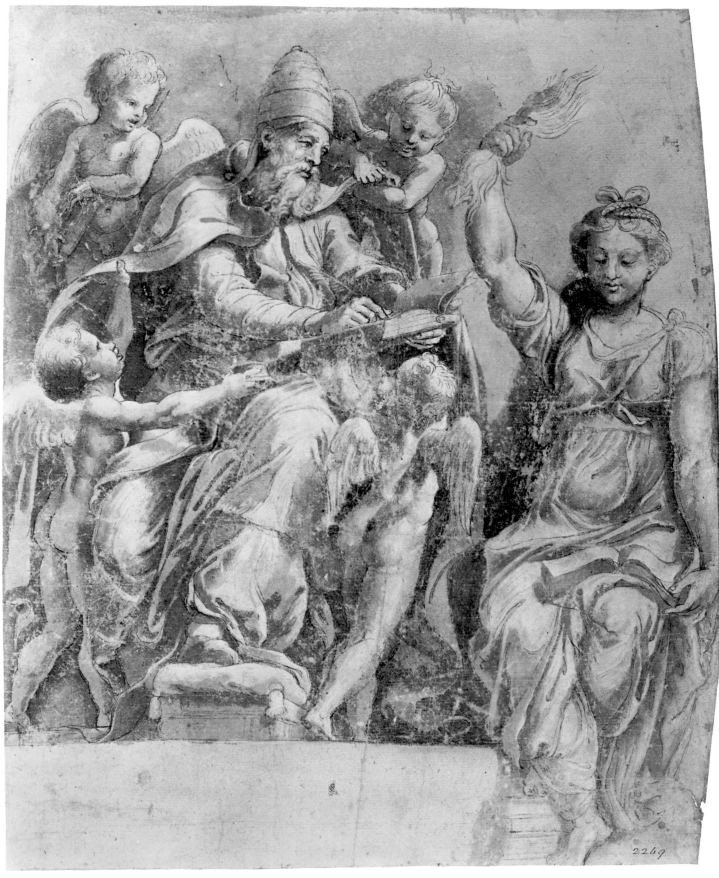

pairs of standing caryatids holding Medici emblems. Vasari's statement that the breaking up of the wall surface in this way was devised by Raphael is borne out by a drawing in the Louvre (4304; Fig. 5), which is to all appearances a *modello* worked up by Penni from a design by Raphael. The niche, canopy and flanking piers are exactly as painted, and there is the same number and arrangement of figures—an angel on either side of the Pope, and in front of the piers the seated Virtues and on top of them the standing caryatids; but the relation of the figures to each other and to the architectural setting is defined with the utmost lucidity, which creates a harmonious balance between the architectural and the figural elements of the design. After Raphael's death, when Giulio had a free hand, the figures and their draperies become increasingly swollen and amorphous; the architectonic structure of the scheme is obscured and it is sometimes even difficult to tell where one figure ends and another begins. (The only places where Raphael's original intention seems to be preserved is in the figures typifying *Justitia* and *Comitas*, on the right respectively of the *Battle* and *Allocution* walls: these are vestiges of the first phase of the decoration when it was intended to carry it out in oil rather than in fresco, and must have been designed, if not necessarily executed, by Raphael himself.)

Ward-Jackson pointed out that the drawing differs from the painting in the position of the legs of the female figure with the thunderbolt, and that it must be either an original study by Giulio or a copy of one. As he adds, in handling it comes very close to Giulio himself. Konrad Oberhuber accepted Giulio's authorship without question. Indeed, one would otherwise have to assume the existence of a copyist capable of exactly counterfeiting the quality and touch of Giulio's "handwriting" and even such morphological idiosyncrasies as the shape of the fingers. The head of the Pope in the drawing is particularly fine, and surely beyond the power of any copyist. The drawing is yet another indication of the rapidity with which Giulio developed his own personal style as soon as he was independent of Raphael's influence.

The inscriptions identifying some of the eight Popes have been renewed at various times, and cannot be considered as reliable. But it is clear that the series must begin with St. Peter, who is on the left of the *Allocution* on the east wall; and likely that it continues clockwise in chronological order as do the four historical episodes. The group on the right of the north wall, for which the drawing is a study, is adjacent to St. Peter and would thus be the last in the series. The inscription has disappeared, and the now generally accepted identification of the Pope as Gregory does not seem to go back beyond Passavant, who interpreted the thunderbolt as a symbol of "spiritual force" and suggested that the Pope was Gregory VII—"a Pontiff of exceptional vigour, who defended the rights of the Church with the thunderbolt of excommunication." Ward-Jackson calls him Gregory I ("the Great") and the female figure *Eloquentia*, who in Ripa's *Iconologia* is described as holding a thunderbolt in her right hand and a book in the other.

Rolf Quednau (*Raffaello a Roma*, p. 246) also identifies the Pope as Gregory I, but

takes the same view as Passavant of the significance of the thunderbolt. He claims that the Pope and the figure symbolizing *Fulminatio* (or *Fulguratio*) have altogether eight books, and that this number refers to Gregory I's threat to excommunicate those who refused to accept the authority of the first four Councils of the Church as equivalent to that of the four Gospels. In spite of Ripa, it does seem likely that this interpretation of the female figure is correct. On the other hand, it could be argued, in support of Passavant's identification of the Pope as Gregory VII, that his excommunication of no less a personage than the Emperor Henry IV was a turning point in the development of the relationship between Church and State and an event of far greater and more conspicuous historical significance than Gregory I's threat to use the weapon of excommunication as a means of enforcing doctrinal uniformity.

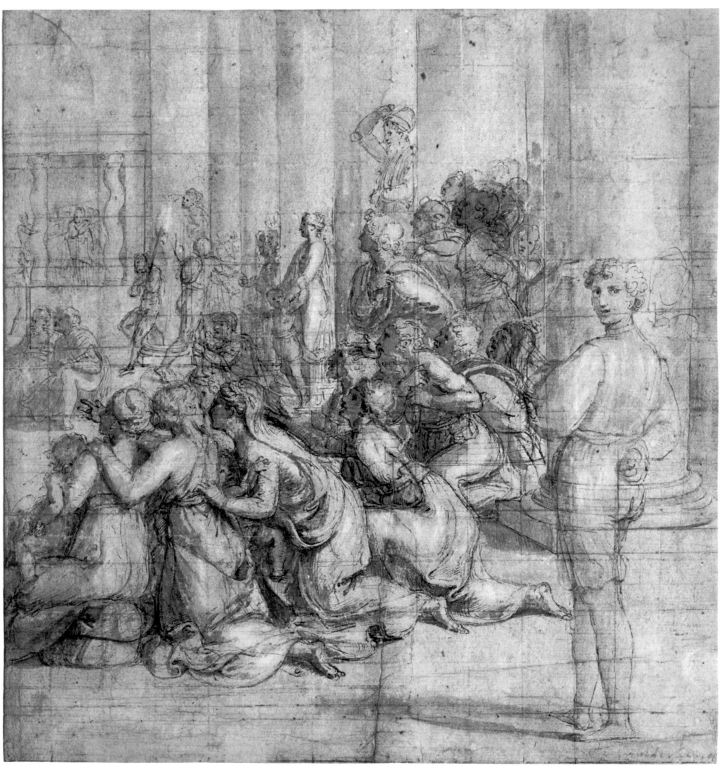

61

61 Part of a Composition of Figures in a Pillared Hall

Pen and grayish-brown ink and brown ink and wash over black chalk, heightened with white and with some touches of red chalk. Squared in black chalk. The outlines indented and the verso blackened for transfer. 273: 247 mm.

PROVENANCE: Lord Brownlow; Victor Koch (both acccording to Parker).

LITERATURE: Parker 248; Hartt 35; Oberhuber-Fischel, p. 189; British Museum 1983, no. 199.

Ashmolean Museum P II 248

P ARKER, who acquired the drawing for the Ashmolean Museum in 1939, recognized its great historical importance as the only surviving preparatory study for the fresco of the *Donation of Constantine* in the Sala di Costantino. It corresponds with the right-hand half of the composition in the architecture and in the background figures, but the group in the foreground is much altered. The two women on the left reappear in the painting, as does the standing man on the extreme right; but the space between is largely occupied by a bearded man, apparently kneeling on one knee, who turns to address an aged kneeling cripple supporting himself on crutches.

Whether or not Raphael had at any stage intended this or a similar subject for one of the four large historical scenes which constitute the principal feature of the decoration (see No. 41), he can have had nothing to do with the *Donation of Constantine* as painted, or with the *Baptism of Constantine* on the end wall. These belong to the second phase of the decoration, when it was resumed after the election of Clement VII at the end of 1523, by Giulio Romano assisted by Giovanni Francesco Penni. The importance of the Ashmolean drawing lies above all in the light that it casts on the nature of their collaboration. Parker catalogued it as "Giulio Romano (?)". He quoted Hartt's opinion (later modified) that the drawing is by Giulio, adding "this seems hard to believe on the evidence of style, unless indeed the artist is here seen in a passing and unfamiliar phase . . . the drawing, rather insipid in character, remains problematical in regard to its authorship." The puzzling character of the sheet is due to its being an unusual example of a drawing demonstrably the work of two distinct hands. This was first recognized by Hartt, who in his monograph attributed the figures to Penni and the architecture to Giulio. The converse explanation was put forward by the present compiler (*Burlington Magazine*, xcix [1957], p. 161), who argued that the original drawing of both architecture and figures seemed to be by a timid hand using a grayish-brown ink, whose drawing was then reworked and brought to life, in much the same way as Rubens retouched and revitalized drawings of earlier masters, by an impatient and more vigorous hand using a reddish-brown ink. The personality of the first draughtsman, which can rightly be described as "insipid," goes well with the group of drawings plausibly

attributed to Penni; the more forceful personality of the second, clearly the senior partner in the enterprise, goes equally well with Giulio's very fully documented mature style of drawing.

The process of reworking did not extend to the languid youth standing in the right foreground of the drawing. The same difference, curiously enough, is apparent in the fresco; the figures, like those in the foreground group in the drawing, are clearly by Giulio, with the exception of the languid youth's counterpart, a foppish young man elaborately overdressed in the height of contemporary fashion who does not conceal his lack of interest in the proceedings and seems to have strolled in from the altogether less Giuliesque *Baptism of Constantine* on the adjacent wall.

62 Back View of a Nude Man about to Throw a Large Stone

Black chalk, somewhat rubbed. The lower right part of the sheet irregularly torn away. Maximum measurements: 390: 124 mm.

PROVENANCE: King George III (Inventory A: *Raffaello d'Urbino e Scuola 36*).

LITERATURE: Passavant, p. 494, *q*; Ruland, p. 324, xx; Popham, *Windsor*, no. 348; Hartt 41; Oberhuber-Fischel, p. 27.

Windsor, Royal Library 0339

THE emphatic curving line just above the left shoulder seems to be a *pentimento* indicating an earlier intention of placing the arm downwards and across the body. The traditional attribution to Raphael was rejected by Passavant and Ruland, but neither proposed any alternative. Popham catalogued the drawing as by Giulio, with the suggestion that the model may have been the same studio assistant as appears in the black chalk study for two figures in the water in the *Battle of Constantine* (No. 40), which he believed was by the same hand. There is undoubtedly a close facial resemblance, but the Ashmolean drawing is certainly by Raphael himself.

Ruland had already suggested that the Windsor drawing must be a study for an executioner in a *Martyrdom of St. Stephen*; as Konrad Oberhuber pointed out, the figure is indeed derived from one in the right foreground of Raphael's drawing of the subject in the Albertina (211; 1983, no. 40; Oberhuber-Fischel 446), which in his opinion, though not in that of John Shearman, is an early sketch for the tapestry cartoon. No such figure appears in Giulio's altarpiece of the subject painted for the church of S. Stefano in Genoa (Hartt, fig. 95), but Popham's suggestion that this may be a discarded study for it has now been confirmed by a drawing in the École des Beaux-Arts in Paris (repr., without inventory no., *Raffaello in Vaticano*, exh. Rome, Vatican, 1984/85, under

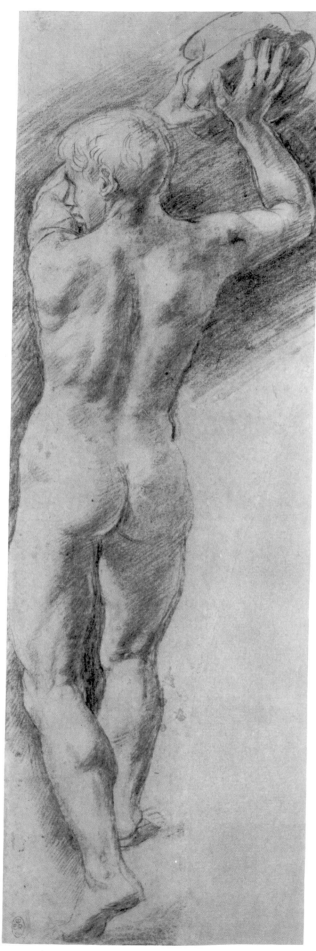

62

no. 118), identified by Silvia Ferino Pagden and Konrad Oberhuber as an old copy of a rejected *modello*: the corresponding figure occupies the right foreground, but the group in the left foreground and in the upper part of the composition are as in the painting. The altarpiece is not dated, but an inscription on the frame referring to Giulio de' Medici as a cardinal establishes that it was completed and installed in the church before his election as Pope Clement VII in November 1523. Hartt (p. 55) argues that "considering how much work Giulio had on his hands in Rome during Leo X's lifetime and how little a month after his death," it was probably painted in the interval between Leo's death on 1 December 1521 and Clement's election.

The drawing thus establishes a fixed point in the course of Giulio's early independent development, and shows once again how rapidly he threw off the style imposed on him in Raphael's studio to reveal his individual personality. The possibility of No. 62 being by Raphael would never cross one's mind. Some of the characteristics analyzed by Oberhuber may be summarized. "The artist has concentrated on rendering the surface of the body, without either idealising it or trying to convey its underlying structure. The attempt to suggest movement in depth has resulted in giving the figure the appearance of a relief. The in places unsatisfactory foreshortening has made for some degree of distortion, and the flickering light with abrupt contrasts of light and dark give an animation to the surface that seems independent of the actual figure. The expression of the drawing is determined not so much by the action of the figure as by the restless animal vitality of the body as a whole, in the movement of which is something uncontrolled, formless and out of proportion."

63 Martha Bringing the Magdalen to Christ

Pen and brown wash, heightened with white, over black chalk. Arched top, the curve made more rounded by the addition of a further piece of paper. Maximum measurements: 224: 332 mm.

PROVENANCE: William, 2nd Duke of Devonshire (Lugt 718).

LITERATURE: Ruland, p. 122, xv, 3; Oberhuber-Fischel, p. 29.

Chatsworth 63

As "ascribed to Raphael" in the Chatsworth catalogue. Other versions of the composition include a pen and ink drawing at Munich (Oberhuber-Fischel, fig. 12; *Italienische Zeichnungen des 16. Jahrhunderts aus eigenem Besitz*, exh., Munich, 1977, no. 79, fig. 10) and an engraving by Marcantonio (Bartsch 45). Hermann Voss was the first to suggest (*Malerei der Spätrenaissance*, 1920, p. 63) that this engraving and one of *The Feast in the House of Simon* also by Marcantonio (Bartsch 28) are after two of the lunettes of subjects from the life of the Magdalen formerly in the upper part of the fifth chapel on the left in the church of S. Trinità dei Monti, said by Vasari (v, pp. 417 and 621) to have been painted by Giulio Romano with the assistance of G. F. Penni. (Ruland had already made the same suggestion about *The Feast in the House of Simon*.) The two engravings are rectangular, but in both drawings the composition has an arched top that would fit the shape of a lunette.

After Giulio's departure from Rome in 1524 the chapel remained half-decorated until about 1540, when it was acquired by Angelo Massimi who commissioned Perino del Vaga to decorate the side walls (see No. 76). In the early nineteenth century the entire decoration of the chapel was swept away, but a few fragments of fresco were successfully detached (*Autour de Raphaël*, p. 133). These included a lunette of the *Assumption of the Magdalen*, acquired in 1852 by the National Gallery, London (inv. no. 225), which now that it has been cleaned is revealed as a characteristic work by Giulio. It presumably came from the upper part of the altar wall, and is higher and narrower in format than the Chatsworth and Munich drawings.

Our knowledge of the first phase of the decoration of this chapel is derived entirely from Vasari, but his account is not reliable in every detail. He says that there were four lunettes in the chapel, and that they and "the four Evangelists on the vault" were engraved by Marcantonio. But Bartsch's description of the only engraving of the *Assumption of the Magdalen* listed by him under the name of Marcantonio (Bartsch 180) in no way corresponds with the London fresco,[1] nor is any engraving described that

1. The group in the London fresco is reproduced, in a landscape setting, in an engraving classified by Bartsch (xvi, p. 311, 4) as "Ecole de Fontainebleau . . . d'après quelque artiste de l'école de Primatice," but there is no reason to associate this with Marcantonio.

63

could be after the fourth lunette. Indeed, it is doubtful if there ever was a fourth lunette, since the lunette-shaped space on the fourth wall of the chapel is occupied by the upper part of the entrance arch. The Evangelists are a likely subject for the decoration of the four triangular compartments of a cross-vaulted ceiling, and Vasari is no doubt correct in saying that they were painted on the vault of the chapel; but again, there are no engravings of them by Marcantonio. Those by his follower Agostino Veneziano (Bartsch 92–95) are not only clearly signed but inscribed with the date 1518, which seems too early for an independent work by Giulio.

Konrad Oberhuber attributes the Munich and Chatsworth drawings to Giulio. He admits that both come close to Penni, especially the one at Chatsworth (a view also expressed by Popham in an annotation in the Chatsworth catalogue), but he sees in them no trace of Penni's "empty prettiness" (leere Lieblichkeit). The distinction between the two drawings is a fine one, but the possibility that No. 63 may be a "fair copy" of Giulio's design by his collaborator, who had been accustomed to perform the same service for Raphael, cannot be completely excluded.

64

64 St. Sebastian

Pen and brown ink. Squared in black chalk. 250: 105 mm.

PROVENANCE: Jean-Baptiste-Joseph Wicar (according to *Lawrence Gallery* catalogue); Sir Thomas Lawrence (Lugt 2445); Samuel Woodburn; Charles Fairfax Murray; J. Pierpont Morgan.

LITERATURE: *Lawrence Gallery* (eighth exhibition: Dürer and Titian) 1836, no. 66; Fairfax Murray, i, no. 60; Oberhuber-Fischel, pp. 33 f.

The Pierpont Morgan Library I, 60

INSCRIBED in an old hand in red chalk (traced over in pen): *Tiziano*. The attribution was accepted by Woodburn, who included the drawing in the Lawrence Gallery with the comment "a study for one of the Saints in the bottom part of the celebrated picture now in Venice"—probably a reference to the altarpiece of *St. Mark Enthroned with Four Saints* (one of whom is Sebastian) in S. Maria della Salute. The drawing was kept under the name of Titian until attributed to Giulio by Philip Pouncey, who considered it to be a very early work; Konrad Oberhuber was inclined to date it rather later, arguing that the continuous bounding contour and the flat modelling characteristic of Giulio's mature style are already apparent. But Giulio's mature personality seems to have come to the fore as soon as he was independent of Raphael's supervision, and it can hardly be claimed that this drawing has the calligraphic suavity of such examples of his mature style as Nos. 66–68. It seems reasonable, therefore, to place it in the early 1520s, not long after Raphael's death.

65 St. Jerome and an Episcopal Saint (Augustine?)

Pen and brown wash, heightened with white, on paper unevenly tinted rose-pink with diluted red chalk wash. Squared in red chalk. 274: 210 mm.

PROVENANCE: Savoia-Aosta (according to Janos Scholz: cf. Lugt 47a); Janos Scholz.

LITERATURE: Konrad Oberhuber and Dean Walker, *Sixteenth Century Italian Drawings from the Collection of Janos Scholz*, exh. Washington-New York, 1973/74, no. 2.

The Pierpont Morgan Library, Janos Scholz Collection 1973.24

PREVIOUSLY attributed to a follower of Gaudenzio Ferrari. The attribution to Giulio Romano was made by Philip Pouncey when the drawing was still in Mr. Scholz's collection. The strong modelling which emphasizes the plasticity of the garments and faces, the relatively slender proportions of the figures and the sharp foreshortening, are features convincingly cited by Oberhuber in support of an early dating, in the period of Giulio's independent activity in Rome between the death of Raphael in 1520 and his departure for Mantua in 1524.

St. Jerome is identified by his attributes of a Cardinal's hat and a lion. Since he is one of the four Doctors of the Church, his companion might be one of his two episcopal fellow Doctors, either St. Ambrose or St. Augustine—more likely the latter, since he does not hold Ambrose's attribute of a scourge. The purpose of the drawing is unknown. This could be a study for the right-hand side of an altarpiece representing a *Sacra Conversazione*, with St. Ambrose and St. Gregory, the other two Doctors, symmetrically placed on the left-hand side of a Virgin and Child enthroned in the center. No such commission is recorded.

65

66 A Tabernacle Containing a Papal Escutcheon Supported by Angels

Pen and brown ink. 454: 334 mm.

PROVENANCE: Sir Peter Lely (Lugt 2092); Prosper Henry Lankrink (Lugt 2090).

Private Collection, London

THE purpose of this drawing is unknown, but the architectural character of the composition suggests a detail of a palace façade or part of some scheme of temporary decoration. The drawing style is that of Giulio's full maturity, and it is conceivable that such a design might have been made in Mantua. On the other hand, a display of the papal arms suggests a Roman origin, and there seems to be no reason for supposing that Giulio's style was not fully developed by the time he left Rome for Mantua in 1524.

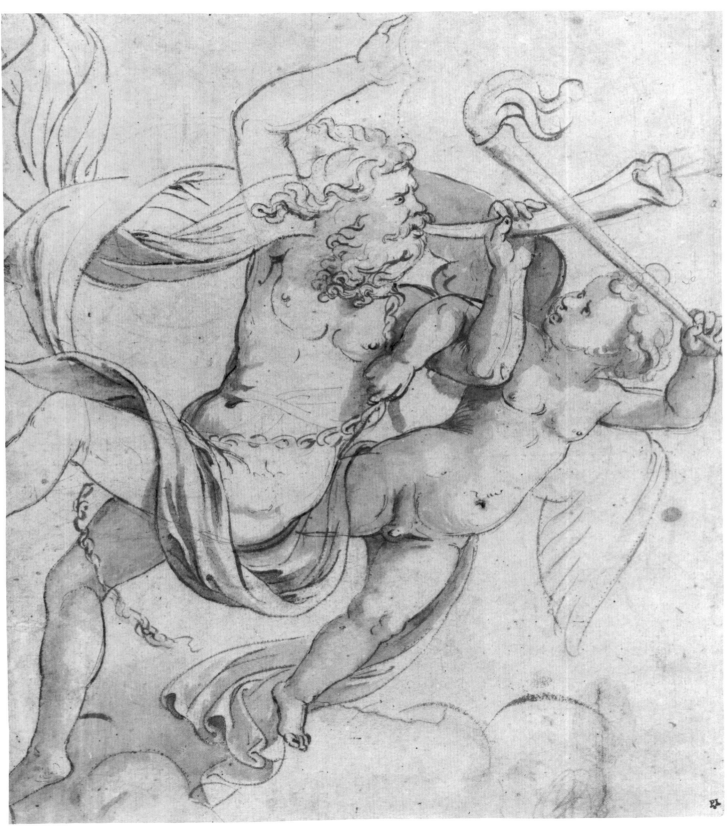

67

67 One of the Winds Unchained (?)

Pen and brown wash, the outlines gone over and strengthened with the brushpoint. Traces of black chalk underdrawing. The outlines pricked throughout. 328: 278 mm.

PROVENANCE: Sir Peter Lely (Lugt 2092); John Skippe; his descendants, the Holland-Martin family; (sale, London, Christie's, 1958, 21 November, lot 104A).

Private Collection, London

INSCRIBED by Skippe on his mat: *Giulio Romano*. A. E. Popham, who compiled the catalogue of the 1958 Skippe sale, entitled the drawing "Aeolus unchained (?)". Aeolus was the god of the Winds, and he himself was not chained; but he unchained the winds at the request of Juno, in order to raise the storm which she hoped would destroy Aeneas's ships (*Aeneid*, i, 81 ff.). The figure in the drawing could be one of the Winds.

The scale of the drawing, larger than that of Giulio's usual preliminary studies, the pricking, and the technique—the reinforcement of the outlines with the brush point is unusual for Giulio but certainly by him—all support Popham's description of it as a cartoon. Its purpose is unknown. One of Giulio's last decorative projects in Mantua was to design a series of subjects from the Trojan War for the Sala di Troia in the Palazzo Ducale (1538–39), but the shipwreck of Aeneas is not among them.

The long fluttering strip of drapery connecting the two figures is an example of Giulio's predeliction for designing in terms of an intricate, continuously flowing arabesque.

Giulio Romano

68

68　Allegory of the Virtues of Francesco Gonzaga

Pen and brown ink over red and black chalk. 220: 294 mm.

PROVENANCE: Nicolas Lanière (Lugt 2996): unidentified collector (Lugt 2883a); Jonathan Richardson, jun. (Lugt 2170); Sir Joshua Reynolds (Lugt 2364); John Malcolm of Poltalloch.

LITERATURE: Robinson, *Malcolm* 201; Hartt 177; Pouncey and Gere 79.

British Museum 1895–9–15–642

INSCRIBED in ink in lower right corner, in a sixteenth- or seventeenth-century hand: *Giulio Romano*. On back of old mat, in Richardson's hand: *Painted in the Palace of T at Mantua*. The Palazzo del Te, Federico Gonzaga's suburban palace on the outskirts of Mantua, was entirely designed and decorated by Giulio Romano. The drawing is a study for the octagonal fresco on the ceiling of the Sala d'Attilio Regolo (Hartt, fig. 289), a room not in the palace itself but in the small pavilion in the garden known as the Casino della Grotta which Hartt dates c. 1530.

No. 68 differs considerably from the finished painting and must be the earliest of the three surviving studies for it. Another, formerly at Chatsworth (sale, London, Christie's, 1984, 3 July, lot 17, repr.) corresponds with the painting in all but small details; the third, in the Louvre (3501) is even closer, and is described by Hartt as a *modello*. The drawing is included as an example of the emphatically linear style of Giulio's maturity.

69

PIERO BUONACCORSI, CALLED PERINO DEL VAGA

FLORENCE 1501–1547 ROME

69 The Descent from the Cross

Red chalk. 325: 274 mm.

PROVENANCE: Samuel Woodburn (sale, London, Christie's, 1854, 19 June, lot 574).

LITERATURE: A. E. Popham, *Burlington Magazine*, lxxxvi (1945), p. 63; Pouncey and Gere 157; Bernice Davidson, *Master Drawings*, i, 3 (1963), p. 8.

British Museum 1854–6–28–13

As Parmigianino in the Woodburn Sale (perhaps on the strength of the old inscription on the former backing: *v[ente?] chabat Parmens*). Later placed, for no known reason, under the name of Giulio Clovio. Perino's hand was first recognized by Popham, who also pointed out the connection between the drawing and two panels traditionally attributed to Perino in the royal collection at Hampton Court, which represent the two Crucified Thieves and are clearly fragments of either a *Crucifixion* or a *Descent from the Cross*. The thieves do not appear in the drawing, but one panel includes a piece of hanging drapery and the upper part of two bearded figures which correspond in relative position, pose and gesture with the two standing figures on the extreme right; the other, a piece of fluttering drapery and the upper part of a reed cross which similarly correspond with details on the other side of the drawn composition. The Hampton Court panels were identified by Kenneth Clark as fragments of an altarpiece of the *Descent from the Cross* described by Vasari (v, p. 599 f.) as having been painted by Perino for the chapel of an unnamed Protonotary Apostolic in the church of S. Maria sopra Minerva, the lower part of which was destroyed by the flood which occurred not long after the Sack of Rome (on 8 October 1530). They were certainly in their present state before being brought to England by King Charles I, for an early seventeenth-century engraving of the interior of an artist's studio, by Pierfrancesco Alberti (Bartsch xvii, p. 313, 1), shows one of them hanging on the wall.

The two fragments of the altarpiece, the drawing, the present physical make-up of the panels and radiographs of them have been subjected to a rigorous analysis by John Shearman (*Scritti di storia dell'arte in onore di Ugo Procacci*, Milan, 1977, ii, pp. 356 ff. and *The Early Italian Pictures in the Collection of Her Majesty the Queen*, 1983, no. 193). His

conclusion is that the thieves, as the drawing suggests, were an afterthought, but that the drawing is not a preparatory *modello* for the altarpiece as originally conceived, but a record by Perino himself of the composition before the addition of the thieves. To judge from the context in which Vasari describes the commission, the altarpiece would have been painted before Perino was forced to leave Rome by the plague of 1522. Shearman draws a distinction in style and technique between what is left of the original painting (notably the two half-figures in the right-hand fragment) and the thieves: by analogy with other early works by Perino, he dates one c. 1519–20 and the other c. 1521–22. As Bernice Davidson observes, the style of the British Museum drawing is still fundamentally Florentine, reflecting the influence of Perino's early master Ridolfo Ghirlandaio rather than of Raphael.

A drawing corresponding very closely with No. 69, also in red chalk and, in addition, squared in red chalk, is in the Louvre (5008). It had in the past been attributed to Francesco Salviati and to Battista Franco. In notes on the mat, Popham suggested that it had been traced from No. 69; and Bernice Davidson, that it is probably by Perino himself.

70 The Presentation of the Virgin

Pen and brown wash, heightened with white, on pale brown paper. Squared in black chalk. The squaring continues on the blank areas of the sheet, which have been washed a greenish-gray color. The left and right-hand borders of the composition are tinted respectively in white and gray bodycolor, in accordance with the direction of the light. 227: 255 mm.

PROVENANCE: Prince Borghese, Rome (according to the *Lawrence Gallery* catalogue); Sir Thomas Lawrence (not stamped with his collector's mark, but described exactly in the *Lawrence Gallery* catalogue); Samuel Woodburn (sale, London, Christie's, 1860, 4 June, etc., lot 981); anonymous sale, London, Sotheby's, 1963, 12 March, lot 20.

LITERATURE: *Lawrence Gallery* 89; Bernice Davidson, *Master Drawings*, i, 2 (1963), p. 14; Bean and Stampfle 84; Bean and Turčić 166.

The Metropolitan Museum of Art, Rogers Fund 63.75.1

A STUDY for one of the four triangular compartments of the cross-vaulted ceiling of the left transept of the church of S. Trinità dei Monti. The transept had been taken over as his family chapel by Cardinal Lorenzo Pucci, who in about 1520 or 1521 commissioned Perino to decorate it. The frescoes on the vault—the others are *Joachim and Anna at the Golden Gate*, the *Birth of the Virgin* and the *Annunciation*—were the first part of the decoration to be carried out, and must date from the period before Perino left Rome to escape the plague which broke out there in the early spring of 1522 (the date 1523 given by Vasari is that of the plague in Florence). The fresco of the

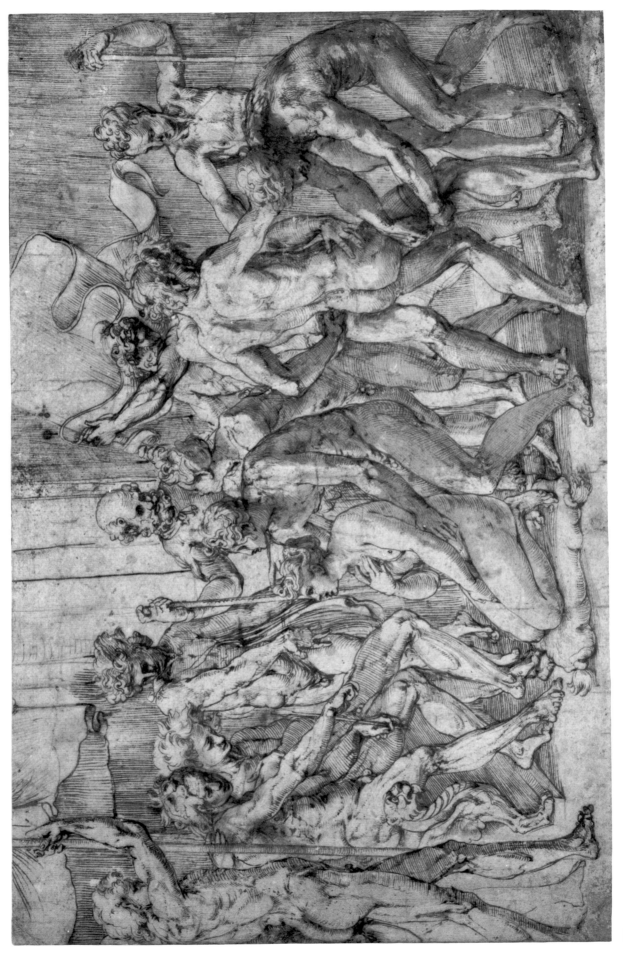

Presentation is in such bad condition that the drawing is the best evidence for its original appearance.

Studies for the other three scenes from the life of the Virgin on the vault are in the Albertina and in the Louvre (repr. Davidson, pls. 6a, 6b, 7b). In technique all three resemble the Loggia *modelli*, but they can hardly be described as "Raphaelesque": Perino's individual personality was already fully formed by the time of Raphael's death in 1520.

71 Composition of Thirteen Nude Figures, including a Woman Kneeling before Two Enthroned Young Men, and a Man Having his Thigh Bandaged

Pen and brown wash. 262: 423 mm.

PROVENANCE: Desneux de la Noue; Evrard Jabach (inscribed on backing: *NB: vient du Cabinet de M^r: Dela Noue: de lui [est la Marque cy-jointe] & ensuite de M^r: Jabac.* The words given in square brackets have been erased: they refer to a paraph in black chalk resembling one of Jabach's, Lugt 2959. His mark Lugt 960ᵃ is also on the backing); Samuel Woodburn (sale, Christie's, 1860, 13 June, lot 1337).

LITERATURE: Pouncey and Gere 158.

British Museum 1860–6–16–118

INSCRIBED on backing in ink in an old hand: *Perino del Vaga.* Attributed to Primaticcio in the Woodburn Sale catalogue, but the old inscription is certainly correct. The drawing seems to date from early in Perino's career, when he was still influenced by Raphael. The legs of the wounded man are derived from the *Standard Bearer* engraved by Marcantonio after a lost drawing by Raphael (see No. 31), and the same subject is treated in a drawing at Lille (Pluchart catalogue, 1889, no. 367, as "attribué à Jules Romain"; Fischel, fig. 192), apparently an old copy of a lost drawing by Raphael which would have resembled his compositions of fighting nudes (e.g. No. 6). The technique, unusually elaborate for Perino, the high degree of finish and the absence of *pentimenti*, suggest the possibility that the drawing was made with an engraving in mind; but no such engraving is known, and the contours of the drawing are not indented for transfer.

The subject is evidently one of the classical legends of "Clemency" or "Magnanimity," but it has never been satisfactorily explained. The Lille drawing, in which there is only one enthroned figure, was entitled by Pluchart *The Clemency of Scipio* and by Fischel *Alexander the Great and Timoclea.* One of the seated youths before whom the woman is kneeling in the version by Perino holds what could be a sceptre and is wearing

a lion's skin headdress. The head of the youthful Hercules on many of the coins of Alexander the Great, which could well be mistaken for that of Alexander himself, is represented with the same headdress. If one of the seated figures is Alexander, the other could be his favorite, Hephaestion. On the other hand, the suppliant woman can hardly be Timoclea, who was pardoned by Alexander for pushing down a well one of his soldiers who had tried to ravish her; the man wounded in the thigh who is such a conspicuous feature of both drawings plays no part in her story. The same objection applies to the Clemency of Scipio, nor would he be represented enthroned with a youthful companion.

72 A Frieze-Shaped Composition of a Subject from Classical History: A Battle and a Sacrifice

Pen and brown wash, heightened with white, on brown-tinted paper. Squared in black chalk. 126: 384 mm. The sheet consists of two pieces of paper, joined about 140 mm. from the left-hand edge.

PROVENANCE: John Skippe; his descendants, the Holland-Martin family (sale, London, Christie's, 1958, 20 November, lot 150).

LITERATURE: Pouncey and Gere 161.

British Museum 1958–12–13–3 (presented jointly by the National Art-Collections Fund and the Holland-Martin family)

INSCRIBED on the old mat in pencil, by Skippe: *Polidoro*. As Popham was the first to point out in the catalogue of the Skippe Sale, the style of the drawing is in fact characteristic of Perino del Vaga. He compared it with the study at Windsor (his no. 976) for the grisaille of *Solon Giving Laws to the Athenians*, in the *basamento* of the Stanza della Segnatura. This, however, is one of Perino's very late works, dating from the 1540s; the ex-Skippe drawing is surely very much earlier and is still Raphaelesque, with vestiges of the Raphael studio style of the Loggia *modelli*. The erroneous attribution to Polidoro is easily explained: the shape of the composition and its frieze-like treatment and the vaguely classical subject matter all reflect the more immediate influence of his monochrome façade paintings in imitation of Antique reliefs. The drawing could well be a design for a decoration of the same kind. Perino is known to have made façade decorations at intervals throughout his career: Vasari records, with the implication that it was an early work datable in the period before 1523, "una facciata di chiaro oscuro, allora messosi in uso per ordine di Polidoro e Maturino . . . condotta molto gagliardamente di disegno e con somma diligenza"; designs for the entrance façade of the

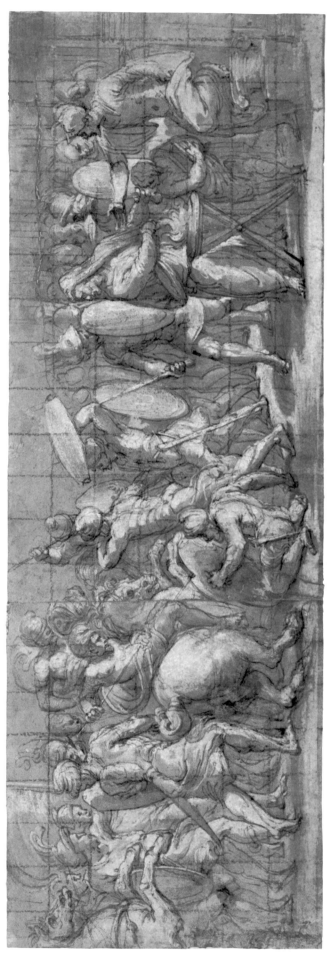

Palazzo Doria in Genoa, where Perino worked from 1528 to 1534, are in the Musée Condé at Chantilly (85[75]: *Hommage à Raphaël*, exh. 1983/84, no. 24) and in the Rijksmuseum (1948:133: Frerichs 1981, n. 115); and a design for the complete façade of a house or small palace in the Louvre (602: *Autour de Raphaël*, no. 102) including the arms of Pope Paul III and thus datable in Perino's last years.

73 Roman Soldiers Bringing Spoils to Lay before an Enthroned Emperor

Pen and brown wash, heightened with white. Squared in black chalk. 275: 412 mm. (size of whole sheet), 211: 395 mm. (size of drawing).

PROVENANCE: Sir Peter Lely (Lugt 2092); William, 2nd Duke of Devonshire (Lugt 718).

Chatsworth 135

As in the case of No. 72, the traditional attribution was to Polidoro da Caravaggio, and it was again A. E. Popham, in a note in the Chatsworth catalogue, who first recognized the hand of Perino del Vaga. Both drawings show Perino in a phase when he comes very close to Polidoro, and are probably datable in the early 1520s. The possibility cannot be ruled out that they may even be connected with the same project—perhaps the decoration of a façade.

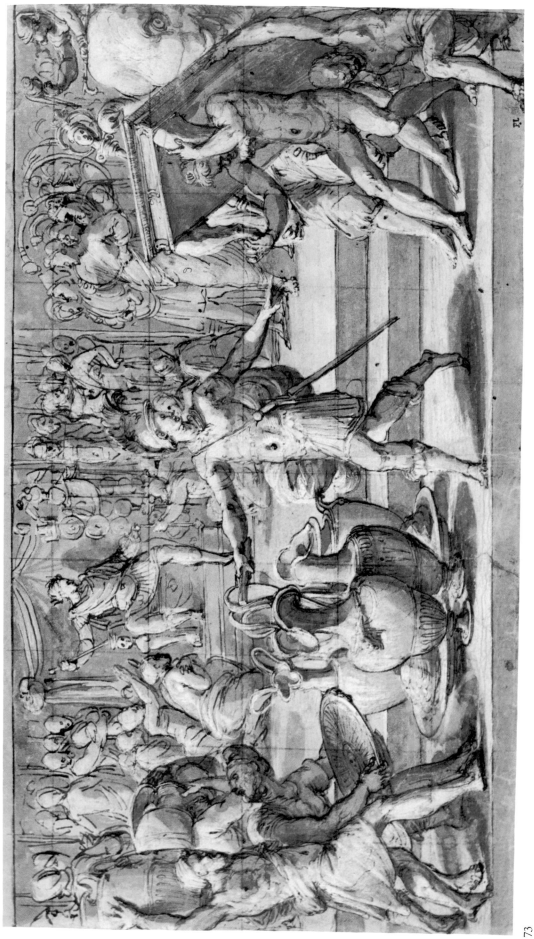

74

74 Design for the Decoration of the Altar Wall of a Chapel, with the *Adoration of the Magi* in the Lunette, and above the Altar the *Crucifixion* Surrounded by Smaller Scenes from the Passion

Pen and brown wash. 410: 268 mm.

PROVENANCE: Commendatore (?) Gelosi (Lugt 545 and *Supplément*); "Mercer"; Sir Charles Robinson (Lugt 1433. Inscribed in his hand on backing: *Bought of Whitehead. Mercer's Collection. April 19/69. £7*); John Malcolm of Poltalloch; his son-in-law, the Hon. A. E. Gathorne-Hardy; by descent to the Hon. Robert Gathorne-Hardy (sale, London, Sotheby's, 1976, 24 November, lot 13).

LITERATURE: *Descriptive Catalogue of Drawings . . . in the possession of the Hon. A. E. Gathorne-Hardy*, London, privately printed, 1902, no. 50; Marabottini, pp. 41 ff.; Ravelli 37.

Private Collection

WHEN in the Gathorne-Hardy Collection attributed, for no conceivable reason, to Dosso Dossi. Philip Pouncey was the first to recognize that the draughtsman was Perino del Vaga, and that the drawing corresponds with the decoration of the left-hand sidewall of the Cappella della Passione in S. Maria della Pietà in Campo Santo Teutonico, a small church within the Vatican City. By a contract dated 14 May 1520, this chapel was assigned to the use of the Pontifical Swiss Guard. Its decoration was commissioned by the Captain of the Guard, Kaspar Roïst, whose coat-of-arms was a conspicuous feature. The arms of Julius II, Leo X and Adrian VI (presumably the Popes whom Roïst had served) were painted on the window embrasure. This must imply that the decoration was completed within the brief pontificate of Adrian VI (January 1522–September 1523). See the article by Rolf Kultzen, "Der Freskenzyklus in der ehemaligen Kapelle der Schweitzergarde in Rom," in *Zeitschrift für schweizerische Archäologie und Kunstgeschichte*, xxi, part 1 (1961), pp. 19 ff.

In 1912 the *Crucifixion* above the altar and the eight small scenes surrounding it were detached from the wall in order to preserve them from further damage by damp, and framed as separate pictures. Their original arrangement, recorded in a photomontage in R. Durrer's history of the Swiss Guard (Lucerne, 1927, i, pl. xii), an outline sketch of which is given by Kultzen, corresponded exactly with the drawing. When Marabottini visited the church in the 1960s, the four scenes immediately below the lunette could not be found. They must have reappeared, since all four are reproduced in color by Ravelli (pls. iii to vii). Comparison of these illustrations with the black and white reproductions given by Kultzen and Marabottini shows that these four paintings at least have been restored.

Though the name of Polidoro da Caravaggio is traditionally associated with the decoration of the chapel, Vasari does not include it in his list of works by Polidoro in Rome; and the first reference to him in this connection by the early seventeenth-century theoretical writer Giulio Mancini (*Considerazioni sulla Pittura*, ed. A. Marucchi and L. Salerno, i, 1956, p. 269) repeats the tradition only to cast doubt on it: "la cappella della Passione che alcuni dicono esser di Polidoro, ma è . . . d'un todesco." There is no documentary evidence for the authorship of these paintings; in fact the only external evidence is that provided by the drawing. The general layout of the design is exactly the same as that of the chapel, but each individual composition in the drawing differs from the corresponding fresco in a way that indicates unmistakably that it is a preparatory study. The nature of the connection is particularly evident in the *Adoration of the Magi* in the lunette of the chapel (Kultzen, pl. 13a; Marabottini, pl. iv), which is composed of the same elements as the drawing—including the conspicuous horse on the left—but arranged in an entirely different way. Perino's hand is particularly evident in this part of the drawing.

The connection between the drawing and the chapel had not been observed when Kultzen published his article. He argued that the paintings in the chapel were an early essay by Polidoro in the use of color (the greater part of his work in Rome being façade decorations in monochrome), and he supported the attribution by a series of comparisons between them and works certainly by Polidoro, and others by Peruzzi, the Roman artist who had the greatest effect on his development. But these resemblances, as Marabottini observes, are of a very general nature.

In his monograph, Ravelli reproduces the four Passion scenes immediately underneath the lunette—the *Last Supper*, the *Agony in the Garden*, *Christ before Pilate* and the *Flagellation*—as early works of Polidoro, to whom he also attributes the drawing, with the comment that "scambi e interazioni di sensibilità diverse erano frequenti, specialmente fra Polidoro e Perino, creando insolvibili problemi di attribuzione." But from the very first, the drawing styles of these two artists are clearly defined and readily distinguishable.

Marabottini takes the view that the drawing is certainly by Perino, and that it is a preparatory design for the chapel decoration. In it, the three papal coats-of-arms are roughly but unmistakably indicated in the embrasure of the window: Leo X's on the left, Julius II's on the right, and Adrian VI's in the center. It must therefore date from after Adrian's election on 9 January 1522. In the spring of that year the plague broke out in Rome, and Perino took refuge in Florence. Marabottini suggests that Perino made the design in the early part of 1522, and that he began work on the upper part of the wall, as a fresco painter naturally would do for practical reasons; but that after completing the *Adoration of the Magi* in the lunette he was interrupted by the outbreak of the plague. If any trace of Polidoro's intervention is to be seen in the chapel, Marabot-

tini looks for it in the scenes immediately below the lunette, which would have been the next to be executed, and which do contain some features that might in a very general way be described as Polidoresque. If Polidoro was concerned, he may also have broken off, perhaps for the same reason as Perino: he certainly left Rome at about the same time, for his presence is recorded in Naples in March 1524 (see Marabottini, p. 30). The condition of the Passion scenes on either side of the *Crucifixion* made them impossible for Marabottini to judge, but he is surely right in maintaining that neither Perino nor Polidoro can have had any hand in the uninspired composition of the *Crucifixion*, and in his contention that the decoration was completed by the clumsy hand of some unskilled journeyman. Even if there is some echo of Polidoro in such a detail as the figure kneeling in the center foreground of the *Agony in the Garden*, with its hunched pose and mop-like head, the echo is a very faint one; and without the suggestion having been implanted in the mind by the old, but to all appearances not very well-founded, tradition, it may be questioned whether the possibility of Polidoro's authorship of the Cappella della Passione decoration would ever have been seriously considered.

75 Decorative Composition: A Papal Escutcheon and Figures of *Faith* and *Justice* Surrounding a Window RECTO.
Studies of Figures VERSO.

Pen and brown wash over black chalk (recto); black chalk (verso). 323: 231 mm.

PROVENANCE: King George III.

LITERATURE: Anthony Blunt, *Supplement to the Catalogue of Italian Drawings*, no. 465, in Edmund Schilling, *The German Drawings in the Collection of Her Majesty the Queen at Windsor Castle*, [c. 1792]; Gaudioso, no. 68.

Windsor, Royal Library 10894

UNTIL recently in one of the volumes of decorative drawings by followers of Perino del Vaga (Luzio Romano and others) which were thought to be of only architectural interest, and thus overlooked by Popham. It was left to Philip Pouncey to recognize this as a particularly fine example of the hand of Perino himself. In a review of the Schilling-Blunt volume (*Burlington Magazine*, cxv [1973], p. 186) Michael Levey suggested that it might be an early idea for the decoration of the Sala Paolina in the Castel Sant'Angelo (see No. 79), which includes personifications of the *Virtues*. But the windows of the Sala Paolina extend almost to the cornice, and the doorways are differently placed. The style of the drawing also seems earlier than the 1540s, and the architectural feature in the lower left corner has every appearance of being the external frame of a window of the Bramantesque type common in Rome in the early sixteenth century. The drawing is more reasonably explained as a design for part of the decoration of a palace façade in the manner of Polidoro da Caravaggio. The handling suggests a date not in the 1540s but in the period before Perino's departure from Rome in 1527 or 1528: it may be compared with that of a sheet of designs for friezes in the British Museum (Pouncey and Gere 162) probably datable on external grounds before 1527.

The Gaudiosos rightly doubt the connection with the Sala Paolina. They suggest instead that a design by Perino for a frieze, in the Courtauld Institute, London (4673; Rome exh., no. 69), with a papal escutcheon in the center and at each extremity a pair of personifications of *Virtues*, may be connected with the same project as the Windsor drawing. But though the two designs are made up of the same components, none of these is particularly unusual, and the difference in format is surely enough to rule out the likelihood of any closer connection. It is perhaps worth suggesting, in parenthesis, that the Courtauld drawing might be an early idea for the cartoon commissioned from

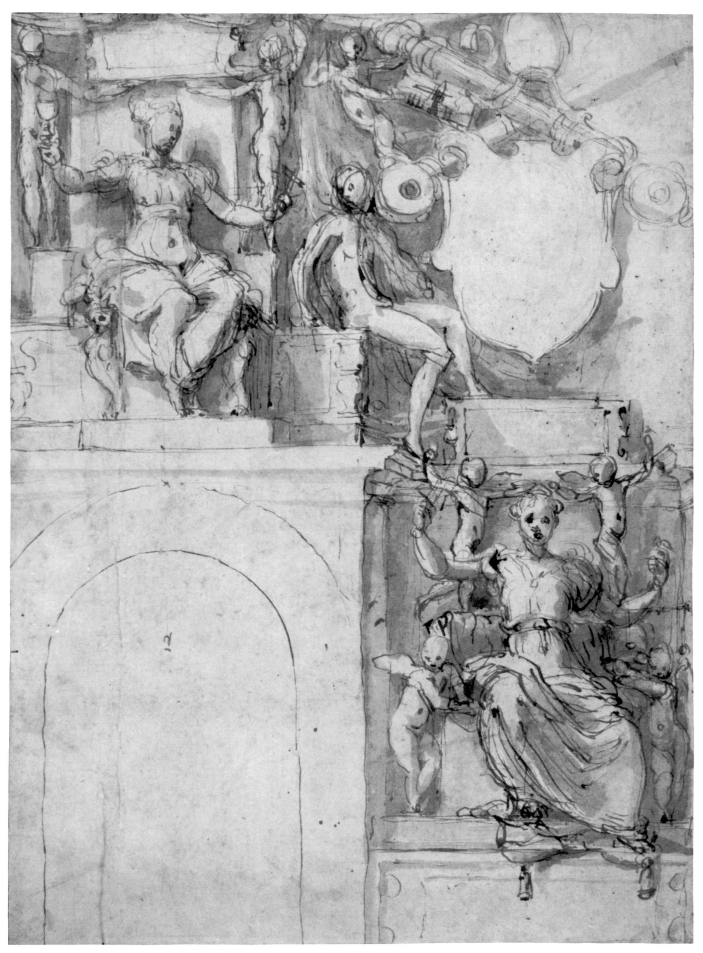

75

75 verso

Perino by Pope Paul III for a tapestry to go underneath Michelangelo's *Last Judgment* in the Sistine Chapel (see Pouncey and Gere 194).

The very slight studies on the verso are mostly for the figures in the recto composition. The one in the center, who is looking downwards with hands outspread, seems to be a sketch for a Christ in a *Last Judgment*.

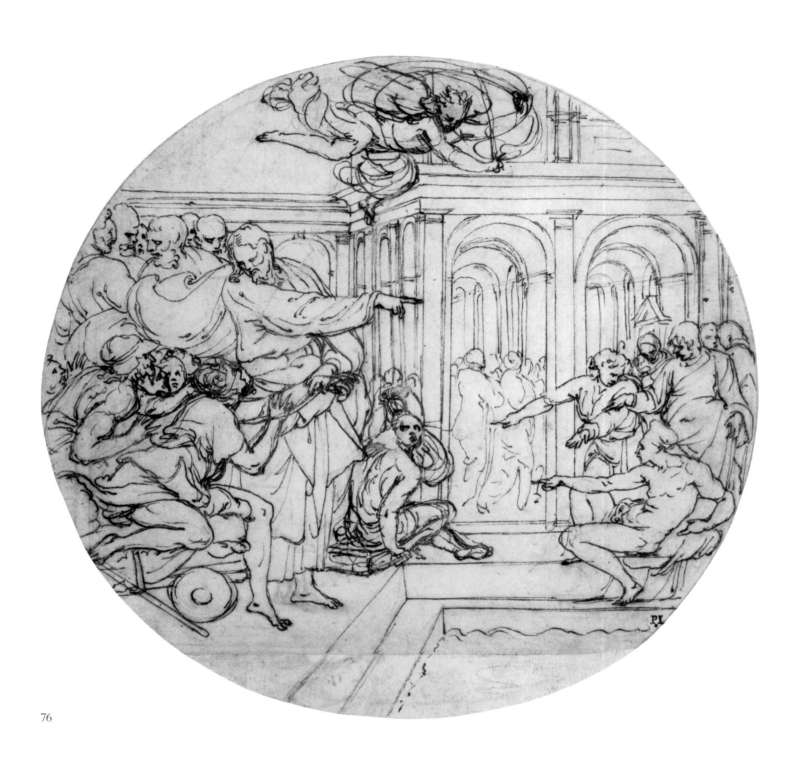

76

76 The Pool of Bethesda

Pen and brown ink. Traces of underdrawing in red chalk. Circular: 204: 201 mm.

PROVENANCE: Sir Peter Lely (Lugt 2092); John Talman (surrounded by one of his characteristic gold-leaf borders); Charles Fairfax Murray; J. Pierpont Morgan.

LITERATURE: Fairfax Murray, iv, no. 47; J. A. Gere, *Burlington Magazine*, cii (1960), p. 13; Bean and Stampfle, no. 85.

The Pierpont Morgan Library IV, 47

THE attribution to Perino del Vaga was made by Otto Benesch in 1940. Fairfax Murray had attributed the drawing to Parmigianino. As Jacob Bean and Felice Stampfle observe, his mistake is surprising in view of the correct attribution of the companion drawing (No. 77); they suggest that he was probably influenced by Bartsch's description of the related chiaroscuro woodcut (see below) as being after Parmigianino.

This drawing and No. 77 are designs for two of a series of six circular rock crystal plaques engraved with subjects from the life of Christ, commissioned by Cardinal Alessandro Farnese from the gem-cutter and medallist Giovanni Bernardi for the decoration of a pair of candlesticks. Vasari describes this commission in his life of Bernardi (v, p. 373), but does not give the name of the designer of the compositions. He lists the subjects of the crystals as *The Centurion Asking Christ to Heal his Son*, the *Pool of Bethesda*, the *Transfiguration*, the *Miracle of the Loaves and Fishes*, the *Expulsion of the Money-Changers from the Temple* and the *Raising of Lazarus*. Two of the crystals were identified by V. Slomann in the Museum of Decorative Art (Kunstindustrimuseet) in Copenhagen (*Burlington Magazine*, xlviii [1926], p. 20) and three—including the *Pool of Bethesda*—by E. Kris in the Treasury of St. Peter's (*Dedalo*, ix [1928–29], pp. 97 ff.). The sixth crystal, of the *Miracle of the Loaves and Fishes*, has disappeared, but there can be no doubt that No. 77 is a study for it.

Drawings by Perino for the *Raising of Lazarus* and the *Expulsion of the Money-Changers* are respectively in the Louvre (RF 239; *Autour de Raphaël*, no. 95) and in Munich (2504 verso; Gere, p. 11, fig. 13); those for *Christ and the Centurion* and the *Transfiguration* were identified in a European private collection by Bernice Davidson, to whom I am indebted for the information and for permission to publish her discovery (Figs. 76a–b). A second drawing of the *Transfiguration*, also at Munich (2485; Gere, p. 11, fig. 14), in which the composition, though identical, is enclosed in an oval, presumably represents an earlier phase of the project. Another drawing of the *Miracle of the Loaves and Fishes*, corresponding exactly with No. 77 but in pen and ink only, has recently come to light in a private collection in London (Fig. 76c). In technique it resembles No. 76, and is certainly from the hand of Perino himself. It is inscribed in the exergue, apparently by the draughtsman,

Fig. 76a Perino del Vaga. *Christ and the Centurion*. Private Collection.

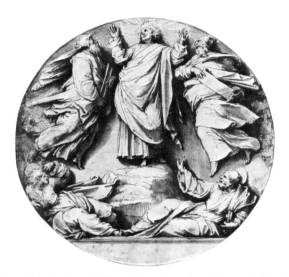

Fig. 76b Perino del Vaga. *Transfiguration*. Private Collection.

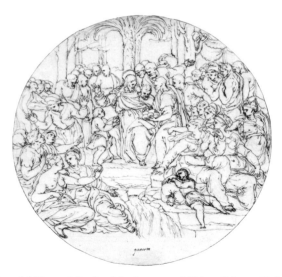

Fig. 76c Perino del Vaga. *Miracle of the Loaves and Fishes*. Private Collection, London.

with the word *quarto*. An even more rapid pen and ink drawing for the *Expulsion of the Money-Changers*, in the Nationalmuseum in Stockholm (NMH 256; Richard Harprath, *Papst Paul III als Alexander der Grosse*, Berlin-New York, 1978, fig. 46), Perino's authorship of which was first recognized by Harprath, is similarly inscribed *qui[n]ta*. (In Vasari's list of the crystals, these subjects are respectively the fourth and fifth.) In all these drawings the composition is closed at the bottom by an exergue, but in No. 76 this has been cut off and the drawing continued by a later hand on the made up area.

All the evidence suggests that the six crystal designs were adapted from the six rectangular compositions representing the same apparently random choice of episodes from the life of Christ which Perino had painted on the sidewalls of the Massimi Chapel in S. Trinità dei Monti, and which had attracted the admiration and interest of Cardinal Alessandro Farnese. When Perino finally returned to Rome after an absence of ten years (probably towards the end of 1537 or early in 1538), he found himself forgotten. Vasari describes the difficulty he had in reestablishing himself, and particularly his failure to attract the all-important patronage of Cardinal Farnese, the Pope's nephew; but how, after "many months" of inactivity, he secured the commission for the Massimi Chapel—"and that work, and all the drawings that he made for it, led the Cardinal to take him into his service and to employ him on many undertakings." The crystal commission must have been one of the earliest of these. Its date is established by a letter of 29 July 1539 in which Bernardi informed the Cardinal that "ho fatto far tutti li cristalli de li candalieri" (see Slomann, ut cit., p. 19), a sentence interpreted by Kris as meaning that the blank crystals were then ready to be engraved.

Perino's work in the Massimi Chapel was swept away in the early nineteenth century (see *Autour de Raphaël*, p. 133). Our knowledge of its appearance is based on Vasari's description, and on two pen and ink drawings by Perino for the decoration of the side walls of a chapel. One, in the Victoria and Albert Museum (Ward-Jackson Catalogue, 1979, no. 362; Gere, p. 12, fig. 16), is inscribed with the word *Massimi* and agrees exactly with Vasari's account in being composed of an elaborate stucco framework enclosing three upright rectangular spaces, each inscribed with the word *storia* and obviously intended for frescoes, the one in the center being very much larger than those on either side. In the other drawing, in the British Museum (Pouncey and Gere 169★), a cartouche in the frame surrounding the central space is inscribed by the draughtsman *probatica piscina* (the Italian term for the Pool of Bethesda).

Vasari says that the two larger frescoes in the chapel were the *Pool of Bethesda* and the *Raising of Lazarus*. A detached fresco of the latter subject, by coincidence also in the Victoria and Albert Museum (C. M. Kauffmann, *Catalogue of Foreign Paintings*, i, 1973, no. 271; Gere, p. 8, fig. 8), corresponds in format with the central space in the drawings of the chapel wall; and in the disposition of the figures (allowance being made for the difference in shape) with the circular crystal design in the Louvre. The traditional

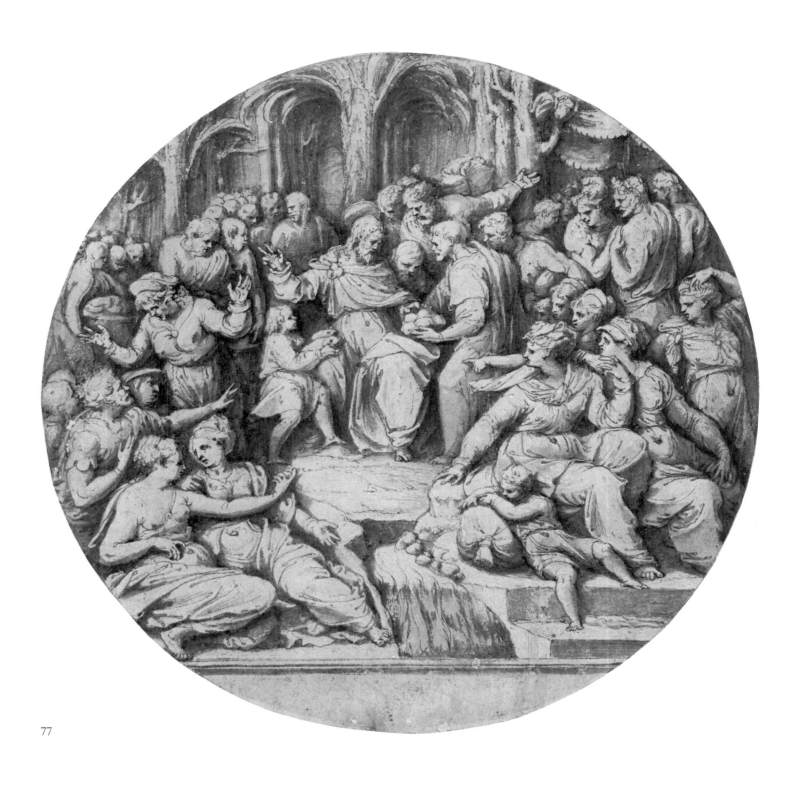

77

attribution to Perino is confirmed by the style of the preparatory study formerly in the collection of Mr. and Mrs. Hugh Squire (Sotheby's, 28 June, 1979, lot 58; Gere, p. 8, fig. 9). A rectangular composition of the *Pool of Bethesda*, of which there is a chiaroscuro woodcut (Bartsch xii, p. 38, 14, as "after Parmigianino") is of the same format as the fresco and corresponds exactly with the crystal design in the principal group of Christ and the cripple in the left foreground. It seems reasonable to suggest that the four smaller frescoes, of which no trace remains, bore much the same relation to the corresponding crystal designs.

77 The Miracle of the Loaves and Fishes

Pen and brown wash, with touches of white heightening. Circular: 213 mm.

PROVENANCE: Charles Fairfax Murray; J. Pierpont Morgan.

LITERATURE: Fairfax Murray, i, no. 21; Bean and Stampfle 86; J. A. Gere, *Burlington Magazine*, as cited in No. 76.

The Pierpont Morgan Library I, 21

Traditionally attributed to Perino del Vaga. See No. 76.

78 A Female Figure Symbolizing *Prudence,* Standing in a Niche

Pen and brown ink and gray wash. Traces of underdrawing in black chalk, particularly on the left arm. 257: 141 mm.

PROVENANCE: Commendatore (?) Gelosi (Lugt 545 and *Supplément*); Professor John Isaacs (sale, Sotheby's, 1964, 27 February, lot 15).

LITERATURE: Bean and Stampfle 87; Richard Harprath, *Papst Paul III als Alexander der Grosse,* Berlin-New York, 1978, p. 73; Gaudioso, ii, p. 135, no. 81; Bean and Turčić 168.

The Metropolitan Museum of Art, Rogers Fund 64.179

INSCRIBED in ink in lower right corner: *P.D.V.* The same inscription occurs on another drawing by Perino for another detail of the decoration of the same room, also from the Gelosi Collection and now in a private collection in London (*Burlington Magazine,* cii [1960], p. 17, fig. 25).

Bernice Davidson was the first to identify No. 78 as a study for the figure on the east sidewall of the Sala Paolina in the Castel Sant'Angelo (Harprath, fig. 21). The correspondence is very close, except that the painted figure does not carry a staff in her left hand but clutches a bunch of her drapery.

The drawing is a fine example of the graceful and elegant decorative style which Perino developed from the aspect of the art of Raphael that most appealed to him.

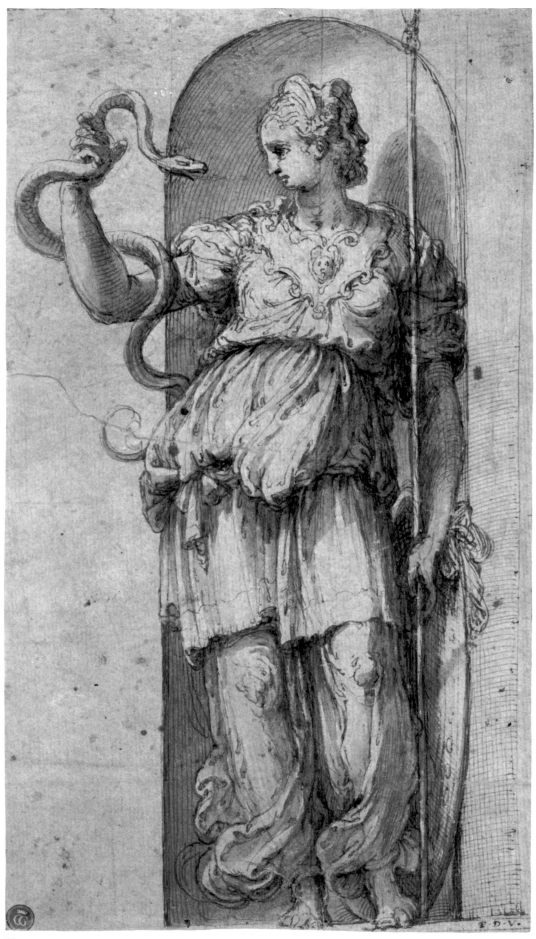

78

79

79 Alexander the Great Cutting the Gordian Knot

Pen and brown ink and gray wash, with a few touches of white heightening. Squared in black chalk. 190: 112 mm.

PROVENANCE: French private collection (sale, Paris, Nouveau Drouot, Salle 7, 1983, 10–11 October, lot 71); John Morton Morris, London.

LITERATURE: Lawrence Turčić, *The Metropolitan Museum of Art: Notable Acquisitions, 1984–1985*, p. 29 (repr. in color).

The Metropolitan Museum of Art, Harry G. Sperling Fund 1984.413

THIS hitherto unknown drawing, described in the Drouot sale catalogue as "Ecole de Polidoro da Caravaggio," was identified by Lawrence Turčić as a study by Perino del Vaga for one of the five large scenes from the life of Alexander the Great which are the chief feature of the decoration of the walls of the Sala Paolina, the principal state apartment on the top floor of the Castel Sant'Angelo. The theme of Alexander the Great was chosen in allusion to the baptismal name of Pope Paul III, who commissioned the decoration of these rooms and who had been Cardinal Alessandro Farnese (see Richard Harprath, *Papst Paul III als Alexander der Grosse*, Berlin-New York, 1978). Gordius, king of Phrygia, had dedicated his chariot to Jupiter, and fastened the pole to the yoke by a knot of bark. An oracle declared that whoever could untie the knot should be ruler of all Asia. Alexander solved the problem by cutting the knot with his sword.

Work began on the construction of the state apartments in 1542 or 1543. The first reference to Perino in the records of payment is dated 20 June 1545; the first payment to him for the decoration of the walls of the Sala Paolina was made on 9 January 1547 and the last on 25 September of the same year, less than a month before his death (19 October 1547). In the past, critics tended to attribute much of the decoration of the walls, including the Alexander scenes, to the youthful Pellegrino Tibaldi, who in 1547 would have been about twenty years old, and who is recorded by Vasari as having executed "in Castel Sant'Angelo alcune cose d'intorno all'opere che fece Perino del Vaga," but the evidence of preparatory drawings establishes beyond any doubt that the entire scheme of the wall decoration, including the design of the Alexander scenes, was due to Perino (see J. A. Gere, *Burlington Magazine*, cii [1960], pp. 14 ff.; M. Hirst, ibid., cvii [1965], pp. 568 ff.; Harprath, op. cit., pp. 79 ff.). The scene *Alexander and the Family of Darius* differs from the other four, notably in the way that the feet and helmet plumes overlap the frame so that the figures seem to be bursting out of it. It has been suggested that Tibaldi executed the fresco after Perino's death and transformed his design in this way.

Preparatory studies by Perino for two other Alexander scenes, one in a private collection in London (Gere, op. cit., p. 17, fig. 25; Gaudioso 73) and the other in that of Mr. Ian Woodner (Gaudioso 74), are larger and more roughly executed than No. 79. They agree with the corresponding frescoes in all essentials. The fresco of *Alexander Cutting the Gordian Knot*, on the other hand, is in the center of the unbroken long wall of the Sala and is considerably wider than the scenes on either side. It differs from the drawing (the composition of which was intended to be complete, as is clear from the framing lines surrounding it) in the addition of another standing figure on the left.

The yellowish-brown monochrome of the Alexander scenes, and the way in which the figures (with the exception of those in *Alexander and the Family of Darius*) are cramped into the frame and seem to be compressed into a shallow space immediately behind the picture plane, were clearly intended to suggest the effect of sculptured reliefs set into the wall. Polidoro da Caravaggio's façade decorations were designed according to the same convention, as simulated reliefs in brown or gray monochrome. The Alexander scenes, which were Perino's very last works, demonstrate the persistence of Polidoro's influence on him.

POLIDORO CALDARA, CALLED POLIDORO DA CARAVAGGIO

CARAVAGGIO (LOMBARDY) c. 1500–c. 1536 MESSINA

80 The Holy Family

Brush drawing in black wash, heightened with white, on dark greenish-gray prepared paper. 210: 158 mm.

PROVENANCE: J. A. Hall, from whom purchased in 1954.

LITERATURE: Parker 481; Marabottini 10; Ravelli 8.

Ashmolean Museum P II 481

THE traditional attribution to Polidoro was followed by Parker, and accepted by Marabottini and by Ravelli who agree in considering the drawing a very early work. It does indeed seem to reveal, in an embryonic form, the personality characteristic of the artist's maturity. In technique it may be compared with the grisaille

80

fresco of *Domine, quo vadis?* in one of the window embrasures of the Stanza dell'Incendio; there is no documentary or traditional evidence for the authorship of these subsidiary details of the decoration (usually invisible because concealed behind the window shutters), but Ravelli's attribution to Polidoro of this grisaille and its companion, *The Fall of Simon Magus* (his p. 38, figs. A and B) deserves consideration.

81 Studies of a Face, and a Right and Left Arm and a Hand, Each Holding a Book RECTO. A Right Hand Holding a Book VERSO.

Red chalk. The top corners cut. Maximum measurements: 206: 149 mm.

PROVENANCE: Sir Peter Lely (Lugt 2092); William Gibson (the pen and ink inscriptions *2.3* on the verso and *6.3* on the old backing are the pricing code devised by him for the guidance of his widow when selling his collection of drawings, and indicate respectively ten shillings and thirty shillings: see under Lugt 2885 and in *Supplément*); William, 3rd Duke of Devonshire? (recorded as having had first pick of the Gibson collection: see Lugt, ut cit.); his brother, Lord James Cavendish (the drawing was in an album with an eighteenth-century binding, other drawings in which bear the collector's mark of N. A. Flinck, whose collection was bought in 1723 by the 2nd Duke of Devonshire. Facsimile engravings by Arthur Pond, one dated 1734, of three drawings in the album are inscribed *E Museo Praehon^lis Dni Dni Jacobi Cavendish*); said to have belonged to the family of his great-great-nephew, Charles Cavendish, 1st Lord Chesham; then by descent until acquired c. 1950 by Mr. L. Colling-Mudge, from whom the album was purchased by the British Museum with the help of a substantial contribution from the National Art-Collections Fund.

LITERATURE: Pouncey and Gere 197; Marabottini 60/61; Ravelli 150/151.

British Museum 1952–1–21–80

INSCRIBED on verso in ink, probably by Gibson: *Raffaello d'Urbino*. Philip Pouncey's convincing attribution to Polidoro is supported by the soft modelling of the face and the unidealized adolescent features which seem somehow too large for the oval circumscribing them: compare, for example, the sketches of a boy's head on a sheet in Mr. Pouncey's own collection (Marabottini 92/93, Ravelli 148/149). To judge from the downcast gaze and the gesture with which the book is held, the studies on No. 81 are for a *Virgin and Child* in which the Virgin is shown reading. The drawing is certainly of a young man, not a young woman as Marabottini and Ravelli maintain. Polidoro must have followed Raphael's practice of using a *garzone di bottega* as model for a female figure.

The dating of Polidoro's drawings is very much a matter of intuition. Both Marabottini and Ravelli place this drawing in the Messinese period of his activity, c. 1530. Pouncey and Gere, on the other hand, argued that "the academic carefulness of the

81

drawing of the sleeve and hand and the fine cross-hatching suggest an early date when [Polidoro] was still under the immediate inspiration of Raphael."

1952–1–21–80

81 verso

82 A Deathbed Scene RECTO.
A Seated Woman VERSO.

Red chalk. 210: 290 mm.

PROVENANCE: Robert Udny (Lugt 2248); Sir Thomas Lawrence (Lugt 2445); anonymous sale, Sotheby's, 1963, 12 March, lot 21.

LITERATURE: *Lawrence Gallery*, 7th Exhibition ("Zucchero, Andrea del Sarto, Polidoro da Caravaggio and Fra Bartolommeo"), 1836, no. 47; Marabottini 51/52 and p. 253; Ravelli 52/53.

Washington, Mr. David E. Rust

As Polidoro in the *Lawrence Gallery* catalogue and subsequently. Marabottini refers to an observation (apparently an oral one) by Konrad Oberhuber, that the recto is related to a painting in the Palazzo Baldassini in Rome. This fresco is reproduced by Catherine Dumont (*Biblioteca Helvetica Romana XII: Francesco Salviati au Palais Sacchetti et la décoration murale italienne (1520–1560)*, Rome, 1973, pl. x, fig. 21), and according to her it is part of the frieze of a small room adjoining the *salone* on the first floor of the palace. The decoration of the *salone* was carried out by Perino del Vaga in the early 1520s (see Vasari, v, pp. 598 f. and Bernice Davidson in *Master Drawings*, i, 3 [1963], pp. 9 f.), and it has been generally assumed that Perino was also responsible for that of the adjacent room. Both Marabottini and Ravelli rightly observe that the drawing has the character of a preliminary sketch rather than a copy, and suggest that Perino may have been provided with a design by Polidoro, who is recorded by Vasari (v, p. 146) as having also worked in the palace. This instance of apparent collaboration between the two artists is seen by Marabottini as a parallel in reverse to that of the Cappella della Passione in the church of S. Maria della Pietà in Camposanto, supposedly decorated by Polidoro on the basis of a design supplied by Perino (see No. 74). But though the drawing for the Cappella della Passione is undoubtedly by Perino, it is by no means certain that Polidoro had any share in the decoration; and it seems evident, even from a small-scale reproduction of the Palazzo Baldassini painting, that it is by Polidoro. Vasari describes Melchiorre Baldassini's search for a painter to decorate the *salone* of his palace: "esaminati molti di que' giovani, acciochè ella fusse bella e ben fatta; si risolve dopo molti darla a Perino." The "giovani" whom he considered employing must have included Polidoro and his partner Maturino, who according to Vasari (v, p. 146) "nella casa di Baldassino fecero graffiti e storie, e nel cortile alcune teste d'imperadori sopra le finestre." As Ravelli points out, the wording implies that they worked inside the palace as well as on the facade of the courtyard. It seems reasonable to suppose that they did so at about the same time as Perino. The death of Melchiorre Baldassini in 1525 establishes a *terminus ante quem*, but Miss Davidson dates Perino's paintings in the *salone* as early as c. 1520–21.

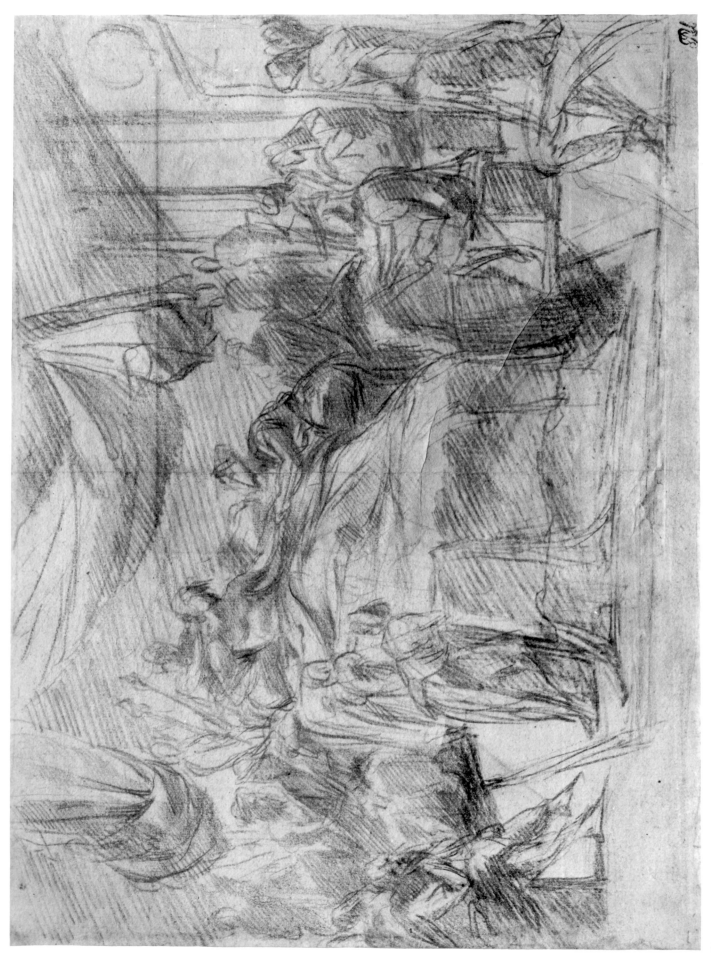

The subject represented can be determined only by reference to the iconography of the other paintings in the frieze. Marabottini entitles the drawing "Alexander and his Physician," but without giving any reason for doing so.

The woman on the verso, holding a cloth out in front of her, looks like an attendant in a birth scene, but she could be an alternative for the figure in the left foreground of the recto composition.

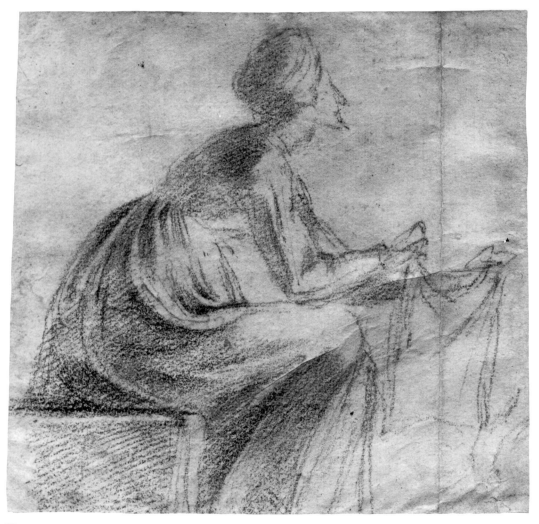

82 verso

83 The Betrayal of Christ

Drawn with the point of the brush in black and gray wash and white bodycolor on dark blue-washed paper. 212: 263 mm.

PROVENANCE: Paul Sandby (Lugt 2112); Sir Thomas Lawrence (Lugt 2445); William Mayor (Lugt 2799: *Descriptive Catalogue of Mr. Mayor's Collection*, 1871 and 1874 eds., no. 63, 1875 ed., no. 43); acquired for the Royal Library in 1875.

LITERATURE: H. Voss, *Malerei der Spätrenaissance in Rom und Florenz*, 1920, p. 76, n.: E. Kris, *Meister und Meisterwerke der Steinschneidekunst*, 1929, pp. 50 ff.; Popham, *Windsor*, no. 692; Marabottini 196; Ravelli 975.

Windsor, Royal Library 050

INSCRIBED in ink in an eighteenth or nineteenth-century hand: *Garofalo*, and so attributed on the facsimile engraving in C. M. Metz's *Imitations of Ancient and Modern Drawings*, 1798 (Weigel 2697).

Voss's brief allusion to this drawing as a design for an oval plaquette by the gem engraver Valerio Belli (c. 1480–1546) was amplified by Kris. The same composition occurs on an engraved rock crystal in the Vatican Library, one of a series of three, each signed by Belli, representing episodes from the Passion of Christ (Kris, figs. 161, 163, 164). The subjects of the others are *Christ Carrying the Cross* and the *Lamentation*. Together with them is an engraved crystal crucifix, also signed by Belli (Kris, fig. 165), obviously intended to be mounted on a metal base into which the three oval plaques were presumably to have been set.

The erroneous attribution to Benvenuto Garofalo (1481–1559), the so-called "Ferrarese Raphael" was maintained in the three catalogues of the Mayor Collection. Voss gave the drawing to Perino del Vaga, who is recorded as having made some of the designs for the oval crystal plaques in the Farnese Casket in the Naples Museum, engraved c. 1543–44 by Giovanni Bernardi da Castelbolognese (see Pouncey and Gere, under no. 171). Antal's oral suggestion of Polidoro was followed by Popham but not by Marabottini or Ravelli. Marabottini, while admitting that there are Polidoresque features in the drawing, found certain "mannerisms and stylizations" impossible to reconcile with his conception of Polidoro himself. Ravelli gave it to Polidoro's Bolognese imitator, Biagio Pupini (d. after 1575); but comparison with any example of Pupini's characteristic messy and incoherent drawing style (e.g. the drawing of the same subject, also at Windsor, Popham, no. 781) reveals in No. 83 a personality very much more intelligent and controlled.

Perino del Vaga does seem to have been involved in the design of at least one of the three oval crystals. The difficulty of working a very hard material like rock crystal, often on a smaller scale than the original design, makes for a degree of simplification

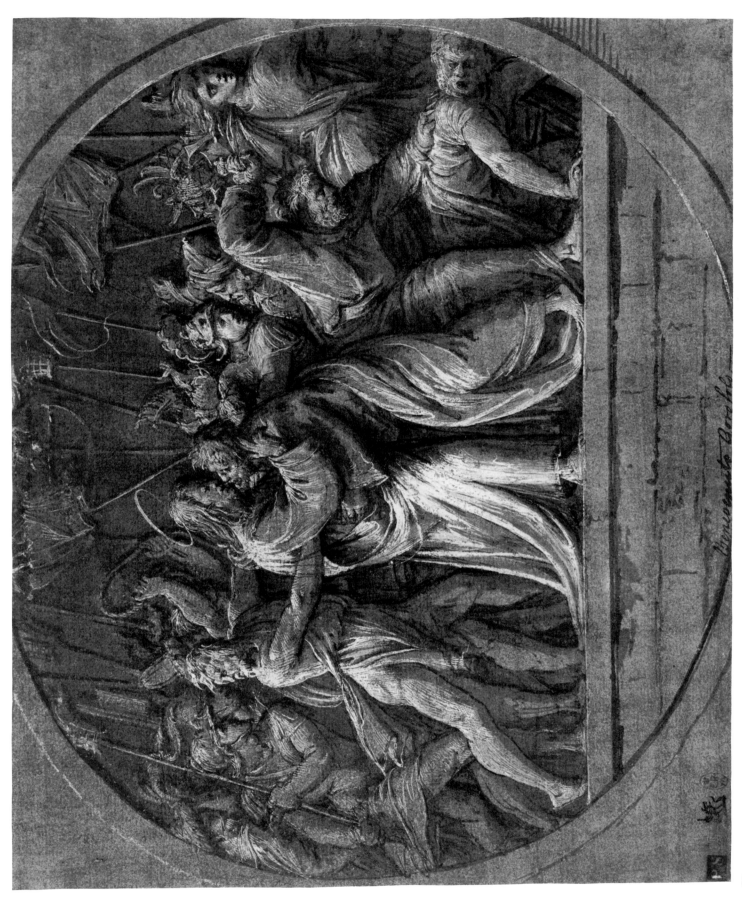

and distortion that sometimes obscures the individual style of the designer. In the *Lamentation* crystal, however, the standing figure on the left seems unmistakably Perinesque, not only in the *contrapposto* pose but also in the profile of the face and the treatment of the hair and beard (Kris fig. 177 is a better reproduction, apparently taken from a bronze cast). But in the half century that has elapsed since the publications of Voss and Kris, Perino's drawing style has become well defined and it is now evident that he cannot have been responsible for the *Betrayal* drawing. At the same time, it is possible to sympathize with Marabottini's doubts about the Polidoro attribution (though his eventual conclusion, that the drawing is the work of an unidentified "master active in Rome between 1520 and 1525" would have been more convincing if he had been able to point to other examples from the hand of this draughtsman). No. 83 is not what might be called a "central" Polidoro drawing, in which his hand is immediately recognizable; but it could still be argued that the underlying personality is consistent with his; that there are morphological similarities, such as the triangular mask of the figure on the extreme right; and that the admittedly somewhat unfamiliar appearance of the drawing may be due to its being a design for a small-scale intaglio. The conception of the design is exactly the same as that of Polidoro's frieze-like façade paintings, which it further resembles in showing the figures on a platform just above the level of the spectator's eye; as John Pope-Hennessy (*The Study and Criticism of Italian Sculpture*, 1980, pp. 216 f.) was the first to point out, in the crystal the design was adjusted so that the floor of the platform is slightly below the spectator's eye level.

Nothing is known of the history of the three oval crystals and the cross before they were discovered in Bologna in 1857 and acquired by Pius IX for the Vatican Library, but they are generally identified with the "croce di cristallo divina" made for Clement VII, for which Valerio Belli received a payment of 1111 gold ducats in 1525 (cf. Vasari, v, p. 380). Kris's insistence that they must date from c. 1540 is based on his erroneous belief that the Windsor drawing is by Perino and of the period of the designs for the Farnese Casket. If the drawing is by Polidoro, who left Rome for good in 1527, this would confirm the earlier dating. Perino was also in Rome in the years before 1527.

84 A Cavalry Battle

Red chalk. 202: 284 mm.

PROVENANCE: Boguslaw Jolles (Lugt 381ᵃ); anonymous sale, Christie's, 1984, 13 December, lot 33.

LITERATURE: David McTavish, *Italian Drawings from the Collection of Duke Roberto Ferretti*, exh. National Gallery of Ontario, Toronto, and The Pierpont Morgan Library, New York, 1985–86, no. 2; J. A. Gere, *Master Drawings*, xxiii–xxiv (1985–86), p. 67.

Montreal, Duke Roberto Ferretti

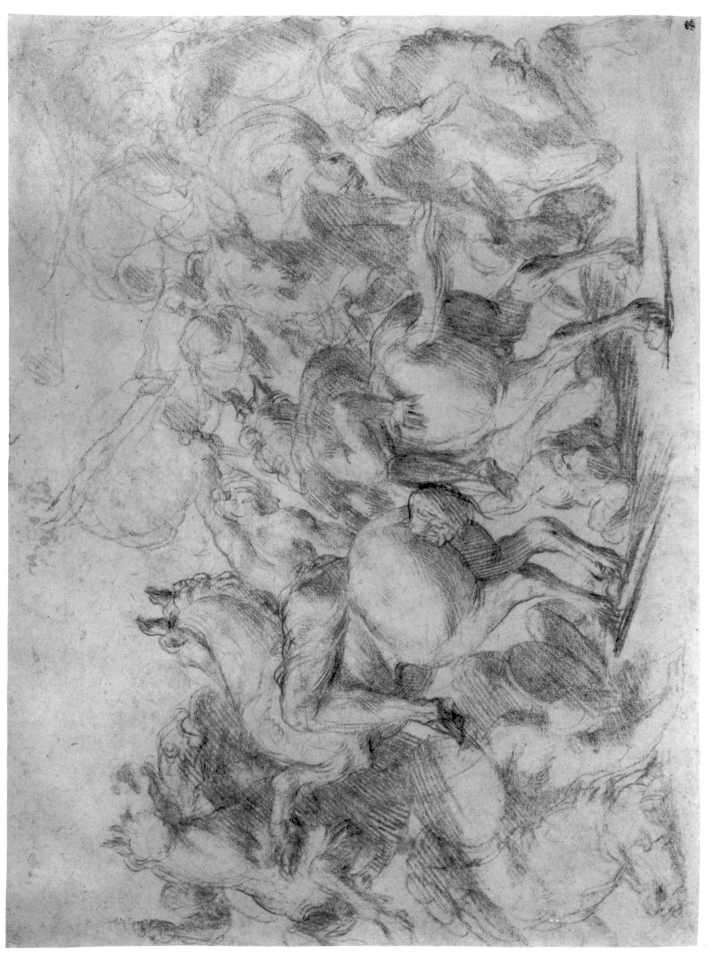

INSCRIBED on verso in red chalk in a sixteenth-century hand: *d'mà Propria d'Raffaiel d'Vr^{no.} C. 3.* The attribution to Polidoro was first put forward in Christie's sale catalogue. The composition owes an obvious debt to Raphael's *Battle of Constantine* and to such drawings by him as the *Cavalry Skirmish* at Chatsworth (British Museum 1983, no. 114), but Polidoro has developed much further the tendency towards Mannerism implicit in his master's late works.

85 The Holy Family with St. Anne and the Infant Baptist

Pen and brown ink and brown and grayish-brown wash over black chalk, heightened with white. Partly squared in pen, lower right and lower left. 177: 228 mm.

PROVENANCE: Pierre Crozat; Jean-Denis Lempereur (inscribed in ink on back of Mariette's mat, within stamped border Lugt 3000: *Polidor de Caravage de Cabinet Crozat, Mariette et Lempereur*); Pierre-Jean Mariette (Lugt 1852); Count Jan Pieter van Suchtelen (Lugt 2332); Eugène Rodrigues (Lugt 897).

LITERATURE: E. Pillsbury and J. Caldwell, *Sixteenth Century Italian Drawings: Form and Function*, exh. Yale University Art Gallery, 1974, no. 6.

Princeton, New Jersey, Mr. Joseph F. McCrindle

THE sheet, numbered in ink in lower right corner *16.2*, is on one of Mariette's gray-blue mats with a cartouche inscribed: *POLIDORI CARAVAGIENSIS*. The dating of Polidoro's drawings is as often as not a matter of intuition, but the authors of the Yale exhibition catalogue are no doubt right in placing No. 85 in the period 1520 to 1525. It certainly seems to belong to an earlier rather than a later phase of the artist's independent career, and illustrates his tendency to interpret such subjects in terms of a kind of rustic genre. A previously unpublished drawing in red chalk (*Master Drawings*, xxiii–xxiv, no. 1 [1985–86], pl. 37) could be a more compact solution for the same group, without the St. Anne.

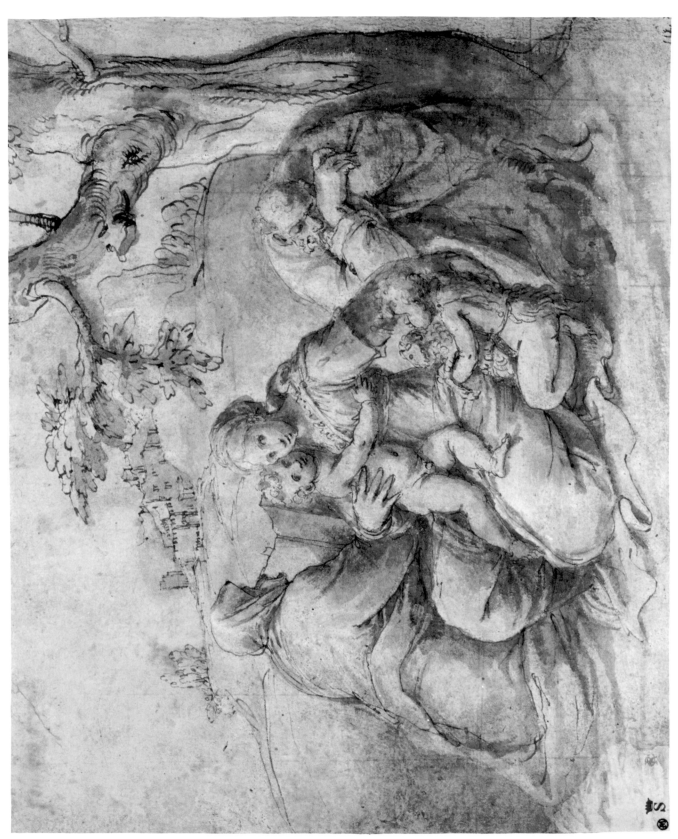

86 The Holy Family Surrounded by Worshipping Figures

Pen and brown wash, heightened with white, on brown-washed paper. Top edge irregularly torn. 204: 284 mm.

LITERATURE: Bean and Stampfle 72; Marabottini 76; Ravelli 119.

New York, Robert and Bertina Suida Manning

AN indistinct inscription in ink in the lower left corner seems to read: *Polidoro*. As Jacob Bean and Felice Stampfle pointed out, the subject cannot be the Adoration of the Magi, as has sometimes been suggested; nor, clearly, is it the Adoration of the Shepherds. Ravelli has suggested that some of the figures (presumably those in the trees in the upper part) are the Patriarchs and Prophets from the Old Testament, and that the others represent suffering humanity. Though there does not seem to be any very compelling reason for identifying any of the figures as Patriarchs or Prophets, this general interpretation may well be correct. Many of Polidoro's drawings reveal a vein of harshly realistic sympathy with human suffering and the dignity of poverty.

Bean and Miss Stampfle observe that the motif of onlookers clinging to trees is a feature of the altarpiece of *Christ Carrying the Cross* now in the Naples Gallery which Polidoro painted in 1534 for the church of the Annunziata dei Catalani in Messina, and date the drawing at about the same time.

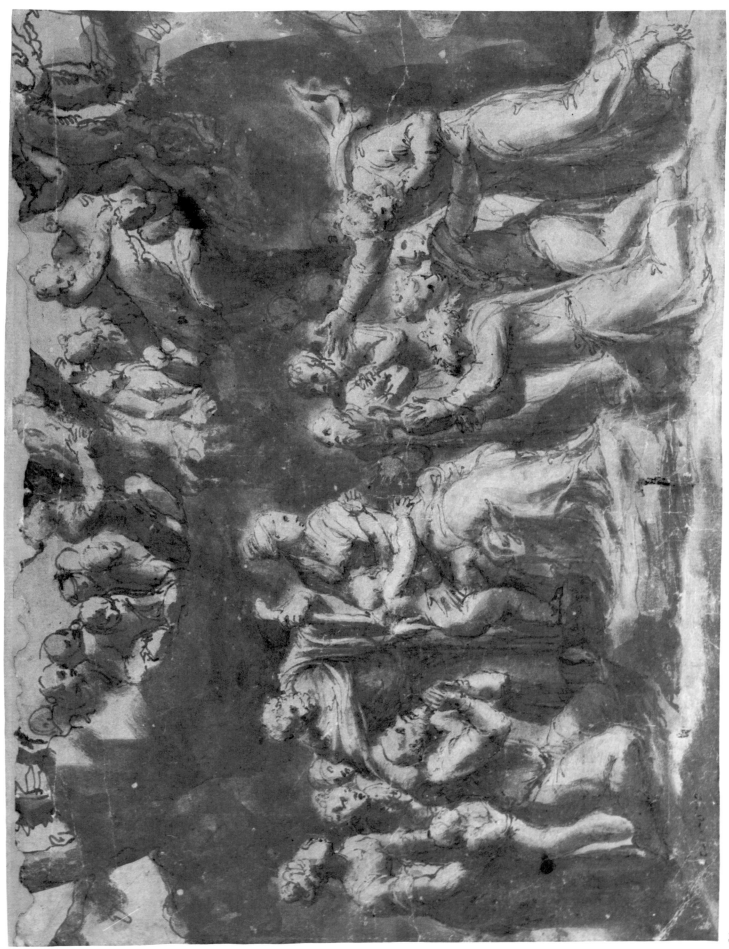

87 A Prisoner Brought before a Judge

Pen and brown and gray wash over black chalk, heightened with white. The vertical framing lines drawn with a ruler. 165: 231 mm.

PROVENANCE: Count Nils Barck (Lugt 1959. An inscription in pencil on the mat, *Crozat, De Tessin, Queen of Sweden [Ulrica], Count de Steenbock, Count de Barck*, is presumably copied from one in Barck's hand like Lugt 3006ᶜ. Lugt explains this provenance in detail in his articles on Barck and on Count Carl Gustav Tessin [his 2985]. Tessin, who was Swedish ambassador in Paris from 1739 to 1742, bought largely at the sale of Pierre Crozat's collection of drawings in 1741. His collection of drawings and prints, which he sold to King Adolf Frederick of Sweden in 1750, is the nucleus of that now in the Nationalmuseum in Stockholm. He had, however, kept back 88 of the best drawings, which he gave to Adolf Frederick's wife, Queen Louisa Ulrica. She bequeathed them to her daughter, Princess Sophia Albertina, from whom they passed to Count Gustav Harold Stenbock, whose son, at some time in the middle of the nineteenth century, exchanged them with Barck for a collection of Antique bronzes); Charles Fairfax Murray; J. Pierpont Morgan.

LITERATURE: Fairfax Murray, i, no. 20; Bean and Stampfle 71; Marabottini 30; Ravelli 30.

The Pierpont Morgan Library I, 20

TRADITIONALLY attributed to Polidoro, this drawing is evidently a design for a detail of a façade decoration, and a characteristic example of his mature Roman drawing style. A large detached fresco in grisaille of a similar subject (Marabottini, pl. cxxxiv and Ravelli, pl. x), now in one of the rooms of the Circolo Uffiziale on the ground floor of the Palazzo Barberini, is recorded in the Barberini Archives as having been transferred in 1633 by order of Cardinal Antonio Barberini from a façade in the Piazza Madama, presumably the one described by Vasari (v, p. 146) as representing "trionfi di Paolo Emilio ed infinite altre storie romane"; but this motif is a not unusual one in Roman façade decoration, and the treatment of it in the drawing does not seem close enough to establish a direct connection.

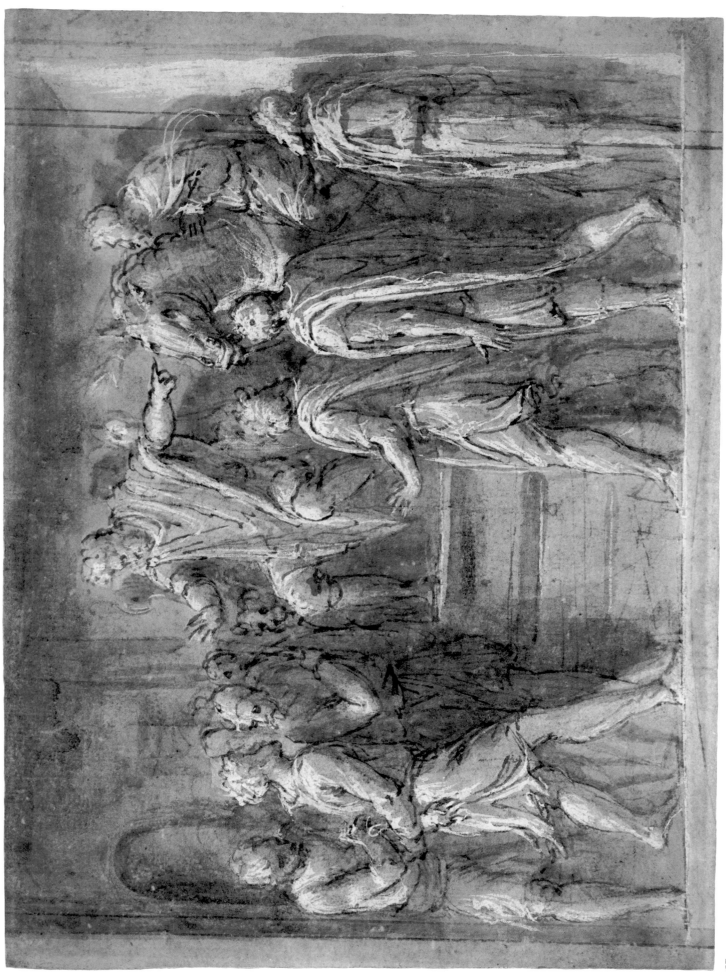

88 The Virgin and Child with Saints

Pen and brown wash, heightened with white. 233: 192 mm.

PROVENANCE: baron Dominique Vivant-Denon (Lugt 779); Robert Stayner Holford (Lugt 2243); Mr. and Mrs. Hugh Squire (sale, Sotheby's, 1979, 28 June, lot 20).

LITERATURE: Ravelli 7.

Vermeer Associates — On loan to the Harvard University Art Museums (Fogg Art Museum)

ATTRIBUTED to Polidoro by Popham. A rapid sketch for the whole composition is on a sheet of studies in the Metropolitan Museum (1972.118.270; Bean and Turčić 188; Marabottini 166; Ravelli 265). A study for the group of the Virgin and Child is at Chatsworth (650; Ravelli 435), and one for the pair of saints in the left foreground (Ravelli 234) belongs to Philip Pouncey. Marabottini refers to Pouncey's discovery of yet another related drawing, in the Albertina (Wickhoff, S. R. 22, as Traini).

Ravelli dated No. 88 at the very beginning of Polidoro's career: it seemed to him to reflect knowledge of such Florentine masters as Andrea del Sarto and Fra Bartolommeo whose work would presumably have been studied by the youthful Polidoro on his way to Rome, and also of such North Italians as Lotto and Pordenone. The Metropolitan Museum sheet, on the other hand, he places in the 1530s, in Polidoro's Messinese period, and makes the farfetched assumption that the theme was taken up after a long interval.

Marabottini is surely right in his late dating of both drawings. No. 88 is too developed to be a work of the early Roman period. A striking feature, characteristic of Polidoro's mature style, is the high, shallow-curved architectural screen behind the group. A similar screen, with the same fluted Corinthian pilasters, of a graceful elegance which anticipates the refinement of Louis XVI Neo-Classicism, is a feature of the drawing of the *Circumcision* in the Uffizi (9004ˢ; Ravelli 144), which Ravelli rightly places in the Messinese period. It is unnecessary to go to Andrea del Sarto or Fra Bartolommeo for a source for the formal arrangement of the enthroned Virgin and Child flanked by pairs of standing saints. The composition is more easily explained as a reminiscence of Raphael's *Madonna del Baldacchino* of 1507–8.

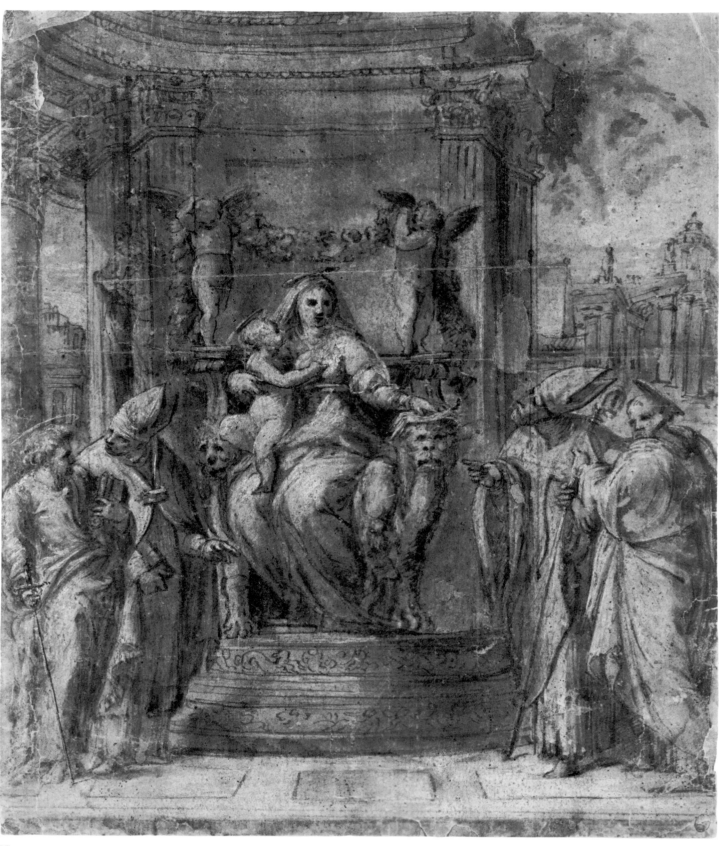

88

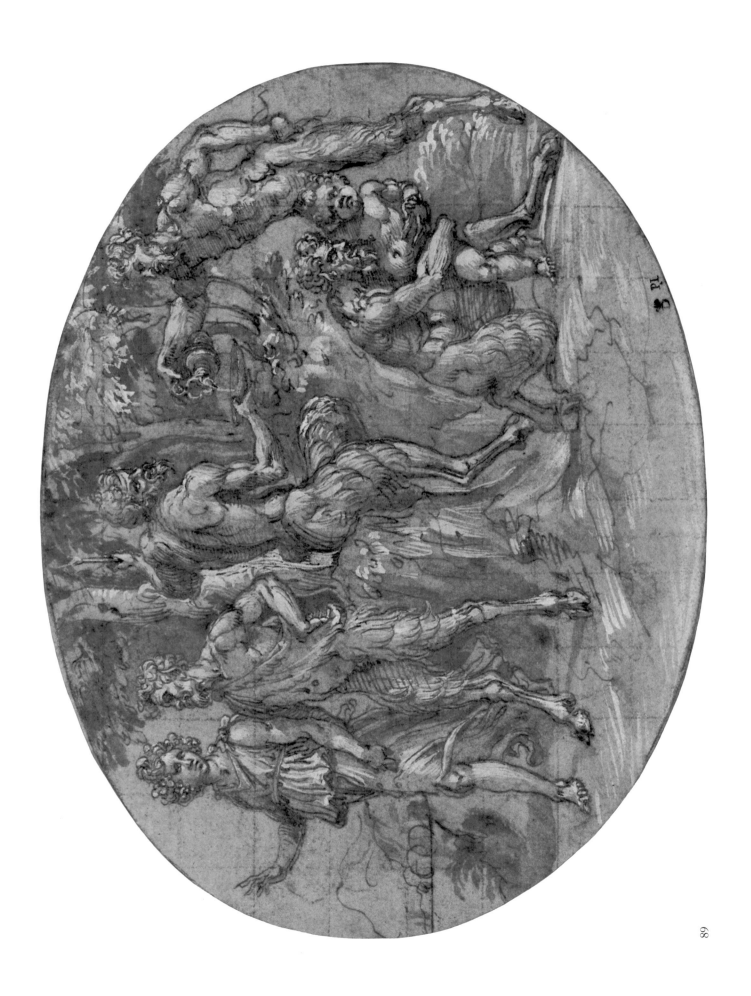

PL.

BALDASSARE PERUZZI

SIENA 1481–1536 ROME

89 Composition of Four Satyrs with a Youth (?) and a Child

Pen and brown wash, heightened with white. Squared in black chalk. Trimmed to an oval.
Maximum measurements: 178: 242 mm.

PROVENANCE: Sir Peter Lely (Lugt 2092); William, 2nd Duke of Devonshire (Lugt 718).

LITERATURE: Frommel 58 c 3.

Chatsworth 41

TRADITIONALLY and correctly attributed to Peruzzi. Philip Pouncey was the first to point out that this is a *modello* for one of the small oval frescoes of mythological subjects on the vaults of the side-sections of the Villa Madama. The Villa, on Monte Mario just to the north of Rome, was designed by Raphael with the help of Giulio Romano for Cardinal Giulio de'Medici (later Pope Clement VII). Its decoration was begun by Giulio and Giovanni da Udine in the summer of 1520, very soon after Raphael's death. Though Peruzzi is not mentioned in this connection by Vasari, and though there is no documentary evidence for associating him with the Villa, his involvement in the decoration of the loggia is established by Pouncey's discovery of this drawing and others all certainly by him.

Frommel observes that these oval paintings served a purely decorative purpose, since they do not have any particular iconographic program: of the other three in the same vault, one represents *Odysseus and the Daughters of Lycomedes* (drawing, formerly also at Chatsworth, now in the J. Paul Getty Museum at Malibu: Chatsworth sale, Christie's, 1984, 3 May, lot 35) and another *The Discovery of Achilles*; but the subject of the third is *Salmacis and Hermaphrodite* (drawing in the Louvre: 10476, *Autour de Raphaël*, no. 17) while that of the fourth, for which No. 89 is a study, is wholly indeterminate. The figure on the left of the group has been described as a nymph, but Frommel may be right in seeing it as a young man. They are all reproduced by Frommel on pls. xlvii–xlviii.

90 Moses Striking the Rock

Pen and brown wash, heightened with white, on dark brown prepared paper. 261: 398 mm.

PROVENANCE: Evrard Jabach (Lugt 960ᵃ followed by paraph, on back of old mat); Sir Joshua Reynolds (Lugt 2364); Charles Fairfax Murray; J. Pierpont Morgan.

LITERATURE: Fairfax Murray, iv, no. 19; Marabottini, p. 350; Ravelli 2; Frommel 67.

The Pierpont Morgan Library IV, 19

INSCRIBED on the old mat, in an eighteenth-century hand: *Polidoro*. It is significant that both Marabottini and Ravelli should accept without question the traditional attribution. Neither of them mentions Philip Pouncey's suggestion that the drawing is by Peruzzi. The drawing does indeed come very close to Polidoro in the grouping and individual poses of the figures and also, to some extent, the technique; but the smooth regularity of the white hatching, and especially the outlining of the sleeve of the figure at the apex of the group in the middle distance, are characteristic of Peruzzi. The confusion is not surprising, for Peruzzi was unquestionably the most important single influence on Polidoro. Vasari emphasizes that the archaeologizing type of grisaille façade painting in imitation of Antique sarcophagus reliefs which became Polidoro's specialty in the 1520s was directly inspired by Peruzzi. Another example of a drawing by him that could easily be mistaken at first sight for one by Polidoro is the *Invention of the Cross* in the British Museum (Pouncey and Gere 251 and Frommel pl. liva; cf. *Master Drawings*, xxiii–xxiv [1985–86], p. 63).

Frommel accepts Pouncey's attribution, and sees an analogy in composition between this drawing and the fresco of *The Gathering of Manna*—another of the miracles of Moses—on the "volta dorata" in one of the rooms of the Palazzo della Cancelleria, which he dates 1519.

The technique of the drawing suggests that it may have been made with a chiaroscuro woodcut in mind, but no such print is known. There is an undescribed and uninscribed engraving of it, in the same direction, in the manner of Marcantonio (impression in the Albertina, Vienna).

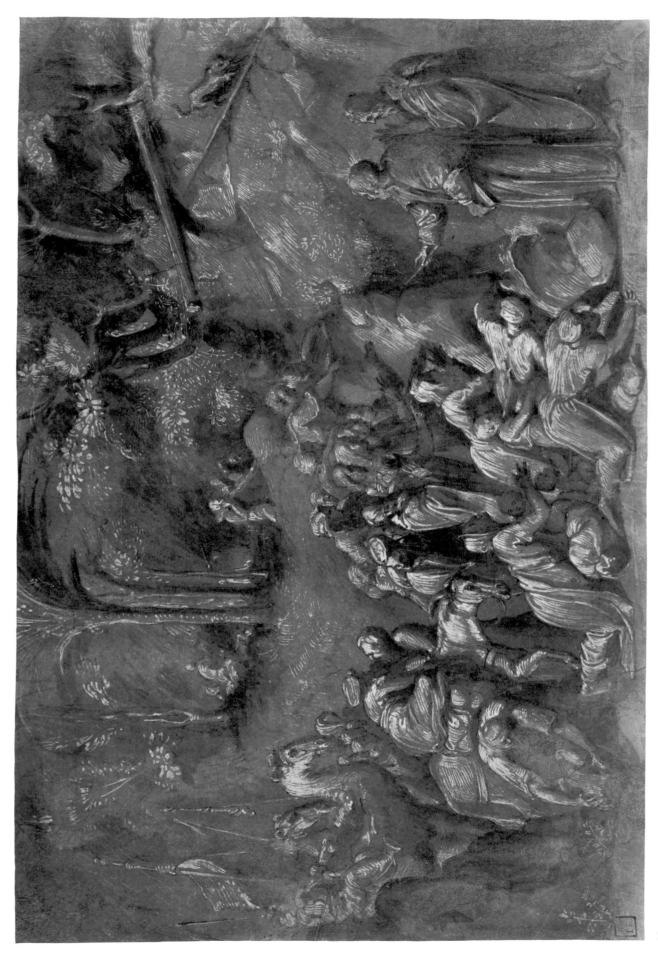

91 The Holy Family and a Donor with Saints

Pen and brown wash. 189: 142 mm.

PROVENANCE: Earl Spencer (Lugt 1532); Charles Fairfax Murray; J. Pierpont Morgan.

LITERATURE: Fairfax Murray, i, no. 44; Bean and Stampfle 47; Frommel 129.

The Pierpont Morgan Library I, 44

INSCRIBED lower left in ink, in a sixteenth-century hand: *tiziano*. Attributed by Fairfax Murray to Sodoma and kept under his name until about 1950, when Peruzzi's authorship was recognized by Philip Pouncey. In the left foreground is an Archangel (probably St. Michael), and behind him two episcopal saints. On the right is a monastic saint presenting a donor to the Virgin and Child. St. Joseph, with folded arms, stands at the back, looking up towards the hovering angels.

The loose scribbly handling shows that this is a late work, dating probably from the 1530s, but the general design of the composition still reveals an evident debt to Raphael.

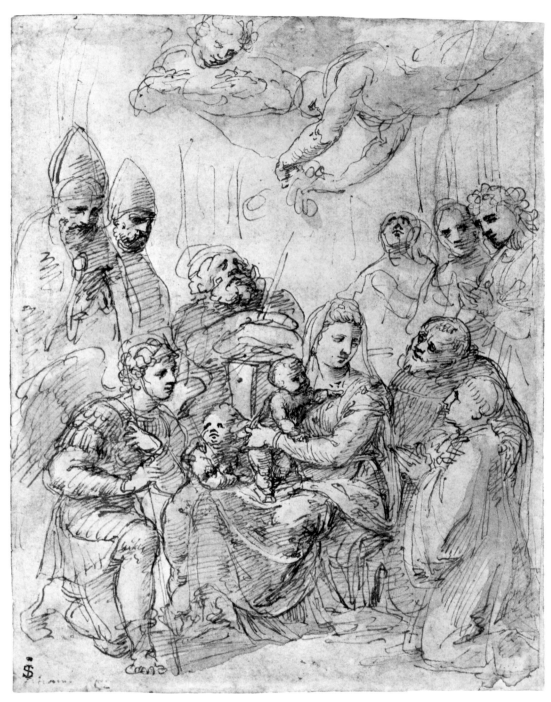

91